ST42 ~ pomo
Lyotard - Pomo as undersc...
modern - what in dialogue w. modern
vs. Jameson - more focused on
loss of historicity / history.

AFTER THE
GREAT DIVIDE

Theories of Representation and Difference

General Editor: Teresa de Lauretis

AFTER THE

Modernism, Mass Culture, Postmodernism

GREAT DIVIDE

Andreas Huyssen

INDIANA UNIVERSITY PRESS

Bloomington and Indianapolis

© 1986 by Andreas Huyssen
All rights reserved

No part of this book may be reproduced or utilized in any form
or by any means, electronic or mechanical, including photocopying
and recording, or by any information storage and retrieval system,
without permission in writing from the publisher. The Association
of American University Presses' Resolution on Permissions constitutes
the only exception to this prohibition.

Manufactured in the United States of America

Library of Congress Cataloging-in-Publication Data

Huyssen, Andreas.
 After the great divide.

 (Theories of representation and difference)
 1. Arts, Modern—20th century. 2. Modernism (Art)
3. Postmodernism. 4. Popular culture. I. Title.
II. Series.
NX456.H89 1987 700'.9'04 85-46010
ISBN 0-253-10057-7
ISBN 0-253-20399-6 (pbk.)

1 2 3 4 5 90 89 88 87 86

ANDREAS HUYSSEN, Professor of German, Columbia University, is an editor of *New German Critique* and an author of books on Romanticism and the *Sturm und Drang*. He also coedited *The Technological Imagination* and *Postmoderne: Zeichen eines kulturellen Wandels*.

Contents

ACKNOWLEDGMENTS

Most of the essays assembled in this book were published over the past ten years either in *New German Critique* or in the *Theories of Contemporary Culture* series published by the Center for Twentieth Century Studies at the University of Wisconsin-Milwaukee. They appear here in essentially unaltered form. My first thanks go to my fellow editors on the journal and to all the friends and colleagues who passed through the Center or work there now. The journal and the Center were two forums of intellectual, political debate and constant stimulation without which these essays could not have been written.

The idea for this book first took shape while I was on a fellowship from the National Endowment for the Humanities. A recent fellowship at the Center for Twentieth Century Studies allowed me to complete the manuscript. As I am about to leave Milwaukee, I want to thank the Center's Director, Kathleen Woodward, and its staff, Jean Lile and Carol Tennessen, for their unfailing support and friendship over all these years.

My special thanks go to three people: first to my wife, Nina Bernstein, a professional writer whose aggressively sensitive editing and ruthless purging of Teutonic syntax and related quirks made my transition from writing German to writing English possible and, after torturous beginnings, even pleasurable. (Of course I had to resist the total liquidation of all traces of my native language, and I will not pretend that she was always satisfied with the end result.) My thanks also go to Teresa de Lauretis, fellow alien on these shores and long-time friend and colleague in Milwaukee, with whom I shared the intellectual adventures of the otherwise dismal 1970s and early 1980s, and who encouraged me to gather these essays into a book. Finally, I want to thank David Bathrick, who not only was coauthor of the essay on Heiner Müller, but is present in many ways in my thinking and writing. He first helped me gain a sense of intellectual purpose in America and taught me everything I know about McDonalds. I am still not fully persuaded by the latter, but my kids are. To them, Daniel and David, I dedicate this book.

INTRODUCTION

Ever since the mid-19th century, the culture of modernity has been characterized by a volatile relationship between high art and mass culture. Indeed, the emergence of early modernism in writers such as Flaubert and Baudelaire cannot be adequately understood on the basis of an assumed logic of "high" literary evolution alone. Modernism constituted itself through a conscious strategy of exclusion, an anxiety of contamination by its other: an increasingly consuming and engulfing mass culture. Both the strengths and the weaknesses of modernism as an adversary culture derive from that fact. Not surprisingly, this anxiety of contamination has appeared in the guise of an irreconcilable opposition, especially in the l'art pour l'art movements of the turn of the century (symbolism, aestheticism, art nouveau) and again in the post–World War II era in abstract expressionism in painting, in the privileging of experimental writing, and in the official canonization of "high modernism" in literature and literary criticism, in critical theory and the museum.

However, modernism's insistence on the autonomy of the art work, its obsessive hostility to mass culture, its radical separation from the culture of everyday life, and its programmatic distance from political, economic, and social concerns was always challenged as soon as it arose. From Courbet's appropriation of popular iconography to the collages of cubism, from naturalism's attack on l'art pour l'art to Brecht's immersion in the vernacular of popular culture, from Madison Avenue's conscious exploitation of modernist pictorial strategies to postmodernism's uninhibited learning from Las Vegas, there has been a plethora of strategic moves tending to destabilize the high/low opposition from within. Ultimately, however, these attempts have never had lasting effects. If anything, they rather seem to have provided, for a host of different reasons, new strength and vitality to the old dichotomy. Thus the opposition between modernism and mass culture has remained amazingly resilient over the decades. To argue that this simply has to do with the inherent "quality" of the one and the depravations of the other—correct as it may be in the case of many specific works—is to perpetuate the time-worn strategy of exclusion; it is itself a sign of the anxiety of contamination. This book will suggest a number of historical and theoretical reasons for the longevity of this paradigm, and it will raise the question to what extent postmodernism can be regarded as a new departure.

The most sustained attack on aestheticist notions of the self-sufficiency of high culture in this century resulted from the clash of the early modernist autonomy aesthetic with the revolutionary politics arising in Russia and Germany out of World War I, and with the rapidly accelerating modernization of life in the big cities of the early 20th century. This attack goes by the name of historical avantgarde, which clearly represented a new stage in the trajectory of the modern. Its most salient manifestations were expressionism and Berlin

Dada in Germany; Russian constructivism, futurism, and the proletcult in the years following the Russian Revolution; and French surrealism, especially in its earlier phase. Of course, this historical avantgarde was soon liquidated or driven into exile by fascism and Stalinism, and its remnants were later retrospectively absorbed by modernist high culture even to the extent that "modernism" and "avantgarde" became synonymous terms in the critical discourse. My point of departure, however, is that despite its ultimate and perhaps inevitable failure, the historical avantgarde aimed at developing an alternative relationship between high art and mass culture and thus should be distinguished from modernism, which for the most part insisted on the inherent hostility between high and low. Such a distinction is not meant to account for each and every individual case; there are modernists whose aesthetic practice was close to the spirit of avantgardism, and one could point to avantgardists who shared modernism's aversion to any form of mass culture. But even though the boundaries between modernism and avantgardism remained fluid, the distinction I am suggesting permits us to focus on sufficiently discernible trends within the culture of modernity. More specifically, it allows us to distinguish the historical avantgarde from late-19th-century modernism as well as from the high modernism of the interwar years. In addition, the focus on the high/low dichotomy and on the modernism/avantgardism constellation in the earlier 20th century will ultimately provide us with a better understanding of postmodernism and its history since the 1960s.

What I am calling the Great Divide is the kind of discourse which insists on the categorical distinction between high art and mass culture. In my view, this divide is much more important for a theoretical and historical understanding of modernism and its aftermath than the alleged historical break which, in the eyes of so many critics, separates postmodernism from modernism. The discourse of the Great Divide has been dominant primarily in two periods, first in the last decades of the 19th century and the first few years of the 20th, and then again in the two decades or so following World War II. The belief in the Great Divide, with its aesthetic, moral, and political implications, is still dominant in the academy today (witness the almost total institutional separation of literary studies, including the new literary theory, from mass culture research, or the widespread insistence on excluding ethical or political questions from the discourse on literature and art). But it is increasingly challenged by recent developments in the arts, film, literature, architecture, and criticism. This second major challenge in this century to the canonized high/low dichotomy goes by the name of postmodernism; and like the historical avantgarde though in very different ways, postmodernism rejects the theories and practices of the Great Divide. Indeed, the birth of the postmodern out of the spirit of an adversary avantgardism cannot be adequately understood unless modernism's and postmodernism's different relationship to mass culture is grasped. Too many discussions of postmodernism fail entirely to address this problem, thereby losing, in a certain sense, their very object and getting bogged down in the futile attempt to define the postmodern in terms of style alone.

After all, both modernism and the avantgarde always defined their identity in relation to two cultural phenomena: traditional bourgeois high culture (especially the traditions of romantic idealism and of enlightened realism and representation), but also vernacular and popular culture as it was increasingly

transformed into modern commercial mass culture. Most discussions of modernism, the avantgarde, and even postmodernism, however, valorize the former at the expense of the latter. If mass culture enters in at all, it is usually only as negative, as the homogeneously sinister background on which the achievements of modernism can shine in their glory. This is what the French poststructuralists have in common with the theorists of the Frankfurt School, despite all their other considerable differences. One explicit aim of this book is to begin to redress this imbalance and, in so doing, contribute to a better understanding of the fault lines between modernism and postmodernism. The point of my argument, however, will not be to deny the quality differences between a successful work of art and cultural trash (Kitsch). To make quality distinctions remains an important task for the critic, and I will not fall into the mindless pluralism of anything goes. But to reduce all cultural criticism to the problem of quality is a symptom of the anxiety of contamination. Not every work of art that does not conform to canonized notions of quality is therefore automatically a piece of Kitsch, and the working of Kitsch into art can indeed result in high-quality works. Further work on specific postmodernist texts will have to explore this dimension. In this book I am more concerned with theoretical and historical questions that can help us understand contemporary culture. The subtext for all of the essays assembled here is the conviction that the high modernist dogma has become sterile and prevents us from grasping current cultural phenomena. The boundaries between high art and mass culture have become increasingly blurred, and we should begin to see that process as one of opportunity rather than lamenting loss of quality and failure of nerve. There are many successful attempts by artists to incorporate mass cultural forms into their work, and certain segments of mass culture have increasingly adopted strategies from on high. If anything, that is the postmodern condition in literature and the arts. For quite some time, artists and writers have lived and worked after the Great Divide. It is time for the critics to catch on.

Adorno, of course, was the theorist par excellence of the Great Divide, that presumably necessary and insurmountable barrier separating high art from popular culture in modern capitalist societies. He developed his theory, which I see as a theory of modernism, for music, literature, and film in the late 1930s, not coincidentally at the same time that Clement Greenberg articulated similar views to describe the history of modernist painting and to envision its future. Broadly speaking, it can be argued that both men had good reasons at the time to insist on the categorical separation of high art and mass culture. The political impulse behind their work was to save the dignity and autonomy of the art work from the totalitarian pressures of fascist mass spectacles, socialist realism, and an ever more degraded commercial mass culture in the West. That project was culturally and politically valid at the time, and it contributed in a major way to our understanding of the trajectory of modernism from Manet to the New York School, from Richard Wagner to the Second Vienna School, from Baudelaire and Flaubert to Samuel Beckett. It found its theoretically more limited expression in the New Criticism (the basic premises of which Adorno clearly would have rejected), and even today some of its basic assumptions continue to assert themselves, even though in altered form, in French poststructuralism and its American progeny. My argument, however, is that this project has run its course and is being replaced by a new paradigm, the paradigm of the

postmodern, which is itself as diverse and multifaceted as modernism had once been before it ossified into dogma. By "new paradigm" I do not mean to suggest that there is a total break or rupture between modernism and postmodernism, but rather that modernism, avantgarde, and mass culture have entered into a new set of mutual relations and discursive configurations which we call "postmodern" and which is clearly distinct from the paradigm of "high modernism." As the word "postmodernism" already indicates, what is at stake is a constant, even obsessive negotiation with the terms of the modern itself.

After the Great Divide, then, is a collection of essays, written roughly in a span of ten years and from the vantage point of the postmodern, that challenge the belief in the necessary separation of high art from mass culture, politics, and the everyday. While my own evolving position vis-à-vis the postmodern is elaborated only in the last essay, it indirectly informs every one of the preceding essays, beginning (chronologically) with those on the European historical avantgarde of the 1920s, and on to the essays on post–World War II German literature, American Pop Art, the international avantgarde exhibits of the 1970s, and the American postmodernism debate of the early 1980s.

The essays were not written in the sequence in which they appear here. Each of the three sections contains both earlier and recent essays. Section I, "The Vanishing Other: Mass Culture," deals theoretically and historically with the relationship between modernism, avantgarde, and mass culture. The first essay, "The Hidden Dialectic," argues in broad outline that technological modernization of society and the arts (through the new media of reproduction) was used by the historical avantgarde to sustain its revolutionary political and aesthetic claims. Technology emerges as a pivotal factor in the avantgarde's fight against an aestheticist modernism, in its focus on new modes of perception, and in its perhaps deluded dream of an avantgardist mass culture. The second essay deals with the major theoretician of the Great Divide, Theodor W. Adorno. Adorno developed his theory of the culture of modernity at a time when the avantgarde's dream of leading art back into life and of creating a revolutionary art had become a nightmarish reality in Hitler's Germany and Stalin's Soviet Union. The essay shows how Adorno's theory of modernism and his critique of modern mass culture are two sides of the same coin and how his interpretation of Richard Wagner, written at the time of the fascist Wagner cult, actually prepares the ground for his later influential condemnations of the American culture industry. For the argument of the book, the essay is central in that it tries to elucidate the aesthetic rationale as well as the historical and political determinations of Adorno's specific version of the Great Divide. The third essay in part I, "Mass Culture as Woman," takes up a feminist line of questioning and discusses how the modernism/mass culture dichotomy has been gendered as masculine/feminine from Flaubert and the brothers Goncourt via Nietzsche, the futurists, and the constructivists, up to Adorno, Roland Barthes, and French poststructuralism. It shows how the gender dichotomy has been inscribed, in subtle and not so subtle ways, into theories of the Great Divide. The point of the essay is not to denounce all modernism or, for that matter, avantgardism as male chauvinist, but rather to contest (even though only indirectly) recent French readings, especially by Kristeva and Derrida, that see modernist experimental writing as per se feminine. The essay can be read as a kind of historical deconstruction of the binary opposition of mass

culture vs. high art which still haunts the poststructuralist project and keeps it within the orbit of modernism theories, an argument developed more fully in the final essay of the volume.

Part II, "Texts and Contexts," offers readings of specific texts in historical context and in light of contemporary theoretical questions regarding sexuality and subjectivity, memory and identification, revolution and cultural resistance. All four essays deal with the problem of modernism/avantgardism/mass culture, and all are related in various ways to the political history of modern Germany, especially to the history of fascism and socialism. They stand for a certain kind of "politics of reading" and thus should be of interest to those concerned with recuperating history and politics for a contemporary theory of reading and interpretation. The essays discuss and analyze a major Weimar film, Fritz Lang's *Metropolis*, which drew as much on the visual vocabulary of the avantgarde as on the long-standing traditions of popular culture and its frequent presentation of technology as woman; an East German play of the late 1960s, Heiner Müller's *Mauser*, which is a post-Stalinist rewriting of Brecht's Lehrstück *The Measures Taken*; the American television drama "Holocaust," its reception in West Germany, and its relationship to German dramas (mainly modernist in form) dealing with Auschwitz and the holocaust; and the role of tradition, memory, and avantgardism in what is perhaps the major German novel of the 1970s, Peter Weiss's *Die Ästhetik des Widerstands*.

Obviously the choice of texts in this section is somewhat arbitrary, and I can only hope that my own aesthetic and political concerns over the years have been stubborn enough to permit the reader to find the red thread connecting these four essays. Implicit throughout this section, however, is the claim that none of these texts and the questions they raise can be adequately approached within the framework of modernism theories, whether they be Adornean, new critical, or poststructuralist. To the extent that these readings can be called paradigmatic, they position themselves in a critical and theoretical space after the Great Divide.

Part III, entitled "Toward the Postmodern," contains three pieces. The first one, "The Cultural Politics of Pop," attempts to describe a new relationship between high culture and the popular as it emerged in the United States in the early 1960s in conscious antagonism toward the canonization of high modernism in the previous decades. Pop Art is interpreted dialectically as both an affirmative and a critical art, and is seen as a pivotal movement initiating the push toward the postmodern in the context of the cultural politics of the 1960s. The second and the third essays are broader efforts to understand key cultural issues raised in America by the specter of the postmodern, which has baffled, irritated, and excited me ever since I began to think about it in the mid-1970s. "The Search for Tradition" begins with a reflection on the meaning of the multiple 1970s exhibits of the art of the historical avantgarde and then goes on to raise a number of questions about contemporary art and culture in Europe and the United States, questions which are more systematically elaborated in "Mapping the Postmodern." This concluding essay sketches a history of the postmodern from its beginnings in the late 1950s to the present, focusing on three constellations only: the relationship of postmodernism to high modernism and the avantgarde, to neoconservatism, and to poststructuralism. My inclination here and throughout is to insist on an approach which would try to

work out the affirmative *and* the critical moments of the postmodern, or, for that matter, the avantgarde, rather than either celebrating it uncritically or condemning it *in toto*. If such an approach were to be called dialectical, it would neither be the Hegelian dialectic with its move toward sublation and telos, nor would it be the Adornean negative dialectic at a standstill. But, clearly, I do not believe that a cultural criticism indebted to the tradition of Western Marxism is bankrupt or obsolete today any more than I would concede to the false dichotomy between postmodern cynicism and the strong defense of modernist seriousness. Neither postmodern pastiche nor the neoconservative restoration of high culture has won the day, and only time will tell who the real cynics are.

Milwaukee, November 1985

PART ONE

The Vanishing Other: Mass Culture

1

The Hidden Dialectic: Avantgarde—Technology— Mass Culture

> Historical materialism wishes to retain that im-
> age of the past which unexpectedly appears to
> man singled out by history at a moment of dan-
> ger. The danger affects both the content of the
> tradition and its receivers. The same threat
> hangs over both: that of becoming a tool of the
> ruling classes. In every era the attempt must be
> made anew to wrest tradition away from con-
> formism that is about to overpower it.
>
> Walter Benjamin
> *Theses on the Philosophy of History*

I

When Walter Benjamin, one of the foremost theoreticians of avant-
garde art and literature, wrote these sentences in 1940 he certainly did
not have the avantgarde in mind at all. It had not yet become part of
that tradition which Benjamin was bent on salvaging. Nor could Ben-
jamin have foreseen to what extent conformism would eventually
overpower the tradition of avantgardism, both in advanced capitalist
societies and, more recently, in East European societies as well. Like a
parasitic growth, conformism has all but obliterated the original icono-
clastic and subversive thrust of the historical avantgarde[1] of the first

This essay was first published in *The Myths of Information: Technology and Postindustrial
Culture*, ed. by Kathleen Woodward (Madison, Wis.: Coda Press, 1980), pp. 151–164.

three or four decades of this century. This conformism is manifest in
the vast depoliticization of post–World War II art and its institution-
alization as administered culture,[2] as well as in academic interpreta-
tions which, by canonizing the historical avantgarde, modernism and
postmodernism, have methodologically severed the vital dialectic be-
tween the avantgarde and mass culture in industrial civilization. In
most academic criticism the avantgarde has been ossified into an elite
enterprise beyond politics and beyond everyday life, though their
transformation was once a central project of the historical avantgarde.

In light of the tendency to project the post-1945 depoliticization of
culture back onto the earlier avantgarde movements, it is crucial to
recover a sense of the cultural politics of the historical avantgarde.
Only then can we raise meaningful questions about the relationship
between the historical avantgarde and the neo-avantgarde, modernism
and post-modernism, as well as about the aporias of the avantgarde
and the consciousness industry (Hans Magnus Enzensberger), the
tradition of the new (Harold Rosenberg) and the death of the avant-
garde (Leslie Fiedler). For if discussions of the avantgarde do not break
with the oppressive mechanisms of hierarchical discourse (high vs.
popular, the new new vs. the old new, art vs. politics, truth vs. ideol-
ogy), and if the question of today's literary and artistic avantgarde is
not placed in a larger socio-historical framework, the prophets of the
new will remain locked in futile battle with the sirens of cultural
decline—a battle which by now only results in a sense of déjà vu.

II

Historically the concept of the avantgarde, which until the 1930s was
not limited to art but always referred to political radicalism as well,[3]
assumed prominence in the decades following the French Revolution.
Henri de Saint Simon's *Opinions littéraires, philosophiques et industrielles*
(1825) ascribed a vanguard role to the artist in the construction of the
ideal state and the new golden age of the future,[4] and since then the
concept of an avantgarde has remained inextricably bound to the idea
of progress in industrial and technological civilization. In Saint Simon's
messianic scheme, art, science, and industry were to generate and
guarantee the progress of the emerging technical-industrial bourgeois
world, the world of the city and the masses, capital and culture. The
avantgarde, then, only makes sense if it remains dialectically related to
that for which it serves as the vanguard—speaking narrowly, to the
older modes of artistic expression, speaking broadly, to the life of the

masses which Saint Simon's avantgarde scientists, engineers, and artists were to lead into the golden age of bourgeois prosperity.

Throughout the 19th century the idea of the avantgarde remained linked to political radicalism. Through the mediation of the utopian socialist Charles Fourier, it found its way into socialist anarchism and eventually into substantial segments of the bohemian subcultures of the turn of the century.[5] It is certainly no coincidence that the impact of anarchism on artists and writers reached its peak precisely when the historical avantgarde was in a crucial stage of its formation. The attraction of artists and intellectuals to anarchism at that time can be attributed to two major factors: artists and anarchists alike rejected bourgeois society and its stagnating cultural conservatism, and both anarchists and left-leaning bohemians fought the economic and technological determinism and scientism of Second International Marxism, which they saw as the theoretical and practical mirror image of the bourgeois world.[6] Thus, when the bourgeoisie had fully established its domination of the state and industry, science and culture, the avantgardist was not at all in the forefront of the kind of struggle Saint Simon had envisioned. On the contrary, he found himself on the margins of the very industrial civilization which he was opposing and which, according to Saint Simon, he was to prophesy and bring about. In terms of understanding the later condemnations of avantgarde art and literature both by the right (*entartete Kunst*) and by the left (bourgeois decadence), it is important to recognize that as early as the 1890s the avantgarde's insistence on cultural revolt clashed with the bourgeoisie's need for cultural legitimation, as well as with the preference of the Second International's cultural politics for the classical bourgeois heritage.[7]

Neither Marx nor Engels ever attributed major importance to culture (let alone avantgarde art and literature) in the working-class struggles, although it can be argued that the link between cultural and political-economic revolution is indeed implicit in their early works, especially in Marx's Parisian Manuscripts and the *Communist Manifesto*. Nor did Marx or Engels ever posit the Party as the avantgarde of the working class. Rather, it was Lenin who institutionalized the Party as the vanguard of the revolution in *What Is to Be Done* (1902) and soon after, in his article "Party Organization and Party Literature" (1905), severed the vital dialectic between the political and cultural avantgarde, subordinating the latter to the Party. Declaring the artistic avantgarde to be a mere instrument of the political vanguard, "a cog and screw of one single great Social Democratic mechanism set in

motion by the entire politically conscious avantgarde of the entire working class,"[8] Lenin thus helped pave the way for the later suppression and liquidation of the Russian artistic avantgarde which began in the early 1920s and culminated with the official adoption of the doctrine of socialist realism in 1934.[9]

In the West, the historical avantgarde died a slower death, and the reasons for its demise vary from country to country. The German avantgarde of the 1920s was abruptly terminated when Hitler came to power in 1933, and the development of the West European avantgarde was interrupted by the war and the German occupation of Europe. Later, during the cold war, especially after the notion of the end of ideology took hold, the political thrust of the historical avantgarde was lost and the center of artistic innovation shifted from Europe to the United States. To some extent, of course, the lack of political perspective in art movements such as abstract expressionism and Pop art was a function of the altogether different relationship between avantgarde art and cultural tradition in the United States, where the iconoclastic rebellion against a bourgeois cultural heritage would have made neither artistic nor political sense. In the United States, the literary and artistic heritage never played as central a role in legitimizing bourgeois domination as it did in Europe. But these explanations for the death of the historical avantgarde in the West at a certain time, although critical, are not exhaustive. The loss of potency of the historical avantgarde may be related more fundamentally to a broad cultural change in the West in the 20th century: it may be argued that the rise of the Western culture industry, which paralleled the decline of the historical avantgarde, has made the avantgarde's enterprise itself obsolete.

To summarize: since Saint Simon, the avantgardes of Europe had been characterized by a precarious balance of art and politics, but since the 1930s the cultural and political avantgardes have gone their separate ways. In the two major systems of domination in the contemporary world, the avantgarde has lost its cultural and political explosiveness and has itself become a tool of legitimation. In the United States, a depoliticized cultural avantgarde has produced largely affirmative culture, most visibly in pop art where the commodity fetish often reigns supreme. In the Soviet Union and in Eastern Europe, the historical avantgarde was first strangled by the iron hand of Stalin's cultural henchman Zhdanov and then revived as part of the cultural heritage, thus providing legitimacy to regimes which face growing cultural and political dissent.

Both politically and aesthetically, today it is important to retain that image of the now lost unity of the political and artistic avantgarde,

which may help us forge a new unity of politics and culture adequate to our own times. Since it has become more difficult to share the historical avantgarde's belief that art can be crucial to a transformation of society, the point is not simply to revive the avantgarde. Any such attempt would be doomed, especially in a country such as the United States where the European avantgarde failed to take roots precisely because no belief existed in the power of art to change the world. Nor, however, is it enough to cast a melancholy glance backwards and indulge in nostalgia for the time when the affinity of art to revolution could be taken for granted. The point is rather to take up the historical avantgarde's insistence on the cultural transformation of everyday life and from there to develop strategies for today's cultural and political context.

III

The notion that culture is a potentially explosive force and a threat to advanced capitalism (and to bureaucratized socialism, for that matter) has a long history within Western Marxism from the early Lukács up through Habermas's *Legitimation Crisis* and Negt/Kluge's *Öffentlichkeit und Erfahrung*.[10] It even underlies, if only by its conspicuous absence, Adorno's seemingly dualistic theory of a monolithically manipulative culture industry and an avantgarde locked into negativity. Peter Bürger, a recent theoretician of the avantgarde, draws extensively on this critical Marxist tradition, especially on Benjamin and Adorno. He argues convincingly that the major goal of art movements such as Dada, surrealism, and the post-1917 Russian avantgarde was the reintegration of art into life praxis, the closing of the gap separating art from reality. Bürger interprets the widening gap between art and life, which had become all but unbridgeable in late 19th century aestheticism, as a logical development of art within bourgeois society. In its attempt to close the gap, the avantgarde had to destroy what Bürger calls "institution art," a term for the institutional framework in which art was produced, distributed, and received in bourgeois society, a framework which rested on Kant's and Schiller's aesthetic of the necessary autonomy of all artistic creation. During the 19th century the increasingly categorical separation of art from reality and the insistence on the autonomy of art, which had once freed art from the fetters of church and state, had worked to push art and artists to the margins of society. In the art for art's sake movement, the break with society—the society of imperialism—had led into a dead end, a fact painfully clear to the best representatives of aestheticism. Thus the histori-

cal avantgarde attempted to transform l'art pour l'art's isolation from reality—which reflected as much opposition to bourgeois society as Zola's *j'accuse*—into an active rebellion that would make art productive for social change. In the historical avantgarde, Bürger argues, bourgeois art reached the stage of self-criticism; it no longer only criticized previous art *qua* art, but also critiqued the very "institution art" as it had developed in bourgeois society since the 18th century.[11]

Of course, the use of the Marxian categories of criticism and self-criticism implies that the negation and sublation (*Aufhebung*) of the bourgeois "institution art" is bound to the transformation of bourgeois society itself. Since such a transformation did not take place, the avantgarde's attempt to integrate art and life almost had to fail. This failure, later often labelled the death of the avantgarde, is Bürger's starting point and his reason for calling the avantgarde "historical." And yet, the failure of the avantgarde to reorganize a new life praxis through art and politics resulted in precisely those historical phenomena which make any revival of the avantgarde's project today highly problematic, if not impossible: namely, the false sublations of the art/life dichotomy in fascism with its aesthetization of politics,[12] in Western mass culture with its fictionalization of reality, and in socialist realism with its claims of reality status for its fictions.

If we agree with the thesis that the avantgarde's revolt was directed against the totality of bourgeois culture and its psycho-social mechanisms of domination and control, and if we then make it our task to salvage the historical avantgarde from the conformism which has obscured its political thrust, then it becomes crucial to answer a number of questions which go beyond Bürger's concern with the "institution art" and the formal structure of the avantgarde art work. How precisely did the dadaists, surrealists, futurists, constructivists, and productivists attempt to overcome the art/life dichotomy? How did they conceptualize and put into practice the radical transformation of the conditions of producing, distributing, and consuming art? What exactly was their place within the political spectrum of those decades and what concrete political possibilities were open to them in specific countries? In what way did the conjunction of political and cultural revolt inform their art and to what extent did that art become part of the revolt itself? Answers to these questions will vary depending on whether one focuses on Bolshevik Russia, France after Versailles, or Germany, doubly beaten by World War I and a failed revolution. Moreover, even within these countries and the various artistic movements, differentiations have to be made. It is fairly obvious that a montage by Schwitters differs aesthetically and politically from a photomontage by John Heartfield, that Dada Zurich and Dada Paris

developed an artistic and political sensibility which differed substantially from that of Dada Berlin, that Mayakovsky and revolutionary futurism cannot be equated with the productivism of Arvatov or Gastev. And yet, as Bürger has convincingly suggested, all these phenomena can legitimately be subsumed under the notion of the historical avantgarde.

IV

I will not attempt here to answer all these questions, but will focus instead on uncovering the hidden dialectic of avantgarde and mass culture, thereby casting new light on the objective historical conditions of avantgarde art, as well as on the socio-political subtext of its inevitable decline and the simultaneous rise of mass culture.

Mass culture as we know it in the West is unthinkable without 20th century technology—media techniques as well as technologies of transportation (public and private), the household, and leisure. Mass culture depends on technologies of mass production and mass reproduction and thus on the homogenization of difference. While it is generally recognized that these technologies have substantially transformed everyday life in the 20th century, it is much less widely acknowledged that technology and the experience of an increasingly technologized life world have also radically transformed art. Indeed, technology played a crucial, if not *the* crucial, role in the avantgarde's attempt to overcome the art/life dichotomy and make art productive in the transformation of everyday life. Bürger has argued correctly that from Dada on the avantgarde movements distinguish themselves from preceding movements such as impressionism, naturalism, and cubism not only in their attack on the "institution art" as such, but also in their radical break with the referential mimetic aesthetic and its notion of the autonomous and organic work of art. I would go further: no other single factor has influenced the emergence of the new avantgarde art as much as technology, which not only fueled the artists' imagination (dynamism, machine cult, beauty of technics, constructivist and productivist attitudes), but penetrated to the core of the work itself. The invasion of the very fabric of the art object by technology and what one may loosely call the technological imagination can best be grasped in artistic practices such as collage, assemblage, montage and photomontage; it finds its ultimate fulfillment in photography and film, art forms which can not only be reproduced, but are in fact designed for mechanical reproducibility. It was Walter Benjamin who, in his famous essay "The Work of Art in the Age of Mechanical Reproduction," first made the point that it is precisely this mechanical reproducibility which

has radically changed the nature of art in the 20th century, transforming the conditions of producing, distributing, and receiving/consuming art. In the context of social and cultural theory Benjamin conceptualized what Marcel Duchamp had already shown in 1919 in *L.H.O.O.Q.* By iconoclastically altering a reproduction of the *Mona Lisa* and, to use another example, by exhibiting a mass-produced urinal as a fountain sculpture, Marcel Duchamp succeeded in destroying what Benjamin called the traditional art work's aura, that aura of authenticity and uniqueness that constituted the work's distance from life and that required contemplation and immersion on the part of the spectator. In another essay, Benjamin himself acknowledged that the intention to destroy this aura was already inherent in the artistic practices of Dada.[13] The destruction of the aura, of seemingly natural and organic beauty, already characterized the works of artists who still created individual rather than mass-reproducible art objects. The decay of the aura, then, was not as immediately dependent on techniques of mechanical reproduction as Benjamin had argued in the Reproduction essay. It is indeed important to avoid such reductive analogies between industrial and artistic techniques and not to collapse, say, montage technique in art or film with industrial montage.[14]

It may actually have been a new experience of technology that sparked the avantgarde rather than just the immanent development of the artistic forces of production. The two poles of this new experience of technology can be described as the aesthetization of technics since the late 19th century (world expos, garden cities, the *cité industrielle* of Tony Garnier, the *Città Nuova* of Antonio Sant'Elia, the *Werkbund*, etc.) on the one hand and the horror of technics inspired by the awesome war machinery of World War I on the other. And this horror of technics can itself be regarded as a logical and historical outgrowth of the critique of technology and the positivist ideology of progress articulated earlier by the late 19th-century cultural radicals who in turn were strongly influenced by Nietzsche's critique of bourgeois society. Only the post-1910 avantgarde, however, succeeded in giving artistic expression to this bipolar experience of technology in the bourgeois world by integrating technology and the technological imagination in the production of art.

The experience of technology at the root of the dadaist revolt was the highly technologized battlefield of World War I—that war which the Italian futurists glorified as total liberation and which the dadaists condemned as a manifestation of the ultimate insanity of the European bourgeoisie. While technology revealed its destructive power in the big *Materialschlachten* of the war, the dadaists projected technology's destructivism into art and turned it aggressively against the sanctified

sphere of bourgeois high culture whose representatives, on the whole, had enthusiastically welcomed the war in 1914. Dada's radical and disruptive moment becomes even clearer if we remember that bourgeois ideology had lived off the separation of the cultural from industrial and economic reality, which of course was the primary sphere of technology. Instrumental reason, technological expansion, and profit maximization were held to be diametrically opposed to the *schöner Schein* (beautiful appearance) and *interesseloses Wohlgefallen* (disinterested pleasure) dominant in the sphere of high culture.

In its attempt to reintegrate art and life, the avantgarde of course did not want to unite the bourgeois concept of reality with the equally bourgeois notion of high, autonomous culture. To use Marcuse's terms, they did not want to weld the reality principle to affirmative culture, since these two principles constituted each other precisely in their separation. On the contrary, by incorporating technology into art, the avantgarde liberated technology from its instrumental aspects and thus undermined both bourgeois notions of technology as progress and art as "natural," "autonomous," and "organic." On a more traditional representational level, which was never entirely abandoned, the avantgarde's radical critique of the principles of bourgeois enlightenment and its glorification of progress and technology were manifested in scores of paintings, drawings, sculptures, and other art objects in which humans are presented as machines and automatons, puppets and mannequins, often faceless, with hollow heads, blind or staring into space. The fact that these presentations did not aim at some abstract "human condition," but rather critiqued the invasion of capitalism's technological instrumentality into the fabric of everyday life, even into the human body, is perhaps most evident in the works of Dada Berlin, the most politicized wing of the Dada movement. While only Dada Berlin integrated its artistic activities with the working-class struggles in the Weimar Republic, it would be reductive to deny Dada Zurich or Dada Paris any political importance and to decree that their project was "only aesthetic," "only cultural." Such an interpretation falls victim to the same reified dichotomy of culture and politics which the historical avantgarde had tried to explode.

V

In Dada, technology mainly functioned to ridicule and dismantle bourgeois high culture and its ideology, and thus was ascribed an iconoclastic value in accord with Dada's anarchistic thrust. Technology took an entirely different meaning in the post-1917 Russian avantgarde—in futurism, constructivism, productivism, and the proletcult.

The Russian avantgarde had already completed its break with tradition when it turned openly political after the revolution. Artists organized themselves and took an active part in the political struggles, many of them by joining Lunacharsky's NARKOMPROS, the Commissariat for Education. Many artists automatically assumed a correspondence and potential parallel between the artistic and political revolution, and their foremost aim became to weld the disruptive power of avantgarde art to the revolution. The avantgarde's goal to forge a new unity of art and life by creating a new art and a new life seemed about to be realized in revolutionary Russia.

This conjunction of political and cultural revolution with the new view of technology became most evident in the LEF group, the productivist movement, and the proletcult. As a matter of fact, these left artists, writers, and critics adhered to a cult of technology which to any contemporary radical in the West must have seemed next to inexplicable, particularly since it expressed itself in such familiar capitalist concepts as standardization, Americanization, and even taylorization. In the mid-1920s, when a similar enthusiasm for technification, Americanism, and functionalism had taken hold among liberals of the Weimar Republic, George Grosz and Wieland Herzfelde tried to explain this Russian cult of technology as emerging from the specific conditions of a backward agrarian country on the brink of industrialization and rejected it for the art of an already highly industrialized West: "In Russia this constructivist romanticism has a much deeper meaning and is in a more substantial way socially conditioned than in Western Europe. There constructivism is partially a natural reflection of the powerful technological offensive of the beginning industrialization."[15] And yet, originally the technology cult was more than just a reflection of industrialization, or, as Grosz and Herzfelde also suggest, a propagandistic device. The hope that artists such as Tatlin, Rodchenko, Lissitzky, Meyerhold, Tretyakov, Brik, Gastev, Arvatov, Eisenstein, Vertov, and others invested in technology was closely tied to the revolutionary hopes of 1917. With Marx they insisted on the qualitative difference between bourgeois and proletarian revolutions. Marx had subsumed artistic creation under the general concept of human labor, and he had argued that human self-fulfillment would only be possible once the productive forces were freed from oppressive production and class relations. Given the Russian situation of 1917, it follows almost logically that the productivists, left futurists, and constructivists would place their artistic activities within the horizon of a socialized industrial production: art and labor, freed for the first time in history from oppressive production relations, were to enter into a new relationship. Perhaps the best example of this tendency is the work of the Central

Institute of Labor (CIT), which, under the leadership of Alexey Gastev, attempted to introduce the scientific organization of labor (NOT) into art and aesthetics.[16] The goal of these artists was not the technological development of the Russian economy at any cost—as it was for the Party from the NEP period on, and as it is manifest in scores of later socialist realist works with their fetishization of industry and technology. Their goal was the liberation of everyday life from all its material, ideological, and cultural restrictions. The artificial barriers between work and leisure, production and culture were to be eliminated. These artists did not want a merely decorative art which would lend its illusory glow to an increasingly instrumentalized everyday life. They aimed at an art which would intervene in everyday life by being both useful and beautiful, an art of mass demonstrations and mass festivities, an activating art of objects and attitudes, of living and dressing, of speaking and writing. Briefly, they did not want what Marcuse has called affirmative art, but rather a revolutionary culture, an art of life. They insisted on the psycho-physical unity of human life and understood that the political revolution could only be successful if it were accompanied by a revolution of everyday life.

VI

In this insistence on the necessary "organization of emotion and thought" (Bogdanov), we can actually trace a similarity between late 19th-century cultural radicals and the Russian post-1917 avantgarde, except that now the role ascribed to technology has been totally reversed. It is precisely this similarity, however, which points to interesting differences between the Russian and the German avantgarde of the 1920s, represented by Grosz, Heartfield, and Brecht among others.

Despite his closeness to Tretyakov's notions of art as production and the artist as operator, Brecht never would have subscribed to Tretyakov's demand that art be used as a means of the emotional organization of the psyche.[17] Rather than describing the artist as an engineer of the psyche, as a psycho-constructor,[18] Brecht might have called the artist an engineer of reason. His dramatic technique of *Verfremdungseffekt* relies substantially on the emancipatory power of reason and on rational ideology critique, principles of the bourgeois enlightenment which Brecht hoped to turn effectively against bourgeois cultural hegemony. Today we cannot fail to see that Brecht, by trying to use the enlightenment dialectically, was unable to shed the vestiges of instrumental reason and thus remained caught in that other dialectic of enlightenment which Adorno and Horkheimer have exposed.[19] Brecht, and to some extent also the later Benjamin, tended toward

fetishizing technique, science, and production in art, hoping that modern technologies could be used to build a socialist mass culture. Their trust that capitalism's power to modernize would eventually lead to its breakdown was rooted in a theory of economic crisis and revolution which, by the 1930s, had already become obsolete. But even there, the differences between Brecht and Benjamin are more interesting than the similarities. Brecht does not make his notion of artistic technique as exclusively dependent on the development of productive forces as Benjamin did in his Reproduction essay. Benjamin, on the other hand, never trusted the emancipatory power of reason and the *Verfremdungseffekt* as exclusively as Brecht did. Brecht also never shared Benjamin's messianism or his notion of history as an object of construction.[20] But it was especially Benjamin's emphatic notion of experience (*Erfahrung*) and profane illumination that separated him from Brecht's enlightened trust in ideology critique and pointed to a definite affinity between Benjamin and the Russian avantgarde. Just as Tretyakov, in his futurist poetic strategy, relied on shock to alter the psyche of the recipient of art, Benjamin, too, saw shock as a key to changing the mode of reception of art and to disrupting the dismal and catastrophic continuity of everyday life. In this respect, both Benjamin and Tretyakov differ from Brecht: the shock achieved by Brecht's *Verfremdungseffekt* does not carry its function in itself but remains instrumentally bound to a rational explanation of social relations which are to be revealed as mystified second nature. Tretyakov and Benjamin, however, saw shock as essential to disrupting the frozen patterns of sensory perception, not only those of rational discourse. They held that this disruption is a prerequisite for any revolutionary reorganization of everyday life. As a matter of fact, one of Benjamin's most interesting and yet undeveloped ideas concerns the possibility of a historical change in sensory perception, which he links to a change in reproduction techniques in art, a change in everyday life in the big cities, and the changing nature of commodity fetishism in 20th-century capitalism. It is highly significant that just as the Russian avantgarde aimed at creating a socialist mass culture, Benjamin developed his major concepts concerning sense perception (decay of aura, shock, distraction, experience, etc.) in essays on mass culture and media as well as in studies on Baudelaire and French surrealism. It is in Benjamin's work of the 1930s that the hidden dialectic between avantgarde art and the utopian hope for an emancipatory mass culture can be grasped alive for the last time. After World War II, at the latest, discussions about the avantgarde congealed into the reified two-track system of high vs. low, elite vs. popular, which itself is the historical expression of the avantgarde's failure and of continued bourgeois domination.

VII

Today, the obsolescence of avantgarde shock techniques, whether dadaist, constructivist, or surrealist, is evident enough. One need only think of the exploitation of shock in Hollywood productions such as *Jaws* or *Close Encounters of the Third Kind* in order to understand that shock can be exploited to reaffirm perception rather than change it. The same holds true for a Brechtian type of ideology critique. In an age saturated with information, including critical information, the *Verfremdungseffekt* has lost its demystifying power. Too much information, critical or not, becomes noise. Not only is the historical avantgarde a thing of the past, but it is also useless to try to revive it under any guise. Its artistic inventions and techniques have been absorbed and co-opted by Western mass mediated culture in all its manifestations from Hollywood film, television, advertising, industrial design, and architecture to the aesthetization of technology and commodity aesthetics. The legitimate place of a cultural avantgarde which once carried with it the utopian hope for an emancipatory mass culture under socialism has been preempted by the rise of mass mediated culture and its supporting industries and institutions.

Ironically, technology helped initiate the avantgarde artwork and its radical break with tradition, but then deprived the avantgarde of its necessary living space in everyday life. It was the culture industry, not the avantgarde, which succeeded in transforming everyday life in the 20th century. And yet—the utopian hopes of the historical avantgarde are preserved, even though in distorted form, in this system of secondary exploitation euphemistically called mass culture. To some, it may therefore seem preferable today to address the contradictions of technologized mass culture rather than pondering over the products and performances of the various neo-avantgardes, which, more often than not, derive their originality from social and aesthetic amnesia. Today the best hopes of the historical avantgarde may not be embodied in art works at all, but in decentered movements which work toward the transformation of everyday life. The point then would be to retain the avantgarde's attempt to address those human experiences which either have not yet been subsumed under capital, or which are stimulated but not fulfilled by it. Aesthetic experience in particular must have its place in this transformation of everyday life, since it is uniquely apt to organize fantasy, emotions, and sensuality against that repressive desublimation which is so characteristic of capitalist culture since the 1960s.

2

Adorno in Reverse:
From Hollywood to
Richard Wagner

Ever since the failure of the 1848 revolution, the culture of modernity
has been characterized by the contentious relationship between high
art and mass culture. The conflict first emerged in its typical modern
form in the Second Empire under Napoleon III and in Bismarck's new
German Reich. More often than not it has appeared in the guise of an
irreconcilable opposition. At the same time, however, there has been a
succession of attempts launched from either side to bridge the gap or at
least to appropriate elements of the other. From Courbet's appropria-
tion of popular iconography to Brecht's immersion in the vernacular of
popular culture, from Madison Avenue's conscious exploitation of
avantgardist pictorial strategies to postmodernism's uninhibited learn-
ing from Las Vegas there has been a plethora of strategic moves
tending to destabilize the high/low opposition from within. Yet this
opposition—usually described in terms of modernism vs. mass culture
or avantgarde vs. culture industry—has proven to be amazingly resil-
ient. Such resilience may lead one to conclude that perhaps neither of
the two combatants can do without the other, that their much heralded
mutual exclusiveness is really a sign of their secret interdependence.
Seen in this light, mass culture indeed seems to be the repressed other
of modernism, the family ghost rumbling in the cellar. Modernism, on
the other hand, often chided by the left as the elitist, arrogant and

This essay was first published in *New German Critique*, 29 (Spring/Summer 1983), 8–38.

mystifying master-code of bourgeois culture while demonized by the right as the Agent Orange of natural social cohesion, is the strawman desperately needed by the system to provide an aura of popular legitimation for the blessings of the culture industry. Or, to put it differently, as modernism hides its envy for the broad appeal of mass culture behind a screen of condescension and contempt, mass culture, saddled as it is with pangs of guilt, yearns for the dignity of serious culture which forever eludes it.

Of course, questions raised by this persistent complicity of modernism and mass culture cannot be solved by textual analysis alone or by recourse to categories such as taste or quality. A broader framework is needed! Social scientists in the Marx-Weber tradition such as Jürgen Habermas have argued that with the emergence of civil society the sphere of culture came uncoupled from the political and economic systems. Such a differentiation of spheres (*Ausdifferenzierung*) may have lost some of its explanatory power for contemporary developments, but it is certainly characteristic of an earlier stage of capitalist modernization. It was actually the historical prerequisite for the twin establishment of a sphere of high autonomous art and a sphere of mass culture, both considered to lie outside the economic and political spheres. The irony of course is that art's aspirations to autonomy, its uncoupling from church and state, became possible only when literature, painting and music were first organized according to the principles of a market economy. From its beginnings the autonomy of art has been related dialectically to the commodity form. The rapid growth of the reading public and the increasing capitalization of the book market in the later 18th century, the commercialization of music culture and the development of a modern art market mark the beginnings of the high/low dichotomy in its specifically modern form. This dichotomy then became politically charged in decisive ways when new class conflicts erupted in the mid-19th century and the quickening pace of the industrial revolution required new cultural orientations for a mass populace. Habermas himself has analyzed this process in his *Strukturwandel der Öffentlichkeit* where he argues convincingly that the period of the Second Reich occupies a central place in the emergence of a modern mass culture and in the disintegration of an older bourgeois public sphere.[1] What Habermas has attempted to do, of course, is to insert a historical dimension into what Adorno and Horkheimer, some twenty years earlier, had postulated as the closed and seemingly timeless system of the culture industry. The force of Habermas' account was not lost on John Brenkman who, in an important article, fully agrees with Habermas' periodization: "This public sphere, like all the

institutions and ideologies of the bourgeoisie in the 19th century, underwent extreme contortions as soon as its repressive functions showed through its initial transforming effects. The ethical-political principle of the public sphere—freedom of discussion, the sovereignty of the public will, etc.—proved to be a mask for its economic-political reality, namely, that the private interest of the capitalist class determines all social and institutional authority."[2] Indeed there can be little doubt that—just as the beginnings of modernism—the origins of modern mass culture date back to the decades around 1848, when, as Brenkman sums up, "The European bourgeoisie, still fighting to secure its triumph over aristocracy and monarchy, suddenly faced the counterrevolutionary task of suppressing the workers and preventing them from openly articulating *their* interests."[3]

While the emphasis on revolution and counterrevolution in the mid-19th century is important to a discussion of the origins of mass culture, it certainly does not tell the whole story. The salient fact is that with the universalization of commodity production mass culture begins to cut across classes in heretofore unknown ways. Many of its forms attract cross-class audiences, others remain class-bound. Traditional popular culture enters into a fierce struggle with commodified culture producing a variety of hybrid forms. Such resistances to the reign of the commodity were often recognized by the modernists who eagerly incorporated themes and forms of popular culture into the modernist vocabulary.[4] When we locate the origins of modern mass culture in the mid-19th century, the point is therefore not to claim that the culture of late capitalism "began" in 1848. But the *commodification of culture* did indeed emerge in the mid-19th century as a powerful force, and we need to ask what its specific forms were at that time and how precisely they were related to the industrialization of the human body and to the commodification of labor power. A lot of recent work in social history, history of technology, urban history and philosophy of time has converged on what Anthony Giddens calls the "commodification of time-space" during the formative decades of industrial capitalism.[5] We only need to think of the well-documented changes in the perception and articulation of time and space brought about by railroad travelling,[6] the expansion of the visual field by news photography, the restructuring of city space with the Haussmannization of Paris, and last but not least the increasing imposition of industrial time and space on the human body in schools, factories, and the family. We may take the periodic spectacles of the World Expositions, those major mass-cultural phenomena of the times, as well as the elaborate staging of the commodity in the first giant department stores as salient symptoms of a changing relationship between the human body and the object world that surrounds

it and of which it is itself a major part. What, then, are the traces of this
commodification of time and space, of objects and the human body, in
the arts? Of course, Baudelaire's poetry, Manet's and Monet's painting,
Zola's or Fontane's novels and Schnitzler's plays, to name but a few
examples, provide us with powerful visions of modern life, as it used to
be called, and critics have focused on a number of social types symp-
tomatic for the age, such as the prostitute and the dandy, the flaneur,
the bohemian and the collector. But while the triumph of the modern
in "high art" has been amply documented, we are only beginning to
explore the place of mass culture vis-à-vis the modernization of the
life-world in the 19th century.[7]

Clearly, Adorno and Horkheimer's concept of the culture industry
does not yield much with regard to specific historical and textual
analyses of 19th-century mass culture. Politically, adherence today to
the classical culture industry thesis can only lead to resignation or
moralizing about universal manipulation and domination. Blaming
the culture industry for capitalism's longevity, however, is metaphysics,
not politics. Theoretically, adherence to Adorno's aesthetics may blind
us to the ways in which contemporary art, since the demise of classical
modernism and the historical avantgarde, represents a new conjunc-
ture which can no longer be grasped in Adornean or other modernist
categories. Just as we would want to avoid elevating Adorno's *Aesthetic
Theory* to the status of dogma, the last thing we want to start with is a
simple projection of the culture industry theory back into the 19th
century.

Yet, a discussion of Adorno in the context of the early stage of the
mass culture/modernism dichotomy may still make sense for a number
of simple reasons. First, Adorno is one of a very few critics guided by
the conviction that a theory of modern culture must address both mass
culture and high art. The same cannot be said for most literary and art
criticism in this country. Nor can it be said of mass communication
research which takes place totally apart from literary and art historical
studies. Adorno actually undermines this very separation. The fact
that he himself insists on fundamental separation between the culture
industry and modernist art is to be understood not as a normative
proposition but rather as a reflection of a series of historical experi-
ences and theoretical assumptions which are open to debate.

Secondly, the theory of the culture industry has exerted a tre-
mendous influence on mass culture research in Germany and, to a
somewhat lesser extent, also in the United States.[8] Recalling the ways in
which Adorno theorized about modern mass culture may not be the
worst place to start. After all, a critical, yet sympathetic discussion may
be quite fruitful in countering two current trends: one toward a

theoretically decapitated and mostly affirmative description of "popular" culture, the other toward a moralizing condemnation of imperial mind management by a media apparatus allegedly totally in the grip of capital and profit interests.

Any discussion of Adorno, however, will have to begin by pointing out the theoretical limitations inherent in his thought which, contrary to what one often hears, cannot be reduced simply to a notion of brainwashing or manipulation. Adorno's blindnesses have to be interpreted as simultaneously theoretical and historical ones. Indeed, his theory may appear to us today as a ruin of history, mutilated and damaged by the very conditions of its articulation and genesis: defeat of the German working class, triumph and subsequent exile of modernism from central Europe, fascism, Stalinism and the Cold War. I do not feel the need to either resurrect or bury Adorno, as the saying goes. Both gestures ultimately fail to place Adorno in the ever shifting context of our attempts to understand the culture of modernity. Both attitudes tend to sap the energy from a body of texts which maintain their provocation for us precisely because they recede from a present which increasingly seems to indulge in a self-defeating narcissism of theory or in the hopeless return of jolly good old humanism.

I will begin, then, by briefly recapitulating some of the basic propositions of the culture industry concept and by pointing to some of the problems inherent in it. In a second section, I will show that Adorno can be read against the grain, that his theory is by no means as closed as it may appear at first sight. The task of this reading is precisely to open Adorno's account to its own hesitations and resistances and to allow it to function in slightly different frames. In the two final sections I will discuss how both Adorno's theory of modernism and the theory of the culture industry are shaped not only by fascism, exile and Hollywood, but also quite significantly by cultural phenomena of the late 19th century, phenomena in which modernism and culture industry seem to converge in curious ways rather than being diametrically opposed to each other. Locating elements of the culture industry, with Adorno, in l'art pour l'art, Jugendstil and Richard Wagner may serve two purposes. It may help sustain the claim that Adorno's view of the culture industry and modernism is not quite as binary and closed as it appears. And, on a much broader level, it may point us—in a reversal of Adorno's strategy—toward a desirable and overdue exploration of how modernism itself appropriates and transforms elements of popular culture, trying like Antaeus to gain strength and vitality from such contacts.[9]

Culture Industry

I will organize this brief outline in four clusters of observations:
 1. Culture industry is the result of a fundamental transformation in
the "superstructure" of capitalist societies. This transformation, com-
pleted with the stage of monopoly capitalism, reaches so deep that the
Marxian separation of economy and culture as base and superstruc-
ture is itself called into question. While Marx's account reflected the
realities of 19th-century liberal capitalism, its free market ideology and
its belief in the autonomy of culture, 20th-century capitalism has
"reunified" economy and culture by subsuming the cultural under the
economic, by reorganizing the body of cultural meanings and symbolic
significations to fit the logic of the commodity. Especially with the help
of the new technological media of reproduction and dissemination
monopoly capitalism has succeeded in swallowing up all forms of older
popular cultures, in homogenizing all and any local or regional dis-
courses, and in stifling by co-option any emerging resistances to the
rule of the commodity. All culture is standardized, organized and
administered for the sole purpose of serving as an instrument of social
control. Social control can become total since in "the circle of manipu-
lation and retroactive need . . . the unity of the system grows ever
stronger."[10] Beyond that, culture industry even succeeds in abolishing
the dialectic of affirmation and critique which characterized high
bourgeois art of the liberal age.[11] "Cultural entities typical of the style of
the culture industry are no longer *also* commodities, they are commod-
ities through and through."[12] Or, in a more precise Marxian version
which plays out Marx's distinction of use value and exchange value
thus making the culture industry all-encompassing and totalitarian:
"The more inexorably the principle of exchange value cheats human
beings out of use values, the more successfully it manages to disguise
itself as the ultimate object of enjoyment."[13] Just as art works become
commodities and are enjoyed as such, the commodity itself in con-
sumer society has become image, representation, spectacle. Use value
has been replaced by packaging and advertising. The commodification
of art ends up in the aesthetization of the commodity. The siren song of
the commodity has displaced the *promesse de bonheur* once held by
bourgeois art, and consumer Odysseus blissfully plunges into the sea of
commodities, hoping to find gratification but finding none.[14] More
than the museum or the academy even, department store and super-
market have become the cemeteries of culture. Culture and commod-
ification have been collapsed in this theory to the extent that the

gravitational pull of the culture industry leaves no meaning, no signification unscathed. For Adorno, modernist art is precisely the result of this conjuncture. But such a black-hole theory of capitalist culture is both too Marxist and not Marxist enough. It is too Marxist in that it rigorously applies a narrow reading of Marx's theory of commodity fetishism (the fetish as mere phantasmagoria) to the products of culture. It is not Marxist enough in that it ignores praxis, bypassing the struggles for meaning, symbols, and images which constitute cultural and social life even when the mass-media try to contain them. I am not denying that the increasing commodification of culture and its effects *in* all cultural products are pervasive. What I would deny is the implied notion that function and use are totally determined by corporate intentions, and that exchange value has totally supplanted use value. The double danger of Adorno's theory is that the specificity of cultural products is wiped out and that the consumer is imagined in a state of passive regression. If cultural products were commodities through and through and had only exchange value, they would no longer even be able to fulfill their function in the processes of ideological reproduction. Since they do preserve this use value for capital, however, they also provide a locus for struggle and subversion. Culture industry, after all, does fulfill public functions; it satisfies and legitimizes cultural needs which are not all *per se* false or only retroactive; it articulates social contradictions in order to homogenize them. Precisely this process of articulation can become the field of contest and struggle.

2. The postulated integration and manipulation of the mass of individual consumers from above into the false totality of the authoritarian state or of the culture industry has its psychoanalytic correlate in the theory of the decay of the ego. Löwenthal once put it this way: culture industry is psychoanalysis in reverse, referring of course to Freud's famous statement: "Where Id is, Ego shall be." In a more serious vein, the Institute's *Studies on Authority and the Family* elaborated a theory postulating the objective decline of paternal authority in the bourgeois family. This decline of paternal authority in turn has led to a change in personality type based on conformity to external standards rather than, as in the liberal age, on the internalization of authority. Internalization of authority, however, is held to be a necessary prerequisite for the later (mature) rejection of authority by a strong ego. The culture industry is seen as one of the major factors preventing such "healthy" internalization and replacing it by those external standards of behavior which inevitably lead to conformism. Of course, this analysis was intimately bound up with the Institute's analysis of fascism. Thus in Germany, Hitler could become the substitute father, and

fascist culture and propaganda provided the external guidance for the weak, gullible ego. The decay of ego formation in the family, according to Adorno, is complemented by the ontogenetically subsequent invasion of the psyche by the laws of capitalist production: "The organic composition of man is growing. That which determines subjects as means of production and not as living purposes, increases with the proportion of machines to variable capital."[15] And further: "In this re-organization the ego as business manager delegates so much of itself to the ego as business-mechanism, that it becomes quite abstract, a mere reference-point: self-preservation forfeits the self."[16]

A lot could be said about this theory of the shrinking ego from the viewpoint of psychoanalysis and gender as well as from that of recent changes in family structure and child rearing. I will limit myself to one observation. While the question of the historical constitution of the subject remains important (against essentialist notions of an autonomous subject as well as against ahistorical notions of a decentered subject), the theory of the decay of the ego seems to imply a nostalgia for the strong bourgeois ego and furthermore remains locked into patriarchal patterns of thought. The culture industry as substitute father—Jessica Benjamin has eloquently criticized this view as "patriarchy without father."[17] Critical Theory also remains tied here to a traditional subject philosophy, and one does not need to resort to a critique of the whole trajectory of Western metaphysics in order to see that the notion of a stable "self" is historically datable and dated with the bourgeois age. Just as in their interpretation of culture Adorno and Horkheimer collapse the structure of art with that of the commodity, here they collapse the economic structure of society with the psychic dismantling of the individual, and again a form of closure prevails. Emptied subject and totality immobilize each other. The world appears frozen into nightmare.

3. The analysis of the culture industry draws out and applies to culture the premises of the Hegelian-Weberian Marx reception which had first been articulated in Lukács' *History and Class Consciousness*, the founding text, if there ever was one, of Western Marxism. Indeed, the culture industry chapter of the *Dialectic of Enlightenment* can be read as a political, theoretical and historical reply to Lukács' reworking of Marx's commodity fetishism and Weber's rationalization theory into a philosophy of social praxis. Adorno and Horkheimer's text gains its political cutting edge from its rejection of Lukács' belief in the proletariat as the identical subject-object of history, and the theory of the culture industry becomes the classical locus where its authors show how and why commodity fetishism and reification have forever lost their

emancipatory function in the dialectic of history. To a large degree, it is this implied political and theoretical debate with Lukács which led to Adorno's excessive privileging of the pivotal critical categories of reification, totality, identity and commodity fetishism and to his presentation of the culture industry as a frozen system. Combined with the fearfully observed decay of the ego, this cluster of categories, however, can only prevent a differentiated analysis of social and cultural practices. It has to block out any insight into the functional autonomy of the various subsystems within the total system of production and reproduction. One is almost tempted to speak of an implosion of categories which translates into the incredible density of Adorno's writing, but which ultimately also makes the individual and serial phenomena of which culture industry consists vanish from sight as a field of concrete historical analysis. Even though Adorno recognizes quite frequently that there are limits to the reification of the human subject, he never asks himself whether perhaps there are also limits to the reification of the cultural commodities themselves, limits which become evident when one begins to analyze in detail the signifying strategies of those cultural commodities and the mesh of repression and wish fulfillment, of the gratification, displacement and production of desire which are invariably involved in them and in their reception. On the other hand, we have to acknowledge that Adorno's contribution to the mass culture debate lies in his struggle against another kind of invisibility. His analysis of mass culture as a means of social control ripped to shreds that mystifying veil cast over the culture industry by those who sell it as "mere entertainment," or, even worse, as a genuinely popular culture.

4. Contrary to what Fred Jameson has recently argued, Adorno never lost sight of the fact that, ever since their simultaneous emergence in the mid-19th century, modernism and mass culture have been engaged in a compulsive *pas de deux*. It indeed never occurred to Adorno to see modernism as anything other than a reaction formation to mass culture and commodification, as my later discussion of Adorno's views of Wagner and Schönberg will show. In a famous letter to Benjamin, in which he criticized Benjamin's reproduction essay, he wrote: "Both [modernist art and mass culture] bear the scars of capitalism, both contain elements of change. Both are torn halves of freedom, to which however they do not add up."[18] Adorno sees the dichotomy as historically produced, and he clearly interprets modernism as a "symptom and a result of cultural crisis rather than as a new 'solution' in its own right."[19] Adorno could not agree more with Jameson's claim that the commodity is "the prior form in terms of which alone modernism can be structurally grasped."[20] Even though Adorno's dialectical view

of the relationship between modernism and mass culture may ulti-
mately not be dialectical enough, it warrants repeating—in face of the
often voiced mandarin reproach—that he is miles apart from the
evaluative schemes of conservative mass culture critics and does not
have much in common with the happy-go-lucky apologists of the
triumph of modernism. Nevertheless, as I will argue in more detail
later on, the problematic nature of Adorno's culture industry theory
results precisely from the fact that it functioned, in the Derridean
sense, as a *supplément* to his theory of modernism. Thus the lack of
breadth and generosity which is so striking in Adorno's canon of
modernism is not simply the result of personal, "elitist" taste, but it
flows from his rigorous and relentless analysis of the cultural effects of
commodification. The validity of that analysis has to be questioned if
one wants to deal critically with Adorno's modernist canon. In this
context, I think it is significant to point out that Adorno's modernism
theory relies on certain strategies of exclusion which relegate realism,
naturalism, reportage literature and political art to an inferior realm.
All forms of representation fall under the verdict of reification which
had been pronounced over the culture industry: *Verdoppelung* and
Reklame, duplication and advertising. Just as the products of the cul-
ture industry, representational modern art is dismissed as a reified
reproduction of a false reality. It is certainly strange to see one of the
most perceptive critics of realism affirm, if only negatively, the power
of language and image to represent reality, to reproduce the referent.
Without pursuing this problem any further I am taking the status of
realism in Adorno's modernism theory as support for my claim that
any critique of the culture industry theory must be grounded to Ador-
no's modernist aesthetic. And I would even make the stronger, more
general claim that to speak of modernism without mentioning capital-
ist mass culture is like praising the free market while ignoring the
multinationals.

Marginal Revisions: Reading Adorno against the Grain

No account of the culture industry theory can be considered adequate
unless it also locates Adorno's hesitations, resistances, and displace-
ments within the texts themselves. In a close reading of Adorno's
"Transparencies on Film" Miriam Hansen has recently made a con-
vincing case for reading Adorno against the grain.[21] Such a reading can
indeed show that Adorno himself frequently cast doubt in the positions
taken in *Dialectic of Enlightenment*. One of the most salient examples,
quoted by Hansen, can be found in the posthumously published draft
"Schema der Massenkultur," which was originally meant to be part of

the culture industry chapter in *Dialectic of Enlightenment*. In capsule form Adorno and Horkheimer give the central thesis of the work: "Human beings, as they conform to the technological forces of production which are imposed on them in the name of progress, are transformed into objects which willingly allow themselves to be manipulated and thus fall behind the actual potential of these productive forces."[22] But then, in a dialectical move, the authors place their hope in the very repetitiveness of reification: "Because human beings, as subjects, still constitute the limit of reification, mass culture has to renew its hold over them in an endless series of repetitions; the hopeless effort of repetition is the only trace of hope that the repetition may be futile, that human beings cannot be totally controlled."[23] Examples such as this one could easily be multiplied. But while reading the classical texts on the culture industry against the grain may testify to Adorno's insight into the potential limitations of his theory, I doubt whether such insights should compel us to fundamentally revise our interpretation of these texts. The difficulty may only have been displaced to another area. The same move in which the monolithic closure of the culture industry theory comes undone in the margins seems to reaffirm another closure at the level of the subject. In the quoted passage any potential resistance to the culture industry is ascribed to the subject, however contingent and hallowed out it may be, rather than, say, to intersubjectivity, social action, and the collective organization of cultural experience in what Negt and Kluge have called counter-public spheres (*Gegenöffentlichkeiten*). It is not enough to reproach Adorno for holding on to a monadic or "bourgeois" notion of the subject. Isolation and privatization of the subject are after all the very real effects of much of capitalist mass culture, and the resulting subjectivity is, in Adorno's own terms, quite different from that of the ascendant earlier bourgeois class. The question rather has to be how Adorno defines that subjectivity which would elude manipulation and control.

Jochen Schulte-Sasse has recently argued that Adorno relies on an ahistorical hypostatization of the subject as a self-identical ego equipped with analytical power.[24] If this reading is correct, the subject resisting reification through mass culture is none other than the critical theorist's younger brother, less stable perhaps and less forceful in his resistance, but the hope for resistance would indeed have to place its trust in the residues of that ego-formation which the culture industry tends to destroy. But here, too, one can read Adorno against the grain and point to passages in his work in which the stable and armored ego is seen as the problem rather than the solution. In his critique of Kant's subject of epistemology Adorno attacks the notion of the self-

identical subject as a historically produced construct bound up with social experiences of objectification and reification: "It is obvious that the hardness of the epistemological subject, the identity of self-consciousness mimics the unreflected experience of the consistent, identical object."[25] Adorno's critique of the deeply problematic nature of such fortifications of the subject, which is reminiscent of the Jena romantics is summed up poignantly when he writes: "The subject is all the more a subject the less it is so; and the more it imagines itself to *be* and to be an objective entity for itself, the less it is a subject."[26]

Similarly, in a critical discussion of Freud and the bourgeois privileging of genital sexuality, Adorno recognized the principle of ego-identity as socially constituted: "Not to be oneself is a piece of sexual utopia . . . : negation of the ego principle. It shakes up that invariant of bourgeois society understood in its broadest sense: the demand of identity. First identity had to be constructed, ultimately it will have to be overcome (*aufzuheben*). That which is only identical with itself is without happiness."[27] Such passages point to Adorno's fragile utopian vision of a reconciliation with nature which, as always in Adorno and Horkheimer, is understood as both outer and inner nature in a way that calls their very separation into question: "The dawning sense of freedom feeds upon the memory of the archaic impulse not yet steered by any solid I. The more the I curbs that impulse, the more chaotic and thus questionable will it find that pre-historic freedom. Without an anamnesis of the untamed impulse that precedes the ego—an impulse later banished to the zone of unfree bondage to nature—it would be impossible to derive the idea of freedom, although that idea in turn ends up in reinforcing the ego."[28] As against the previous quote from *Eingriffe* where the *Aufhebung* of bourgeois ego-formation seemed to hold out a promise, here the dialectic ends in aporia. Surely, one problem is that Adorno, like Freud in *Civilization and Its Discontents*, metaphorically collapses the phylogenetic with the ontogenetic level. He permits his historical and philosophical speculations about the dialectic of self-preservation and enlightenment to get in the way of pursuing the question, in relation to mass culture, to what extent and for what purposes the products of the culture industry might precisely speak to and activate such pre-ego impulses in a non-regressive way. His focus on how the commodification of culture dissolves ego-formation and produces mere regression blinds him to that possibility. He founders on the aporia that in his philosophy of civilization these impulses preceding the ego simultaneously contain a sign of freedom and the hope for a reconciliation with nature on the one hand while on the other hand they represent the archaic domination of nature over man which had to be fought in the interest of self-preservation.

Any further discussion of such pre-ego impulses (e.g., partial instincts) in relation to mass culture would lead to the central question of identification, that ultimate bogeyman of Adorno's—and not only Adorno's—modernist aesthetic. Adorno never took that step. The suspension of critical distance which is at stake in any identification with the particular leads inexorably to a legitimation of the false totality. While Adorno recognized that there were limitations to the reification of human subjects through the culture industry which made resistance thinkable at the level of the subject, he never asked himself whether perhaps such limitations could be located in the mass cultural commodities themselves. Such limits do indeed become evident when one begins to analyze in detail the signifying strategies of specific cultural commodities and the mesh of gratification, displacement and production of desires which are invariably put in play in their production and consumption. How precisely identification works in the reception of mass culture, what spaces it opens and what possibilities it closes off, how it can be differentiated according to gender, class and race— these are questions to which the theory of the culture industry might have led had it not been conceived, in the spirit of the negative dialectic, as the threatening other of modernism. And yet, reading Adorno against the grain opens up precisely some of these spaces inside his texts where we might want to begin rewriting his account for a postmodern age.

Prehistory and Culture Industry

To write a prehistory of the modern was the stated goal of Benjamin's never completed arcades project on 19th-century Paris. The dispute between Benjamin and Adorno revolving around their different readings of cultural commodification and of the relationship between prehistory and modernity is well-documented and researched. Given Adorno's trenchant critique of Benjamin's 1935 exposé of the arcades project it is somewhat baffling to find that he never wrote about mass culture in the 19th century. Doing so would have allowed him to refute Benjamin on his own ground, but the closest he ever came to such an undertaking is probably the book on Wagner written in London and New York in 1937 and 1938. Instead he chose to battle Benjamin, especially the Benjamin of "The Work of Art in the Age of Mechanical Reproduction," in his analysis of the 20th-century culture industry. Politically, this choice made perfect sense in the late 1930s and early 1940s, but the price he paid for it was great. Drawing on the experience of mass culture in fascism and developed consumer capitalism, the

theory of the culture industry was itself affected by the reification it decried since it left no room for historical development. Culture industry represented for Adorno the completed return to prehistory under the sign of the eternal recurrence of the same. While Adorno seemed to deny mass culture its own history, his critique of Benjamin's arcades exposé shows clearly that he saw the later 19th century as prefiguring that cultural commodification which reached its fully organized state in the culture industry of the 20th century. If the late 19th century, then, already lives under the threat of cultural barbarism and regression, one might want to take Adorno another step further back. After all, throughout his work he interpreted the culture of modernity with its twin formation of modernism and culture industry as tied to high or monopoly capitalism which in turn is distinguished from the preceding phase of liberal capitalism. The decline of the culture of liberal capitalism, never very strong in Germany in the first place, was by and large complete with the foundation of the Second Reich, most certainly by the 1890s. The history of that crucial transition from the culture of liberal capitalism to that of monopoly capitalism never receives much explicit attention in Adorno's writing, certainly not as much as the artistic developments in the later 19th century which led to the emergence of Adorno's modernism. But even here Adorno writes about the major artists of the period only (the late Wagner, Hofmannsthal, George) while ignoring the popular literature of the times (Karl May, Ganghofer, Marlitt) as well as working-class culture. For naturalism he only reserves some flippant remarks and the early developments of technological media such as photography and film are all but absent from his accounts of the late 19th century. Only with Wagner does Adorno reach back to that earlier stage; and it is no coincidence that Wagner is indeed the pivotal figure in Adorno's prehistory of the modern.

Another point needs to be raised pertaining to this curious absence of 19th-century mass culture in Adorno's writing. Already in the 1930s Adorno must have been aware of historical research on mass culture. He only had to look at the work of one of his fellow researchers at the Institute, Leo Löwenthal, who did much of his work on 18th- and 19th-century German culture, high and low, and who never tired of drawing the connections that existed between 20th-century critiques of mass culture and earlier discussions of the problem in the work of Schiller and Goethe, Tocqueville, Marx and Nietzsche, to name only the most salient figures. Again the question presses itself upon us: why does Adorno ignore the mass culture of the Second Reich? He could have made much of the observation that many of the late 19th-century

popular classics were still common fare in the Third Reich. Interpret-
ing such continuities could have contributed significantly to the under-
standing of the prehistory of fascist culture[29] and the rise of authoritar-
ianism, the process George Mosse has described as the nationalization
of the masses. But that was just not Adorno's primary interest. His first
and foremost goal was to establish a theory of *die Kunst der Moderne*, not
as a historian, but as a participant and critic reflecting upon a specific
stage in the development of capitalist culture and privileging certain
trends within that stage. Adorno's prime example for the emergence of
a genuinely modernist art was the turn to atonality in the music of
Arnold Schönberg rather than, as for Benjamin and many historians of
modernism, the poetry of Baudelaire. For my argument here the
difference in choice of examples is less important than the difference
in treatment. Where Benjamin juxtaposes Baudelaire's poetry with the
texture and experience of modern life showing how modern life in-
vades the poetic text, Adorno focuses more narrowly on the develop-
ment of the musical material itself which he nevertheless interprets as
fait social, as an aesthetic texturing and constructing of the experience
of modernity, however mediated and removed from *subjective* experi-
ence that construction may ultimately turn out to be. Given Adorno's
belief that the late 19th-century commodification of culture prefigures
that of the culture industry and sets the stage for the successful mod-
ernist resistance to commodification in the works of Schönberg, Kafka
and Kandinsky, it seems only logical that Adorno should attempt to
locate the germs of the culture industry in the high art of the late 19th
century which precedes modernism—in Wagner, Jugendstil and l'art
pour l'art. We are faced, then, with the paradox of having to read
Adorno on the high art of the times if we want to find traces of the mass
culture problematic in his writings on 19th-century culture. Here I
anticipate the habitual battlecry of "elitism" which usually serves to end
all discussion. Certainly, the bias is there in Adorno. But it is not as if
the questions he raises had ever been convincingly answered. If mod-
ernism is a response to the long march of the commodity through
culture, then the effects of cultural commodification and all it entails
also need to be located *in* the development of the artistic material itself
rather than only in the department store or in the dictates of fashion.
Adorno may be wrong in his answers—and his rigorously atrophied
account of modernism simply leaves too much out—but he is most
certainly right in his questions. Which, again, is not to say that his
questions are the only ones we should ask.

 How, then, does Adorno deal with the late 19th century? On the face
of it his history of modernism seems to coincide with that of Anglo-

American criticism which sees modernism evolving continuously from the mid-19th century to the 1950s, if not to the present. Despite occasional shifts in the evaluation of certain authors (e.g., George and Hofmannsthal) Adorno privileges a certain trend of modernist literature—to take but one medium—from Baudelaire and Flaubert via Mallarmé, Hofmannsthal and George to Valéry and Proust, Kafka and Joyce, Celan and Beckett. The notion of a politically committed art and literature is anathema for Adorno as it is for the dominant account of modernism in Anglo-American criticism. Major movements of the historical avantgarde such as Italian futurism, Dada, Russian constructivism and productivism as well as surrealism are blatantly absent from the canon, an absence which is highly significant and which bears directly on Adorno's account of the late 19th century.

A closer look at Adorno's aesthetic theory will indeed dispel the notion of unilinear evolutionary development of modernism since the mid-19th century. It will show on the contrary that Adorno locates a major rupture in the development of modern art after the turn of the century, i.e., with the emergence of the historical avantgarde movements. Of course, Adorno has often been described as a theorist of the avantgarde, a use of terminology based on the problematic collapsing of the notion of the avantgarde with that of modernism. Since Peter Bürger's *Theory of the Avantgarde*, however, it seems no longer permissible to use the terms interchangeably, even though Bürger himself, at least in his earlier work, still talks about Adorno as a theorist of the avantgarde.[30] But if it is true, as Bürger argues, that the main goal of the historical avantgarde was the reintegration of art into life, a heroic attempt that failed, then Adorno is not a theorist of the avantgarde, but a theorist of modernism. More than that, he is a theorist of a construct "modernism" which has already digested the failure of the historical avantgarde. It has not gone unnoticed that Adorno frequently scorned avantgarde movements such as futurism, Dada, and surrealism, and that he acidly rejected the avantgardes' various attempts to reintegrate art and life as a dangerous regression from the aesthetic to the barbaric. This insight, however, has often prevented critics from appreciating the fact that Adorno's theory of modernism owes as much to the historical avantgarde's onslaught against notions of the work of art as organism *or* as artificial paradise as it owes to late 19th-century aestheticism and to the autonomy aesthetic. Only if one understands this double heritage will statements such as the following in the *Philosophy of Modern Music* be fully comprehensible: "Today the only works which really count are those which are no longer works at all."[31] As far as I can see, only Peter Bürger has located this historical core of Adorno's

aesthetic theory when he wrote in a more recent essay: "Both the radical separation of art from life completed by aestheticism *and* the reintegration of art and life intended by the historical avantgarde movements are premises for a view which sees art in total opposition to any rationally organized life-praxis and which at the same time attributes to art a revolutionary force challenging the basic organization of society. The hopes which the most radical members of the avantgarde movements, especially the dadaists and early surrealists, invested in this possibility of changing society through art, these hopes live on residually in Adorno's aesthetic theory, even though in a resigned and mutilated form. Art is that 'other' which cannot be realized in the world."[32] Adorno indeed holds in charged tension two diverging tendencies: on the one hand aestheticism's insistence on the autonomy of the art work and its double-layered separateness from everyday life (separate *as* work of art *and* separate in its refusal of realistic representation) and, on the other, the avantgarde's radical break with precisely that tradition of art's autonomy. In doing so he delivers the work's autonomy to the social while preserving it at the same time: "Art's double character, its being autonomous and fait social, relentlessly pervades the zone of its autonomy."[33] Simultaneously he radicalizes modernity's break with the past and with tradition in the spirit of avantgardism: "Contrary to past styles, it [the concept of modernity] does not negate earlier art forms; it negates tradition per se."[34] We need to remember here that the radical break with tradition, first articulated by artists such as Baudelaire and Manet, becomes dominant in German culture much later than in France: in Schönberg rather than Wagner, Kafka rather than George, i.e., after the turn of the century. From the perspective of German developments Baudelaire could then be seen as Adorno sees Poe in relation to Baudelaire: as a lighthouse of modernity.[35]

Adorno's fundamental indebtedness to the project of the post-1900 historical avantgarde can be gleaned from the ways in which he discusses l'art pour l'art, Jugendstil and the music of Richard Wagner. In each case, the emergence of "genuine" modernism is seen as resulting from a deterioration *within* forms of high art, a deterioration which bears witness to the increasing commodification of culture.

Adorno's work bristles with critiques of aestheticism and the l'art pour l'art movements of the 19th century. In his essay "Standort des Erzählers im zeitgenössischen Roman" (1954) we read: "The products [of modernist art] are above the controversy between politically committed art and l'art pour l'art. They stand beyond the alternative which pits the philistinism of *Tendenzkunst* against the philistinism of art as

pleasure."[36] In *Dialectic of Enlightenment* Adorno relates l'art pour l'art polemically to political advertising: "Advertising becomes art and nothing else, just as Goebbels—with foresight—combines them: l'art pour l'art, advertising for its own sake, a pure representation of social power."[37] L'art pour l'art, advertising and the fascist aesthetization of politics can only be thought together under the sign of that false universal of modernity which is the commodity. In a more historical vein, to give a third example, Adorno writes in *Ästhetische Theorie*: "L'art pour l'art's concept of beauty is strangely hollow, and yet it is obsessed with matter. It resembles an art nouveau event as revealed in Ibsen's charms of hair entwined with vine leaves and of a beautiful death. Beauty seems paralyzed, incapable of determining itself which it could only do by relating to its 'other.' It is like a root in the air and becomes entangled with the destiny of the invented ornament."[38] And somewhat later: "In their innermost constitution the products of l'art pour l'art stand condemned by their latent commodity form which makes them live on as Kitsch, subject to ridicule."[39] Adorno's critique here is actually reminiscent of Nietzsche's, that most trenchant and yet dubious critic of mass culture in Imperial Germany, whose influence on Critical Theory has recently been the subject of much debate. But while Nietzsche criticizes l'art pour l'art, for instance in *Beyond Good and Evil*, as a form of decadence and relates it metaphorically to the culture of deluded scientific objectivity and of positivism, Adorno succeeds in grounding the critique systematically with the help of Marx's notion of the commodity form. It is this emphasis on the commodity form (to which Nietzsche was totally oblivious) which permits Critical Theory to articulate a consistent critique of the objectivistic social sciences and of a reified aestheticism. And it furthermore connects Adorno's critique of l'art pour l'art with his discussion of Jugendstil, a style which in a certain sense aimed at reversing l'art pour l'art's separation from life.

The Jugendstil of the turn of the century is indeed pivotal to Adorno's historical account of the emergence of modernist art. Although he highly values certain individual works that were part of Jugendstil culture (e.g., works by the early Stefan George and the young Schönberg), he argues that the commodity character of art which had been an integral, though somewhat hidden part of all emancipated bourgeois art becomes external in Jugendstil, tumbling, as it were, out of the art works for all to see. A longer quote from *Ästhetische Theorie* is appropriate here: "Jugendstil has contributed greatly to this development, with its ideology of sending art back into life as well as with the sensations created by Wilde, d'Annunzio and Maeterlinck, all of them preludes to the culture industry. Increasing subjective differentiation

and the heightened dissemination of the realm of aesthetic stimuli made these stimuli manipulable. They could now be produced for the cultural market. The tuning of art to the most fleeting individual reactions allied itself with art's reification. Art's increasing likeness to a subjectively perceived physical world made all art abandon its objectivity thus recommending it to the public. The slogan l'art pour l'art was but the veil of its opposite. This much is true about the hysterical attacks on decadence: subjective differentiation reveals an element of ego weakness which corresponds to the spiritual make-up of the clients of the culture industry. The culture industry learned how to profit from it."[40] Three brief observations: Adorno's aversion against later avantgardist attempts to reintegrate art and life may have been as strong as it was because he held those attempts, however one-sidedly, to be similar to that of Jugendstil. Secondly, the avantgarde's attempts to dissolve the boundaries between art and life—whether those of Dada and surrealism or those of Russian productivism and constructivism— had ended in failure by the 1930s, a fact which makes Adorno's skepticism toward sending art back into life quite understandable. In a sense never intended by the avantgarde, life had indeed become art— in the fascist aesthetization of politics as mass spectacle as well as in the fictionalizations of reality dictated by the socialist realism of Zhdanov and by the dream world of capitalist realism promoted by Hollywood. Most importantly, however, Adorno criticizes Jugendstil as a prelude to the culture industry because it was the first style of high art to fully reveal the commodification and reification of art in capitalist culture. And it would not be Adorno if this account of Jugendstil did not precisely thrive on the paradox that the culture industry's antecedents are traced to a style and an art which is highly individualistic and which was never meant for mass reproduction. Jugendstil, nevertheless, marks that moment of history in which the commodity form has pervaded high art to the extent that—as in Schopenhauer's famous example of the bird hypnotized by the snake—it throws itself blissfully into the abyss and is swallowed up. That stage, however, is the prerequisite for Adorno's negative aesthetic of modernism that first took shape in the work of Schönberg. Schönberg's turn to atonality is interpreted as the crucial strategy to evade commodification and reification while articulating it in its very technique of composition.

Richard Wagner: Phantasmagoria and Modern Myth

Schönberg's "precursor" in the medium of music of course is Richard Wagner. Adorno argues that the turn toward atonality, that supreme achievement of musical modernism, is already latent in certain composition techniques of Richard Wagner. Wagner's use of dissonance

and chromatic movement, his multiple subversions of classical har-
mony, the emergence of tonal indeterminacy and his innovations in
color and orchestration are seen as setting the stage for Schönberg and
the Vienna School. And yet, Schönberg's relation to Wagner, which is
central to Adorno's account of the birth of modernism in the arts, is
described as one of continuation *and* resistance, most succinctly
perhaps in the "Selbstanzeige des Essaybuches 'Versuch über
Wagner'": "All of modern music has developed in resistance to his
[Wagner's] predominance—and yet, all of its elements are latently
present in him."[41] The purpose of Adorno's long essay on Wagner,
written in 1937/38, was not to write music history or to glorify the
modernist breakthrough. Its purpose was rather to analyze the social
and cultural roots of German fascism in the 19th century. Given the
pressures of the times—Hitler's affiliation with Bayreuth and the in-
corporation of Wagner into the fascist culture machine—Wagner's
work turned out to be the logical place for such an investigation. We
need to remember here that whenever Adorno says fascism, he is also
saying culture industry. The book on Wagner can therefore be read
not only as an account of the birth of fascism out of the spirit of the
Gesamtkunstwerk, but also as an account of the birth of the culture
industry *in* the most ambitious high art of the 19th century. On the face
of it such an account would seem patently absurd since it appears to
ignore the existence of a well developed industrial mass culture in
Wagner's own time. But then Adorno's essay does not claim to give us a
comprehensive historical description of the origins of mass culture as
such, nor does he suggest that the place to develop a theory of the
culture industry is high art alone. What he does suggest, however, is
something largely lost in the dominant accounts of modernism which
emphasize the triumphal march of abstraction and surface in painting,
textual self-referentiality in literature, atonality in music and irrecon-
cilable hostility to mass culture and Kitsch in all forms of modernist art.
Adorno suggests that the social processes that give shape to mass
culture cannot be kept out of art works of the highest ambition and that
any analysis of modernist or, for that matter, premodernist art will
have to trace these processes in the trajectory of the aesthetic materials
themselves. The ideology of the art work's autonomy is thus under-
mined by the claim that no work of art is ever untouched by the social.
But Adorno makes the even stronger claim that in capitalist society
high art is always already permeated by the textures of that mass
culture from which it seeks autonomy. As a model analysis of the
entanglements of high art with mass cultural commodification the
Wagner essay is actually more stimulating than, say, the *Philosophy of
Modern Music* which in many ways represents the negative version of

modernist triumphalism. Preceding Jugendstil and l'art pour l'art which are blamed for simply capitulating to the commodity, it is the body of Wagner's oeuvre, towering as it does at the threshold of modernity, which becomes the privileged locus of that fierce struggle between tradition and modernity, autonomy and commodity, revolution and reaction, and, ultimately, myth and enlightenment.

As I cannot possibly do justice here to Adorno's various writings on Wagner, I will only outline those elements which connect Wagner's aesthetic innovations to features of the modern culture industry. The other half of Adorno's Wagner—Wagner as premodernist—will have to remain under-exposed.

To begin with, Adorno concedes throughout his essay that in his time Wagner represented the most advanced stage in the development of music and opera. However, he consistently emphasizes both progressive *and* reactionary elements in Wagner's music making the point that the one cannot be had without the other. He credits Wagner for heroically attempting to elude the market demands for "easy" opera and for trying to avoid its banality. But this flight, according to Adorno, leads Wagner even more deeply into the commodity. In his later essay "Wagner's Aktualität" (1965) Adorno finds a powerful image for this dilemma: "Everything in Wagner has its historical core. Like a spider, his spirit sits in the gigantic web of 19th-century exchange relations."[42] No matter how far Wagner would spin out his music, spider and web will always remain one. How, then, do these exchange relations manifest themselves in Wagner's music? How does the music get caught in the web of cultural commodification? After a discussion of Wagner as social character, which I will skip here, Adorno turns to an analysis of Wagner's role as composer-conductor. He argues that Wagner disguises the growing estrangement of the composer from the audience by conceiving his music "in terms of the gesture of striking a blow" and by incorporating the audience into the work through calculated "effects": "As the striker of blows . . . the composer-conductor gives the claims of the public a terrorist emphasis. Democratic considerateness towards the listener is transformed into connivance with the powers of discipline: in the name of the listener, anyone whose feelings accord with any measure other than the beat of the music is silenced."[43] In this interpretation of Wagner's "gesture" Adorno shows how the audience becomes "the reified object of calculation by the artist."[44] And it is here that the parallels with the culture industry emerge. The composer-conductor's attempt to beat his audience into submission is structurally isomorphic to the way in which the culture industry treats the consumer. But the terms of the isomorphism are reversed. In

Wagner's theater the composer-conductor is still visible and present as an individual—a residue of the liberal age, as it were—and the spectators are assembled as a public in the dark behind the conductor's baton. The industrial organization of culture, however, replaces the individual conductor with an invisible corporate management and it dissolves the public into the shapeless mass of isolated consumers. The culture industry thus reverses the relations typical of the liberal age by de-individualizing cultural production and privatizing reception. Given Adorno's description of Wagner's audience as the reified object of aesthetic calculations it comes as no surprise that he would claim that Wagner's music is already predicated on that ego-weakness which would later become the operational basis of the culture industry: "The audience of these giant works lasting many hours is thought of as unable to concentrate—something not unconnected with the fatigue of the citizen in his leisure time. And while he allows himself to drift with the current, the music, acting as its own impresario, thunders at him in endless repetitions to hammer its message home."[45] Such endless repetitions manifest themselves most obviously in Wagner's leitmotiv technique which Adorno relates to Berlioz's *idée fixe* and to the Baudelairian spleen. Adorno interprets the leitmotiv's double character as allegory and advertising. As allegory the leitmotiv articulates a progressive critique of traditional totalizing musical forms and of the "symbolic" tradition of German idealism. At the same time, however, it functions like advertising in that it is designed to be easily remembered by the forgetful. This advertising aspect of the leitmotiv is not something projected back onto it from hindsight. Adorno already locates it in the reactions of Wagner's contemporaries who tended to make crude links between leitmotivs and the persons they characterized. The commercial decay of the leitmotiv, latent in Wagner, becomes full-blown in Hollywood film music "where the sole function of the leitmotiv is to announce heroes or situations so as to help the audience to orientate itself more easily."[46]

Reification emerges as the conceptual core of Adorno's account. "Allegorical rigidity" has not only infected the motiv like a disease, it has infected Wagner's oeuvre as a whole—its music and its characters, its images and myths, and last but not least its institutionalization in Bayreuth as one of the major spectacles of the times. Adorno goes on to discuss reification, which can be regarded as the effect of commodification *in* the musical material, on the levels of melody, color, and orchestration. The overriding concern here is the question of what happens to musical time in Wagner's oeuvre. Adorno argues that time becomes abstract and as such defies musical and dramatic development on the

level of melody as well as on that of character. The musical material is pulverized, characters are frozen and static. The construction of motiv as temporal sequence is replaced by impressionistic association: "For the composer the use of the beat is a fallacious method of mastering the empty time with which he begins, since the measure to which he subjects time does not derive from the musical content, but from the reified order of time itself."[47] The predominance of "sound" in Wagner also dissolves the temporal pressures of harmony. It spatializes musical time, depriving it, as it were, of its historical determinations.[48]

These observations about the leitmotiv, the reified order of time and the atomization of musical material lead Adorno to a central point where he affiliates Wagner's composition technique with the mode of production: "It is difficult to avoid the parallel with the quantification of the industrial labor process, its fragmentation into the smallest possible units . . . Broken down into the smallest units, the totality is supposed to become controllable, and it must submit to the will of the subject who has liberated himself from all pre-existing forms."[49] The parallel with the culture industry becomes fully obvious when we read a little further on: "In Wagner's case what predominates is already the totalitarian and seigneurial aspect of atomization; that devaluation of the individual vis-à-vis the totality, which excludes all authentic dialectical interaction."[50]

What Adorno describes here, of course, is the reflection of the 19th-century industrialization of time and space in Wagner's oeuvre. The devaluation of the individual vis-à-vis the totality appears in Wagner's orchestration as the tendency to drown out the voice of the individual instrument in favor of a continuum of timbres and large-scale melodic complexes. The "progress" of such orchestration techniques is as suspect to Adorno as the progress of the industrial upsurge of the Bismarck era to which it is compared.

If reification of musical and dramatic time is one major element of Adorno's account, then subjectivistic association and ambiguity of musical meaning is the other side of the same coin. What is at stake here is that which Wagner's contemporaries described as nervousness and hypersensitivity, what Nietzsche called decadence, and what we might call Wagner's modernity. It is interesting to take notice of Adorno's scattered references to the relationship of Wagner's modernity to that of Baudelaire and Monet: "Like Baudelaire's, his reading of bourgeois high capitalism discerned an anti-bourgeois, heroic message in the destruction of *Biedermeier*."[51] In the essay "Wagner's Aktualität" the discussion of the composer's handling of color unmistakably conjures up the art of Monet: "Wagner's achievement of a differentiation of

color by dissolution into minute detail is supplemented by his technique of combining the most minute elements constructively in such a way that something like integral color emerges."[52] Yet Wagner only approaches that threshold which Baudelaire and Monet had already crossed: "No comparison of Wagner with the impressionists will be adequate unless it is remembered that the credo of universal symbolism to which all his technical achievements subscribe is that of Puvis de Chavannes and not Monet's."[53] Therefore Adorno calls Wagner an "impressionist *malgré lui*" and relates his backwardness to the backwardness of economic and aesthetic developments in mid-19th-century Germany. The key point that emerges from this comparison is the paradox that Wagner's anticipation of the culture industry is proportionate to his aesthetic backwardness in his own time. His music conjures up a distant future because it has not yet succeeded in shedding a past rendered obsolete by modern life. To put it differently, the modernity of allegory and dissonance in Wagner's work is consistently compromised by that "universal symbolism" which simulates a false totality and forges an equally false monumentality, that of the Gesamtkunstwerk.

Wagner's affinity to the culture industry is worked out most explicitly by Adorno in the chapters on phantasmagoria, Gesamtkunstwerk, and myth. Adorno's characterization of Wagner's opera as phantasmagoria is an attempt to analyze what happens to aesthetic appearance (*ästhetischer Schein*) in the age of the commodity and as such it is the attempt to come to terms with the pressure commodity fetishism puts on works of art. As phantasmagorias Wagner's operas have veiled all traces of the labor that went into their production. Blocking out traces of production in the work of art is of course one of the major tenets of an earlier idealist aesthetic and as such nothing new in Wagner. But that is precisely the problem. As the commodity form begins to invade all aspects of modern life, all aesthetic appearance is in danger of being transformed into phantasmagoria, into the "illusion of the absolute reality of the unreal."[54] According to Adorno, Wagner yields to the pressures of the commodity form. With some minor changes the following passage taken from the chapter on phantasmagoria could easily be imagined as part of the mass culture chapter in *Dialectic of Enlightenment*: "It [the illusion of the absolute reality of the unreal] sums up the unromantic side of the phantasmagoria: phantasmagoria as the point at which aesthetic appearance becomes a function of the character of the commodity. As a commodity it purveys illusions. The absolute reality of the unreal is nothing but the reality of a phenomenon that not only strives unceasingly to spirit away its own origins

in human labor, but also, inseparably from this process and in thrall to exchange value, assiduously emphasizes its use value, stressing that this is its authentic reality, that it is 'no imitation'—and all this in order to further the cause of exchange value. In Wagner's day the consumer goods on display turned their phenomenal side seductively towards the mass of consumers while diverting attention from their merely phenomenal character, from the fact that they were beyond reach. Similarly, in the phantasmagoria, Wagner's operas tend to become commodities. Their tableaux assume the character of wares on display (*Ausstellungscharakter*)."[55] At this point myth enters the stage as the embodiment of illusion and as regression to prehistory: "Phantasmagoria comes into being when, under the constraints of its own limitations, modernity's latest products come close to the archaic. Every step forward is at the same time a step into the remote past. As bourgeois society advances it finds that it needs its own camouflage of illusion simply in order to subsist."[56] As phantasmagoria Wagner's opera reproduces the dream world of the commodity in the form of myth: "He [Wagner] belongs to the first generation to realize that in a world that has been socialized through and through it is not possible for an individual to alter something that is determined over the heads of men. Nevertheless, it was not given to him to call the overarching totality by its real name. In consequence it is transformed for him into myth."[57] Myth becomes the problematic solution to Wagner's struggle against the genre music of the Biedermeier period, and his gods and heroes are to guarantee the success of his simultaneous flight from the banality of the commodity age. But as the present and the mythical merge in the Gesamtkunstwerk, Wagner's divine realm of ideas, gods, and heroes is nothing but a deluded transcription of the banal world of the present. In a number of scattered observations Adorno juxtaposes, in a quite Benjaminean way, moments of Wagner's oeuvre to the culture of everyday life in late 19th-century Germany. Thus the *Mastersingers* are said to conjure up—like the images on the box containing the famous *Nürnberger Lebkuchen*—the bliss of an unsullied, premodern German past, which later fed seamlessly into völkisch ideology. Elsa's relationship to Lohengrin ("My lord, never shall this question come from me") celebrates the subjugation of women in marriage. Wotan is interpreted as the phantasmagoria of the buried revolution, Siegfried as the "natural" rebel who accelerates rather than prevents the catastrophic destruction of civilization. The thunder motiv from the *Ring* becomes the signal sounded by the horn of the Emperor's motor car. Adorno gets to the historical core of Wagner's modern mythology when he writes: "It is impossible to overlook the relationship between Wag-

nerian mythology and the iconic world of the Empire, with its eclectic architecture, fake Gothic castles, and the aggressive dream symbols of the New-German boom, ranging from the Bavarian castles of Ludwig to the Berlin restaurant that called itself 'Rheingold'. But the question of authenticity is as fruitless here as elsewhere. Just as the overwhelming power of high capitalism forms myths that tower above the collec-,tive conscious, in the same way the mythic region in which the modern consciousness seeks refuge bears the marks of that capitalism: what subjectively was the dream of dreams is objectively a nightmare."[58] Thus the drama of the future, as Wagner called his Gesamtkunstwerk, prefigures that nightmarish regression into an archaic past which completes its trajectory in fascism. The Gesamtkunstwerk is intended as a powerful protest against the fragmentation and atomization of art and life in capitalist society. But since it chooses the wrong means it can only end in failure: "Like Nietzsche and subsequently Art Nouveau, which he [Wagner] anticipates in many respects, he would like, single-handed, to will an aesthetic totality into being, casting a magic spell and with defiant unconcern about the absence of the social conditions necessary for its survival."[59] While the mythic dimension of Wagner's opera conjures up fascism, its homogenization of music, word, and image is said to anticipate the essential features of Hollywood film: "Thus we see that the evolution of the opera, and in particular the emergence of the autonomous sovereignty of the artist, is intertwined with the origins of the culture industry. Nietzsche, in his youthful enthusiasm, failed to recognize the art work of the future in which we witness the birth of film out of the spirit of music."[60] The totality of Wagner's music drama, however, is a false totality subject to disintegration from within: "Even in Wagner's lifetime, and in flagrant contradiction to his programme, star numbers like the Fire Music and Wotan's farewell, the Ride of the Valkyries, the Liebestod and the Good Friday music had been torn out of their context, re-arranged and become popular. This fact is not irrelevant to the music dramas, which had cleverly calculated the place of these passages within the economy of the whole. The disintegration of the fragments sheds light on the fragmentariness of the whole."[61] The logic of this disintegration leads to Schönberg's modernism on the one hand and to the Best of Wagner album on the other. Where high art itself is sucked into the maelstrom of commodification, modernism is born as a reaction and a defense. The point is made bluntly in *Philosophy of Modern Music*: "The liberation of modern painting from representation (*Gegenständlichkeit*), which was to art the break that atonality was to music, was determined by the defensive against the mechanized art commodity—above all

photography. Radical music, from its inception, reacted similarly to the
commercial depravity of the traditional idiom. It formulated an antith-
esis against the extension of the culture industry into its own domain."[62]
While this statement seems quite schematic, especially in its mechanical
derivation of abstraction in painting, it serves to remind us again that
modernism itself is held hostage by the culture industry and that
theories of modernism neglecting this conjuncture are seriously de-
ficient. Adorno's bleak description of modern mass culture as dream
turned nightmare has perhaps outlived its usefulness and can now take
its place as a historically contingent and theoretically powerful reflec-
tion on fascism. What has not outlived its usefulness, however, is
Adorno's suggestion that mass culture was not imposed on art only
from the "outside," but that art was transformed into its opposite
thanks precisely to its emancipation from traditional forms of
bourgeois art. In the vortex of commodification there was never an
outside. Wagner is the case in point.

Coda

Reading Adorno in reverse, from *Dialectic of Enlightenment* backwards
to the Wagner essay of 1937/38, from fascism and the capitalist culture
industry back to Imperial Germany, leads to the conclusion that the
framework for his theory of the culture industry was already in place
before his encounter with American mass culture in the United States.
In the Wagner book the pivotal categories of fetishism and reification,
ego-weakness, regression, and myth are already fully developed, wait-
ing, as it were, to be articulated in terms of the American culture
industry. At the same time, reading Adorno's brilliant tour de force on
Wagner—and a tour de force it is—produces a strange sense of déjà vu
in which the temporal terms are once more displaced. It is as if accom-
panying Adorno on his travels into the 19th century we were simul-
taneously travelling into yet another time-space Adorno himself did
not live to experience: that of the postmodern. Large segments of the
book on Wagner could be read as a modernist polemic against post-
modernism. It is indeed easy to imagine how Adorno would have
panned those facile citations of the historical idiom in postmodern
architecture and music, how he would have poured scorn over the
decay of allegory into the "anything goes" of the art "scene," how he
would have resisted the new mythology of aesthetic experience, the
cult of performance, of self-help and of other forms of narcissistic
indulgence. Adorno would not have hesitated one moment to see the
disintegration of modernism as a return to its prehistory and to col-
lapse the prehistory of the modern with its posthistory.

After all, the art work is still in the grip of the commodity form, more so, if anything, than in the 19th century. The giant spider web of exchange relations Adorno spoke of has certainly expanded since that time. The late 19th century still had resistant popular cultures and it left more uncolonized spaces for possible evasions and challenges than today's thoroughly administered culture. If such a reading is by and large correct we will have to ask what the chances are for a genuine contemporary art after the demise of classical modernism. One conclusion would be to see the only possibility for contemporary art in a further elaboration of the modernist project. Possibly, Adorno would have advocated this route even though he was perfectly aware of the dangers of alexandrian sterility, of a dogmatic ossification of modernism itself. Another conclusion, however, would be to try and relocate contemporary artistic production and practices in the interstices between modernism and mass culture. Commodification invaded Wagner's oeuvre without completely debilitating it. On the contrary, it actually gave rise to great works of art. But then one must be permitted to ask why it should not be possible today to produce ambitious and successful works of art which would draw both on the tradition of modernism and on mass culture, including various subcultures. Some of the most interesting art of our time seems to pursue precisely this project. Of course Adorno would argue that the conjuncture that produced Wagner's oeuvre is irretrievably past. True enough, but I am not suggesting simply to revive Wagner's art as a model for the present. Where something like that is being done, e.g., in the films of Syberberg, the results are often less than convincing. The point is rather to take heart from Adorno's account of Wagner's contradictions and dilemmas and to abandon that set of purist stances which would either lock all art in the laboratory of ever more involuted modernist experimentation or reject, uncompromisingly, any attempt to create a contemporary art precisely out of the tensions between modernism and mass culture. Who, after all, would want to be the Lukács of the postmodern . . .

3

Mass Culture as Woman:
Modernism's Other

I

One of the founding texts of modernism, if there ever was one, is
Flaubert's *Madame Bovary*. Emma Bovary, whose temperament was, in
the narrator's words, "more sentimental than artistic," loved to read
romances.[1] In his detached, ironic style, Flaubert describes Emma's
reading matter: "They [the novels] were full of love and lovers, perse-
cuted damsels swooning in deserted pavilions, postillions slaughtered
at every turn, horses ridden to death on every page, gloomy forests,
romantic intrigue, vows, sobs, embraces and tears, moonlit crossings,
nightingales in woodland groves, noblemen brave as lions, gentle as
lambs, impossibly virtuous, always well dressed, and who wept like
fountains on all occasions."[2] Of course, it is well known that Flaubert
himself was caught by the craze for romantic novels during his student
days in the Collège at Rouen, and Emma Bovary's readings at the
convent have to be read against this backdrop of Flaubert's life his-
tory—a point which critics rarely fail to make. However, there is ample
reason to wonder if the adolescent Flaubert read these novels in the
same way Emma Bovary would have, had she actually lived—or, for
that matter, as real women at the time read them. Perhaps the answer
to such a query will have to remain speculative. What is beyond spec-
ulation, however, is the fact that Emma Bovary became known, among

This essay originally appeared in *Studies in Entertainment: Critical Approaches to Mass
Culture*, edited by Tania Modleski (Bloomington: Indiana University Press, 1986).

other things, as the female reader caught between the delusions of the trivial romantic narrative and the realities of French provincial life during the July monarchy, a woman who tried to live the illusions of aristocratic sensual romance and was shipwrecked on the banality of bourgeois everyday life. Flaubert, on the other hand, came to be known as one of the fathers of modernism, one of the paradigmatic master voices of an aesthetic based on the uncompromising repudiation of what Emma Bovary loved to read.

As to Flaubert's famous claim: "Madame Bovary, c'est moi," we can assume that he knew what he was saying, and critics have gone to great lengths to show what Flaubert had in common with Emma Bovary—mostly in order to show how he transcended aesthetically the dilemma on which she foundered in "real life." In such arguments the question of gender usually remains submerged, thereby asserting itself all the more powerfully. Sartre, however, in his monumental *L'Idiot de la Famille*, has analyzed the social and familial conditions of Flaubert's "objective neurosis" underlying his fantasy of himself as woman. Sartre has indeed succeeded in showing how Flaubert fetishized his own imaginary femininity while simultaneously sharing his period's hostility toward real women, participating in a pattern of the imagination and of behavior all too common in the history of modernism.[3]

That such masculine identification with woman, such imaginary femininity in the male writer, is itself historically determined is clear enough. Apart from the subjective conditions of neurosis in Flaubert's case, the phenomenon has a lot to do with the increasingly marginal position of literature and the arts in a society in which masculinity is identified with action, enterprise, and progress—with the realms of business, industry, science, and law. At the same time, it has also become clear that the imaginary femininity of male authors, which often grounds their oppositional stance vis-à-vis bourgeois society, can easily go hand in hand with the exclusion of real women from the literary enterprise and with the misogyny of bourgeois patriarchy itself. Against the paradigmatic "Madame Bovary, c'est moi," we therefore have to insist that there is a difference. Christa Wolf, in her critical and fictional reflections on the question "who was Cassandra before anyone wrote about her?," put it this way:

> "We have admired this remark [Flaubert's 'Madame Bovary, c'est moi']
> for more than a hundred years. We also admire the tears Flaubert shed
> when he had to let Madame Bovary die, and the crystal-clear calculation of
> his wonderful novel, which he was able to write despite his tears; and we
> should not and will not stop admiring him. But Flaubert was *not* Madame

Bovary; we cannot completely ignore that fact in the end, despite all our good will and what we know of the secret relationship between an author and a figure created by art."[4]

One aspect of the difference that is important to my argument about the gender inscriptions in the mass culture debate is that woman (Madame Bovary) is positioned as reader of inferior literature—subjective, emotional and passive—while man (Flaubert) emerges as writer of genuine, authentic literature—objective, ironic, and in control of his aesthetic means. Of course, such positioning of woman as avid consumer of pulp, which I take to be paradigmatic, also affects the woman writer who has the same kind of ambition as the "great (male) modernist." Wolf cites Ingeborg Bachmann's tortured novel trilogy *Todesarten* (Ways of Dying) as a counterexample to Flaubert: "Ingeborg Bachmann *is* that nameless woman in *Malina*, she *is* the woman Franza in the novel fragment *The Franza Case* who simply cannot get a grip on her life, cannot give it a form; who simply cannot manage to make her experience into a presentable story, cannot produce it out of herself as an artistic product."[5]

In one of her own novels, *The Quest for Christa T*, Wolf herself foregrounded the "difficulty of saying I" for the woman who writes. The problematic nature of saying "I" in the literary text—more often than not held to be a lapse into subjectivity or kitsch—is of course one of the central difficulties of the postromantic, modernist writer. Having first created the determining conditions for a certain historically specific type of subjectivity (the Cartesian cogito and the epistemological subject in Kant, as well as the bourgeois entrepreneur and the modern scientist), modernity itself has increasingly hollowed out such subjectivity and rendered its articulation highly problematic. Most modern artists, male or female, know that. But we only need to think of the striking contrast between Flaubert's confident personal confession, "Madame Bovary, c'est moi," and the famed "impassibilité" of the novel's style to know that there is a difference. Given the fundamentally differing social and psychological constitution and validation of male and female subjectivity in modern bourgeois society, the difficulty of saying "I" must of necessity be different for a woman writer, who may not find "impassibilité" and the concomitant reification of self in the aesthetic product quite as attractive and compelling an ideal as the male writer. The male, after all, can easily deny his own subjectivity for the benefit of a higher aesthetic goal, as long as he can take it for granted on an experiential level in everyday life. Thus Christa Wolf concludes, with some hesitation and yet forcefully enough: "Aesthetics, I say, like philosophy and science, is invented not so much to

enable us to get closer to reality as for the purpose of warding it off, of protecting against it."[6] Warding something off, protecting against something out there seems indeed to be a basic gesture of the modernist aesthetic, from Flaubert to Roland Barthes and other poststructuralists. What Christa Wolf calls reality would certainly have to include Emma Bovary's romances (the books *and* the love affairs), for the repudiation of *Trivialliteratur* has always been one of the constitutive features of a modernist aesthetic intent on distancing itself and its products from the trivialities and banalities of everyday life. Contrary to the claims of champions of the autonomy of art, contrary also to the ideologists of textuality, the realities of modern life and the ominous expansion of mass culture throughout the social realm are always already inscribed into the articulation of aesthetic modernism. Mass culture has always been the hidden subtext of the modernist project.

II

What especially interests me here is the notion which gained ground during the 19th century that mass culture is somehow associated with woman while real, authentic culture remains the prerogative of men. The tradition of women's exclusion from the realm of "high art" does not of course originate in the 19th century, but it does take on new connotations in the age of the industrial revolution and cultural modernization. Stuart Hall is perfectly right to point out that the hidden subject of the mass culture debate is precisely "the masses"—their political and cultural aspirations, their struggles and their pacification via cultural institutions.[7] But when the 19th and early 20th centuries conjured up the threat of the masses "rattling at the gate," to quote Hall, and lamented the concomitant decline of culture and civilization (which mass culture was invariably accused of causing), there was yet another hidden subject. In the age of nascent socialism *and* the first major women's movement in Europe, the masses knocking at the gate were also women, knocking at the gate of a male-dominated culture. It is indeed striking to observe how the political, psychological, and aesthetic discourse around the turn of the century consistently and obsessively genders mass culture and the masses as feminine, while high culture, whether traditional or modern, clearly remains the privileged realm of male activities.

To be sure, a number of critics have since abandoned the notion of *mass* culture in order to "exclude from the outset the interpretation agreeable to its advocates: that it is a matter of something like a culture that arises spontaneously from the masses themselves, the contempo-

rary form of popular art."[8] Thus Adorno and Horkheimer coined the
term culture industry; Enzensberger gave it another twist by calling it
the consciousness industry; in the United States, Herbert Schiller
speaks of mind managers, and Michael Real uses the term mass-
mediated culture. The critical intention behind these changes in termi-
nology is clear: they all mean to suggest that modern mass culture is
administered and imposed from above and that the threat it represents
resides not in the masses but in those who run the industry. While such
an interpretation may serve as a welcome corrective to the naive notion
that mass culture is identical with traditional forms of popular art,
rising spontaneously from the masses, it nevertheless erases a whole
web of gender connotations which, as I shall show, the older terminol-
ogy "mass culture" carried with it—i.e., connotations of mass culture as
essentially feminine which were clearly also "imposed from above," in a
gender-specific sense, and which remain central to understanding the
historical and rhetorical determinations of the modernism/mass cul-
ture dichotomy.

It might be argued that the terminological shift away from the term
"mass culture" actually reflects changes in critical thinking about "the
masses." Indeed, mass culture theories since the 1920s—for instance,
those of the Frankfurt School—have by and large abandoned the
explicit gendering of mass culture as feminine. Instead they emphasize
features of mass culture such as streamlining, technological repro-
duction, administration, and Sachlichkeit—features which popular
psychology would ascribe to the realm of masculinity rather than
femininity. Yet the older mode of thinking surfaces time and again in
the language, if not in the argument. Thus Adorno and Horkheimer
argue that mass culture "cannot renounce the threat of castration,"[9]
and they feminize it explicitly, as the evil queen of the fairy tale when
they claim that "mass culture, in her mirror, is always the most beauti-
ful in the land."[10] Similarly, Siegfried Kracauer, in his seminal essay on
the mass ornament, begins his discussion by bringing the legs of the
Tiller Girls into the reader's view, even though the argument then
focuses primarily on aspects of rationalization and standardization.[11]
Examples such as these show that the inscription of the feminine on the
notion of mass culture, which seems to have its primary place in the late
19th century, did not relinquish its hold, even among those critics who
did much to overcome the 19th century mystification of mass culture as
woman.

The recovery of such gender stereotypes in the theorizing of mass
culture may also have some bearing on the current debate about the
alleged femininity of modernist/avant-gardist writing. Thus the

observation that, in some basic register, the traditional mass culture/
modernism dichotomy has been gendered since the mid-19th century
as female/male would seem to make recent attempts by French critics to
claim the space of modernist and avant-garde writing as predomi-
nantly feminine highly questionable. Of course this approach, which is
perhaps best embodied in Kristeva's work, focuses on the Mallarmé-
Lautréamont-Joyce axis of modernism rather than, say, on the
Flaubert-Thomas Mann-Eliot axis which I emphasize in my argument
here. Nevertheless, its claims remain problematic even there. Apart
from the fact that such a view would threaten to render invisible a
whole tradition of women's writing, its main theoretical assumption—
"that 'the feminine' is what cannot be inscribed in common lan-
guage"[12]—remains problematically close to that whole history of an
imaginary male femininity which has become prominent in literature
since the late 18th century.[13] This view becomes possible only if
Madame Bovary's "natural" association with pulp—i.e., the discourse
that persistently associated women with mass culture—is simply
ignored, and if a paragon of male misogyny like Nietzsche is said to be
speaking from the position of woman. Teresa de Lauretis has recently
criticized this Derridean appropriation of the feminine by arguing that
the position of woman from which Nietzsche and Derrida speak is
vacant in the first place, and cannot be claimed by women.[14] Indeed,
more than a hundred years after Flaubert and Nietzsche, we are facing
yet another version of an imaginary male femininity, and it is no
coincidence that the advocates of such theories (who also include major
women theoreticians) take great pains to distance themselves from any
form of political feminism. Even though the French readings of mod-
ernism's "feminine" side have opened up fascinating questions about
gender and sexuality which can be turned critically against more domi-
nant accounts of modernism, it seems fairly obvious that the wholesale
theorization of modernist writing as feminine simply ignores the
powerful masculinist and misogynist current within the trajectory of
modernism, a current which time and again openly states its contempt
for women and for the masses and which had Nietzsche as its most
eloquent and influential representative.

Here, then, some remarks about the history of the perception of
mass culture as feminine. Time and again documents from the late
19th century ascribe pejorative feminine characteristics to mass cul-
ture—and by mass culture here I mean serialized feuilleton novels,
popular and family magazines, the stuff of lending libraries, fictional
bestsellers and the like—not, however, working-class culture or re-
sidual forms of older popular or folk cultures. A few examples will

have to suffice. In the preface to their novel *Germinie Lacerteux* (1865), which is usually regarded as the first naturalist manifesto, the Goncourt brothers attack what they call the false novel. They describe it as those "spicy little works, memoirs of street-walkers, bedroom confessions, erotic smuttiness, scandals that hitch up their skirts in pictures in bookshop windows." The true novel (*le roman vrai*) by contrast is called "severe and pure." It is said to be characterized by its scientificity, and rather than sentiment it offers what the authors call "a clinical picture of love" (*une clinique de l'amour*).[15] Twenty years later, in the editorial of the first issue of Michael Georg Conrad's journal *Die Gesellschaft* (1885), which marks the beginning of "die Moderne" in Germany, the editor states his intention to emancipate literature and criticism from the "tyranny of well-bred debutantes and old wives of both sexes," and from the empty and pompous rhetoric of "old wives criticism." And he goes on to polemicize against the then popular literary family magazines: "The literary and artistic kitchen personnel has achieved absolute mastery in the art of economizing and imitating the famous potato banquet. . . . It consists of twelve courses each of which offers the potato in a different guise."[16] Once the kitchen has been described metaphorically as the site of mass cultural production, we are not surprised to hear Conrad call for the reestablishment of an "*arg gefährdete Mannhaftigkeit*" (seriously threatened manliness) and for the restoration of bravery and courage (*Tapferkeit*) in thought, poetry, and criticism.

It is easy to see how such statements rely on the traditional notion that women's aesthetic and artistic abilities are inferior to those of men. Women as providers of inspiration for the artist, yes, but otherwise *Berufsverbot* for the muses,[17] unless of course they content themselves with the lower genres (painting flowers and animals) and the decorative arts. At any rate, the gendering of an inferior mass culture as feminine goes hand in hand with the emergence of a male mystique in modernism (especially in painting), which has been documented thoroughly by feminist scholarship.[18] What is interesting in the second half of the 19th century, however, is a certain chain effect of signification: from the obsessively argued inferiority of woman as artist (classically argued by Karl Scheffler in *Die Frau und die Kunst*, 1908) to the association of woman with mass culture (witness Hawthorne's "the damned mob of scribbling women") to the identification of woman with the masses as political threat.

This line of argument invariably leads back to Nietzsche. Significantly, Nietzsche's ascription of feminine characteristics to the masses

is always tied to his aesthetic vision of the artist-philosopher-hero, the suffering loner who stands in irreconcilable opposition to modern democracy and its inauthentic culture. Fairly typical examples of this nexus can be found in Nietzsche's polemic against Wagner, who becomes for him the paradigm of the decline of genuine culture in the dawning age of the masses and the feminization of culture: "The danger for artists, for geniuses . . . is woman: adoring women confront them with corruption. Hardly any of them have character enough not to be corrupted—or 'redeemed'—when they find themselves treated like gods: soon they condescend to the level of the women."[19] Wagner, it is implied, has succumbed to the adoring women by transforming music into mere spectacle, theater, delusion:

> "I have explained where Wagner belongs—*not* in the history of music. What does he signify nevertheless in that history? *The emergence of the actor in music.* . . . One can grasp it with one's very hands: great success, success with the masses no longer sides with those who are authentic—one has to be an actor to achieve that. Victor Hugo and Richard Wagner—they signify the same thing: in declining cultures, wherever the decision comes to rest with the masses, authenticity becomes superfluous, disadvantageous, a liability. Only the actor still arouses *great* enthusiasm."[20]

And then Wagner, the theater, the mass, woman—all become a web of signification outside of, and in opposition to, true art: "No one brings along the finest senses of his art to the theater, least of all the artist who works for the theater—solitude is lacking; whatever is perfect suffers no witnesses. In the theater one becomes people, herd, female, pharisee, voting cattle, patron, idiot—*Wagnerian*."[21] What Nietzsche articulates here is of course not an attack on the drama or the tragedy, which to him remain some of the highest manifestations of culture. When Nietzsche calls theater a "revolt of the masses,"[22] he anticipates what the situationists would later elaborate as the society of the spectacle, and what Baudrillard chastises as the simulacrum. At the same time, it is no coincidence that the philosopher blames theatricality for the decline of culture. After all, the theater in bourgeois society was one of the few spaces which allowed women a prime place in the arts, precisely because acting was seen as imitative and reproductive, rather than original and productive. Thus, in Nietzsche's attack on what he perceives as Wagner's feminization of music, his "infinite melody"—"one walks into the sea, gradually loses one's secure footing, and finally surrenders oneself to the elements without reservation"[23]—an extremely perceptive critique of the mechanisms of bourgeois culture goes hand in hand with an exhibition of that culture's sexist biases and prejudices.

III

The fact that the identification of woman with mass has major political implications is easily recognized. Thus Mallarmé's quip about *"report-age universel"* (i.e., mass culture), with its not so subtle allusion to *"suffrage universel,"* is more than just a clever pun. The problem goes far beyond questions of art and literature. In the late 19th century, a specific traditional male image of woman served as a receptacle for all kinds of projections, displaced fears, and anxieties (both personal and political), which were brought about by modernization and the new social conflicts, as well as by specific historical events such as the 1848 revolution, the 1870 Commune, and the rise of reactionary mass movements which, as in Austria, threatened the liberal order.[24] An examination of the magazines and the newspapers of the period will show that the proletarian and petit-bourgeois masses were persistently described in terms of a feminine threat. Images of the raging mob as hysterical, of the engulfing floods of revolt and revolution, of the swamp of big city life, of the spreading ooze of massification, of the figure of the red whore at the barricades—all of these pervade the writing of the mainstream media, as well as that of right-wing ideo-logues of the late 19th and early 20th centuries whose social psychol-ogy Klaus Theweleit has perceptively analyzed in his study *Male Phantasies.*[25] The fear of the masses in this age of declining liberalism is always also a fear of woman, a fear of nature out of control, a fear of the unconscious, of sexuality, of the loss of identity and stable ego bound-aries in the mass.

This kind of thinking is exemplified by Gustave Le Bon's enor-mously influential *The Crowd* (*La Psychologie des foules*, 1895), which as Freud observed in his own *Mass Psychology and Ego Analysis* (1921) merely summarizes arguments pervasive in Europe at the time. In Le Bon's study, the male fear of woman and the bourgeois fear of the masses become indistinguishable: "Crowds are everywhere distin-guished by feminine characteristics."[26] And: "The simplicity and exag-geration of the sentiments of crowds have for result that a throng knows neither doubt nor uncertainty. Like women, it goes at once to extremes. . . . A commencement of antipathy or disapprobation, which in the case of an isolated individual would not gain strength, becomes at once furious hatred in the case of an individual in a crowd."[27] And then he summarizes his fears with a reference to that icon which perhaps more than any other in the 19th century—more even than the Judiths and Salomés so often portrayed on symbolist canvases—stood for the feminine threat to civilization: "Crowds are

somewhat like the sphinx of ancient fable: it is necessary to arrive at a solution of the problems offered by their psychology or to resign ourselves to being devoured by them."[28] Male fears of an engulfing femininity are here projected onto the metropolitan masses, who did indeed represent a threat to the rational bourgeois order. The haunt-ing specter of a loss of power combines with fear of losing one's fortified and stable ego boundaries, which represent the *sine qua non* of male psychology in that bourgeois order. We may want to relate Le Bon's social psychology of the masses back to modernism's own fears of being sphinxed. Thus the nightmare of being devoured by mass cul-ture through co-option, commodification, and the "wrong" kind of success is the constant fear of the modernist artist, who tries to stake out his territory by fortifying the boundaries between genuine art and inauthentic mass culture. Again, the problem is not the desire to differentiate between forms of high art and depraved forms of mass culture and its co-options. The problem is rather the persistent gender-ing as feminine of that which is devalued.

IV

Seen in relation to this kind of paranoid view of mass culture and the masses, the modernist aesthetic itself—at least in one of its basic regis-ters—begins to look more and more like a reaction formation, rather than like the heroic feat steeled in the fires of the modern experience. At the risk of oversimplifying, I would suggest that one can identify something like a core of the modernist aesthetic which has held sway over many decades, which manifests itself (with variations due to respective media) in literature, music, architecture, and the visual arts, and which has had an enormous impact on the history of criticism and cultural ideology. If we were to construct an ideal type notion of what the modernist art work has become as a result of successive canoniza-tions—and I will exclude here the poststructuralist archeology of mod-ernism which has shifted the grounds of the debate—it would probably look somewhat like this:

—The work is autonomous and totally separate from the realms of mass culture and everyday life.
—It is self-referential, self-conscious, frequently ironic, ambiguous, and rigorously experimental.
—It is the expression of a purely individual consciousness rather than of a Zeitgeist or a collective state of mind.
—Its experimental nature makes it analogous to science, and like science it produces and carries knowledge.

—Modernist literature since Flaubert is a persistent exploration of and encounter with language. Modernist painting since Manet is an equally persistent elaboration of the medium itself: the flatness of the canvas, the structuring of notation, paint and brushwork, the problem of the frame.

—The major premise of the modernist art work is the rejection of all classical systems of representation, the effacement of "content," the erasure of subjectivity and authorial voice, the repudiation of likeness and verisimilitude, the exorcism of any demand for realism of whatever kind.

—Only by fortifying its boundaries, by maintaining its purity and autonomy, and by avoiding any contamination with mass culture and with the signifying systems of everyday life can the art work maintain its adversary stance: adversary to the bourgeois culture of everyday life as well as adversary to mass culture and entertainment which are seen as the primary forms of bourgeois cultural articulation.

One of the first examples of this aesthetic would be Flaubert's famous "impassibilité" and his desire to write "a book about nothing, a book without external attachments which would hold together by itself through the internal force of its style." Flaubert can be said to ground modernism in literature, both for its champions (from Nietzsche to Roland Barthes) and for its detractors (such as Georg Lukács). Other historical forms of this modernist aesthetic would be the clinical, dissecting gaze of the naturalist[29]; the doctrine of art for art's sake in its various classicist or romantic guises since the late 19th century; the insistence on the art-life dichotomy so frequently found at the turn of the century, with its inscription of art on the side of death and masculinity and its evaluation of life as inferior and feminine; and finally the absolutist claims of abstraction, from Kandinsky to the New York School.

But it was only in the 1940s and 1950s that the modernism gospel and the concomitant condemnation of kitsch became something like the equivalent of the one-party state in the realm of aesthetics. And it is still an open question to what extent current poststructuralist notions of language and writing and of sexuality and the unconscious are a postmodern departure toward entirely new cultural horizons; or whether, despite their powerful critique of older notions of modernism, they do not rather represent another mutation of modernism itself.

My point here is not to reduce the complex history of modernism to an abstraction. Obviously, the various layers and components of the ideal modernist work would have to be read in and through specific works in specific historical and cultural constellations. The notion of

autonomy, for instance, has quite different historical determinations for Kant, who first articulated it in his *Kritik der Urteilskraft*, than for Flaubert in the 1850s, for Adorno during World War II, or again for Frank Stella today. My point is rather that the champions of modernism themselves were the ones who made that complex history into a schematic paradigm, the main purpose of which often seemed to be the justification of current aesthetic practice, rather than the richest possible reading of the past in relation to the present.

My point is also not to say that there is only one, male, sexual politics to modernism, against which women would have to find their own voices, their own language, their own feminine aesthetic. What I am saying is that the powerful masculinist mystique which is explicit in modernists such as Marinetti, Jünger, Benn, Wyndham Lewis, Céline et al. (not to speak of Marx, Nietzsche, and Freud), and implicit in many others, has to be somehow related to the persistent gendering of mass culture as feminine and inferior—even if, as a result, the heroism of the moderns won't look quite as heroic any more. The autonomy of the modernist art work, after all, is always the result of a resistance, an abstention, and a suppression—resistance to the seductive lure of mass culture, abstention from the pleasure of trying to please a larger audience, suppression of everything that might be threatening to the rigorous demands of being modern and at the edge of time. There seem to be fairly obvious homologies between this modernist insistence on purity and autonomy in art, Freud's privileging of the ego over the id and his insistence on stable, if flexible, ego boundaries, and Marx's privileging of production over consumption. The lure of mass culture, after all, has traditionally been described as the threat of losing oneself in dreams and delusions and of merely consuming rather than producing.[30] Thus, despite its undeniable adversary stance toward bourgeois society, the modernist aesthetic and its rigorous work ethic as described here seem in some fundamental way to be located also on the side of that society's reality principle, rather than on that of the pleasure principle. It is to this fact that we owe some of the greatest works of modernism, but the greatness of these works cannot be separated from the often one-dimensional gender inscriptions inherent in their very constitution as autonomous masterworks of modernity.

V

The deeper problem at stake here pertains to the relationship of modernism to the matrix of modernization which gave birth to it and

nurtured it through its various stages. In less suggestive terms, the question is why, despite the obvious heterogeneity of the modernist project, a certain universalizing account of the modern has been able to hold sway for so long in literary and art criticism, and why even today it is far from having been decisively displaced from its position of hegemony in cultural institutions. What has to be put in question is the presumably adversary relationship of the modernist aesthetic to the myth and ideology of modernization and progress, which it ostensibly rejects in its fixation upon the eternal and timeless power of the poetic word. From the vantage point of our postmodern age, which has begun in a variety of discourses to question seriously the belief in unhampered progress and in the blessings of modernity, it becomes clear how modernism, even in its most adversary, anti-bourgeois manifestations, is deeply implicated in the processes and pressures of the same mundane modernization it so ostensibly repudiates. It is especially in light of the ecological and environmental critique of industrial and postindustrial capitalism, and of the different yet concomitant feminist critique of bourgeois patriarchy, that the subterranean collusion of modernism with the myth of modernization becomes visible.

I want to show this briefly for two of the most influential and by now classical accounts of the historical trajectory of modernism—the accounts of Clement Greenberg in painting and of Theodor W. Adorno in music and literature. For both critics, mass culture remains the other of modernism, the specter that haunts it, the threat against which high art has to shore up its terrain. And even though mass culture is no longer imagined as primarily feminine, both critics remain under the sway of the old paradigm in their conceptualization of modernism.

Indeed, both Greenberg and Adorno are often taken to be the last ditch defenders of the purity of the modernist aesthetic, and they have become known since the late 1930s as uncompromising enemies of modern mass culture. (Mass culture had by then of course become an effective tool of totalitarian domination in a number of countries, which all banished modernism as degenerate or decadent.) While there are major differences between the two men, both in temperament and in the scope of their analyses, they both share a notion of the inevitability of the evolution of modern art. To put it bluntly, they believe in progress—if not in society, then certainly in art. The metaphors of linear evolution and of a teleology of art are conspicuous in their work. I quote Greenberg: "It has been in search of the absolute that the avant-garde has arrived at 'abstract' or 'nonobjective' art—and poetry, too."[31] It is well known how Greenberg constructs the story of mod-

ernist painting as a single-minded trajectory, from the first French modernist avant-garde of the 1860s to the New York School of abstract expressionism—his moment of truth.

Similarly, Adorno sees a historical logic at work in the move from late romantic music to Wagner and ultimately to Schönberg and the second school of Vienna, which represent *his* moment of truth. To be sure, both critics acknowledge retarding elements in these trajectories—Stravinsky in Adorno's account, surrealism in Greenberg's—but the logic of history, or rather the logic of aesthetic evolution, prevails, giving a certain rigidity to Greenberg's and Adorno's theorizing. Obstacles and detours, it seems, only highlight the dramatic and inevitable path of modernism toward its telos, whether this telos is described as triumph as in Greenberg or as pure negativity as in Adorno. In the work of both critics, the theory of modernism appears as a theory of modernization displaced to the aesthetic realm; this is precisely its historical strength, and what makes it different from the mere academic formalism of which it is so often accused. Adorno and Greenberg further share a notion of decline that they see as following on the climax of development in high modernism. Adorno wrote about "Das Altern der Neuen Musik," and Greenberg unleashed his wrath on the reappearance of representation in painting since the advent of Pop Art.

At the same time, both Adorno and Greenberg were quite aware of the costs of modernization, and they both understood that it was the ever increasing pace of commodification and colonization of cultural space which actually propelled modernism forward, or, better, pushed it toward the outer margins of the cultural terrain. Adorno especially never lost sight of the fact that, ever since their simultaneous emergence in the mid-19th century, modernism and mass culture have been engaged in a compulsive *pas de deux*. To him, autonomy was a relational phenomenon, not a mechanism to justify formalist amnesia. His analysis of the transition in music from Wagner to Schönberg makes it clear that Adorno never saw modernism as anything other than a reaction formation to mass culture and commodification, a reaction formation which operated on the level of form and artistic material. The same awareness that mass culture, on some basic level, determined the shape and course of modernism is pervasive in Clement Greenberg's essays of the late 1930s. To a large extent, it is by the distance we have traveled from this "great divide" between mass culture and modernism that we can measure our own cultural postmodernity. And yet, I still know of no better aphorism about the imaginary adversaries, modernism and mass culture, than that which Adorno articulated in a letter to Walter

Benjamin: "Both [modernist art and mass culture] bear the scars of capitalism, both contain elements of change. Both are torn halves of freedom to which, however, they do not add up."[32]

But the discussion cannot end here. The postmodern crisis of high modernism and its classical accounts has to be seen as a crisis both of capitalist modernization itself and of the deeply patriarchal structures that support it. The traditional dichotomy, in which mass culture appears as monolithic, engulfing, totalitarian, and on the side of regression and the feminine ("Totalitarianism appeals to the desire to return to the womb," said T. S. Eliot[33]) and modernism appears as progressive, dynamic, and indicative of male superiority in culture, has been challenged empirically and theoretically in a variety of ways in the past twenty years or so. New versions of the history of modern culture, the nature of language, and artistic autonomy have been elaborated, and new theoretical questions have been brought to bear on mass culture and modernism; most of us would probably share the sense that the ideology of modernism, as I have sketched it here, is a thing of the past, even if it still occupies major bastions in cultural institutions such as the museum or the academy. The attacks on high modernism, waged in the name of the postmodern since the late 1950s, have left their mark on our culture, and we are still trying to figure out the gains and the losses which this shift has brought about.

VI

What then of the relationship of postmodernism to mass culture, and what of its gender inscriptions? What of postmodernism's relationship to the myth of modernization? After all, if the masculinist inscriptions in the modernist aesthetic are somehow subliminally linked to the history of modernization, with its insistence on instrumental rationality, teleological progress, fortified ego boundaries, discipline, and self-control; if, furthermore, both modernism and modernization are ever more emphatically subjected to critique in the name of the postmodern—then we must ask to what extent postmodernism offers possibilities for genuine cultural change, or to what extent the postmodern raiders of a lost past produce only simulacra, a fast-image culture that makes the latest thrust of modernization more palatable by covering up its economic and social dislocations. I think that postmodernism does both, but I will focus here only on some of the signs of promising cultural change.

A few somewhat tentative reflections will have to suffice, as the amorphous and politically volatile nature of postmodernism makes the

phenomenon itself remarkably elusive, and the definition of its bound-
aries exceedingly difficult, if not per se impossible. Furthermore, one
critic's postmodernism is another critic's modernism (or variant
thereof), while certain vigorously new forms of contemporary culture
(such as the emergence into a broader public's view of distinct minority
cultures and of a wide variety of feminist work in literature and the
arts) have so far rarely been discussed *as* postmodern, even though
these phenomena have manifestly affected both the culture at large
and the ways in which we approach the politics of the aesthetic today.
In some sense it is the very existence of these phenomena which
challenges the traditional belief in the necessary advances of modern-
ism and the avantgarde. If postmodernism is to be more than just
another revolt of the modern against itself, then it would certainly have
to be defined in terms of this challenge to the constitutive forward
thrust of avantgardism.

I do not intend here to add yet another definition of what the
postmodern *really* is, but it seems clear to me that both mass culture and
women's (feminist) art are emphatically implicated in any attempt to
map the specificity of contemporary culture and thus to gauge this
culture's distance from high modernism. Whether one uses the term
"postmodernism" or not, there cannot be any question about the fact
that the position of women in contemporary culture and society, and
their effect on that culture, is fundamentally different from what it
used to be in the period of high modernism and the historical avant-
garde. It also seems clear that the uses high art makes of certain forms
of mass culture (and vice versa) have increasingly blurred the bound-
aries between the two; where modernism's great wall once kept the
barbarians out and safeguarded the culture within, there is now only
slippery ground which may prove fertile for some and treacherous for
others.

At stake in this debate about the postmodern is the great divide
between modern art and mass culture, which the art movements of the
1960s intentionally began to dismantle in their practical critique of the
high modernist canon and which the cultural neo-conservatives are
trying to re-erect today.[34] One of the few widely agreed upon features
of postmodernism is its attempt to negotiate forms of high art with
certain forms and genres of mass culture and the culture of everyday
life.[35] I suspect that it is probably no coincidence that such merger
attempts occurred more or less simultaneously with the emergence of
feminism and women as major forces in the arts, and with the concom-
itant reevaluation of formerly devalued forms and genres of cultural
expression (e.g., the decorative arts, autobiographic texts, letters, etc.).

However, the original impetus to merge high art and popular cul-
ture—for example, say in Pop Art in the early 1960s—did not yet have
anything to do with the later feminist critique of modernism. It was,
rather, indebted to the historical avantgarde—art movements such as
Dada, constructivism, and surrealism—which had aimed, unsuccess-
fully, at freeing art from its aestheticist ghetto and reintegrating art
and life.[36] Indeed, the early American postmodernists' attempts to
open up the realm of high art to the imagery of everyday life and
American mass culture are in some ways reminiscent of the historical
avantgarde's attempt to work in the interstices of high art and mass
culture. In retrospect, it thus seems quite significant that major artists
of the 1920s used precisely the then wide-spread "Americanism"
(associated with jazz, sports, cars, technology, movies, and photogra-
phy) in order to overcome bourgeois aestheticism and its separateness
from "life." Brecht is the paradigmatic example here, and he was in
turn strongly influenced by the post-revolutionary Russian avantgarde
and its daydream of creating a revolutionary avantgarde culture for
the masses. It seems that the European Americanism of the 1920s then
returned to America in the 1960s, fueling the fight of the early post-
modernists against the high-culture doctrines of Anglo-American
modernism. The difference is that the historical avantgarde—even
where it rejected Leninist vanguard politics as oppressive to the artist—
always negotiated its political Selbstverständnis in relation to the revolu-
tionary claims for a new society which would be the sine qua non of the
new art. Between 1916—the "outbreak" of Dada in Zurich—and 1933/
34—the liquidation of the historical avantgarde by German fascism
and Stalinism—many major artists took the claim inherent in the
avantgarde's name very seriously: namely, to lead the whole of society
toward new horizons of culture, and to create an avantgarde art for the
masses. This ethos of a symbiosis between revolutionary art and revolu-
tionary politics certainly vanished after World War II; not just because
of McCarthyism, but even more because of what Stalin's henchmen
had done to the left aesthetic avantgarde of the 1920s. Yet the attempt
by the American postmodernists of the 1960s to renegotiate the rela-
tionship between high art and mass culture gained its own political
momentum in the context of the emerging new social movements of
those years—among which feminism has perhaps had the most lasting
effects on our culture, as it cuts across class, race, and gender.

 In relation to gender and sexuality, though, the historical avant-
garde was by and large as patriarchal, misogynist, and masculinist as
the major trends of modernism. One needs only to look at the

metaphors in Marinetti's "Futurist Manifesto," or to read Marie Luise
Fleisser's trenchant description of her relationship to Bertolt Brecht in
a prose text entitled "Avantgarde"—in which the gullible, literarily
ambitious young woman from the Bavarian province becomes a guinea
pig in the machinations of the notorious metropolitan author. Or,
again, one may think of how the Russian avantgarde fetishized produc-
tion, machines, and science, and of how the writings and paintings of
the French surrealists treated women primarily as objects of male
phantasy and desire.

There is not much evidence that things were very different with the
American postmodernists of the late 1950s and early 1960s. However,
the avantgarde's attack on the autonomy aesthetic, its politically moti-
vated critique of the highness of high art, and its urge to validate other,
formerly neglected or ostracized forms of cultural expression created
an aesthetic climate in which the political aesthetic of feminism could
thrive and develop its critique of patriarchal gazing and penmanship.
The aesthetic transgressions of the happenings, actions, and perform-
ances of the 1960s were clearly inspired by Dada, Informel, and action
painting; and with few exceptions—the work of Valie Export, Char-
lotte Moorman, and Carolee Schneemann—these forms did not trans-
port feminist sensibilities or experiences. But it seems historically sig-
nificant that women artists increasingly used these forms in order to
give voice to their experiences.[37] The road from the avantgarde's
experiments to contemporary women's art seems to have been shorter,
less tortuous, and ultimately more productive than the less frequently
traveled road from high modernism. Looking at the contemporary art
scene, one may well want to ask the hypothetical question whether
performance and "body art" would have remained so dominant during
the 1970s had it not been for the vitality of feminism in the arts and the
ways in which women artists articulated experiences of the body and of
performance in gender-specific terms. I only mention the work of
Yvonne Rainer and Laurie Anderson. Similarly, in literature the re-
emergence of the concern with perception and identification, with
sensual experience and subjectivity in relation to gender and sexuality
would hardly have gained the foreground in aesthetic debates (against
even the powerful poststructuralist argument about the death of the
subject and the Derridean expropriation of the feminine) had it not
been for the social and political presence of a women's movement and
women's insistence that male notions of perception and subjectivity (or
the lack thereof) did not really apply to them. Thus the turn toward
problems of "subjectivity" in the German prose of the 1970s was

initiated not just by Peter Schneider's *Lenz* (1973), as is so often claimed, but even more so by Karin Struck's *Klassenliebe* (also 1973) and, in retrospect, by Ingeborg Bachmann's *Malina* (1971).

However one answers the question of the extent to which women's art and literature have affected the course of postmodernism, it seems clear that feminism's radical questioning of patriarchal structures in society and in the various discourses of art, literature, science, and philosophy must be one of the measures by which we gauge the specificity of contemporary culture as well as its distance from modernism and its mystique of mass culture as feminine. Mass culture and the masses as feminine threat—such notions belong to another age, Jean Baudrillard's recent ascription of femininity to the masses notwithstanding. Of course, Baudrillard gives the old dichotomy a new twist by applauding the femininity of the masses rather than denigrating it, but his move may be no more than yet another Nietzschean simulacrum.[38] After the feminist critique of the multilayered sexism in television, Hollywood, advertising, and rock 'n' roll, the lure of the old rhetoric simply does not work any longer. The claim that the threats (or, for that matter, the benefits) of mass culture are somehow "feminine" has finally lost its persuasive power. If anything, a kind of reverse statement would make more sense: certain forms of mass culture, with their obsession with gendered violence are more of a threat to women than to men. After all, it has always been men rather than women who have had real control over the productions of mass culture.

In conclusion, then, it seems clear that the gendering of mass culture as feminine and inferior has its primary historical place in the late 19th century, even though the underlying dichotomy did not lose its power until quite recently. It also seems evident that the decline of this pattern of thought coincides historically with the decline of modernism itself. But I would submit that it is primarily the visible and public presence of women artists in *high* art, as well as the emergence of new kinds of women performers and producers in mass culture, which make the old gendering device obsolete. The universalizing ascription of femininity to mass culture always depended on the very real exclusion of women from high culture and its institutions. Such exclusions are, for the time being, a thing of the past. Thus, the old rhetoric has lost its persuasive power because the realities have changed.

PART TWO

Texts and Contexts

4

The Vamp and the Machine:
Fritz Lang's *Metropolis*

Fritz Lang's famous and infamous extravaganza *Metropolis* has never had a good press. While its visual qualities have been praised,[1] its content, more often than not, has been condemned as simplistic, ill-conceived, or plain reactionary. When the film was first released in the United States in 1927, Randolph Bartlett, the *New York Times* critic, reproached the director for his "lack of interest in dramatic verity" and for his "ineptitude" in providing plot motivation, thus justifying the heavy re-editing of the film for American audiences.[2] In Germany, critic Axel Eggebrecht condemned *Metropolis* as a mystifying distortion of the "unshakeable dialectic of the class struggle" and as a monu-mental panegyric to Stresemann's Germany.[3] Eggebrecht's critique, focusing as it does on the emphatic reconciliation of capital and labor at the end of the film, has been reiterated untold times by critics on the left. And indeed, if we take class and power relations in a modern technological society to be the only theme of the film, then we have to concur with these critics. We would also have to agree with Siegfried Kracauer's observation concerning the affinity that exists between the film's ideological punch line, "The heart mediates between hand and brain," and the fascist "art" of propaganda which, in Goebbels' words, was geared "to win the heart of a people and to keep it."[4] Kracauer pointedly concluded his comments on *Metropolis* with Lang's own words describing a meeting of the filmmaker with Goebbels that took place shortly after Hitler's rise to power: "'He (i.e., Goebbels) told me

This essay was first published in *New German Critique*, 24–25 (Fall/Winter 1981–82), 221–237.

that, many years before, he and the Führer had seen my picture
Metropolis in a small town, and Hitler had said at that time that he
wanted me to make the Nazi pictures.' "5

One problem with such ideology critiques based on notions of class
and political economy is that they tend to blur the political differences
between the Weimar Republic and the Third Reich by suggesting that
social-democratic reformism inexorably contributed to Hitler's rise to
power. The more important problem with this approach is that it
remains blind to other aspects which are at least as important to the
film's social imaginary, especially since they are clearly foregrounded
in the narrative. While the traditional ideology critique is not false, its
blind spots lock us into a one-dimensional reading of the film which
fails to come to terms with the fascination *Metropolis* has always exerted
on audiences. This fascination, I would argue, has to do precisely with
those elements of the narrative which critics have consistently
shrugged aside. Thus the love story between Freder, son of the Master
of Metropolis, and Maria, the woman of the depths who preaches
peace and social harmony to the workers, has been dismissed as sen-
timental and childish (Eisner, Jensen); the elaborate recreation of
Maria as a machine-vamp in Rotwang's laboratory has been called
counterproductive to the flow of events (Kracauer); certain actions of
the mechanical vamp such as the belly dance have been called ex-
traneous and inexplicable (Jensen); and the medieval religious-
alchemical symbolism of the film has been criticized as inadequate for
the portrayal of a future—or, for that matter, present—urban life
(Eggebrecht). I am suggesting, however, that it is precisely the doubl-
ing of Maria, the use of religious symbolism, the embodiment of
technology in a woman-robot and Freder's complex relationship to
women and machines, sexuality and technology, which give us a key to
the film's social and ideological imaginary. Even though Kracauer's
concrete analysis of *Metropolis* remained blind to this constitutive mesh
of technology and sexuality in the film, he was essentially correct when
he wrote in *From Caligari to Hitler: "Metropolis* was rich in subterranean
content that, like contraband, had crossed the borders of consciousness
without being questioned."6 The problem is how to define this sub-
terranean content, a task which Kracauer does not even begin to tackle
in his analysis of the film.

Of course the critics' attention has always been drawn to the film's
powerful sequences involving images of technology, which, to a large
degree, control the flow of the narrative.

—The film begins with a series of shots of the great machines of
Metropolis moving and turning in inexorable rhythms.

—The machine room where Freder witnesses the violent explosion and has his vision of technology as moloch devouring its victims, and the sun-like spinning disk of the central power-house present technology as an autonomous deified force demanding worship, surrender, and ritual sacrifice.

—The imagery of the tower of Babel (the machine center of Metropolis is actually called the New Tower of Babel) relates technology to myth and legend. The biblical myth is used to construct the ideological message about the division of labor into the hands that build and the brains that plan and conceive, a division which, as the film suggests, must be overcome.

—The capital/labor conflict is present in the sequences showing the Master of Metropolis in his control and communications center and the workers in the machine room, with the machines being subservient to the master but enslaving the workers.

—Finally, and perhaps most importantly, technology is embodied in a female robot, a machine-vamp who leads the workers on a rampage and is subsequently burned at the stake.

Eggebrecht and Kracauer were certainly correct in relating Lang's representation of technology to the machine-cult of the 1920s which is also manifest in the literature and the art of *Neue Sachlichkeit*.[7] In my view, however, it is not enough to locate the film within the parameters of *Neue Sachlichkeit* only. The simple fact that stylistically *Metropolis* has usually and mainly been regarded as an expressionist film may give us a clue. And indeed, if one calls expressionism's attitude toward technology to mind, one begins to see that the film actually vacillates between two opposing views of modern technology which were both part of Weimar culture. The expressionist view emphasizes technology's oppressive and destructive potential and is clearly rooted in the experiences and irrepressible memories of the mechanized battlefields of World War I. During the 1920s and especially during the stabilization phase of the Weimar Republic this expressionist view was slowly replaced by the technology cult of the *Neue Sachlichkeit* and its unbridled confidence in technical progress and social engineering. Both these views inform the film. Thus on the one hand, *Metropolis* is strongly indebted to Georg Kaiser's expressionist play about technology, *Gas*. In both works the primary technology is energy, gas and electricity respectively, and the industrial accident sequence in *Metropolis* is remarkably similar to the explosion of the gas works in act I of Kaiser's play. But, on the other hand, the shots of the city Metropolis, with its canyon-like walls rising far above street level and with its bridges and elevated roads thrown between towering factories and office buildings

are reminiscent of Hannah Höch's dadaist photomontages and of scores of industrial and urban landscape paintings of the *Neue Sachlichkeit* (Karl Grossberg, Georg Scholz, Oskar Nerlinger).

Historically and stylistically then Lang's *Metropolis*, which was conceived in 1924 during a visit to the United States (including New York) and released in January 1927, is a syncretist mixture of expressionism and *Neue Sachlichkeit*, and, more significantly, a syncretist mixture of the two diametrically opposed views of technology we can ascribe to these two movements. More precisely, the film works through this conflict and tries to resolve it. Ultimately the film, even though it pretends to hold on to the humanitarian anti-technological ethos of expressionism, comes down on the side of *Neue Sachlichkeit*, and the machine vamp plays the crucial role in resolving a seemingly irreconcilable contradiction. For his indictment of modern technology as oppressive and destructive, which prevails in most of the narrative, Lang ironically relies on one of the most novel cinematic techniques. Schüfftan's *Spiegeltechnik*, a technique which by using a camera with two lenses, focuses two separate images, those of models and actors, onto a single strip of film. As I shall argue later, doubling, mirroring and projecting not only constitute the technological make-up of this film, but they lie at the very core of the psychic and visual processes that underlie its narrative.

The Machine-Woman: A Historical Digression

To my knowledge, the motif of the machine-woman in *Metropolis* has never been analyzed in any depth. In his recent reinterpretation of *Metropolis*, Stephen Jenkins has taken an important step by pushing the question of the significance of the female presence in Lang's films to the forefront.[8] Although many of Jenkins' observations about Maria and Freder are correct, his analysis is deficient in three areas: his reading remains too narrowly Oedipal moving as it does from Maria's initial threat to the Law of the Father to her and Freder's reintegration into Metropolis' system of domination; secondly, Jenkins never problematizes Lang's representations of technology and thus remains oblivious to that central political and ideological debate of the 1920s; and thirdly, he never explores the question how or why male fantasies about women and sexuality are interlaced with visions of technology in the film. It is my contention that only by focusing on the mechanical vamp can we fully comprehend the cohesion of meanings which the film transports.

Why indeed does the robot, the *Maschinenmensch* created by the

inventor-magician Rotwang and intended to replace the human work-
ers, appear with the body features of a woman? After all, the world of
technology has always been the world of men while woman has been
considered to be outside of technology, a part of nature, as it were. It is
too simple, to suggest, as Jenkins does, that the vamp's main function is
to represent the threat of castration to Freder; that purpose could have
been achieved by other narrative means, and it also leaves unanswered
the question of what technology may have to do with female sexuality
and castration anxiety. Precisely the fact that Fritz Lang does not feel
the need to explain the female features of Rotwang's robot shows that a
pattern, a long standing tradition is being recycled here, a tradition
which is not at all hard to detect, and in which the *Maschinenmensch*,
more often than not, is presented as woman.

A historical digression is in order.[9] In 1748 the French doctor Julien
Offray de la Mettrie, in a book entitled *L'Homme machine*, described the
human being as a machine composed of a series of distinct, mechani-
cally moving parts, and he concluded that the body is nothing but a
clock, subject as all other matter to the laws of mechanics. This extreme
materialist view with its denial of emotion and subjectivity served
politically in the 18th century to attack the legitimacy claims of feudal
clericalism and the absolutist state. It was hoped that once the meta-
physical instances, which church and state resorted to as devices of
legitimizing their power, were revealed as fraud they would become
obsolete. At the same time, however, and despite their revolutionary
implications such materialist theories ultimately led to the notion of a
blindly functioning world machine, a gigantic automaton, the origins
and meaning of which were beyond human understanding. Conscious-
ness and subjectivity were degraded to mere functions of a global
mechanism. The determination of social life by metaphysical legitima-
tions of power was replaced by the determination through the laws of
nature. The age of modern technology and its legitimatory appa-
ratuses had begun.

It is no coincidence that in the same age literally hundreds of me-
chanics attempted to construct human automata who could walk and
dance, draw and sing, play the flute or the piano, and whose perform-
ances became a major attraction in the courts and cities of 18th-
century Europe. Androids and robots such as Vaucanson's flutist or
Jacquet-Droz's organ player captured the imagination of the times and
seemed to embody the realization of an age-old human dream. With
the subsequent systematic introduction of laboring machines, which
propelled the industrial revolution, the culture of androids declined.
But it is precisely at that time, at the turn of the 18th to the 19th

century, that literature appropriates the subject matter transforming it significantly. The android is no longer seen as testimony to the genius of mechanical invention; it rather becomes a nightmare, a threat to human life. In the machine-man writers begin to discover horrifying traits which resemble those of real people. Their theme is not so much the mechanically constructed automaton itself, but rather the threat it poses to live human beings. It is not hard to see that this literary phenomenon reflects the increasing technologization of human nature and the human body which reached a new stage in the early 19th century.

While the android builders of the 18th century did not seem to have an overriding preference for either sex (the number of male and female androids seems to be more or less balanced), it is striking to see how the later literature prefers machine-women to machine-men.[10] Historically, then, we can conclude that as soon as the machine came to be perceived as a demonic, inexplicable threat and as harbinger of chaos and destruction—a view which typically characterizes many 19th-century reactions to the railroad to give but one major example[11]—writers began to imagine the *Maschinenmensch* as woman. There are grounds to suspect that we are facing here a complex process of projection and displacement. The fears and perceptual anxieties emanating from ever more powerful machines are recast and reconstructed in terms of the male fear of female sexuality, reflecting, in the Freudian account, the male's castration anxiety. This projection was relatively easy to make; although woman had traditionally been seen as standing in a closer relationship to nature than man, nature itself, since the 18th century, had come to be interpreted as a gigantic machine. Woman, nature, machine had become a mesh of significations which all had one thing in common: otherness; by their very existence they raised fears and threatened male authority and control.

The Ultimate Technological Fantasy: Creation without Mother

With that hypothesis in mind let us return to *Metropolis*. As I indicated before, the film does not provide an answer to the question of why the robot is a woman; it takes the machine-woman for granted and presents her as quasi-natural. Thea von Harbou's novel, however, on which the film is based, is quite explicit. In the novel, Rotwang explains why he created a female robot rather than the machine *men* Frederson had ordered as replacements of living labor. Rotwang says: "Every man-creator makes himself a woman. I do not believe that humbug about the first human being a man. If a male god created the

world . . . then he certainly created woman first."[12] This passage does not seem to fit my hypothesis that the machine-woman typically reflects the double male fear of technology and of woman. On the contrary, the passage rather suggests that the machine-woman results from the more or less sublimated sexual desires of her male creator. We are reminded of the Pygmalion myth in which the woman, far from threatening the man, remains passive and subordinated. But this contradiction is easily resolved if we see male control as the common denominator in both instances. After all, Rotwang creates the android as an artifact, as an initially lifeless object which he can then control and dominate.

Clearly the issue here is not just the male's sexual desire for woman. It is the much deeper libidinal desire to create that other, woman, thus depriving it of its otherness. It is the desire to perform this ultimate task which has always eluded technological man. In the drive toward ever greater technological domination of nature, Metropolis' master-engineer must attempt to create woman, a being which, according to the male's view, resists technologization by its very "nature." Simply by virtue of natural biological reproduction, woman had maintained a qualitative distance to the realm of technical production which only produces lifeless goods. By creating a female android, Rotwang fulfills the male phantasm of a creation without mother; but more than that, he produces not just any natural life, but woman herself, the epitome of nature. The nature/culture split seems healed. The most complete technologization of nature appears as re-naturalization, as a progress back to nature. Man is at long last alone and at one with himself.

Of course it is an imaginary solution. And it is a solution that does violence to a real woman. The real Maria has to be subdued and exploited so that the robot, by way of male magic, can be instilled with life, a motif, which is fairly symptomatic of the whole tradition. The context of the film makes it clear that in every respect, it is male domination and control which are at stake: control of the real Maria who, in ways still to be discussed, represents a threat to the world of high technology and its system of psychic and sexual repression; domination of the woman-robot by Rotwang who orders his creature to perform certain tasks; control of the labor process by the Master of Metropolis who plans to replace inherently uncontrollable living labor by robots; and, finally, control of the workers' actions through Frederson's cunning use of the machine-woman, the false Maria.

On this plane, then, the film suggests a simple and deeply problematic homology between woman and technology, a homology which results from male projections: Just as man invents and constructs

technological artifacts which are to serve him and fulfill his desires, so woman, as she has been socially invented and constructed by man, is expected to reflect man's needs and to serve her master. Furthermore, just as the technological artifact is considered to be the quasi-natural extension of man's natural abilities (the lever replacing muscle power, the computer expanding brain power), so woman, in male perspective, is considered to be the natural vessel of man's reproductive capacity, a mere bodily extension of the male's procreative powers. But neither technology nor woman can ever be seen as solely a natural extension of man's abilities. They are always also qualitatively different and thus threatening in their otherness. It is this threat of otherness which causes male anxiety and reinforces the urge to control and dominate that which is other.

Virgin and Vamp: Displacing the Double Threat

The otherness of woman is represented in the film in two traditional images of femininity—the virgin and the vamp, images which are both focused on sexuality. Although both the virgin and the vamp are imaginary constructions, male-imagined "ideal types" belonging to the realm Silvia Bovenschen has described as *"Imaginierte Weiblichkeit,"*[13] they are built up from a real core of social, physiological, and psychological traits specific to women and should not be dismissed simply as yet another form of false consciousness. What is most interesting about *Metropolis* is the fact that in both forms, femininity, imagined as it is from the male perspective, poses a threat to the male world of high technology, efficiency, and instrumental rationality. Although the film does everything in terms of plot development and ideological substance to neutralize this threat and to reestablish male control in Metropolis, the threat can clearly be perceived as such throughout the film. First, there is the challenge that the real Maria poses to Frederson, the Master of Metropolis. She prophesies the reign of the heart, i.e., of affection, emotion, and nurturing. Significantly, she is first introduced leading a group of ragged workers' children into the pleasure gardens of Metropolis' *jeunesse dorée*, suggesting both childbearing ability and motherly nurturing. But she also alienates Freder from his father by introducing him to the misery of working-class life. While at the end of the film Maria has become a pawn of the system, at the beginning she clearly represents a threat to the Master of Metropolis. This shows in the sequence where Frederson, led by Rotwang, secretly observes Maria preaching to the workers in the catacombs. The very fact that Frederson did not know of the existence of the catacombs deep under-

neath the city proves that there is something here which escapes his
control. Looking through an aperture in a wall high above the assem-
bly at the bottom of the cavern, Frederson listens to Maria preaching
peace and acquiescence to the workers, not revolt. Prophesying the
eventual reconciliation between the masters and the slaves she states:
"Between the brain that plans and the hands that build, there must be a
mediator." And: "It is the heart that must bring about an understand-
ing between them." Rather than perceiving this notion as a welcome
ideological veil to cover up the conflict between labor and capital,
masters and slaves (that is certainly the way Hitler and Goebbels read
the film), Frederson backs away from the aperture and, with a stern
face and his fists plunged into his pockets, he orders Rotwang to make
his robot in the likeness of Maria. Then he clenches one fist in the air
and continues: "Hide the girl in your house, I will send the robot down
to the workers, to sow discord among them and destroy their confi-
dence in Maria." In social and ideological terms this reaction is inexpli-
cable, since Maria, similar to Brecht's Saint Joan of the Stockyards,
preaches social peace. But in psychological terms Frederson's wish to
disrupt Maria's influence on the workers makes perfect sense. The
threat that he perceives has nothing to do with the potential of orga-
nized workers' resistance. It has, however, a lot to do with his fear of
emotion, of affection, of nurturing, i.e., of all that which is said to be
embodied in woman, and which is indeed embodied in Maria.

The result of Frederson's fear of femininity, of emotion and nurtur-
ing, is the male fantasy of the machine-woman who, in the film, em-
bodies two age old patriarchal images of women which, again, are
hooked up with two homologous views of technology. In the machine-
woman, technology and woman appear as creations and/or cult objects
of the male imagination. The myth of the dualistic nature of woman as
either asexual virgin-mother or prostitute-vamp is projected onto tech-
nology which appears as either neutral and obedient or as inherently
threatening and out-of-control. On the one hand, there is the image of
the docile, sexually passive woman, the woman who is subservient to
man's needs and who reflects the image which the master projects of
her. The perfect embodiment of this stereotype in the film is the
machine-woman of the earlier sequences when she obeys her master's
wishes and follows his commands. Technology seems completely
under male control and functions as intended as an extension of man's
desires. But even here control is tenuous. We understand that Rotwang
has lost a hand constructing his machine. And when the robot advances
toward Frederson, who stands with his back to the camera, and extends
her hand to greet him Frederson is taken aback, and recoils in alarm, a

direct parallel to his first spontaneous physical reaction to Maria. Later Rotwang transforms the obedient asexual robot into Maria's living double, and Frederson sends her down to the workers as an *agent provocateur*. She now appears as the prostitute-vamp, the harbinger of chaos, embodying that threatening female sexuality which was absent (or under control) in the robot. Of course, the potent sexuality of the vamp is as much a male fantasy as the asexuality of the virgin-mother. And, indeed, the mechanical vamp is at first as dependent on and obedient to Frederson as the faceless robot was to Rotwang. But there is a significant ambiguity here. Although the vamp acts as an agent of Frederson's manipulation of the workers, she also calls forth libidinal forces which end up threatening Frederson's rule and the whole social fabric of Metropolis and which therefore have to be purged before order and control can be reestablished. This view of the vamp's sexuality posing a threat to male rule and control, which is inscribed in the film, corresponds precisely to the notion of technology running out-of-control and unleashing its destructive potential on humanity. After all, the vamp of the film *is* a technological artifact upon which a specifically male view of destructive female sexuality has been projected.

The Male Gaze and the Dialectic of Discipline and Desire

It is in this context of technology and female sexuality that certain sequences of the film, which have often been called extraneous, assume their full meaning. The mechanical vamp, made to look exactly like Maria, the virgin-mother-lover figure is presented to an all male gathering in a spectacular *mise-en-scène* which Rotwang has arranged in order to prove that nobody will be able to tell the machine from a human being. In steam and light the false Maria emerges from a huge ornamental urn and then performs a seductive strip-tease attracting the lustful gaze of the assembled male guests. This gaze is effectively filmed as an agitated montage of their eyes staring into the camera. Cinematically, this is one of the film's most interesting sequences, and it casts a significant light on earlier sequences involving appearances of Maria and the robot. The montage of male eyes staring at the false Maria when she emerges from her cauldron and begins to cast off her clothes illustrates how the male gaze actually constitutes the female body on the screen. It is as if we were witnessing the second, public creation of the robot, her flesh, skin, and body not only being revealed, but constituted by the desire of male vision. Looking back now on earlier sequences it becomes clear how the eye of the camera always places the spectator in a position occupied by the men in the film: the

workers looking spell-bound at Maria preaching from her candle-lit altar; Frederson, his back to the camera, staring at Rotwang's robot; Rotwang's flashlight pinning Maria down in the caverns, and symbolically raping her; and, finally, the transference of Maria's bodily features onto the metallic robot under the controlling surveillance of Rotwang's gaze. Woman appears as a projection of the male gaze, and this male gaze is ultimately that of the camera, of another machine. In the mentioned sequences, vision is identified as male vision. In Lang's narrative, the male eye, which is always simultaneously the mechanical eye of the camera, constructs its female object as a technological artifact (i.e., as a robot) and then makes it come to life through multiple instances of male vision inscribed into the narrative. This gaze is an ambiguous mesh of desires: desire to control, desire to rape, and ultimately desire to kill, which finds *its* gratification in the burning of the robot.

It is also significant that the artificial woman is constructed from the inside out. First Rotwang constructs the mechanical "inner" woman; external features such as flesh, skin, and hair are added on in a second stage when the body features of the real Maria are transferred to or projected onto the robot in an elaborate chemical and electric spectacle. This technical process in which woman is divided and fragmented into inner and outer nature is later mirrored in the subsequent stages of the vamp's destruction: the outer features of the vamp burn away on the stake until only the mechanical insides are left and we again see the metallic robot of the earlier scenes. My point here is not only that construction and destruction of the female body are intimately linked in *Metropolis*. Beyond that, it is male vision which puts together and disassembles woman's body, thus denying woman her identity and making her into an object of projection and manipulation. What is interesting about Lang's *Metropolis* is not so much that Lang uses the male gaze in the described way. Practically all traditional narrative cinema treats woman's body as a projection of male vision. What is interesting, however, is that by thematizing male gaze and vision in the described way the film lays open a fundamental filmic convention usually covered up by narrative cinema.

But there is more to it than that. Lang's film may lead us to speculate whether the dominance of vision *per se* in our culture may not be a fundamental problem rather than a positive contribution to the advance of civilization as Norbert Elias would have it in his study of the civilizing process.[14] Actually Elias' sources themselves are open to alternative interpretations. He quotes for example from an 18th-century etiquette manual, La Salle's *Civilité* (1774): "Children like to

touch clothes and other things that please them with their hands. This urge must be corrected, and they must be taught to touch all they see only with their eyes." And then Elias concludes as follows: "It has been shown elsewhere how the use of the sense of smell, the tendency to sniff at food or other things, comes to be restricted as something animal-like. Here we see one of the interconnections through which a different sense organ, the eye, takes on a very specific significance in civilized society. In a similar way to the ear, and perhaps even more so, it becomes a mediator of pleasure, precisely because the direct satisfaction of the desire for pleasure has been hemmed in by a multitude of barriers and prohibitions."[15] The language both in the source and in Elias' text is revealing. Corrections, barriers, prohibition—the terms indicate that there is more at stake here than the satisfaction of desire or the progress of civilization. It is of course Michel Foucault who, in his analysis of modernization processes, has shown in *Discipline and Punish* how vision and the gaze have increasingly become means of control and discipline. While Elias and Foucault differ in their evaluation of the observed phenomena, their micrological research on vision corroborates Adorno and Horkheimer's macrological thesis that the domination of outer nature via science and technology in capitalist society is dialectically and inexorably linked with the domination of inner nature, one's own as well as that of others.[16]

I would argue that it is precisely this dialectic which is the subterranean context of Lang's *Metropolis*. Vision as pleasure and desire has to be subdued and manipulated so that vision as technical and social control can emerge triumphant. On this level, the film pits the loving, nurturing gaze of Maria against the steely, controlled and controlling gaze of the Master of Metropolis. In the beginning Maria eludes his control since the catacombs are the only place in Metropolis remaining outside of the panoptic control system of the Tower; if only for that she must be punished and subdued. Beyond that, her "inner nature" is replaced by the machine. Ironically, however, the attempt to replace the real woman by the machine-woman fails, and Rotwang and Frederson have to face the return of the repressed. Once Maria has become a machine or, which is the other side of the process, the machine has appropriated Maria's external appearance, she again begins to elude her master's control. It seems that in whatever form woman cannot be controlled. True, the robot Maria does perform the task she has been programmed to do. In an inflammatory speech supported by sensual body language she seduces the male workers and leads them to the rampage in the machine rooms. In these sequences, the expressionist fear of a threatening technology which oppresses

workers is displaced and reconstructed as the threat female sexuality poses to men and, ironically, to technology. Thus the machine-woman, who is no longer recognized as a machine, makes all men lose control: both the upperclass men who lust after her at the belly-dance party, and who, later, run deliriously with her through the streets of Metropolis shouting "Let's watch the world going to the devil," and the workers in the catacombs whom she turns into a raging machine-destroying mob. Significantly the riot is joined by the workers' wives who are shown for the first time in the film—in a state of hysteria and frenzy. The mob scenes thus take on connotations of a raging femininity which represents *the* major threat not only to the great machines, but to male domination in general. The threat of technology has successfully been replaced by the threat of woman. But while the machines only threatened the men who worked them the unleashed force of female sexuality, represented by the vamp and the working-class women,[17] endangers the whole system of Metropolis, uptown and downtown, masters and slaves, and especially the workers' children who were abandoned underground to the floods unleashed by the destruction of the central powerhouse.

The Female Minotaur as Technology-out-of-control

Cliché has had it that sexually women are passive by nature and that the sexually active woman is abnormal, if not dangerous and destructive. The machine vamp in *Metropolis* of course embodies the unity of an active and destructive female sexuality and the destructive potential of technology. This pairing of the woman with the machine is in no way unique to Lang's film. Apart from the literary examples I cited earlier, it can be found in numerous 19th-century allegorical representations of technology and industry as woman.[18] More interesting for my purposes here, however, is Jean Veber's early 20th-century painting entitled "Allégorie sur la machine dévoreuse des hommes."[19] In the right half of the painting we see a gigantic flywheel which throws up and devours dozens of dwarf-like men. A large rod connected with the flywheel moves to and fro into a metal box on which a giant woman is sitting naked, with parted legs and smiling demonically. Clearly the painting is an allegory of sexual intercourse, of a destructive female sexuality unleashed upon men. It suggests that the woman has appropriated the phallic power and activity of the machine and that she now turns this power violently against men. It is easy to see that the allegory is indicative of male sexual anxieties, of the fear of an uncontrolled female potency, of the vagina dentata, of castration by woman.

Whereas in this painting woman and machine are not identical, but stand in a relationship allegorizing a specific kind of female sexuality as imagined and feared by men, woman and machine are collapsed into one in the machine-vamp of *Metropolis*. Since the painting is sexually more explicit, it can help us unearth another major aspect of the film's subterranean content. What Eduard Fuchs, the famous art collector and art critic, said about Veber's allegorical painting in 1906, he could have said as well, with even more justification, of the machine-vamp in *Metropolis:* "Woman is the symbol of that terrifying, secret power of the machine which rolls over anything that comes under its wheels, smashes that which gets caught in its cranks, shafts, and belts, and destroys those who attempt to halt the turning of its wheels. And, vice versa, the machine, which coldly, cruelly and relentlessly sacrifices hecatombs of men as if they were nothing, is the symbol of the man-strangling Minotaur-like nature of woman."[20] A perfect summary of male mystifications of female sexuality as technology-out-of-control!

Exorcism of the Witch Machine

In light of Veber's painting and Fuchs' interpretation even earlier sequences of the film assume a different meaning. In her first appearance Maria, accompanied by the workers' children, seems to represent only the stereotypical innocent virgin-mother figure, devoid of sexuality. Such an interpretation is certainly in character, but it is nevertheless only one side of the story. It is significant, I think, that Freder's first gaze at Maria is heavily loaded with sexual connotations. Just before their encounter, Freder is playfully chasing a young woman back and forth around a fountain splashing water at her. Finally they collide in front of the fountain. Freder takes her in his arms, bends over her, and is about to kiss her when the doors open and Maria enters with the children. Freder releases the woman in his arms and in point of view shot stares raptured at Maria. This context of Maria's appearance as well as the hazed iris effect surrounding Maria as Freder gazes at her clearly indicate that Maria has instantaneously become an object of desire. To be sure, the passions she arouses in Freder are different from the playful sexuality suggested by the preceding sequence, but they are anything but asexual. The use of water imagery can give us another cue here. Just as the floods of the later sequences allegorize female frenzy (the proletarian women) and threatening female sexuality (the vamp), the fountain assumes sexual meaning as well. Except that here the water imagery suggests a controlled, channelled and non-threatening sexuality, the playful kind that is permitted in Me-

tropolis. Similarly, the choreography of body movements in the foun-
tain scene emphasizes geometry, symmetry and control, aspects which
also inform the preceding track race sequence in the Masterman Sta-
dium which was later cut from the film. Both athletics and the sexual
games of the Eternal Gardens are presented as carefree, but controlled
diversions of Metropolis' gilded youth. These scenes show us the
upper-class equivalent of Lang's ornamental treatment of the workers
in geometric, mechanically moving columns.[21] Already here Maria
clearly disrupts the status quo. In response to her appearance Freder's
body movements and gestures assume a new quality. From this point
he becomes all impulse and desire, charges blindly from place to place,
and seems unable to keep his body under control. Even more impor-
tantly, it is in pursuit of Maria that Freder descends underground and
ends up in the vast machine halls of Metropolis. Whether she has "led"
him there or not, the narrative links Freder's first exposure to the great
machines with his sexual desire, a link which becomes even more
manifest in the explosion sequence. For all of the subsequent events in
the machine room actually mirror Freder's internal situation. The
temperature rises relentlessly above the danger point and the
machines run out of human control. Several blasts throw workers off
the scaffoldings. Steam whirls and bodies fly through the air. Then
comes a sequence in which Freder, in a total state of shock, begins to
hallucinate. In his vision, the aperture high up in the belly of the great
machine, in which we can see revolving cranks, changes into a gro-
tesque mask-like face with a gaping mouth equipped with two rows of
teeth. A column of half-naked workers moves up the pyramid-like
steps, and two priests standing on either side of the fiery and blinding
abyss supervise several muscular slaves who hurl worker after worker
against the gleaming cranks which keep rising and falling amid clouds
of smoke and steam. Of course, the meaning of Freder's nightmarish
hallucination is quite clear: technology as moloch demanding the sac-
rifice of human lives. But that is not all. If we assume that Freder in
pursuit of Maria is still sexually aroused, and if we remember that his
second hallucination in the film deals explicitly with sexuality (that of
the machine-vamp Maria), we may want to see the imagery in this
sequence as a first indication of the vagina dentata theme, of castration
anxiety, of the male fear of uncontrolled female potency displaced to
technology.

Such an interpretation has implications for the way in which we
perceive the real Maria. Rather than keeping the "good," asexual
virgin Maria categorically apart from the "evil" sexual vamp,[22] we
become aware of the dialectical relationship of these two stereotypes.

On the level of sexual politics, the point of the film is precisely to subdue and to control this threatening and explosive female sexuality which is inherently and potentially there in any women, even the virgin. It is in this context that the elaborate sequence portraying the laboratory creation of the machine-vamp is—contrary to Kracauer's claims—absolutely essential for a full understanding of the technology/ sexuality link in the film. After Rotwang has brought Maria under his control, he proceeds to take her apart, to disassemble and to deconstruct her. In a complicated chemical and electrical process he filters her sexuality out of her and projects it onto the lifeless robot who then comes alive as the vamp Maria. The sexuality of the vamp is thus the sexuality of the real woman Maria transformed by a process of male projections onto the machine. After this draining experience, the real Maria is no longer the active enterprising woman of before, but assumes the role of a helpless mother figure who is totally dependent on male support. Thus in the flood sequences she seems paralyzed and has to wait for Freder to save the children, and in the end again she has to be saved from Rotwang's hands.

Just as Maria, under the male gaze, has been disassembled and doubly reconstructed as a docile sexless mother figure and as a potent destructive vamp who is then burnt at the stake, so Freder's desires have to be disentangled and controlled, and the sexual element purged. This happens mainly in the sequences following Freder's encounter with the false Maria in his father's arms. Freder suffers a physical and mental breakdown. During recovery in bed he hallucinates with terrified wide open eyes precisely that *mise-en-scène* of the vamp which Rotwang had set up on that same evening. Although this sequence can be read according to the Freudian account of the primal scene, the castration threat of the father, and the Oedipal conflict,[23] such a reading remains too limited. The goal of the narrative here is not just to bring Freder back under the Law of the Father by resolving the Oedipal conflict; it is rather to associate all male sexual desire for women with the threat of castration. This becomes amply clear as Freder's hallucination ends with a vision of the cathedral sculptures of the Seven Deadly Sins. As the central figure of Death moves toward Freder/the camera/the spectator swinging his scythe, Freder screams in horror and sinks back into his pillows.

The fact that Freder has learned his lesson and has been healed from sexual desire shows when he reappears in the catacombs and attempts to expose the false Maria and to keep her from seducing the workers. Separating the false, sexual Maria from the real Maria in his mind suggests that he is now working actively against his own sexual desires.

This point is allegorically emphasized by his successful struggle against the floods inundating the workers' quarters where he saves Maria and the children. By the end of the film, Maria is no longer an object of sexual desire for Freder. Sexuality is back under control just as technology has been purged of its destructive, evil, i.e., "sexual," element through the burning of the witch machine.

It is, then, as if the expressionist fear of technology and male perceptions of a threatening female sexuality had been both exorcised and reaffirmed by this metaphoric witch-burning, which, as all witch burnings, guarantees the return of the repressed. It is as if the destructive potential of modern technology, which the expressionists rightfully feared, had to be displaced and projected onto the machine-woman so that it could be metaphorically purged. After the dangers of a mystified technology have been translated into the dangers an equally mystified female sexuality poses to men, the witch could be burnt at the stake and, by implication, technology could be purged of its threatening aspects. What remains is the serene view of technology as a harbinger of social progress. The transition from expressionism to the *Neue Sachlichkeit* is complete. The conflict of labor and capital—such was the belief of the *Neue Sachlichkeit* and such is the implicit message of the film—would be solved through technological progress. The notion that the heart has to mediate between the hands and the brain is nothing but a lingering residue of expressionism, an ideological veil which covers up the persisting domination of labor by capital and high technology, the persisting domination of woman by the male gaze and the reestablished repression of female and male sexuality. The final shots of the film with their visual separation of the workers from their masters and with the resumed ornamental treatment of human bodies in motion show that the hands and the brain are as separate as ever. Henry Ford's infamous categorization of humankind into the many hands and the few brains, as it was laid out in his immensely popular autobiography, reigns supreme. It is well-known how German fascism reconciled the hands and the brain, labor and capital. By then, Fritz Lang was already in exile.

5

Producing Revolution:
Heiner Müller's *Mauser*
as Learning Play

Heiner Müller's *Mauser* is a play *about* and *for* revolution.* As a work about revolution, it reaches beyond its historic context to thematize antinomies and conflicts which join it to a literary tradition peculiar to European drama after the French Revolution. Büchner's *Danton's Death*, Vishnevsky's *Optimistic Tragedy*, Wolf's *The Sailors of Cattaro*, Camus' *Les Justes* and Brecht's *The Measures Taken* are some of its philosophical forebears. As a learning play (*Lehrstück*), *Mauser* stands with and beyond Brecht's *The Measures Taken* as a new kind of drama with which revolutionaries are to explore the dialectics of historical change as a process of self-critical, self-educating "carrying through of certain behaviors" (Brecht). Written in the GDR in 1970, its premises are formed by and take issue with specific processes of social change and domination in that society. More precisely its focus on the production of revolution, and revolution as production, radically explores the reification of consciousness and the crisis of sectarian mentality in the workings of the Leninist party. As such, it both accepts and critiques the conditions upon which it rests. And in refusing to close its contradictions, it offers the form of the *Lehrstück* as a means for going through and overcoming them.

The central theme in *Mauser* focuses on the necessity of killing and

This essay was first published in *New German Critique*, 8 (Spring 1976), 110–121. It was written with David Bathrick.

the meaning of violence for the realization of a larger social goal. In the dramatic tradition with which it is linked, this theme is often portrayed as having tragic implications. For instance, the hero of Büchner's play is the focal point from which is viewed an inexorable social process which, "like Saturn devours its children." The demise of Danton is an individual tragedy within an emerging historical necessity. Camus' *The Just*, written 110 years later in cold war France, poses a similar dichotomy, but is even more insistent in its emphasis upon individual moral crisis. Kaliayev, the poet of love and now of revolutionary violence, stands stained and finally consumed by the "plague" of modern political necessity. Where in Büchner's view history and objective forces belie and ultimately qualify the dilemma of individual tragedy, the existential moralist Camus is unequivocating in refusing to legitimize violence through the revolutionary ethos. Yet, for many in the 20th century, the Bolshevik Revolution had altered the framework of the problem. Vishnevsky's *Optimistic Tragedy* plays the conflict from the other side—the tragedy is an optimistic one because the dilemma is resolved back into a greater good for the greatest number. Wolf's *The Sailors of Cattaro* and Brecht's *The Measures Taken* are also in this tradition; but with Brecht, the terms have again been altered, this time to abandon the notion of tragedy as a central concern. In so doing he was forced to change the terms of drama itself. As will be indicated, *The Measures Taken* can and has been read as a dramatic tragedy. Yet, to do so exclusively is to ignore Brecht's own intentions as dramatist and revolutionary.

How is it that a work in which a naive young revolutionary must be executed is not a tragedy? To begin with, this play was theoretically conceived not as a teaching, but as the demonstration of a process of contradictions.[1] It is not an object lesson but an example lesson. An object lesson would say: the young comrade was wrong in being humane; he learned from the consequences of his error and sacrificed his life for the greater collective and the revolution. An example lesson would say: here is the representation of a contradictory process and the mental reflections of and upon that process; play these contradictions through. Don't learn *from* them (object lesson, theater as finished product, uncritical acceptance of thesis), but, by actively reproducing them, learn *through* them (example lesson, re-production of a process, *Bei-Spiel*, critical trying out of behavior). At the core of the *Lehrstück* lies a theory of praxis grounded in a dialectic of lived theory and thought behavior. But at its root also lie two fundamental presuppositions: a) specific historicity and concreteness within the play is suspended in order to explore the logic of contradiction, a process which is itself

informed by the historicity of the performers-actors-viewers-participants; b) a dialectical-materialist understanding of that historicity. A tragic situation is in the play but not central to it; central is the learning process. Brecht gives us an extreme example with three constituent points of a situation: the tasks to be accomplished; the beliefs, world-view and consequent behavior of the young comrade; the teaching of the Marxist classics as the practice of the party-collective. All of these constituent parts represent a force field of interaction within a given necessity. The point of the *Lehrstück* is to isolate and explore given factors of a reality as a means of concretizing and questioning them within the experience of the actor-viewer, not simply to arrive at judgments about the rectitude (ABC of communism, party decisions) or the falseness of any of the constituent parts.

Thus in its purest form the *Lehrstück* was not intended for a larger mass audience, as both Eisler and Brecht emphasized on numerous occasions. Eisler: "It is a special kind of political seminar for questions concerning party strategy and tactics. . . . The learning play is not intended for concert use. It is a means for pedagogical work with students from Marxist schools and proletarian collectives. . . . It is very important that the singers do not accept the text as a matter of course but rather discuss it in rehearsals."[2]

The difficulties with *The Measures Taken* have arisen from problems both within and without the text. The misunderstandings caused by the mass performance in 1932–33 could have been predicted. Clearly an audience schooled in the tradition of Aristotelian theater and imbued with production-consumption mechanisms of a capitalist culture industry would have been unable to throw off old ways of seeing and learning. This was of course compounded by the fact that the play was written as propaganda (*Lehrstück*) and used as agitation: Lenin makes a distinction between propaganda as a tool for teaching the classics and raising the consciousness of party and organizational workers and agitation as mass political work around specific political issues. But the problem also lies within *The Measures Taken* itself. In many ways Brecht did not carry the form through to its logical extreme.

In point of fact *The Measures Taken* contains naturalistic, indeed tragic, moments which go against its claimed intention as a *Lehrstück*. One example of this can be found in the tender solidarity surrounding the death of the young comrade. This tenderness is nothing but a melodramatic gesture, tacked on as a means to emphasize the message (*die Lehre*). What is more, given the tight construction of the plot, the audience cannot but interpret the death of the young comrade as the telos of the entire play. Here again we see how the form of the *Lehrstück*

has not yet developed its full potential. There is still too much plot, too much (hi)story. There is still a cathartic moment which shows the affinity of Brecht's play to the bourgeois (individual) tragedy. The hero is sacrificed, sacrifices himself, experiencing catharsis and transcendence. The thrust is toward salvation, rather than toward changing society. Of course, the social and political aspects of the young comrade's death are paramount for Brecht, but, to use Müller's terminology, the death itself is too much a concrete *object* of the play. The example quality, which the *Lehrstück* as a form is actually trying to achieve, is not yet fully developed in *The Measures Taken*. The misunderstanding of this play as tragedy is rooted in the play itself.

In order to show how Müller indeed radicalizes Brecht's learning play some critical remarks on Brecht scholarship are in order, remarks which will eventually lead into a critique of *The Measures Taken* as a learning play of limited value.

Two diametrically opposed interpretations of *The Measures Taken* have been dominant in Brecht research. One of them, perhaps best represented by Reinhold Grimm, sees the play as a tragedy dealing with the insoluble conflict of freedom versus necessity. According to this view, a clash of absolute values inevitably leads to guilt and death of the individual hero. The second position, as developed by Reiner Steinweg and first publicized in the journal *Alternative*, takes Brecht's theory of the learning play as its point of departure and attempts to prove that *The Measures Taken* is an *Übungstext* (exercise text) rather than a tragedy. Steinweg sees Brecht's work as a perfect realization of the learning play, and he can thus dismiss the tragedy theory as inadequate.

It is clear that both interpretations have political implications. The first interpretation frequently served to enhance cold war arguments against Brecht. Seeing the play as a tragedy, critics compared the role of the Bolshevist party to the deadly function of the cruel Olympic gods in Greek tragedy (Benno von Wiese); they spoke of the nihilist Brecht's longing for total authority and of his alleged immersion in the *credo quia absurdum* (Martin Esslin); or they bluntly labelled Brecht a Stalinist and saw the play as an anticipation of the Moscow trials of the 1930s (Ruth Fischer). Whenever the learning plays were not used to dismiss Brecht as a vulgar materialist or Stalinist, they were certainly downplayed as dry and didactic and seen as representing nothing more than a transitional phase in Brecht's life before he reached maturity with the less openly political epic plays of the late 1930s and the 1940s. This attempt to depoliticize Brecht is of course concomitant to the cold war attacks. The second interpretation, on the other hand, is the result of a

radical repoliticization of Brecht's work evolving out of the Brecht reception by the German left in the late 1960s. But this interpretation, though obviously closer to Brecht's intentions, has a shortcoming as well. While Steinweg and the editors of *Alternative* correctly attacked traditional Brecht scholarship for its political bias, they did not meet head-on the political problems posed by *The Measures Taken*. Their attempt to dismiss the tragedy theory altogether could legitimately be regarded as another kind of *Verharmlosung* (neutralization) of the problem of Brecht's politics, since they placed all emphasis on the formal aspects of the learning play while never even questioning the political meaning of Brecht's Leninism either then or today.

In light of these developments, it is interesting that the most recent interpretation of *The Measures Taken*, contained in Wolfgang Schivelbusch's book on socialist drama in the GDR after Brecht,[3] picks up the traditional view of the play as a tragedy and frees it from the dead weight of cold war arguments without, however, abandoning the theory itself. Schivelbusch's argument goes roughly as follows: in *The Measures Taken* we are confronted with a contradiction between communist humanity (*Menschlichkeit*) and the spontaneous individual humanity of the young comrade. The young comrade recognizes his mistake by its consequences and agrees to his own execution, accepting his death as a result of "premature humanity" (*vorzeitige Menschlichkeit*). Schivelbusch, as other critics before him, views this premature humanity somewhat too positively and neglects its consequences for those who are exposed to it; in his revisions of the play, Brecht tried to emphasize the fact that this premature humanity had indeed disastrous consequences, endangering several people's lives and the very success of the revolutionary mission. Schivelbusch sees the young comrade as the victim of a tragic clash between two incompatible values: precisely that which is spontaneous and human in him simultaneously endangers the revolutionary realization of humanity. But for Schivelbusch, in opposition to the older view, the young comrade is not a tragic figure because of his mistaken behavior. The tragedy is that he discovers the truth only when it is too late to put it into practice. Nevertheless, Schivelbusch emphasizes the unity of contradictions (*Einheit der Widersprüche*), i.e., the final reconciliation, in the solidarity, tenderness and *Einverständnis* (understanding) with which the killing takes place. Thus Schivelbusch works off the old tragedy theory and gives it a new political meaning by interpreting *The Measures Taken* as an optimistic tragedy. When Schivelbusch talks about the "brotherly form of killing," or the "humane annihilation" of the young comrade, he too covers up the major problem of the play—Brecht's unquestioned

acceptance of Leninist *Realpolitik*. With regard to this particular aspect, Schivelbusch is of course closer to Steinweg than to the earlier proponents of the tragedy thesis. At the same time, however, he still reads Brecht's play as if it were a realistic drama, as if the young comrade were indeed an individual, a character on stage. In opposition to this view, Reiner Steinweg has pointed out that strictly speaking the young comrade is not a "person" at all since his role is played alternately by those who have killed him. The role playing with its retrospective character does not permit any existential interpretation of the play based on traditional concepts of tragedy. It would seem that it also separates Brecht's learning play from optimistic tragedies such as Friedrich Wolf's *Sailors of Cattaro* and Vishnevsky's *Optimistic Tragedy*.

Reiner Steinweg's learning play thesis is crucial to all further Brecht research. But it needs a corrective, not only a political one but a formal one as well. Steinweg interprets *The Measures Taken* as a model for the learning play theory which it is not. *The Measures Taken* contains naturalistic moments which clearly go against the grain of the learning play as described by Steinweg and thus partially vindicate Schivelbusch's renewed attempt to read the play as a tragedy.

It is this background that Müller picks up and tries to transcend. His corrective to the Brechtian text is a purer form of the *Lehrstück*, a realization of the inherent intentions of the form itself. Müller's play also reflects a later stage along the continuum of historical revolution. If Brecht's *Lehrstücke* grew out of an attempt to negate the bourgeois theater and drama, then Müller's *Mauser* can be regarded as the negation of the negation. Shortly before his death Brecht said that he considered *The Measures Taken* as a model for the theater of the future. *Mauser* is conceived as such a *Lehrstück* written in and for that future. While it had been Brecht's task to convey experiences of revolution to a pre-revolutionary audience in a capitalist society. Müller, writing in a society which he views as socialist, sees his task as conveying historical experiences while they are still being made; it is indeed the Brechtian *Lehrstück* which permits him to achieve this goal.

Brecht's young comrade appears in *Mauser* as B in only one short scene. He is reintroduced as a backdrop in order to establish the point of departure of the play. In *Mauser* there is no teleological moment. It is even questionable whether there is any plot to speak of. Concrete history has been almost totally eliminated. Knowledge and consciousness are not reached at the end, but are constructed, de-constructed, and reconstructed in the course of the play. The play does not offer a solution for the audience to carry home. Nor does it present the contradiction between an abstract spontaneous humanity—proven in

its consequences to be inhumane—and the revolution's claim to realizing humanity in the future. Instead, throughout the play, the revolutionary claim remains in dialectical tension with the inhumanity of the individual which is the unavoidable result of the collectively organized work of killing—"a job like any other/a job like no other." Unavoidable, not because A should be seen as a revolutionary cannibal but, on the contrary, because A preserves the perspective of revolutionary humanity.

A has to live through a contradiction which tears him apart. Desperate to escape the contradiction, he asks to be relieved of his work. But the collective does not, cannot let him go. Even if he were no longer in charge of the revolutionary tribunal, he would remain part of the collective. Thus he would be unable to escape responsibility for killing if someone else took over his work. The chorus understands the dilemma from the standpoint of the collective; A sees it only from his personal perspective. He acts as an individual, both when asking to be relieved and when fighting death, tooth and nail. Only later does he say, "What counts is the example, death means nothing." His death does not count as an individual death, as the physiological end of this life; it only counts as an example, as a social fact. In a recent conversation, Heiner Müller said that the impact a person has is the most important aspect of that person ("Das Wichtigste an einer Person sind ihre Folgen"). A's death will indeed have an impact. He passes on for the collective the experience of the insoluble contradiction of revolution. His last words are no longer spoken against the chorus; they propel him back into the collective. Human beings only count as human beings as they relate to others, as they articulate themselves as part of a continuum.

Twice A abandons the dialectic between collective and individual: first, when he becomes one with his Mauser and kills like a machine; then, when he loses himself in an orgy of blood and destruction and tries to claim the bodies of the dead with his boots in a kind of dance of death. At the play's end, the dialectic is reconstituted, but significantly the contradiction is not, cannot be resolved into harmony or reconciliation. If the revolutionary situation makes killing unavoidable, then everything depends upon how this killing is carried out. Precisely this is the pivotal and most problematic point of the play, the problem Müller tries to come to terms with: killing as a function of life, as a job like any other and like no other, dialectically organized by the collective and organizing the collective. It is mandatory that both individual and collective remain conscious of the insoluble contradiction between death and life, between killing and the human claim of the revolution.

The revolution is betrayed as soon as the individual (or the collective) loses this consciousness (mechanical killing) or breaks out of the collective (orgiastic killing). Thus Müller actually retains the human perspective of revolution where *Mauser* appears particularly inhumane: when the chorus demands that A, who killed for the revolution, agree to his own execution precisely because he did the work he had been asked to do. It is significant, however, that while in *The Measures Taken* the young comrade's death has already taken place when the work begins, A's death is not shown in *Mauser*. A's death is not a tragic sacrifice offered to the revolution so that it can purge itself and go on.

Thus Müller has not written a naturalistic historical drama. He constructs a model which reflects upon itself and in so doing attempts to articulate a specific experience—the experience of contradiction between humanity and inhumanity of which any legitimate revolution must remain conscious. There is no reconciliation of contradictions, no aura of tenderness and solidarity in death. If there is a unity of contradictions to speak of, it emerges in the consciousness of those who are destroyed by the conflict but who, because they remain within it, are the example.

In form and content, then, Müller has radicalized *The Measures Taken* by dehistoricizing it. Where in Brecht we have the young comrade (bourgeois intellectual turned revolutionary) and the party-chorus (replete with quotes from the classics—Lenin), in Müller's play the names and many of the historical referents are gone. A is clearly any one of the collective; the problem is not a historical character in a situation, but the situation itself. By eliminating "history" as a naturalist element within the play, Müller creates the formal framework for bringing himself-ourselves, his-our history into the play. Secondly, construction of the play denies the story-plot as a separate "narratable" entity. In *The Measures Taken* the chorus tells in lock-step the story of the young comrade in the vise of retrospective narrative. In *Mauser*, Müller cuts through and breaks up the different narrated time levels to intermix narration-experience with experience itself. Historical subjectivity and consciousness are allowed back into the play through the process of participation.

But Müller's play is about more than just revolution. Like his earlier industrial plays *Der Bau* and *Der Lohndrücker*, it is also a play about production. It is in this context that we begin to see its connection to the GDR. What Müller tells us is that the process of making revolution, like production itself, entails objectification, reification and the loss of consciousness of one's actions. The problem of this play is not simply the loss of humanity through killing (this would presuppose some

abstract notion of humanity) but the loss of humanity through the loss of consciousness of one's actions. Within this paradigm A would be seen losing his humanity through two opposing types of reification. Reification is loss of consciousness when A becomes a reified object (example: A's mechanical killing). Reification is also loss of consciousness when A becomes an unmediated subject (A's reclaiming the self in orgiastic killing):

> But when your hand became one with the revolver
> And you became one with your work
> And were no longer *conscious* of it
> That it must be done here today
> So that it must be done no longer and by no one
> Your post in our front was a gap.

Müller gives a process—namely, killing as production (a job like every other/like no other), and in this extreme form (no other) of any production (any other) he demonstrates the loss of balance, the loss of consciousness of one's production as an inevitable constituent of revolution-production itself. Hence the point of the play is expressed through the form of the *Lehrstück*. It is not simply the lesson that one shouldn't lose consciousness and that to lose it is inhumane (object lesson); rather, we are presented with a learning experience as a process of reification and de-reification. Müller presents us with a form in which one can create the process of an immediate construction and de-construction of reification out of the experience of a momentary suspension of history (*momentane Geschichtslosigkeit*). The very abstractness of the model demands the historicity and activity of the participants and thus explodes the strictures of traditional drama.

The problem of reification is also the moment in which Müller's play is most clearly an expression of his experience as a playwright in the GDR. Where Brecht poses as a contradiction the relationship of the party to an outside individual and with this relationship the problem of strategy, Müller puts aside these dimensions to explore more radically the workings within the party and within a given strategy. By closing off completely the *what* (individual-party, correct or incorrect strategy) to focus entirely on the *how* (killing as production), Müller legitimizes, in a way that Brecht does not, the party-collective as a given objective reality. This is his "post-revolutionary" experience. Thus the paradox: the pureness of the form—its ahistorical play quality—masks the historical reality (the party) upon which it rests.

But there is also another paradox. In the moment that Müller's play is most Leninist, it is also most critical of the Leninist experience. By presenting the workings of the party as a process of production and

reification. Müller opens up directly the problem of fetishism under socialism. The equation of revolutionary party work with the alienation of labor in the production process ("that must be done here today so that it must be done no longer and by no one") points to the technification of mind and practice which has long been a legacy of the Leninist party. Lenin himself, prior to the Russian Revolution, referred to the party as an "immense factory." His optimism that the capitalist factory as "a means for organization"[4] could be distinguished from the capitalist factory as "a means of exploitation" and thus be taken over unaltered as a model instrument of revolution evades the problem of instrumentalist ideology which lies at the heart of the organizational form itself.[5] It is this problematic which Müller's metaphor of revolution as production pushes to the fore. In *Mauser*, as a *Lehrstück*, we are presented with the industrialization of the party in its extreme form as a tool with which to counter such instrumentalization. However, unlike "the practical workers of the new Iskra" (Lenin) who rejected Lenin's visualization of the party as factory (Lenin called them aristocratic anarchists), Müller accepts, indeed constructs this instrument as a means for going through and beyond it.

In this his notion of revolutionary change is very close to Brecht's who always spoke of going *through* capitalism, not of transcending (Marcuse) or simply negating (Adorno) it.[6] *Mauser* takes us to the center of contradiction: to the experience of mechanistic, labor-consuming and life-destroying activity as the means to create new life:

> I am a human. A human is not a machine.
> Killing and killing, the same after each death
> I could not do it. Give me the sleep of the machine.

and to the cutting edge between apology and historical necessity as the experienced consciousness of collective-sectarian praxis:

> Your work was bloody and like no other
> But it must be done like other work
>
> For what is natural is not natural
>
> For killing is a science
> And must be learned so that it ceases.

And precisely in this absolute seizure of contradiction, this move to the heart of fetishism, Müller opens up for reified socialism the exploration of a repressed history. The "ahistorical" *Mauser* carries with it the legacy of Leninism past and present, not as an idealistic rejection of that tradition, but as the necessary appropriation prerequisite to "exploding the continuum of normality."

Given the historical context of this work, what does it mean to publish and produce it outside of that context. Can Western audiences adequately understand this play? How are they to react to the lack of historicity, to the absence of plot, characters and action? Considering the dramaturgical expectations of American theater audiences, is it not almost inevitable that the play will be understood as a moral exercise about killing rather than an attempt to create the consciousness of reification and dialectical contradiction? Reactions to performances in Madison and Milwaukee (by a group of students of the University of Wisconsin-Milwaukee) point to expected difficulties. Some spectators said that revolutionary violence should be rejected. Others talked about a gut level reaction against violence, but said they could justify it intellectually. In any case, *Mauser* was seen mainly as a play that legitimizes revolutionary killing. The execution of A and B was cited as an example of the total arbitrariness of revolutionary violence. And many people were outraged that A should agree to his own execution. In their view, both the killing and demand for A's acquiescence were unnecessary disciplinary measures imposed by an inhumane party.

This kind of response has its precedent. In October of 1947, it determined the course of Brecht's hearing before the House Committee on Unamerican Activities, a hearing at which *The Measures Taken* was the bone of contention. That the audience reaction to *Mauser* should be the same today points perhaps less to continued attitudes of anti-communism than to the problems of doing a learning play as a broad theatrical production. Brecht was always conscious of this, requesting that *The Measures Taken* not be put on at all. Certainly any production of *Mauser* in this country must take careful cognizance of its reception both by "actors" and by "audience." The Texas performance, for instance, which had an all-women cast, was successful in opening up questions, particularly for the women involved, about the multi-layered violence in everyday life. This was the result of a long, self-educating and exploratory process within the cast itself, which is of course the point of the *Lehrstück* in the first place.

Thus *Mauser* should be understood as an important political play precisely because it obstructs any facile glorification of revolution or violence. It is in this sense that it might have relevance for this country. Where the concept of revolution is reified beyond recognition in bicentennial celebrations and marketed for profit by the buy-centennial business, where history is systematically exorcised to produce an unchangeable present, in *Mauser* a socialist playwright attempts to convey the experiencing of history as a problem of the day.

Thus the play stands not only in opposition to Gerald Ford's absurd attempt to appropriate Thomas Paine's *Common Sense*, but also against the unmediated sectarian rhetoric of the American Left, itself often subject to a similarly fetishized notion of revolution. In both cases, history is annihilated, both as past and present. The future never even enters the picture.

6

The Politics of Identification:
"Holocaust" and West
German Drama

I

Since it was produced for a US audience, the American TV series
"Holocaust" had a totally unanticipated and unintended impact in
West Germany. Commentary following the showing there hailed it as
the media event of the decade. In the heated debates preceding the
telecast, however, "Holocaust" was condemned by critics of all political
camps as a cheap popularization of complex historical processes which
could not possibly help the Germans come to terms with their recent
past.

The tremendous emotional impact of the series, which went far
beyond that of any of the earlier film, TV, and theater productions on
the same subject matter, led a number of critics to change their mind
and certainly vindicated those few who had argued in favor of telecast-
ing "Holocaust" in West Germany in the first place. But the majority of
left and left liberal critics was unable to come to terms with the scope of
the emotional explosion triggered by the series. Their arguments
stressed that the melodramatic and sentimental treatment of "Holo-
caust" clouded the "real" issues and prevented spectators from under-
standing German history. The left especially was adamant in criticizing
the series for not providing a total historical explanation of National

This essay originally appeared in *New German Critique*, 19 (Winter 1980), 117–136.

Socialism, capitalism, and anti-Semitism. At the same time it was argued that the series' success could and should be used to start a post-"Holocaust" campaign of rational political enlightenment which would focus on the roots of anti-Semitism and, more importantly, on the social, economic, and ideological roots of National Socialism under which the problem of anti-Semitism and the Holocaust could then safely be subsumed.

It is time to criticize left theories of fascism which relegate the Holocaust to the periphery of historical events, and which demonstrate the indifference of many German leftists toward the specificity of the "Final Solution." The left's instrumentalization of the suffering of the Jews for the purpose of criticizing capitalism then and today is itself a symptom of post-war German amnesia. To what extent, indeed, is the German left's insistence on comparing Auschwitz to Vietnam different from the right's claim that Auschwitz is balanced out by Dresden or Hiroshima? Certainly, the grounds on which the comparisons are made are different, and the underlying political intentions are diametrically opposed. But the right and the left share a universalizing and totalizing mind-set which in both cases overlooks the specificity and concreteness of human suffering in history, subsuming it either under a universal critique of capitalism or under the concept of an unchanging "human condition." The danger inherent in all such "universalizing" is that eventually it serves to legitimize power, losing any critical edge it once might have possessed.

Rather than dismissing the success of "Holocaust" as a result of clever marketing (which undoubtedly played its role in getting people to watch the program) or condescendingly attributing it to its trivial emotional appeal (Why are emotions trivial? Who says?), we should probe deeper and raise again a number of questions which emerged in the German discussions of "Holocaust," but which at best were left hanging in the air. To me, the key problem with critical appraisals of "Holocaust" in Germany lies in their common assumption that a cognitive rational understanding of German anti-Semitism under National Socialism is *per se* incompatible with an emotional melodramatic representation of history as the story of a family. Left German critiques of "Holocaust" betray a fear of emotions and subjectivity which itself has to be understood historically as in part a legacy of the Third Reich. Precisely because Hitler was successful in exploiting emotions, instincts, and the "irrational," this whole sphere has in turn become deeply suspect to post-war generations. At the same time, however, we know that one of the major failures of the left already in the Weimar Republic had been its exclusive reliance on rational political enlighten-

ment in the public sphere and its blindness to the private sphere, to people's subjective needs and fears, desires, and anxieties, which were abandoned to Nazi propaganda and effectively organized by it. Despite the fact that this problem has often been acknowledged—notably by Ernst Bloch already in *Erbschaft dieser Zeit* (1932)—the post-war German left on the whole does not seem ready to draw necessary conclusions for its own theoretical discourse and political strategies. Even when critics themselves experienced the emotional impact of "Holocaust" and acknowledged it as such, the interpretive discourse more often than not returns to demands for objective analysis thus evading the problem of subjectivity and its implications.

Of course, "Holocaust" was never meant to provide us with a *total historical understanding* of German anti-Semitism and its function in the fascist system. But the key question which must be faced in the light of "Holocaust's" success in Germany is precisely why this series has opened up an understanding of the Holocaust which all the enlightened, rational, and objective discourses and representations of the past decades failed to produce. Underlying the vehemence of German debates about the validity of Hollywood type fictionalizations versus documentaries, political theater, and a modern aesthetic is the whole history of attempts made by German writers and artists to come to terms with the past. "Holocaust" indeed raises questions about that history, questions which, in the German debates, remained buried in the false dichotomies of high versus low, avantgarde versus popular, political theater versus soap opera, truth versus ideology and manipulation: To what extent did "Holocaust" invalidate earlier attempts of *Vergangenheitsbewältigung*, either in the theater, television productions, or attempts by intellectuals and educators to fight the social and political amnesia so characteristic of the post-war decades in the Federal Republic? How do we reevaluate that whole tradition of *Bewältigungsdrama* from the stage version of Anne Frank's diaries to Max Frisch's *Andorra*, Rolf Hochhuth's *Deputy*, and Peter Weiss's *Investigation*? More specifically, what does the reception of "Holocaust" in West Germany tell us about the limits of that so-called "second enlightenment" of the 1960s of which most of those plays were a part? And finally, to what extent does "Holocaust" then challenge a specific type of Brechtian and post-Brechtian political aesthetic that has been taken for granted on the left—and not only on the left—for at least the past 15 to 20 years?

One difficulty in comparing "Holocaust" with those earlier German dramas should be faced head on. In its narrative strategies, manipulation of images, use of music, stereotypes and clichés, "Holocaust" betrays very clearly and often unnervingly its origins in the culture

industry. Even though it is exaggerated to claim that it makes Auschwitz into another serialized Western,[1] "Holocaust" certainly operates on an aesthetic level distinct from that of say Weiss's *Investigation* or Schönberg's *Survivor of Warsaw*. But the point here is not to compare the aesthetic structure of "Holocaust" to that of political documentaries and avantgarde art works and then to reassert once again the superiority of the latter. Neither do I wish to advocate the exclusive adoption of Hollywood-type fictionalizations for political education and the abandonment of documentaries and avantgarde forms of aesthetic expression. It is not a question of either/or. I am not suggesting that TV narrative can save us from the aporias of the avantgarde. What I am proposing is that certain products of the culture industry and their popular success point to shortcomings in avantgardist or experimental modes of representation which cannot be explained away by the standard reference to television as an instrument of manipulation and domination. It is with these questions in mind that I want to review the problem of *Vergangenheitsbewältigung* and some of the best known German dramas dealing with the Holocaust, all of which had a considerable impact on cultural and political debates in West Germany in the 1960s. The success of "Holocaust," it seems to me, does indeed cast a new light on a number of attitudes and beliefs that used to be taken for granted by writers and intellectuals critical of West German society in the 1960s. What is at stake is not just a limited body of literary works, but rather a reevaluation of our own cultural "heritage."

II

What really is *Vergangenheitsbewältigung* (coming to terms with the past), and what could its meaning be in post-war Germany? In their book *Die Unfähigkeit zu trauern* (1967), Alexander and Margarete Mitscherlich described *Vergangenheitsbewältigung*, of which the Holocaust is an essential but not the only component, as the psychic process of remembering, repeating, and working through, a process which has to begin in the individual, but which can only be successfully completed if it is supported by the collective, by society at large.[2] The theater, the media and educational institutions all could have helped create a climate favorable to a collective *Vergangenheitsbewältigung* if indeed a confrontation with the past had been given social and political priority in Germany. The opposite, however, was the case. The reasons for the lack of serious *Vergangenheitsbewältigung* on the individual as well as on the social level have been described convincingly and in great detail by

the Mitscherlichs, Adorno, W. F. Haug, and Reinhard Kühnl.[3] In particular the notion—popular among the allies right before the end of the war and in the immediately following years until the Cold War erupted with full force—that the Germans were collectively guilty for the atrocities and mass murders committed during the Third Reich called forth a whole network of mechanisms which all aimed at repressing, denying, and making unreal (*Entwirklichung*) Germany's Nazi past.[4] Given the further lack of an adequate understanding of the economic, social, and ideological roots of German fascism—manifest in the popular German view that the Third Reich was a historical accident—any fictional or documentary representation of the Third Reich and the Holocaust on stage or on television almost necessarily had to create an illusion of *Vergangenheitsbewältigung* which was not taking place in reality. *Vergangenheitsbewältigung* as spectacle came dangerously close to functioning as a substitute and pacifier. Time and again this reproach was voiced even against the best works on the subject, and, needless to say, it was also raised against "Holocaust."

And yet, it was precisely such fictional representation that for the first time seemed to explode the collectively operating mechanisms of denial and repression. Actually, the success of "Holocaust" gives additional weight to the Mitscherlichs' social psychological explanation, which finds its 'natural' place within a left intellectual context, but which, precisely there, has been shoved aside by economic and political arguments emphasizing the structural continuity of fascism and capitalism. Of course, these latter arguments contained a valid critique of the Federal Republic's legitimizing ideology which—despite reparation payments (*Wiedergutmachung*) to survivors and to Israel—was based on the assumption of a total break between the Third Reich and the Federal Republic. But this critique of West German capitalism and of the reemergence of an authoritarian state in the 1970s (*Berufsverbot*, build-up of the police and surveillance apparatus, terrorism hysteria) led to a new kind of amnesia on the left: the Holocaust remained outside of this scheme of explication. I am not proposing to ignore continuities between the Third Reich and the Federal Republic. On the contrary, the point is to grasp those continuities on a level not reached by left discussions of German authoritarianism, capitalism, and the state. The impact of "Holocaust" substantiates the Mitscherlichs' insight that the post-war denial of one's complicity in the Holocaust has remained an explosive and vital issue and has left deep and visible marks on the German social character and on post-war German culture, both in the older and younger generations.

Peter Märthesheimer, who as dramaturg with the WDR in Cologne

was instrumental in acquiring the series "Holocaust" for West German television, used the Mitscherlichs' socio-psychological explanation of the Germans' inability to mourn in his attempt to shed light on the series' success. The accusation of collective guilt, even though it was abandoned by the end of the 1940s, has been a powerful reproach bound to make a deep impression on the Germans, who had just experienced total defeat, and who, psychologically speaking, had suffered the loss of their collective ego-ideal, the Führer, and were thus vitally threatened in their feelings of self-worth and identity. Confronted with the reality of Nazi horrors, the Germans now were quick to blame everything on the Führer (*Hitler war an allem schuld*), and they mounted individual defenses against the accusation of collective guilt. Märthesheimer writes: "To have felt oneself guilty of mass murder would have meant seeing oneself as a mass murderer. To have admitted shame would have meant admitting responsibility for a barbarism that one had not desired. . . . And the seducer, Hitler, who had taken all the responsibility on his shoulders—hence relieving everyone else of responsibility—this seducer has removed himself from the picture while the myth around him still persisted and before hatred could have been directed against him. For the first time individual Germans bore a responsibility alone without ever having had to bear this responsibility for themselves and for their actions. . . . In 1945 these people put their soul on ice."[5]

To Märthesheimer, "Holocaust" was not only a major media event, but, more importantly a social psychological event. Its success was less related to the "quality" of the series than to the special situation of Germany in 1979, its history, its consciousness, and its unconscious.[6] Where the cognitive, purely rational efforts of allied reeducation officers, of teachers and journalists, playwrights and documentarists failed to crack open the emotional bond and regressive identification with the past and the Führer, "Holocaust" succeeded. Märthesheimer argues, I think correctly, that the secret of "Holocaust's" immediate impact is to be found in its narrative strategy: "This narrative strategy places us (the viewers, A. H.) on the side of the victims, makes us suffer with them and fear the killers. It thus frees us from the horrible, paralyzing anxiety that has remained repressed for decades, that in truth we were in league with the murderers. Instead we are able to experience, as in the psychodrama in a therapeutic experiment, every phase of horror—which we were supposed to have committed against the other—in ourselves . . . to feel and suffer it—and thereby finally in the truest sense of the word to deal with it as our own trauma."[7]

Identification with the victims, the Weiss family, can indeed be

regarded as key to "Holocaust's" impact in West Germany. But it is short-sighted to acknowledge that fact and then move on to the 'real' agenda: either to political enlightenment via rational argument and documentation or to art works which transcend, i.e., invalidate, "Holocaust's" effective and allegedly outdated mechanisms of audience involvement and identification. The success of "Holocaust" forces us to rethink certain aesthetic and political notions mostly concerned with Brechtian theater and its politics on the one hand and with Frankfurt School avantgarde aesthetics on the other.

III

If we look back over the history of Holocaust dramas in West Germany, we will find only two plays which facilitated emotional identification with the victims as Jews: Frances Goodrich and Albert Hackett's play based on the diaries of Anne Frank and, in a more limited and mediated way, Hochhuth's *Deputy*, both distinctly non-Brechtian plays which rely heavily on audience identification with the protagonists.

As a matter of fact, it was the American stage version of Anne Frank's diaries which for the first time took the Holocaust directly to the German stage. The year was 1956. Up to this time the Holocaust provided only the implicit background to a series of *Bewältigungsdramen* which focused mostly on the role of the Wehrmacht in the Third Reich and on the resistance movement of July 20, 1944.[8] The alibi function of many of those plays is evident in retrospect. They served to exculpate the army and thus contributed substantially to the silent rejection of collective guilt.

Silence, however of a different kind, characterized the German reaction to the Anne Frank play. The postscript to the American edition describes this reaction in words similar to those used twenty-three years later about German reactions to "Holocaust": "On October 1, 1956, *The Diary of Anne Frank* opened simultaneously in seven German cities. Audiences there greeted it in stunned silence. The play released a wave of emotion that finally broke through the silence with which Germans had treated the Nazi period."[9] It was clear at the time that emotional and personal identification with the destiny of Anne Frank was the basis for the play's success, just as identification with the Weiss family explains the impact of "Holocaust." And yet, another twenty-three years had to pass until the renewed denial of the past exploded on an even larger scale. What happened between 1956 and 1979? After all, these were the years of Eichmann's trial in Jerusalem

(1961), of the Frankfurt Auschwitz trial (1963–65), of a wave of documentary plays about the Holocaust, of the student and protest movements which time and again focused on the lack of *Vergangenheits-bewältigung* in academic, political, and cultural institutions in West Germany. If indeed the effect of the Anne Frank play and the book on which it was based was as deep and substantial as historians make it out to have been, then why did later plays not build on this model and further develop the process of genuine *Vergangenheitsbewältigung* which seemed to have been set in motion in 1956, at least in the younger generation? How can it be explained that the student generation of 1979 when confronted with "Holocaust" proved to be as uninformed about the past as that of 1956? Again there are no easy answers, but, as far as West German dramatic presentations of the Nazi past are concerned, a number of facts and speculations can be offered from a post-"Holocaust" perspective.

The model of the 18th- and 19th-century historical drama lost its viability after 1945. Its humanistic optimism and belief in historical progress as well as its dramaturgy glorifying the great individual as the vehicle of history already had been proven obsolete in expressionist drama. In the years following the defeat of the Third Reich, history inspired horror rather than respect and awe. Despairing of the meaning of history some authors, who still held on to a realistic dramaturgy by and large, resorted to a simplistic dualism pitting individual moral integrity against a historical process which was presented as demonic and out of control. The individual is presented as victim rather than as a carrier of history. This view is evident in Zuckmayer's *The Devil's General* (1946), a play which was extremely successful in the late 1940s and in the 1950s since it fed into the dominant tendency at that time to demonize the Third Reich and to view it as a "natural" disaster of German history. Demonization of course was one of the welcome mechanisms of denying one's own involvement in the past, not for the emigrant Zuckmayer, but certainly for the protagonist of the play itself and thus also for post-war audiences in Germany, who identified with the devil's general. It seems fairly obvious in retrospect that identification with a German air force general was not the politically, educationally, and psychologically appropriate strategy to make Germans face the realities of the past. But even this identification with Harras, the basically good but tragically misled individual, may have helped some spectators at least to face the problem of their own personal history during the Third Reich in a way which some of the later plays would no longer permit.

By the late 1950s, traditional individualistic dramaturgy had been all but abandoned in the German *Bewältigungsdrama*. The reasons for this shift seem understandable enough. How indeed could a dramaturgy based on individual protagonists and their actions adequately cope with the problem of collective guilt? Already in 1931 Brecht argued that in the 20th century traditional realistic dramaturgy was no longer viable and that reality itself required a new mode of representation.[10] The traditional practice of using individual characters to symbolize the universal had become questionable in an age in which individuality itself had undergone significant mutations or, as some critics argued, a specific historical form of individuality was threatened with extinction. A possible solution to this dilemma was offered by the Brechtian parable play, which, rather than mirroring historical reality by way of individualizations, attempts to represent reality as a network of relations and presents individuals in terms of their functions only. The "abstract" model of the parable then would point the spectators back toward their own reality, toward history and the present. According to Brecht, the parable gains its effectiveness precisely from its distance to the present. This distance enables the spectator to develop a rational understanding of phenomena rather than being engulfed in a stream of conflicting emotional identifications. The parable form recommended itself for yet another reason. The best post-war playwrights did not just want to put the Third Reich on stage, isolating it from the present. They aimed at criticizing the social and economic, psychological and ideological continuity that they perceived to exist between the Third Reich and the Federal Republic. This continuity, this unbroken bond was at the heart of denial and suppression, and it had to be articulated if there ever was to be any genuine *Vergangenheitsbewälti-gung*. The irony is that while the abstractness of the parable form enabled playwrights both to attack the Third Reich and to criticize official FRG culture, this same dramaturgy prevented audience identification with the historic specificity of Jewish suffering in the Third Reich. The parable form prevented that mourning for the victims deemed so essential by the Mitscherlichs and was therefore itself an obstacle to a successful coming to terms with the past. It also seems significant that Jews are conspicuously absent from the parable plays. Only one of the major parable plays features a Jew, Andri in Frisch's *Andorra*, but even he turns out to be a gentile. Most parable plays of the late 1950s and early 1960s focused not on the victims, but rather on the role of the petit-bourgeoisie in the inception of dictatorship, on the inevitable rise of the dictator, and on the totalitarian system of domination. More often than not the parable was sucked into the dominant

trend of the grotesque and the absurd and thus forfeited the Brechtian dialectic of parable form and history.[11] A serious *Vergangenheitsbewälti- gung* becomes practically impossible when the world is presented as chaotic and absurd, when the petit-bourgeois running amok repre- sents the measure of history. Furthermore, blaming fascism on the petit-bourgeois was certainly an approach the mainly upper middle- class theater audiences could live with, since it did not confront them with their own involvement in the Third Reich.

But there is another, more serious problem with the parable form, a problem which affected even the best examples of this genre such as Siegfried Lenz's *Zeit der Schuldlosen* (1961) and Max Frisch's *Andorra* (1961). The time and placelessness of the parable, which on the one hand was its strength, was also its crucial weakness. Since the parable refers only indirectly to the specifics of history, it is vulnerable to political misunderstanding unless it is a parable *à clef* as Brecht's *Der aufhaltsame Aufstieg des Arturo Ui*. Especially in a period when the totalitarianism theory, with its equation of right and left, of fascist and communist dictatorships, was fast gaining ground in West Germany,[12] a parable play such as Max Frisch's *Firebugs*, which one would think points fairly unambiguously toward the rise of fascism, could be seen by major critics as an attack on communism, as a play about Czechoslo- vakia in 1948 or Hungary in 1956.[13] Here the parable form produced the very denial and suppression which it was intended to overcome.

A more complex case in point is Frisch's parable *Andorra*, a play that mixes the abstractness of the parable with a dramaturgy of identifica- tion thus opening ways of understanding which remained foreclosed in a parable *à clef* such as Brecht's *Arturo Ui*. The construction of the parable is concrete enough to leave no doubt as to what kind of totalitarianism is in question. And yet, there remains a basic ambiguity. Andorra is a small mountain state threatened by invasion from an overwhelmingly powerful neighbor, clearly a reference to Switzerland, Frisch's home country, during the latter half of the Third Reich. In the play, the invasion does take place and leads to the execution of Andri, the protagonist who is thought to be Jewish. In reality, of course, the Germans never invaded Switzerland. Thus, a Swiss audience could easily repress Switzerland's mostly shabby treatment of German Jewish refugees arguing that the parable does not concern the Swiss so much as it concerns the Germans who after all were the ones responsible for Auschwitz. German audiences had another way out. Of course they could not claim in good faith that the play is about Swiss anti-Semitism only, and so they accepted *Andorra* as standing for Germany in 1933. But then the construction of the parable reinforced a stock idea in the

arsenal of German denial mechanisms, namely that the Nazis were not something indigenous, but that they came in from the outside as an alien force. To be a German and to be a Nazi, the play seemed to suggest, were two substantially different things. On the one hand, then, the play allows spectators to hold the problem at arm's length keeping questions about their own past at a safe distance. Thus the critic Heinz Beckmann praises Frisch for "having led us out of the dead-end street of so-called *Zeitstücke*" and goes on to describe *Andorra* as "an exemplary modern play which successfully masters the method of estrangement (*Distanzierung*)."[14] What Beckmann overlooks is that despite its parable form and its dramaturgy of estrangement, *Andorra* also offers audiences possibilities of identification with an individual which run counter to the dramaturgy of estrangement and are absent from other parable plays of the 1960s. Throughout the first half of the play the audience is led to identify emotionally with Andri who is being victimized by the Andorrans. Especially for a German audience, this identification became possible precisely because the play suggested that being German was not identical to being a Nazi. Thus it is the historically ambiguous construction of the parable which helped Germans to identify with the victim rather than seek refuge in the apologetic defensiveness of the accused.

What makes it so difficult to evaluate *Andorra* is not only the impact of its mixed dramaturgy on audiences, but also the fact that the play itself, in its second half, undermines the identification process it successfully engendered during the first half. When Andri (and with him the audience) finds out that he is not the Jewish orphan secretly smuggled into Andorra and adopted by the teacher, but rather the latter's illegitimate son, the play no longer allows for unambiguous emotional identification with the Jewish victim, but focuses rather on the problem of shifting identity in Andri himself. The audience is now asked to reflect upon the problem of identity and societal image-making rather than to identify. The Jewish identity of Andri, which after all is a prerequisite for audience identification with him as a Jew, proves to be imaginary, a social construct. Suddenly the play has moved to a level of rational argument where the question of Jews and anti-Semitism is universalized and subsumed under the much broader notion of social identity, prejudice and scapegoating, and the audience is several steps removed from the Holocaust. Andri who had been stereotyped as other by the Andorrans to the extent that his whole behavior, thinking, and character underwent a substantial transformation, now refuses to accept the fact that he is not Jewish. He consciously and existentially chooses his "Jewish" identity which will make his

execution inevitable once the "blacks," i.e., the fascist enemy, invade Andorra. Apart from the fact that Jewish identity is rarely a matter of choice and not just a result of prejudice, certainly not in the Third Reich, Frisch's parable operates with the questionable notion that modern anti-Semitism is just another form of racial prejudice and scape-goating. Interestingly enough, Frisch only portrays traditional anti-Semitic prejudices. What Moishe Postone characterizes as the modern form of anti-Semitism—the image of the Jew as responsible for finance capitalism *and* bolshevism—is completely absent from Frisch's play. Ironically, the lack of historical specificity of Frisch's parable (Andorra standing for Switzerland on the one hand and for Germany on the other), which proved to be a strength in one instance, also results in a flaw of the play. Anti-Semitism, at the end of the play, has become just another form of universal prejudice and social imaging. Frisch himself of course doubted that history could ever be represented on stage. Instead he advocated play as a "self-affirmation of man against historicity."[15] This existentialist view may have its validity in Frisch's imaginative universe, but it certainly founders when applied to anti-Semitism and the Holocaust. The key problem, however, with *Andorra* and other parable plays is not so much the presence or absence of historically recognizable events or characters but rather the question of identification. To the extent that Frisch's *Andorra* allows for such identification it shows us something about the reality of fascism which the historically much more precise Brechtian parable *à clef*, such as *Der aufhaltsame Aufstieg des Arturo Ui*, is unable to get at.

Frisch's *Andorra* premiered in 1961, an election year, which marked a substantial shift in the political and cultural climate of the Federal Republic. Underneath the surface of the social and intellectual stagnation which characterized the Adenauer restoration as much as the *Wirtschaftswunder* did, things began to stir. While writers and intellectuals during the 1950s had abstained from politics and subscribed to what Hans Mayer has described as "der totale Ideologieverdacht"[16] (the total suspicion of ideology), they now intervened in increasing numbers in matters of public policy. Shortly before the 1961 election Martin Walser edited a collection of essays *The Alternative or Do We Need a New Government?* in which leading West German intellectuals advocated political change and, mostly from a position of skeptical liberalism, took sides for the SPD as the "smaller evil."[17] Time and again the authors based their commitment to change on the failure of the Adenauer government to come to terms with the past. Especially the Eichmann trial in Jerusalem in the spring of 1961 had made it clear to what extent the past had been denied and suppressed despite official

policies of *Wiedergutmachung* toward camp survivors and Israel. The systematic legal prosecution of those directly responsible for the "Final Solution" had begun in the Federal Republic in 1958, but it was only after the Eichmann trial that the question of the Holocaust became a dominant theme in the German courts, in the media, and on stage. The malaise was pervasive. In 1962 Ulrich Sonnemann stated poignantly: "In the consciousness of West German society, that which is wrong with it can be summed up succinctly in the phrase of 'unbewältigte Vergangenheit,' the inability to come to terms with the past."[18] In that same year, Martin Walser demanded: "Today German writers have to treat exclusively figures which either conceal or express the years from 1933 to 1945. . . . Every sentence of a German author that is silent about this historical reality conceals something."[19]

Between 1961 and 1965, a wave of plays dealing with the Holocaust, the Third Reich, and its aftermath flooded the German theaters. One group of plays emphasizes consciousness and denial, memory and repression. These plays usually take place in the post-war period, and their major aim is to critique the Federal Republic rather than to understand the Holocaust. Examples would be Heinar Kipphardt's *Der Hund des Generals* (1962), Walser's *Der schwarze Schwan* (1964) and Hans Günter Michelsen's *Helm* (1965). More interesting in the present context, however, are those other plays which directly or indirectly focus on the concrete historical events relating to the Holocaust: the documentary plays *The Deputy* (1963) by Rolf Hochhuth, *Joel Brandt oder Geschichte eines Geschäfts* (1965) by Heinar Kipphardt and *The Investigation* (1965) by Peter Weiss.

Especially Hochhuth's and Weiss's plays stirred up wide-ranging public debates in the media, but, compared with the impact of "Holocaust," their reception remained necessarily limited. Even though *The Investigation* premiered simultaneously in 16 German theaters and was later on successfully shown on TV, it never even came close to matching the impact of "Holocaust." And Hochhuth's *Deputy*, which received more publicity than either *Andorra* or *The Investigation*,[20] was performed more often outside than inside Germany. This much said, we can proceed to compare those documentary plays, their successes and their failures, with those of "Holocaust." After all, such a comparison cannot be based only on a quantitative measurement of impact since the different modes of representation involved may have affected the quality and depth of that impact in a more substantial way.

Hochhuth's *Deputy* above all raises the question of identification, both in terms of its content and its dramatic strategy. Hochhuth uses a traditional pre-Brechtian dramaturgy based on notions of character,

individual moral responsibility, freedom of choice, personal guilt, and personal tragedy. The play invites audience identification and in that respect seems to come close to the Anne Frank play of 1956. Such a comparison, however, is somewhat misleading. Hochhuth's play calls forth identification not with the Jews, but rather with Ricardo, the Catholic priest, who challenges the acquiescence of Pope Pius XII to Nazi barbarism, and, who, after massive internal turmoil, decides to accompany a group of Roman Jews to Auschwitz in order to die as the "real" deputy of Christ. This kind of mediated identification with the victims of the Holocaust nevertheless opened up key moral and political questions about actions and non-actions of people in the Third Reich. The play forced Germans, who had looked the other way when Jews were "deported" during the Third Reich, and who denied the Holocaust after 1945, to identify with a dramatic figure who took his individual Christian and human responsibility seriously. The play's demand for identification with Ricardo and his heroic struggle to fight evil and to maintain his active humanity explains the play's success as well as the multiple attacks on *The Deputy*. One wonders indeed whether Hochhuth's difficulties in getting the play published and the subsequent angry, often vicious denunciations were only motivated by the desire of faithful Catholics to maintain an untarnished image of Pope Pius XII, or whether the intensity of these attacks did not as well reflect energies mobilized to deny guilt and to repress the past.

Although audience identification focuses on the mediating figure of the Catholic priest there are two scenes in *The Deputy* where immediate emotional identification with the Jewish victims becomes possible. These few scenes in Act 3, which show the SS capturing a Jewish family in Rome, come closest to the narrative structure of "Holocaust" and its focus on the destruction of family life. To be sure, these scenes are marginal and—from the viewpoint of traditional dramaturgy—somewhat haphazardly integrated, but they are some of the most powerful scenes in the whole body of *Bewältigungsdramatik*, precisely because the identification with Ricardo here shifts toward the direct identification with Jews in a family setting.

Nevertheless, there is a basic problem with Hochhuth's play. Already in the 1960s, Hochhuth's dramaturgy, which reduces a complex historical event to the issue of individual moral choice and the struggle of good vs. evil, was strongly criticized by Theodor W. Adorno in his "Open Letter to Rolf Hochhuth."[21] Adorno's critique was triggered by Hochhuth's contribution to a Lukács *Festschrift* published in 1965. In his essay "Die Rettung des Menschen"[22] Hochhuth here justified his dramaturgy by referring back to Lukács' conviction that the point of

departure for all literature is the concrete, individual human being. As a result of a facile reading of Lukács, whom he misunderstands as thoroughly as Adorno, Hochhuth defends the individual, his freedom of choice, and his responsibility for history as the basis of any drama. By polemicizing against Adorno's notion of the decay of individuality in 20th-century capitalist society, he rejects the whole avantgarde aesthetic of which Adorno and Brecht are prime exponents. It is no coincidence that Adorno's letter to Hochhuth holds up Brecht's *The Private Life of the Master Race* with its focus on the common people of the Third Reich and contrasts it with Hochhuth's dramaturgy of VIPs, ambassadors and generals, cardinals, the Pope, and the devil incarnate. Adorno criticizes Hochhuth for adopting the narrative strategy of the culture industry which tends to personalize even the most anonymous societal processes by simply ascribing important events to important people. According to Adorno, only the avantgarde aesthetic can do justice to 20th-century life in general and to the Holocaust in particular: "No traditional dramaturgy based on major protagonists can achieve it. The absurdity of reality demands a form which dismantles the realistic facade."[23] Of course Brecht would take issue with Adorno's notion that reality is absurd. But as an avantgardist, he would agree with Adorno's demand for a mode of artistic representation which dismantles traditional forms of realism and their modern updates. The problem with this avantgarde aesthetic, however, is precisely that the dismantling of realistic façades also prevents emotional audience identification, which inherently depends on individually recognizable human figures. To be sure, Brecht's plays elicit emotions, but mostly not the kind of emotions that lead to identification with individual characters which Brecht rejects explicitly, especially in his Lehrstück phase. And one simply does not identify with any of Beckett's truncated human beings, even though one may well acknowledge that they express something essential about our culture and society. Similarly, to give yet another example, it is hard to see how Schönberg's *Survivor of Warsaw* could ever arouse the kind of emotional identification triggered by "Holocaust."

The evolution of artistic forms best represented by the historical avantgarde clashes with the needs of audiences for emotional identification with specific human characters, their problems, and their contradictions. Of course, these needs are not "natural." They are socially constructed from early childhood on and in our society they are persistently reinforced by the culture industry. The abstraction and opacity so characteristic of many avantgarde art works, on the

other hand, can be regarded as sedimentations of the increasing abstractness and opacity of social life in technologically advanced societies. This is precisely where the truth content of these works lies. What "Holocaust" calls into question is not so much this truth content itself, but rather the avantgarde's claims of universality (under whatever guise they come) and its neglect of, if not contempt for what Bloch described as nonsynchronism in social and cultural life.[24]

A successful integration of avantgarde form and "realistic" representation was achieved in Peter Weiss's highly stylized documentary play *The Investigation*, which is perhaps the best drama about the Holocaust. Contrary to Hochhuth, who did not have any compunction about dragging Auschwitz on stage in the last act of *The Deputy*, Weiss knows that Auschwitz cannot be represented in such a crude and unmediated way. More than any other theme, Auschwitz required a dismantling of the "realistic facade."[25] The question was how to do that while at the same time maintaining a level of realism that would keep the play from veering off into the parable or some other metaphoric form. Weiss's solution is as simple as it is genial. He does not write a play about Auschwitz, but rather about the Auschwitz trial, which took place in Frankfurt from 1963 to 1965. Almost word by word, the play is based on the trial reports of the *Frankfurter Allgemeine Zeitung*, which are rearranged in such a way as to lead the audience from the ramp, where the trains arrived, through various locations of the camp to the gas chambers and crematoria. The structure of Weiss's oratory parallels that of Dante's *Divine Comedy*, specifically the *Inferno:* there are 11 songs to the oratory, each divided into 3 parts, thus totalling 33 parts. The symbolic weight given to the number 3 in Dante reappears in *The Investigation* in yet another way: there are 3 representatives of the court, 9 witnesses and 18 accused. Auschwitz is not shown on stage; it is recreated through the memory of the accused, the witnesses and survivors who confront each other a second time in the courtroom trying to testify and to articulate what happened another time at another place. Auschwitz is represented through language only. It is precisely this reduction of Auschwitz to memory and language, manifest in the survivors' reports and in the rationalizations and exculpations of the accused, which makes the play so powerful. *The Investigation* is a strictly formalized collage of trial reports, but the avantgarde form never blocks accessibility. The reality of Auschwitz is described in a grey, matter-of-fact, curt prose. It comes alive especially in the speeches of the accused which exemplify the language of denial and apology so characteristic of post-war Germany in general. The play not

only speaks about the past, but the past itself is still alive in the language of the accused which betrays the mental and behavioral attitude fascism could build on in its extermination program.

Weiss's play did not invite the same kind of identification with the victims we witnessed during the showing of "Holocaust." At the same time there is no question that Weiss, himself a Jew, who left Germany with his parents in 1934, feels the deepest bonds with those who died in Auschwitz. In a short essay written in 1964 and entitled *Meine Ortschaft*, Weiss describes a recent visit to Auschwitz as coming "twenty years too late.": "It is the one place which I was destined for and which I escaped."[26] Maybe it was precisely this fundamental level of identification—an identification resulting from identity with the victims—which made it unnecessary for Weiss to base his play on a dramaturgy of identification. For him identification was a given, not something to be achieved as in the case of his post-war German audiences. And yet, at the time of his visit Auschwitz was nothing more than a museum to him, remnant of a perished world. At the end of Weiss's text, the guilt feeling of the survivor, based as it is on identification, is complemented by an experience of estrangement. The living are unable to grasp what happened; all they have are numbers, written reports, statements of witnesses, but they lack the experience of what it is to be beaten, kicked, and chained. It is precisely this tension between the author's identification and his sense of estrangement and distance which pervades *The Investigation* and prevents the type of unmediated emotional identification triggered by "Holocaust." Actually individual victims are never highlighted as they are in the TV series. The witnesses, mostly Auschwitz survivors, describe the multiple aspects of the camp and of camp life for a court, and thus their descriptions are limited to objective fact. The accumulation of facts has a deep emotional impact on audiences, but it evokes shock or numbness, not identification. If Weiss names individual cruelties and brutalities, he does so in order to affect consciousness rather than emotions of sadism or horrified empathy. To Weiss the enormity of Auschwitz itself forbids emotional identification with individual victims. This is what Adorno had in mind when he criticized the Anne Frank play for focusing on an individual victim which consequently permitted the audience to forget the whole. Weiss's play seems indeed most convincing in its presentation of the relationship between individual suffering and collective destiny of the Jews. Descriptions of individual cases such as that of Lili Tofler are strategically placed to make mass murder concrete and imaginable for the audience and to keep Auschwitz from becoming just an abstract symbol of horror. At the same time individual destinies, both on the

side of the victims as on that of the henchmen, are related not *as* individual destinies, but rather as examples of a calculated system of destruction, as points in a network which, seemingly arbitrary in its component parts, inexorably leads to death. Certainly, Weiss's play is successful as a work of art, and one can say without exaggeration that the Auschwitz trial received more intense publicity and exposure through the performances of *The Investigation* than through Bernd Naumann's original trial reports published in the *FAZ*.[27]

There is nevertheless one major problem with this play, too. It is not primarily a problem of dramaturgy as in the case of Hochhuth. Nor is it just the fact that the play does not allow for identification with the victims. The problem is political. *The Investigation* stipulates an unmediated causal nexus between capitalism and Auschwitz. The extermination of the Jews is presented and interpreted as an extreme form of capitalist exploitation "where the oppressor/could expand his authority/to a degree never known before/and/the oppressed/was forced to yield up/the fertilizing dust/of his bones."[28] Of course, Weiss can legitimately point to the dependence of the German war industry on camp labor and on the presence of plants and factories in the immediate vicinity of Auschwitz. Even the presentation of Auschwitz itself as a highly organized and taylorized death factory is plausible and can be amply documented. But this is as far as it goes before the limitations of the play become visible. Weiss never attempts to deal with the history and specificity of anti-Semitism in Germany. By blaming Krupp and IG Farben, Weiss subsumes the death of six million Jews to a universal Marxist critique of capitalism. Here Weiss comes dangerously close to depriving the victims of their personal and collective history and identity as Jews, and he just about instrumentalizes Auschwitz in order to advance a questionable interpretation of fascism as a necessary stage of capitalism. In the late 1960s, when the German student movement turned increasingly to orthodox Marxist interpretations of the Third Reich, *The Investigation* became part of a left discourse which can be regarded as yet another way of denying the past. Not that the facts were denied. On the contrary, they were to be used to enlighten the German populace about capitalism, fascism, and its continuing presence in West German society. But all this rational enlightenment and its universal indictment of capitalism lapsed into silence when it came to the specifics of Jewish destiny in the Third Reich.[29] A mode of intellectual discourse emerged on the left which tended to eliminate the Holocaust itself, and thus it is not surprising, in retrospect, that Weiss's play of 1965 marks the end of the Holocaust drama in West German literature. A level of discussion and interpretation had been

reached which seemed to make any further plays about the Holocaust obsolete. As a result, yet another generation of students had to rediscover in 1979 what the student generations of 1956 and 1965 had discovered, but had been unable to transmit to the following generations. The breaking of the cycle of denial and repression had to begin anew.

IV

Beyond these differences between the generation of the 1960s and that of the 1970s, however, it can be said that the three major German plays aiming at *Vergangenheitsbewältigung*—Frisch's *Andorra*, Hochhuth's *Deputy* and Weiss's *Investigation*—shared a universalizing gesture of moral and political accusation which in many instances inhibited rather than furthered the coming to terms with the past. While Frisch and Hochhuth allowed for some audience identification with their plays, none of the works discussed aimed consistently at bringing about mourning via identification. Their impact remained ambiguous: they provoked genuine attempts to come to terms with the past—especially in the younger generation—but they also fed into that facile breast-beating which was often coupled with denials of personal guilt or shame.

Frisch ignored the specifics of modern anti-Semitism and saw it as but one example of universal prejudice thus undermining the initial audience identification with the victim as Jew. Hochhuth advanced a universal ethics of individual responsibility and avoided even posing the question about the social origins and evolution of modern anti-Semitism. Weiss made anti-Semitism an appendage of capitalist exploitation. None of the three authors opted for a dramatic strategy which would have consistently allowed German audiences to identify with the vicims as Jews. The Jews, to the extent that they are recognizable as Jews in the plays, remained in the position of the other. They are presented as outsiders or marginal figures with whom a non-Jewish audience cannot fully identify, especially since the plays stipulate an identity between persecutors and audience in Germany and thus revive the collective guilt thesis which was partially responsible for the denial in the first place. Even more surprising is the fact that the three plays are so deficient in their presentation of Jewish characters. Hochhuth at least made an attempt to introduce a number of Jews as side figures (Jakobsen, the Luccani family), but Frisch's hero turns out to be a gentile and Weiss's witnesses remain anonymous. The very word "Jew" is absent from the best play about Auschwitz!

It is against this very complex background of German aesthetics, drama, and politics that the success of "Holocaust" and the critiques of the program have to be seen. Like numerous standard television programs, "Holocaust" thrived on the audience's emotional identification with the individual members of a family. It is actually this identification with a family which facilitated identification with them as Jews.[30] This identification with a Jewish family is further enhanced by the fact that the Weisses are assimilated Jews who totally identify with German culture. But audience identification was not only triggered by narrative strategies internal to the series. Identification with the Weiss family was further enhanced by the medium and its reception context which is substantially different from that of the theater. TV watching is after all a family affair and takes place in the private sphere of the home rather than in a public space such as the theater. The semantic structure of the story is made more powerful in the context of reception. At the same time, the identification process did not only function on the personal, private level, from family to family, as it were. Watching the four installments of "Holocaust" was a national event which dominated public debates and personal conversations day after day, at least during the week of the telecast. This is what some critics meant when they spoke of a national or collective catharsis. The flow of identification went out to the Jewish family on screen *and* toward those millions of other Germans, who also identified with the victims and perhaps for the first time showed signs of collective mourning. With the exception of that other *American* play twenty-three years earlier, this was the first time that a German mass-audience could identify with the Jews as Jews—like themselves members of a family, united by and conflicting in their emotions, their outlook, their everyday concerns. The emotional explosion that took place in Germany in the week when the four installments of "Holocaust" were telecast shows how desperately the Germans needed identification in order to break down the mechanisms of denial and suppression. Though it is still too early to judge the long-term impact of "Holocaust" on German politics and culture, it seems unlikely that the whole system of defense and denial mechanisms will regain its original power. And yet, even if "Holocaust" should succeed in setting in motion a process of collective mourning which would in the long run affect German culture and society, it will necessarily remain a one-way street, i.e., a problem of German identity. Indeed, it remains to be seen whether "Holocaust" did help Germans of various generations open up the multiple questions about their national, cultural, and social identity which in the past decades remained buried in the rhetorics of verbose amnesia and universal

rationalization and which would eventually have to reach beyond the identification process made possible by "Holocaust."

If, from the viewpoint of social psychology, identification and collective catharsis were necessary, then "Holocaust" was successful with such a large segment of the audience precisely because it was a TV program and, as such, used the basic form of TV narrative. As a TV program, "Holocaust" brought certain limitations of the earlier theater plays out into the open. In post-war German drama, the socio-psychological need for identification with the Jews as victims clashed to varying degrees with the dramaturgic and narrative strategies of avant-garde and/or documentary theater. The historic evolution of dramatic form and the canon of political educators emphasizing document, rational explanation, and social theory had bypassed the specific needs of spectators. Of course, I am suggesting that this is not only true in this special case, but that the success of this American TV series in Germany does indeed point to broader aesthetic and political problems which we are only now beginning to explore. The vehemence of some left objections to "Holocaust" would then not only point to the blindness of the German left to the specificity of the Holocaust; it could furthermore be interpreted as a rear-guard struggle to hold on to an avantgarde aesthetic and politics of an earlier period which by now has become historical, if not obsolete, in its claim to universality and rationality.

7

Memory, Myth, and the Dream of Reason: Peter Weiss's *Die Ästhetik des Widerstands*

> Behind him the past washes ashore, piles debris on his wings and shoulders, with the noise of buried drums, while before him the future dams up, impresses itself down on his eyes, bursts his eyeballs like a star, twists his words into a sounding muzzle, chokes him with its breath. For a time one can still see the beating of his wings, hear into the roar the landslide coming down before above behind him, louder the more furious his futile movement, sporadic as it languishes. Then the moment closes down over him: standing, buried by debris quickly, the hapless angel comes to rest, waiting for history in the petrification of flight glance breath. Until the renewed roar of mighty beating wings propagates itself in undulations through the stone and announces his flight.
>
> Heiner Müller, *The Hapless Angel*

Ever since his first major international success with the *Marat/Sade* of 1964, Peter Weiss has persisted in trying to rescue the radical moment of the historical avantgarde for an age which by and large had comfortably regressed to a domesticated modernism and to an apolitical avantgardism of formal experiment. Plays like the *Marat/Sade* or *The Investigation*, the play about the Frankfurt Auschwitz trial, effectively

challenged the complacencies of the institutionalized ideology of modernism of the 1950s and its dogmatic uncoupling of art from politics. In West Germany, the art/politics dichotomy served not only to obliterate the original radical impetus of modernism itself, but also to repress any memory of that cultural catastrophe that was German fascism. By focusing on Germany's contributions to international modernism one could quickly forget the disastrous miscarriage of the national culture. Peter Weiss's plays of the mid-1960s thus represented something like the return of the repressed. Of course, Weiss's voice was that of a permanently displaced exile writer, but the impact of his plays connected him inseparably with the rise of the student movement in West Germany and with the cultural politics of the 1960s which have left us with a remarkable body of works in the writings of Weiss, Enzensberger, Kluge, Kroetz, and Martin Walser among others; the films of, again, Kluge, Straub-Huillet, and Fassbinder; the visual experiments of the Gruppe Zero, the Vienna action and performance artists, Gerhard Richter, and Joseph Beuys.

Weiss's theater has often been described as an uneasy, but fascinating blend of Artaud and Brecht, of the theater of cruelty and the theater of the epic *Lehrstück*, a project that could be compared to that of the East German "successor" of Bertolt Brecht, Heiner Müller. Both authors realized that the classical avantgardism of Brecht had become precisely that: classical. And they tried to rework and revitalize it through a fusion with that other, more submerged, radical tradition of the historical avantgarde, i.e., surrealism. Of course, Brecht's hostility to surrealism is well known, and the very attempt by Weiss and Müller to somehow dissolve the boundary between the two major trends within the historical avantgarde places them in a clearly post-Brechtian *and* postsurrealist situation. In terms of Weiss's development as a writer, however, we should remember that contrary to Heiner Müller he did not start out with Brecht, but rather with surrealism. Weiss's and Müller's project to go beyond Brecht and beyond surrealism was of course never only an aesthetic choice. It was as much, if not more, determined by the historical experiences of fascism, Stalinism, and post-war capitalism which made the Brechtian and Artaudian solutions alone increasingly unsatisfactory. At the same time it was precisely the attempt to rewrite the parameters of avantgardism which makes their work representative for an age which has since then come to be called postmodern.

A few comments on Weiss's development as an artist may be in order. He actually began his artistic career in the 1930s in Swedish exile as a painter of magical realist canvases which were very much indebted

to German expressionism and to the Neue Sachlichkeit of the later 1920s.[1] It was only after the war that he switched entirely to writing, at first without any real public success at all. At the same time he underwent analysis and became increasingly fascinated with Jarry, Rimbaud, Buñuel, and the French surrealists. His first major prose texts to be published in West Germany—*Im Schatten des Körpers des Kutschers* (1960) and the two autobiographical texts *Abschied von den Eltern* (1961) and *Fluchtpunkt* (1962)—are unthinkable without the impact of surrealism, but again, they were not much of a success, probably because of their radical experimental subjectivity which baffled German readers used to Böll and Frisch. In the English-speaking world to this day, Peter Weiss is only known as the author of a few major plays who later lapsed into a merely propagandistic play-writing with his didactic dramatic ballads about the Vietnam war and Portuguese colonialism in Angola. The pretense of a revived avantgardist unity of aesthetics and politics seemed to have exhausted itself aesthetically and politically after Weiss's "conversion" to Marxism in 1965. Or so the mainstream critics thought.

But then Weiss wrote *Die Ästhetik des Widerstands*, a 950-page novel that was published in three volumes in 1975, 1978, and 1981 and that was accompanied by two volumes of notebooks, published simultaneously with the third volume of the novel in 1981. The novel is doubtlessly one of the major literary events of the 1970s. It can be read not only as the *summa artistica et politica* of the writer Peter Weiss, but also as a sustained narrative reflection, from the viewpoint of the 1970s, on the vicissitudes of avantgardism in relation to political vanguardism in the 20th century. It is this latter aspect, which, I would suggest, pulls Peter Weiss's *opus magnum* into the orbit of the postmodern. Even though he himself did not live to witness the increasingly heated polemics about postmodernism in Europe, it is possible to map the space his novel occupies in the current aesthetic debate. Thus *Die Ästhetik des Widerstands* acknowledges the per se problematic nature of the historical avantgarde's attempt to merge art and life, aesthetics and politics, but at the same time Weiss clearly privileges avantgardist writing strategies such as montage and collage, the documentation of dreams and the blurring of the rigid boundary between fact and fiction. In its writing strategies and overall composition the novel rejects the oeuvre-oriented presuppositions of classical modernism, its focus on individual consciousness and its categorical separation of art and life, literature and politics. Significantly, the novel was published in three large workbooks bound in gray paper, with relatively large print and broad margins for the reader to write on, all of it modeled after

Brecht's famous *Versuche* of the early 1930s. But what we have before us is a massive block of unchangeable text, not a script for a play which would be rewritten in the course of each and every production. Thus Weiss does hold on to a notion of the work of art, cleansed, however, of its pretense to autonomy, self-sufficiency, unity, and wholeness.

Somehow, then, Weiss's aesthetic position seems to be located somewhere on the fault lines between high modernism and the historical avantgarde, both of which have been called in question aesthetically and politically since the 1960s. He operates in a field of tension which has come to be called postmodern, and nowhere more so than where he turns against the modernist dogma of the death of the subject and the concomitant death of the author. Just imagine how the classics of the modernism debate of the 1930s might react to Weiss's novel. Neither Brecht, nor Adorno, not to speak of Lukács, would have an easy time reconciling *Die Ästhetik des Widerstands* with their conceptualizations of a modern aesthetic or, for that matter, with their differing notions of resistance. Where Brecht would probably see a sellout to surrealism, to irrationality and melancholy, and would miss a concept of a *eingreifende Kunst*, Adorno would presumably suspect yet another kind of forced reconciliation, this time between a still too orthodox Marxism and a regressive aesthetic mixture of documentary realism with a fetishistic surrender to the unconscious. This incompatibility of the novel with any of the prominent positions of those earlier theorists of modernity seems all the more surprising since the emphatic link between resistance and the aesthetic was a shared ground of all those writers, and in this sense Weiss does indeed carry on their project. How, then, is Weiss's writing different from that modern tradition as theorized earlier by Adorno or Brecht? And is that difference enough to pull his work into the orbit of the postmodernism problematic?

To some it may seem repugnant even to associate Weiss with postmodernism. Champions of the postmodern, of subtle ironies and of writerly pleasure, will not be able to swallow either Weiss's politics or his tortured and tormented view of human history. Opponents of postmodernism, especially on the left, will have a hard time digesting Weiss's writing strategies, his melancholy world view, and, in the case of "real existing socialists," his presentation of Stalinist horrors as well; but they will still want to salvage Weiss from the taint of the postmodern which they see as only aestheticist and apolitical. As the reception of the novel in the two Germanies shows, Weiss has written a book totally against the grain of the "Zeitgeist," against the grain especially— and this must be emphasized—of what Hal Foster has called an affirmative postmodernism. The question then becomes to what extent

we may read Weiss's novel in light of what critics such as Foster have recently posited as a postmodernism of resistance.

But whether we include Peter Weiss's novel in the emerging body of postmodernist works or not is a question of secondary importance. It is more important to show how the novel participates in a problematic that distinguishes contemporary culture from high modernism and the avantgarde, a problematic, in other words, that is rooted in the experiences and constellations of the 1960s and 1970s. And, secondly, how within the problematic of the postmodern in Germany Weiss's novel marks a position which cannot easily be recuperated by the culture apparatus, let alone turned into a literary fashion to keep the presses rolling. Against the political and aesthetic amnesia of the Zeitgeist Weiss posits the labor of memory and remembrance. Against the postmodern strategies of forgetting through the quick fix of historical citation or subjectivist immediacy he posits broad (though never totalizing) historical reconstruction and an alternative notion of subjectivity in writing. Against fashionable simulacra theories of apocalypse and nuclear holocaust he focuses on the real pain and suffering of human beings in a deadly struggle for survival. And against the cultural neoconservatives' attempt to resurrect a domesticated modernism as canon for the conservative 1980s he insists upon the radical claims both of modernism and the historical avantgarde, reinscribing them in altered form into the present. Some feel that Weiss has written the classical (if not classicist) German novel of the post-1960s era. Others claim that *Die Ästhetik des Widerstands* is the only truly radical and avantgardist work of literature in a desiccated literary landscape from which the creative imagination has increasingly migrated toward the cinema. I would suggest that it is neither, or, put differently, that perhaps it is both.

II

What, then, is the story of this novel which, more than any other literary work of the 1970s in Germany, resists easy recuperation. The story is deceptively simple and can be told *as if* we were dealing with a conventional historical novel. Weiss develops a "collective fiction"[2] of the tragic history of the working-class movement after World War I and of the antifascist resistance in the late 1930s and during Hitler's war. The novel's trajectory takes us from the illegal work of the socialist resistance in Berlin to the battlefields of the Spanish Civil War, the haunted, persistently threatened life of the German exiles in Paris and Sweden (Peter Weiss's own final space of exile) and back into the belly

of the beast, Berlin, Plötzensee, the meat-hooks, the ropes, the serial executions of trapped resistance fighters after the failed plot on Hitler's life in July 1944.

But then the story can be told in another deceptively simple way, *as if* we were dealing with a conventional novel of development, a *Bildungsroman* even, though with an added political dimension. The first-person narrator, born in the year of the October revolution (one year after Peter Weiss himself), is a literarily ambitious, class-conscious young worker in search of his artistic and political identity. This "I," nameless throughout the narration which starts off in 1937, reports his experiences in the years from 1933 to 1945. Hitler's rise to power abruptly cut short his and his friend Coppi's education while their friend Heilmann continued to attend the Gymnasium. The motor of their friendship is a real need for literature and art as a means to become conscious of the world, "to escape that speechlessness" (I, 54) against which Weiss himself struggled all his life. Thus the first volume begins with a powerful description of the Pergamon altar frieze in Berlin's museum which the three friends experience aesthetically and emotionally, relating it to their social position and political consciousness. Ancient art and modern history are thus woven together in an act of cultural reception which provides the basis for Weiss's notion of an aesthetics of resistance. Kafka's *The Castle* and Dante's *Inferno*, Géricault's *Raft of the Medusa* and Picasso's *Guernica* are other art works actively appropriated at crucial junctions of the narrative web.

From his father, always a Social Democrat, the narrator hears the story of the German working-class movement after 1918, its internecine battles and deadly splits which later facilitated Hitler's rise to power. With the help of the Prague Committee on Spain, the narrator joins the Spanish Civil War where he works as a hospital attendant on the side of the defenders of the Republic. Here he meets the physician and psychoanalyst Max Hodann, who had been one of the leading figures of the sexual reform movement of the Weimar Republic and now becomes the narrator's mentor. While taking care of the wounded, he continues his studies of history and politics, art and literature, in the shadow of the Moscow Trials, Stalin's betrayal of the Spanish left, and the irresistible advance of Franco's armies. When the Republic goes down, the narrator is washed, on the raft of the Medusa, as it were, into Paris and later to Stockholm where he finds asylum and work among other exiles. In Sweden he meets Bertolt Brecht and plunges himself into a literary project. Simultaneously, he works as a messenger for the illegal and persecuted exile organization of German communists and

their newspaper. In the third and last volume, the personal voice of the male narrator fades almost completely into the background and a variety of women's voices emerge, voices into which speechlessness, loss of self, insanity, and death are even more powerfully inscribed than in the primarily male voices of the earlier volumes: the fall into muteness of the narrator's mother after she witnesses the horrors of Nazi domination in Eastern Europe; the despair of Rosalinde Ossietzky, daughter of the Nobel peace prize winner killed in a Nazi concentration camp; the suicide of Karin Boye, the Swedish poet and writer; and, finally, the return of Lotte Bischoff, member of the Rote Kapelle resistance group, in 1944 into the smouldering ruins of Berlin, that ultimate monument to what the novel calls "die Raserei der Männer" (the rage of the men). Coppi, Heilmann, and the other friends are executed. Lotte Bischoff survives. But the final pages of the novel, written in the future subjunctive I which anticipates the post-war era, give little comfort. The aesthetics of resistance has not been able to prevent the death of the resistance, nor would it succeed in preventing the emergence of that other deadly confrontation of the nuclear age; and yet, the novel suggests, such an aesthetics will remain essential to any future attempts to resist forms of domination which Weiss and, in the novel, Hodann see as rooted not just in the contradiction of labor and capital which communism was meant to overcome, but even more fundamentally in the libidinal economy of the modern patriarchy which capitalism and communism have in common.

And then, finally, there is a third way of reading the story, again conditionally, as Peter Weiss's *Wunschautobiographie* (Would-be-auto-biography), a term Weiss himself introduced into the debate and which was turned viciously and sarcastically against him by his critics. Here the narrator would become the fictional embodiment of a life on the left and in the antifascist resistance which Peter Weiss, the self-absorbed artist of bourgeois upbringing who came to socialism only in his late forties, would have desired for himself. Indeed there are those considerable parallels between narrator and author, almost the same year of birth, the same friends, the same encounters, similar experiences. But Weiss is far from simply identifying himself with his proletarian narrator or, for that matter, from simply rewriting the history of the bourgeois subject as that of an imaginary proletarian subject. Such *Tendenzwende* criticism, which jumps on Weiss's politics with intent to denounce, presupposes the literal meaning of *Wunschautobiographie* and thus reintroduces and insists on the categorical boundary between fact and fiction which the novel, like so many other modernist

and postmodernist texts, works to erase. Given this political hostility to
Weiss, one is almost not surprised to hear established literary critics
complain that Weiss's characters are not believable, that the novel is
remiss in its representation of feelings, that reflections smother action,
that, in one word, the novel is too damned difficult. As so often, the
political allergies Weiss has given the West German critical establish-
ment make for lousy aesthetics, but in the critics, not in Weiss.[3] Never-
theless it is precisely this suggested reading of the novel as a *Wunsch-
autobiographie*, as an ambitious attempt to link the problematics of
history and subjectivity without erasing the tensions between docu-
ment, history, and fiction, which may serve to highlight the distance
that separates Weiss from the ways in which modernists such as Kafka,
Musil, and Thomas Mann treated the relationship between auto-
biography and fiction in their writing.[4] Thus the narrator's search for
identity, in its never-reconciled oscillation between extreme subjectiv-
ity and almost total self-effacement, is and is not Peter Weiss's own
search for himself and reflects the author's difficulty of saying "I."

Three stories, then—one documenting the historical events shaping
the work of the German resistance group Rote Kapelle of which Coppi,
Heilmann, and Bischoff were members; the second, in close relation
with the first, constructing the aesthetic and literary struggles of the
fictional narrator; and the third inscribing Peter Weiss's real/fictional
identity as a political artist into the novel. A fourth story, that of Peter
Weiss's actual work on the novel in the 1970s, which is documented in
the accompanying two volumes of the *Notizbücher*, will have to remain
outside my considerations for the moment. So let us enter this maze of
histories and fictions by focusing on a specific, to my mind crucial, layer
of the narration: Weiss's reconstruction of the avantgarde problematic
in the earlier 20th century which, like the narrative account of the work
of the Rote Kapelle, is undertaken in the name of Mnemosyne, the
goddess of memory and mother of the nine muses. The historical
avantgarde serves to raise the issue of cultural resistance in the twofold
sense which the novel suggests: the resistance to fascism constructs its
own aesthetics, vital to its political functioning, *and* aesthetics itself, in
the most general way, is inherently able to mobilize resistance to
domination of whatever kind. As a historical novel, *Die Ästhetik des
Widerstands* incorporates the debates of the 1930s on modernism and
avantgardism with great force and discrimination. As a historical novel
written in the 1970s, it offers much more than only a retrospective,
academic account. In an age of growing cynicism and postmodern
burnout, Weiss has given us a political aesthetic in the form of a novel
which both rescues and sheds the historical avantgarde for the present.

III

Weiss works through the problem of artistic and political avantgardes in four narrative *Engführungen*. In the first volume, the exhaustive and programmatic description of the Pergamon frieze representing the monumental battle between the Olympians and the "Titans, Giants, Cyclopes and Erinnyes" (I, 10) is followed by a long debate on art in the Coppis' kitchen in Berlin; central to that debate is the relationship of the avantgarde to cultural tradition. In volume II, in the Paris of the popular-front struggles of the late 1930s, the German communist Willi Münzenberg tells the narrator of his memories of Zurich 1916, Spiegelgasse, Lenin, and the Cabaret Voltaire; the relationship of Dada and revolutionary politics is at stake. The third *Engführung*, also in volume II, involves the narrator's encounters with Brecht in Sweden which turn out to be crucial for his development as a writer. And the fourth and last one, in volume III, is what Weiss has called the *Hadeswanderung*, the inferno of the avantgarde under the pressure of the events after 1939: the Hitler-Stalin pact, the war, and the holocaust.

What I am describing here as Weiss's reconstruction of the historical avantgarde is not incorporated into the novel in the form of essay-like digressions, as we would find them for instance in a modernist classic such as Hermann Broch's *Sleepwalkers* or, in a different way, in Thomas Mann's *Doctor Faustus*. The avantgarde problematic rather remains intimately bound up with the experiences and learning processes of a small group of young workers and intellectuals (Coppi, Heilmann, and the narrator) who dedicate themselves to cultural studies while working at the same time in the Berlin resistance. "Our studying was always revolt," they say (I, 53). "Every inch we moved closer toward the painting, the book, was a battle, we crawled, pushed each other forward, our eyelids were blinking, sometimes this blinking made us laugh and the laughter made us forget where we were heading" (I, 59). Place and time—Berlin 1937—point to the fact that in the novel the historical avantgarde appears already in retrospective. Goebbels' Munich exhibition of "entartete Kunst" (degenerate art) has already taken place. For four years already, Germany has been systematically cut off from the international avantgarde, and its fate in the Soviet Union had been sealed three years before at the 1934 First All-Union Congress of Soviet Writers which marked the emergence of "socialist realism" as official dogma. The retrospective appropriation of the avantgarde in the novel takes place at a time when the avantgarde had already been suffocated in Berlin and Moscow, at a time furthermore when certain

participants in the famous expressionism debate, especially Brecht, Anna Seghers, and Ernst Bloch, attempted to salvage the impetus of the avantgarde for socialism against Zhdanovism and the aesthetics of the popular front. And just as Seghers, Brecht, Bloch, Lukács, and others articulated different positions in that debate, Peter Weiss also introduces different voices, structuring his attempt to salvage the avantgarde dialogically rather than giving the reader a hard and fast position. The positive voice dominates in these exchanges in Coppi's kitchen, but it is always shadowed by a critical and questioning counter-voice. This kind of dialogic double-tracking, I would suggest, contains Peter Weiss's own "position," which is consciously bent on avoiding forced reconciliations of one or the other kind. This narrative doubling, which is already implicit in the identity and nonidentity of the bourgeois exile writer Peter Weiss and his nameless, proletarian, first-person narrator, is unfolded in the first great avantgarde passage in volume I; Weiss's position is separated out into the voices of Heilmann, "our Rimbaud" (I, 8), and of his friend and comrade Coppi. The narrator listens. Here is a paradigmatic sample taken from the debate in Coppi's kitchen:

> In the years around October, painting and architecture had projected constructive possibilities which coincided with the essence of revolution. Why did we now, asked Heilmann, have to fall back behind what had been achieved, why was this art which was revolutionary denied and denounced, why were these works which gave voice to the experimentation of their epoch, which were revolutionary because the life that surrounded them was changing from the bottom up, why were these daring, soaring metaphors of a new departure replaced by the customary, why was a narrow limit imposed on the capabilities of perception if a Mayakovsky, Blok, Bedny, Yesenin and Bely, a Malevich, Lissitzky, Tatlin, Vachtangov, Tairov, Eisenstein or Vertov had discovered the language which was identical with a new universal consciousness. What the expressionists and cubists stirred up in the decade before October, said Coppi, articulated itself in a framework of forms which required special training to understand. It was a revolt of art, a rebellion against norms. It expressed the commotion of society, the latent violence, the thrust toward change, but the workers and soldiers of November seventeen had never seen nor heard anything of these artistic metaphors. The Dadaists and Futurists in Moscow continued with these mutations on a level with which the combatants were not familiar. [. . .] It did not help them much to hear that the revolution of forms should now be united with the revolutionary transformation of everyday life. The projections of the literary and artistic avantgarde had to remain unintelligible to the Russian workers. (I, 66 f.)

It is hard to escape the plausibility of Coppi's arguments. Art as a semi-autonomous system of articulation has indeed developed a de-

gree of complexity and unfamiliarity in the early 20th century so that those who, due to determinations of class, were not familiar with its trajectory necessarily had to have serious reception problems. And yet, Coppi's skeptical voice does not become dominant. The antagonism between Heilmann and Coppi, as it breaks open in the cited passage, is later taken back into a collective "we" which includes Coppi and which differentiates Heilmann's earlier enthusiasm:

> In the paintings of Max Ernst, Klee, Kandinsky, Schwitters, Dali, Magritte we saw the dismantling of visual prejudice, the lightning flash on fermentation and decay, panic and radical change, we distinguished attacks on an exhausted and perishing world from merely shocking gesturing which ultimately did nothing to challenge the market. (I, 57)

Of course, one might argue that this collective "we" speaks already with the benefit of a retrospective view, twenty and more years after that eruption of revolution in art and in the streets. But understanding or, for that matter, acceptance of the avantgarde's project had not increased by much since 1917. On the contrary, things had become considerably worse. Thus the narrator concludes this debate on the avantgarde by explicitly criticizing the imposition of political discipline and censorship on modern art and literature:

> Not only did our education have to overcome the obstacles of a class society, it also proceeded as a struggle against the principles of a socialist view of culture which sanctioned the masters of the past and excommunicated the pioneers of the twentieth century. We insisted that Joyce and Kafka, Schönberg and Stravinsky, Klee and Picasso belonged in the same ranks with Dante whose Inferno we had recently begun to study. (I, 79)

But the appropriation of modernism and the avantgarde by a small group of intellectually curious workers in volume I is not only a scathing indictment of socialist culture politics of the Second and Third Internationals. In its very mode of operation it provides the counterexample to Coppi's argument that this art has to remain totally alien to a worker's imagination. Weiss does not minimize the problems of reception, but he insists, in truly avantgarde spirit, that the revolution in the forms of representation was interactively related to new modes of perceiving and experiencing a rapidly changing lifeworld which in turn grounded the hopes for social and political revolution. In a limited sense, Weiss holds on to the historical avantgarde's much discussed project to return art back into life, but he gives this project a significant shift away from the emphasis on production (dissolution of the category of the oeuvre, critique of the institution art, etc.) and

focuses instead on reception and on how specific historically and socially positioned subjects relate the art/life problematic *in* the works to their own perceptions and experiences of modern life.

IV

The second *Engführung* of the avantgarde problematic leads us back to the year 1916 in Zurich where the dadaist revolution occurred literally under the eyes of Lenin. Lenin, still in exile, lived, organized, and wrote in a small rented room in that same Spiegelgasse in Zurich's *quartier latin* where Dada emerged out of the activities and provocations of Hugo Ball's Cabaret Voltaire. This *Engführung* of politics and art in Zurich's Spiegelgasse has a precedent in Weiss's work. In his 1970 play *Trotsky in Exile*, Hugo Ball and Tristan Tzara find themselves in irreconcilable opposition to both Lenin and Trotsky. "Foul magic" and "pseudorevolutionaries" is all Lenin has to say about the revolution in art. In the novel, however, this antagonistic constellation is articulated in one voice which is missing in the Trotsky play and which succeeds in holding the two extremes together without wiping out the differences. It is the voice of the German communist Willi Münzenberg who, in the Paris of 1938, tells the narrator about those past events in which he himself had participated: "In the upper part of this humped lane, the planning was taking place, while further down toward the bottom a fantastic unreason was bursting forth. The Spiegelgasse became an emblem of that violent double revolution, the waking and the dreaming one" (II, 59). At the same time, Münzenberg is fully aware that there was no mutual understanding: "The artists of the Spiegelgasse were as little conscious of their real task, that is of expanding the political revolution, as the politicians who did not believe art capable of any revolutionizing effects" (II, 58). The rigid one-sidedness of the hostile positions of 1916 is overcome in Münzenberg's own reflections, which do have close affinities to Weiss's thinking:

> The point was, said Münzenberg, to articulate the hypothesis of a comprehensive social and artistic revolution in order then to prove that the elements which had heretofore always been treated separately really belonged together. We did not yet need to demand that art whose task it was to topple the spiritual realities should also carry a political mission. Art did what its media were best equipped to do. And it was not the point of politics to sweep art along with it. What would be new and not even today fully understood would be the acknowledgment of both forces in their specificity and equivalence; it would imply not playing them out against each other, but finding a common denominator to their parallel unfold-

ing, their simultaneous creations. There was agreement in the intensity of
those revolutionary artistic and political actions, as well as in their interna-
tionalist goals. (II, 62)

Revolutionary and artistic avantgardes are understood by Münzen-
berg in their mutual proximity. Whereas Lenin looked into the mirror
of revolutionary art and could see nothing but disfiguration and de-
struction, the dadaists, in their gaze into the mirror of political revolu-
tion, only saw a continuation of power politics with other means. The
mirrorings of the Spiegelgasse remained mutually exclusive. Münzen-
berg, however, saw the other in each of the two mirrors, that other
which is irrevocably part of either revolution's identity and yet has to be
understood in its otherness. But Münzenberg's vision was rendered
obsolete by historical events such as the course of socialism in the Soviet
Union rather than by any inherent incompatibility between radical art
and radical politics. In the novel, as in reality, Münzenberg was killed
by Stalin's henchmen. The fact that Weiss shares Münzenberg's convic-
tions becomes clear in the *Notizbücher*, where he states: "Time and
again the experimental form in art, akin as it is to revolutionary energy,
had to yield to conservatism, time and again the practitioners of social-
ist revolution fell back onto their atavistic habits"[5]

V

But atavism is not only a problem of the practitioners of the revolution.
It is also inherent in the avantgarde itself, both as a problem of real-life
behavior and as a problem of artistic strategy and execution. Weiss's
insistence on the inseparability of art, life, and politics blocks the easy
escape route of suggesting that, yes, vanguard revolutionary politics is
atavistic, but experimental revolutionary art can somehow remain free
from it. In the novel, it is Bertolt Brecht who becomes the paradigmatic
case of the atavism of the left avantgarde artist, the same Brecht who
has for so long served as model and inspiration for playwrights, film
makers, and critics dedicated to the project of a political art that would
preserve the achievements of the historical avantgarde.

The encounter of the young narrator with Brecht in Swedish exile,
then, is the third *Engführung* of the avantgarde problematic in the
novel. It is different from the earlier two in a number of significant
ways. The debate in Coppi's kitchen is *about* the avantgarde, about the
politics of its aesthetic experimentation as mirrored in the reading and
studying of three young socialists. The discussion between Münzen-
berg and the narrator in Paris then introduces a level of real-life

memories by someone who actually participated, even if only in a marginal way, in the events of the year 1916; but Münzenberg is a political intellectual, not an artist, who tries to push beyond the "misunderstandings" between political vanguard and artistic avantgarde. Thus even here, the reader is confronted with a discourse *about* the promises and failures of the avantgarde. It is only in the second part of volume II that the avantgarde is actually embodied in one of its major representatives, Bertolt Brecht. Inside the novel, we no longer have a discourse about the avantgarde, but we see it operating, in process, in action. And, significantly, the narrator, in his encounter with Brecht, abandons his receptive and reflective stance and takes his first major steps in becoming a writer—the writer, ultimately, of *Die Ästhetik des Widerstands* itself. However, Weiss certainly does not idealize left avantgardism, as it has been so often idealized (and understandably so) since the 1960s; but he also avoids the simplistic kinds of polemics against Brecht and political art which have grown in volume and viciousness after the various political and cultural rollbacks in Western countries in the 1970s.

How, then does Brecht enter the novel? The facts can easily be summarized. Brecht was in Stockholm from August 1939 until April 1940 when he fled on to Finland. During those months of Franco's victory in Spain, the disintegration of the French popular front, the Hitler-Stalin pact, the beginning of the Second World War, and the Polish partition, the German occupation of Denmark and Norway, the absolute nadir of the antifascist resistance, Peter Weiss himself actually met Brecht in Stockholm, and he had this to say in an interview about the encounter: "I was only marginally involved with Brecht at that time. I didn't really like him because he was not interested in me. I also had feelings of inferiority. I didn't have anything to show him, no finished works. I was an inexperienced beginner, and he was the master. In our short encounters this role of master became evident immediately. He was surrounded by people who looked up to him, who helped him and who were constantly ready to clear his path of all sorts of things. At that time in Sweden he was only looking for people who could help him along."[6]

Weiss's brief experience with Brecht, expanded by a thorough study of all the available materials documenting Brecht's exile, becomes the basis for the narrator's representation of Brecht as a kind of *Urvater* of a primeval horde, an exploitative monster in his personal relations with family, women, collaborators, an embodiment of a "massively atavistic cult of masculinity."[7] He presses those around him into bondage, thrives on his domination of the numerous women (Weigel, Berlau,

Steffin) whom he keeps busy in the service of his work and sexuality, and ignores even the simplest standards of human courtesy and decency. His looks are pale, teary-eyed, and repelling; his voice sounds sharp and croaking. As he seldom takes a bath, he spreads a stench. He wears thick woolen socks and long underwear, and he satisfies his sexual needs without taking his clothes off. In a word, he appears as an authoritarian and petit-bourgeois tyrant.[8]

But Brecht's personal behavior extends into his work habits, too. He uses those around him as tools for his work, turns people into machines in his literary factory; his idiosyncrasies are justified as objective conditions of production: "In his factory which was running at full steam he was hurrying back and forth, supervising all the departments, giving brief instructions here and there, following the trajectory of the various products, checking the results and keeping them at hand for further use" (II, 213). Weiss describes Brecht as a literary Leninist whose denial of subjectivity goes hand in hand with a total self-centeredness of will power and the obsession of keeping his literary factory going.

No doubt, through his example of trying to maintain historical perspectives on the politics of the present, Brecht provides an antidote to the political depression and disorientation which at the time threatened to tear the antifascist resistance apart. Thus some critics have defended the Brecht of the novel by arguing that he becomes "a source of stability in an unstable world."[9] This is certainly true for the narrator. Even though Brecht's relationship to him is totally devoid of any subjective investment, even bare of the slightest personal interest, the older writer becomes a political and aesthetic anchor to the narrator, who works closely with Brecht providing him with materials and information from Swedish sources for the projected, but never finished, play on Engelbrekt, the popular leader of a 15th-century Swedish peasant revolt. The collision of politics and literature the narrator observes in Brecht galvanizes him and, at least for the time being, captures him totally even though he is painfully aware of his role as merely "a messenger, a medium, a servant" (II, 204) of the master:

> I was not yet familiar with the mechanism of production which was taking place here. It was of no importance that Brecht withdrew behind a protective cover of coldness, all that counted were his works which, down to the smallest poem, spoke of the participation in events which touched my own existence. This calling together of experts, the lying in wait as if inside a megaphone, the sudden move forward of his body to take in information, the process of recasting impulses, all of this seemed to be part of his method of working. The collective knowledge he sucked in

gave everything he wrote a generally valid political meaning. [. . .] It was
as if I could hear the hammering which forged a chain of consistencies out
of contraries. But how was it possible, I asked myself, to transfer this
political ability into literature to such a degree that the literary work was
totally part of the present while simultaneously achieving total autonomy.
(II, 168 f.)

The sense of admiration a passage like this conveys is unmistakable.
But neither Weiss nor the narrator is ultimately satisfied by this schiz-
oid split between Brecht's personality and his work. The atavism of the
personality, as it enters the process of literary creation, takes its toll: "I
found myself in a factory workshop or, as the constant exertion to get
to know the tools and machines almost made me faint, in a torture
chamber" (II, 169). In short, the narrator experiences production as
mutilation, as torture. Yes, the narrator learns invaluable lessons in
avantgarde writing from Brecht, but in one crucial respect, Brecht's
method has to fail him. While he makes the narrator conscious of the
collision between politics and literature, he also calls forth the narra-
tor's need to "leave my anonymity" (II, 168), to trace and to construct
his own identity, however fractured and torn it might turn out to be.
Brecht's programmatic denial of subjectivity, his refusal to deal with
the irrational and the unconscious, however, make precisely this task
impossible. That Brecht's iron discipline and rational self-control are
themselves based on a fundamental repression is acknowledged by
Weiss in a moving passage where Brecht, faced with the swastikas on
German ships in Stockholm's harbor, collapses physically and has to be
carried aboard the ship that is to take him, his books and manuscripts
to the next station of his exile. Any look at Weiss's own trajectory as a
writer from the early experimental text *Im Schatten des Körpers des
Kutschers* via *Marat/Sade* to this last monumental novel will convince us
that he sees the shortcomings of Brecht's literary Leninism quite
clearly. In the *Notizbücher* we read: "The schooling we received from
him was to set aside our own person, to view ourselves as members of a
collective, and this corresponded to a strict Leninist principle, as it
affected the notion of cultural revolution. That is, we were asked to
consciously enter a process in which creative work was a movement
shared by all and experienced by all."[10]
But the questionable nature of this avantgardist/modernist oblitera-
tion of one's own person in the process of writing is made explicit in the
novel itself, not just in Brecht's own breakdown or in those comments
by the narrator which lend themselves to be read as an implicit critique
of Brecht's position. Literary Leninism, which I take to be paradig-
matic of certain—and not just leftist—trends of the avantgarde and of

modernism, is challenged in the most fundamental way in volume III, and it is ultimately overcome by the writing of *Die Ästhetik des Widerstands* itself. The third *Engführung*, however, would suggest that, on one level, Weiss's postmodernism emerges out of a critical appropriation of the Brechtian aesthetic, a project which has also occupied several other contemporary German writers, notably Heiner Müller, Alexander Kluge, and, in a very different mode, Christa Wolf.

VI

This brings me to the fourth and last *Engführung* of the avantgarde problematic in volume III. Here Weiss achieves a kind of high-voltage writing which, in its poetic density and coldly passionate, surreal imagery, has no match in contemporary German literature. The text begins with the fall into silence of the narrator's mother who has witnessed unimaginable horrors on her flight through Poland during the fascist assault. Once in safety in Swedish exile, she is not able to forget. Her gaze is irrevocably turned inward. She drifts through the images of what she has seen and what remains forever uncommunicable, beyond language and representation. Some of the mother's experiences in Poland are rendered in the father's accounts of their flight, but he never reaches down to the experiential depth level which blocks her speech, and there are significant gaps in his story. The mother's speechlessness assumes mythic proportions, and in her son's mind the image of her face is soon overlaid by that of the earth mother Ge whose death, together with that of her favorite son, the narrator remembers from the Pergamon frieze: "Returning to Stockholm on the train and looking out of the window, I saw this face, big, grey, worn out by the images which had assaulted it, a stony mask, with blinded eyes on the fractured surface" (III, 20).

It is his mother's descent into insanity, or, as another character suggests, into a state of paralyzing illumination, which fundamentally shakes the narrator's confidence in the Brechtian project. He realizes that his mother's imagination lies beyond the means of a Brechtian aesthetic, perhaps beyond representation altogether, and he is forced to develop a new kind of receptivity of the nonverbal senses in order to nurture her in her pain, the pain of a Cassandra who has lost her ability to speak. In order to render the mother's experience and state of mind at all in his novel, the narrator has to resort to other means of representation. And he chooses precisely those of the surrealist tradition shunned by Brecht. As Klaus Scherpe has pointed out, however, Weiss's multiple use of a surrealist mode of writing in this novel is not

intended to give the lie to the rational political discourse of other figures.[11] It rather attempts somehow to take cognizance of the atavism always already inscribed into rationality, to articulate the threat and terror of atavism artistically, thus keeping it at bay and maintaining a sense of self at the edge of the abyss: the terror zones of fascism and Stalinism.

The narrator, and with him Weiss, barely manages to maintain that position. The Swedish poet Karin Boye, who enters the novel as a kind of mentor to the narrator during the time of his mother's illness, did not escape the vertigo of the abyss. Clearly, Weiss parallels Boye's death by suicide with the slow withering away of the mother. But Boye is a writer; she gives voice to her experiences in her wide-ranging discussions with the narrator. A political activist in Sweden in her student days, she became disillusioned with socialism during a trip to the Soviet Union. She withdraws into her private life and her writing, but it is precisely a literary experience which pushes her out of hiding. While translating Thomas Mann's *Magic Mountain* into Swedish, she is at first captured by the "memorable love story," but then increasingly filled with disgust about the arrogance of the male perspective of this major modernist novel which "suddenly turns from tenderness and desire to a denigration and humiliation of the woman" (III, 32 f.). Boye ends her marriage and sets out to liberate herself from male oppression. In 1932 she goes to Berlin to undergo psychoanalysis, but is briefly sucked into the mass hysteria of a fascist rally in Berlin's *Sportpalast*. Analysis does not really help her, except to free her latent lesbian desire to love and live with another woman. But there, too, she does not find happiness. The Berlin experience of what Boye describes as the "orgiastic world of men" (III, 33) then leads to her last major work, a dystopian novel entitled *Kallocain*.

We read that Boye's *Kallocain* was published in Sweden a few months after the murder of Trotsky and only a few days after the news of Münzenberg's death. Significantly, Weiss thus relates the narrator's reading of *Kallocain* directly not just to Boye's experience of fascism, but also to Stalin's murder of two men who, within the trajectory of the Third International, had always eloquently defended the experiments of the avantgarde. Now the project of the avantgarde appears as total failure. But as the narrator reflects upon Münzenberg's death in a remote forest in France, it becomes clear that this failure is largely determined by the onslaught of historical events:

> Thinking about this execution in the forest [. . .] I tried to imagine the second in which the wire tightened around Münzenberg's neck, the second under the branch from which he was hanged, the second in which

the memory blisters burst in his brain and this dense, unique world exploded into a grey substance, tearing apart the engrams of the Spiegelgasse and killing Lenin, with him, one more time. . . . (III, 23)

The story of Karin Boye is crucial for the novel as a whole. It is here that Weiss pursues his critique of avantgardism from a feminist perspective. In the narrative economy of the novel, the lesbian poet Karin Boye is clearly devised as a literary counterpart to Bertolt Brecht: the relatively unknown woman writer versus the male master-avantgardist. It is through Boye that the narrator becomes familiar with an entirely different set of assumptions about writing and living. She helps him understand the suffering of his mother and the meaning (one hesitates to use the word) of her silence for his aesthetic. As his mother approaches death he reflects about the endangered future of his own writing:

Up until now there was no contradiction between life and art. In art, reality had found its highest expression. But as my mother's life was now moving away from me, art too began to be more distant. The more inescapable the separation from my mother became, the more questionable and strange my artistic means appeared to me. How could I continue to find closeness and certainty in art if my mother, who had been closest to me, did not let herself be known any longer. Nothing was left of reason, the intellectual energies that enter into the creative process; only impulses of a bodily kind could be sensed as they might well lie at the origin of art. (III, 130 f.)

But the danger to his conscious desire to write does not lie only in the disturbing experience of his mother's withdrawal into silence, which pushes him toward the edge of what is representable and what is not. The danger to his writing, like his mother's illness, is historically determined. Karin Boye's artistic project stands paradigmatically for the inherently questionable nature of revolutionary (e.g., Brechtian *and* surrealist) avantgardism after the Moscow Trials, the fascist aesthetization of politics and the Hitler-Stalin pact. Boye's novel *Kallocain*, a political ice-age dystopia, is described by Weiss as a visionary anticipation of a world divided into two gigantic blocs, the World State and the Universal State, in which even the memory of freedom and culture has been extinguished. Boye's suicide shortly after the completion of her novel seems to seal her dystopian vision of a present which has liquidated both aesthetics and resistance:

Things had come this far with her, with this childlike woman, that the inner language of poetry could no longer be reconciled with the outer forms of life, that the demand for absolute freedom in art had to founder on its unattainability dictated by life. The Party as an ideological and

political organization, imagined as a tool for the perfection of man, had become the State itself, a prototype of invariability, definitiveness and ossification, a principle opposed to art which had to rage ever more murderously the more firmly it entrenched itself until, from a certain perspective, nothing was left, and the impulse which still tried to produce poetry consumed itself inwardly. (III, 4)

Boye's death, this suicide brought on by despair about "the rage of the men" (III, 248), and the affinity of this death to the image-saturated speechlessness of the mother pushes the narrator toward the limits of his own perceptions and receptivity, the limits which Boye and the mother had crossed forever. He tries to come to terms with Boye's life and death in a discussion with Max Hodann, his (and Peter Weiss's) long-time friend:

It may be the case that while one person was obsessed with the notion of an unbridgeable chasm between art and political life, another would insist that art and politics are inseparable. Perhaps these were only different opinions of one and the same thing, and the one who suggested that she had foundered not on the pressures exerted on art by external conditions, but rather on the impaired ability to affect a seemingly unshakable reality through art and independent thinking, that person had only put on a life-preserver in order to keep drifting at the surface whereas art could not desist from diving as deeply as possible. But what was her search for truth like, Hodann asked. As she constantly tested the contradiction, had she not lost sight of the synthesis, finding only a paradox, a tragic paradox which ended up breaking her. Shaken by a coughing attack Hodann fled into a doorway, spit into his handkerchief and said, his lungs rattling, that the uncanny—and here he connected Boye's fate with that of my mother—was not in those visions of terror, [. . .] but rather in that which is fixed once and for all, this gigantic, inaccessible order which hardly exudes anything disquieting, which is only there, continues to exist in self-evidence determining everything that ultimately and in however remote ways strangles and annihilates us. (III, 46 f.)

In Hodann's reflections the Marxian view of history as a history of class struggles seems to merge with a notion of human history as a "history of butchery" (III, 47). Modernity's dream of progress and universality, to which in however subtle ways the historical avantgarde was indebted, reveals itself as a nightmare. Dürer's *Melancholia* becomes an emblem for Boye's and the mother's paralysis of speech and vision and for their self-abandonment to the unnameable, a threat which in Weiss's view always haunts the creation of art. The cultural optimism of modernity and revolutionary avantgardism gives way to a deeply darkened vision of the dialectic of enlightenment.

The dilemma Weiss articulates in his novel is visually perhaps best expressed in Francisco Goya's famous etching *El sueño de la razon*

produce monstruos. The etching shows a sleeping male figure sitting on a chair and burying his head in his arms on a table on which we see writing tools and paper. Swarms of owls and bats emerge threateningly from a darkened background and settle on the sleeper's body. *Sueño de la razon,* however, does not only mean the sleep of reason, but also the dream of reason, an ambiguity which allows both for an enlightened and for an anti-enlightenment reading of Goya's etching. The enlightenment always claimed to overcome the sleep of reason, which, as myth and superstition, populates its world with monsters holding the human subject in bondage. The dream of reason, however, that revolutionary dream of an emancipated mankind, produces its own cycle of violence and terror. Münzenberg's distinction between the waking political and the dreamt artistic revolution which should complement each other, it seems, becomes untenable in face of the nightmares of modern revolutionary history. For if the waking revolution itself is nothing but a nightmare of reason to which the dream of artistic revolution is inseparably tied, then the aporia is complete. There seems to be no way out, and the fate of the avantgarde seems sealed. Its techniques and aesthetic strategies may live on, but its utopian, often messianic hopes for another life would seem to be irredeemable.

VII

And yet, Peter Weiss's desire is of course to wake from that nightmare of vanguardism, to banish and overcome the terror and the monsters. Positioned dangerously close to the edge of the abyss he describes, he guards himself against the fall into silence as well as against the lure of self-destruction. But his postmodern acknowledgment of the nightmare of revolutionary history and of the avantgarde's implication in this history does not end in a fashionable *posthistoire,* nor is he ever in danger of simply lapsing into cynicism. And this is where his aesthetics of resistance achieves its persuasiveness as a work of art. Weiss abandons the revolutionary avantgarde's heroic delusion of moving art back into life, and he jettisons its totalizing claims for the "new man" and the "new art" as inherently dangerous.

Paradoxically, it is the history of fascism and Stalinism, the two fiercest enemies of aesthetic experimentation, which revealed to him the highly questionable depth structure of the avantgarde itself. And it is precisely Weiss's insistence on the deeply political nature of all art which enables him to voice a critique of avantgardism that reaches deeper than, say, Peter Bürger's theory of the avantgarde as an ultimately futile attack on the bourgeois institution art, not to speak of the

contemporary neoconservatives' vitriolic denunciations of the avant-garde in the name of high modernism. At the same time, this critique is intimately bound up with Weiss's dissatisfactions with his own Marx-ism, dissatisfactions which were in turn determined, as the novel shows, by the culture of the 1970s: the ecological and political critiques of modernization, the feminist critique of patriarchy and the concern with a concept of subjectivity freed from the dead weight of the idealist tradition as well as from the modernist denial of the subject.

In his critique, Weiss never obliterates the tension between the noble and utopian aspirations of the historical avantgarde and their inevi-table political miscarriage. But he resists the ideologically motivated view of the post–World War II period which celebrated the experi-mentations of the avantgarde because it had been victimized by the totalitarianism of the right and the left, thus making it into a tool of the hard-core liberalism of the Cold War period. Weiss's act of remem-brance in *Die Ästhetik des Widerstands* salvages the memory of the avant-garde precisely by submitting it to an unflinching political critique which insists on the political moment of the avantgarde's aesthetic itself. But it is not an annihilating critique. It is rather a critique that retracts the aesthetics of subversion and revolution characteristic of the high modern era between the wars replacing it with a more modest and yet broader aesthetics of resistance. It is more modest in that it rejects the absolutist revolutionary claims of avantgardism and relies instead on art as a medium which can help construct experience and subjectiv-ity, thus counteracting the homogenizing forces of capitalist culture. And it is broader because it does not privilege only the most advanced means of artistic articulation; in an almost Benjaminian mode, it rather tries to harness the expressive powers of the art of past ages to the articulation of a space of resistance in the present. It is, after all, no coincidence that the majority of art works discussed by Heilmann, Coppi, and the narrator in the novel are pre-avantgarde works. But the choice of the works discussed—the Pergamon frieze, Géricault's *Raft of the Medusa*, Dante's *Divine Comedy*, Brueghel's visions of hell—has very much to do with the problematic which is central to avantgarde art and to the experience of modernity, namely, the dialectic of enlighten-ment. Nevertheless, one might ask whether Weiss's turn to the art of past ages isn't just another (leftist) version of postmodern historical pastiche, or, equally questionable, an embodiment of the socialist East European *Erbetheorie*. I think it is neither. Weiss's privileging of pre-modern art works in his novel is as far removed from the quick fix of historical citation so typical of an anti-avantgardist affirmative post-modernism as it is from a universalizing humanist canonization of

tradition, whether in its Western or in its socialist guise. Weiss is never in danger of succumbing to either one of these two positions simply because in the novel the appropriation of the cultural past remains dialogically related to the historical contingencies and needs of the present; it is rooted in the life-world of the antifascist resistance, and thus prone neither to universal truth claims nor to parodistic postmodern posturing.

It is in and through art, Weiss suggests with *Die Ästhetik des Widerstands*, that the inherent terror of reason can be contained, that the threat of barbarism and atavism can be staved off. The historical avantgarde, under the extreme pressure of political events of the times and in its perhaps inescapable links with the master narratives of liberation, sometimes came dangerously close to that terror of reason, but it also provided the artistic means to render the experience of terror itself. And perhaps the one could not have been had without the other. We may speak of Weiss's attempt to rescue the avantgarde to the extent that he makes ample use of avantgardist writing strategies while simultaneously subjecting the different sides of avantgardism to a retrospective critique. He achieves this by keeping both the Brechtian and the surrealist tendency in constant dialogue in the novel without ever reconciling them. But the novel as a whole is anything but an avantgardist work in the traditional sense. The monumental, solemn, and highly rhythmic ductus of its language, the extended curves of seemingly interminable syntactic blocks, the presentation of history as an inexorable machinery of death, and the strange oscillation of the narrator's identity between fragmented subjectivity and anonymity make the novel look rather like an attempt to recreate the epic out of the failure of the avantgarde. Weiss's long-standing fascination with Dante's *Divine Comedy*, especially with the "Purgatorio" and the "Inferno," is, after all, not merely a subjective whim.

As appropriate for the struggle to achieve epic breadth in an age which has proclaimed not only the death of the epic, but also the death of the novel, Weiss always insists on maintaining a level of rational control over the artistic material and the creative process. Ultimately his aesthetics is an aesthetics of expanded consciousness which attempts to harness the powers of the unconscious and atavistic through representation and writing. But ultimately the goal of resisting the threat of atavism is a political goal for Weiss. How that goal can be achieved is not stated in the novel, or rather it is represented in mythic images only at the very beginning and at the end of the trilogy: in the description of the Pergamon frieze. There is the absence in the frieze that marks the hope for liberation, the absence of Heracles who

is visually there on the frieze only with the remnants of his lion hide's powerful claw. The subject of history as an empty space still to be filled—this is what Weiss suggests on the final page of the novel:

> I would go before the frieze on which the sons and daughters of earth rose against the powers which time and again wanted to deprive them of what they had struggled to achieve, I would see Coppi's parents and my parents in the rubble, it would whistle and roar from the factories, dockyards and mines, bank vaults would bang shut, jail gates would screech, a permanent din of iron-clad boots would be about them, the burst of machine-gun fire, rocks would tear through the air, fire and blood would shoot up, bearded faces, wrinkled faces, with little lamps above the forehead, black faces with shining teeth, yellow faces under helmets made of woven bast, young faces, almost childlike, would press forward and disappear again in the smoke, and, blinded by the long battle, those who revolted against oppression would assault each other, would strangle and crush each other, just like those above, weighted down by their heavy armor, would roll over each other mangling and tearing to pieces everything in their way, and Heilmann would quote Rimbaud and Coppi would cite the Manifesto, and a space in the scuffle would remain free, the lion's claw would hang there, waiting to be seized, and as long as down below they would not stop fighting each other, they would not see the claw of the lion's hide, and nobody known to them would come to fill the empty space, they would have to empower themselves for this single grasp, this striking and swinging motion which would finally sweep away the terrible pressure that was weighing them down. (III, 267f.)

As in Heiner Müller's postmodern rewriting of Benjamin's angel of history, the vision of waking from the nightmare of history is described in entirely mythic terms. The way in which Weiss frames this vision clearly distinguishes him from the modernists within Western Marxism, from Brecht as much as from Adorno. But to the extent that he does insist on such a vision at all rather than celebrate the immateriality of the world or the apocalypse of meaning, he also differs from many postmodernists and opens up a unique space within contemporary culture. Weiss adamantly resists the lure of apocalyptic closure which characterizes the sensibility of *posthistoire*, but perhaps his attempt, in *Die Ästhetik des Widerstands*, to think the present through the past and to maintain, however tentatively, a space for a future free from terrors and nightmares, is only another way to say what other postmoderns are saying differently. But those differences do make all the difference.

PART THREE

Toward the Postmodern

8

The Cultural Politics of Pop

In the mid 1960s, when the student movement broadened its criticism of the university system to include attacks on West German society, politics and institutions in general, a wave of pop enthusiasm swept the Federal Republic. The notion of pop that attracted people almost magically not only referred to the new art by Warhol, Lichtenstein, Wesselmann and others; it also stood for beat and rock music, poster art, the flower child cult and the drug scene—indeed for any manifestation of "subculture" and "underground." In short, pop became the synonym for the new life style of the younger generation, a life style which rebelled against authority and sought liberation from the norms of existing society. As an "emancipation euphoria" spread, mainly among high school and university students, pop in its broadest sense became amalgamated with the public and political activities of the anti-authoritarian New Left.

Consequently, the conservative press once more decried the general decay of Western culture, not deeming it necessary to investigate whether the protest—political or apolitical—was in any way legitimate. The traditionally conservative cultural critics reacted accordingly. Since they preferred to meditate in seclusion about Kafka and Kandinsky, experimental literature and abstract expressionism, they denounced Pop art as non-art, supermarket-art, Kitsch-art, and as a coca-colonization of Western Europe.[1] But various branches of industry and business (producing and marketing records, posters, films, textiles) understood immediately that the youth movement created needs that could be exploited economically. New markets opened up for cheap silk screens and small sized graphic works. Mini-galleries

This essay was first published in *New German Critique*, 4 (Winter 1975), 77–98.

were inaugurated as frequently as mini-boutiques.[2] The art experts, of course, continued to feud about whether Pop should or should not be accepted as a legitimate form of art.

Meanwhile, a predominantly young art audience had begun to interpret American Pop art as protest and criticism rather than affirmation of an affluent society.[3] It would be worthwhile to examine why this view of Pop as critical art was much more widespread in Germany than in the United States. The strong German tradition of culture criticism (*Kulturkritik*) certainly has something to do with the difference in reception; another factor, however, was that in Germany the Pop reception coincided with the student movement, while in the United States Pop preceded university unrest. When Pop artists exhibited commodities or declared that serial productions of Coca-Cola bottles, filmstars or comic strips were art works, many Germans did not see these works as affirmative reproductions of mass produced reality; they preferred to think that this art was intended to denounce the lack of values and criteria in art criticism and that it sought to close the gap between high or serious, and low or light, art. The works themselves only partially suggested such an interpretation, but it was strengthened by the needs and interests of individual recipients, determined as they were by age, class origin, and contradictions of consciousness. The interpretation of Pop as critical art was certainly fostered in Europe by the fact that European artists of the 1960s, whose works were often exhibited together with American Pop works, were indeed trying to develop an art of social criticism. The crucial factor, however, was the atmosphere created by anti-authoritarian protest and its adherence to Marcuse's cultural theories, an atmosphere that cast an aura of social criticism over many cultural phenomena which appear quite different from today's perspective.

When I saw the Pop *Documenta* in Kassel in 1968 and the famous Ludwig collection on exhibit in Cologne's Wallraf-Richartz-Museum, I found sensual appeal and excitement not only in the works by Rauschenberg and Johns, but especially in those by Warhol, Lichtenstein, Wesselmann, and Indiana. I, like many others, believed that Pop art could be the beginning of a far reaching democratization of art and art appreciation. This reaction was as spontaneous as it was false. Right or wrong notwithstanding, the very real feeling of liberation which many art spectators experienced at that time was more important: Pop seemed to liberate art from the monumental boredom of Informel and Abstract Expressionism; it seemed to break through the confines of the ivory tower in which art had been going around in circles in the 1950s. It seemed to ridicule the deadly serious art criticism which never

acknowledged fantasy, play, and spontaneity. Pop's almost indiscrimi-
nate use of bright colors was overwhelming. I was won over by its
obvious enjoyment of play, its focus on our daily environment, and at
the same time by what I took to be its implied critique of this same
environment. Art audiences were expanding considerably. In the
1950s, most art exhibits had been exclusive events for a small circle of
experts and buyers. In the 1960s, hundreds, even thousands of people
came to the opening of a single exhibition. No longer did exhibitions
take place only in small galleries; modern art invaded the big art
institutes and the museums. Of course, it was still a bourgeois audience,
including many young people, many students. But one was tempted to
believe that the expansion of interest in art would be unlimited. As for
the derogatory and condemning judgments by conservative critics,
they only seemed to prove that the new art was indeed radical and
progressive. The belief in consciousness raising by means of aesthetic
experience was quite common in those days.

Still something else recommended this art to the younger genera-
tion. The "realism" of Pop, its closeness to objects, images and repro-
ductions of everyday life, stimulated a new debate about the rela-
tionship between art and life, image and reality, a debate that filled the
culture pages of the national newspapers and weeklies. Pop seemed to
liberate high art from the isolation in which it had been kept in
bourgeois society. Art's distance "from the rest of the world and the
rest of experience"[4] was to be eliminated. A new avenue seemed to lead
almost by necessity to the bridging of the traditional gap between high
and low art. From the very beginning, Pop proclaimed that it would
eliminate the historical separation between the aesthetic and the non-
aesthetic, thereby joining and reconciling art and reality. The secular-
ization of art seemed to have reached a new stage at which the work of
art rid itself of the remnants of its origins in magic and rite. In
bourgeois ideology, the work of art—in spite of its almost complete
detachment from ritual—still functioned as a kind of substitute for
religion; with Pop, however, art became profane, concrete and suitable
for mass reception. Pop art seemed to have the potential to become a
genuinely "popular" art and to resolve the crisis of bourgeois art, which
had been evident since the beginning of this century.

The Crisis of Bourgeois Art: Adorno and Marcuse

Those who had confidence in the critical nature and emancipatory
effect of Pop art were well aware of this crisis of bourgeois art. In
Thomas Mann's *Doctor Faustus* it results in the pact between the com-

poser Adrian Leverkühn and the devil, whose help became a pre-
requisite for all of Leverkühn's compositions. In the novel the devil
speaks as an art critic: "But the sickness is general, and the straightfor-
ward ones shew the symptoms just as well as the producers of back-
formations. Does not production threaten to come to an end? And
whatever of serious stuff gets on to paper betrays effort and distaste.
[. . .] Composing itself has got too hard, devilishly hard. Where work
does not go any longer with sincerity how is one to work? But so it
stands, my friend, the masterpiece, the self-sufficient form, belongs to
traditional art, emancipated art rejects it."[5] Why, one asks, has compos-
ing become so difficult? Why is the masterwork a thing of the past?
Changes in society? The devil answers: "True, but unimportant. The
prohibitive difficulties of the work lie deep in the work itself. The
historical movement of the musical material has turned against the
self-contained work."[6] The emancipated art on which Thomas Mann's
devil elaborates is still a highly complex art which can neither break out
of its isolation nor resolve the radical opposition of aesthetic illusion
(*Schein*) and reality. It is well known that Thomas Mann took ideas
from Adorno's philosophy of music and integrated them into the
novel. The devil speaks Adorno's mind. Adorno himself always in-
sisted on the separation of art and reality. For him, serious art could
only negate the negativity of reality. It is only through negation, he
believed, that the work maintains its independence, its autonomy, its
claim to truth. Adorno found such negation in the intricate writings of
Kafka and Beckett, in the prohibitively difficult music of Schönberg
and Berg. After reading Thomas Mann's novel one might come to the
conclusion that the crisis of art takes place in a realm hermetically
sealed off from the outer world and from the production relations of
art that any modern artist must deal with. But Adorno's arguments
have to be understood within the framework of his analysis of culture
industry, which is contained in his *Dialektik der Aufklärung* (1947),
co-authored with Max Horkheimer.[7] To Adorno, it seemed necessary
and unavoidable that serious art negate reality; this view was a result of
his American experiences, which convinced him that in the modern,
rationally organized capitalist state even culture loses its independence
and is deprived of its critical substance. The manipulative praxis of this
culture industry—Adorno thought mainly of record, film, and radio
production—subordinates all spiritual and intellectual creation to the
profit motive. Adorno again summed up his conclusions—equally pes-
simistic for high and low art—in a 1963 radio lecture: "Culture indus-
try is the purposeful integration of its consumers from above. It also
forces a reconciliation of high and low art, which have been separated

for thousands of years, a reconciliation which damages both. High art is deprived of its seriousness because its effect is programmed; low art is put in chains and deprived of the unruly resistance inherent in it when social control was not yet total."[8] It follows that art in a traditional sense has become unconceivable today.

Certainly the Pop enthusiasts of the 1960s found less support in Adorno's thesis of total manipulation than in Marcuse's demand for a sublation (*Aufhebung*) of culture which they believed Pop art was about to initiate. In his essay "The Affirmative Character of Culture," which was first printed in 1937 in the *Zeitschrift für Sozialforschung* and republished by Suhrkamp in 1965, Marcuse reproached classical bourgeois art for secluding itself from the realities of social labor and economic competition and for creating a world of beautiful illusion, the supposedly autonomous realm of the aesthetic which fulfills longings for a happy life and satisfies human needs only in an unreal and illusory way: "There is a good reason for the exemplification of the cultural ideal in art, for only in art has bourgeois society tolerated its own ideals and taken them seriously as a general demand. What counts as utopia, phantasy and rebellion in the world of fact is allowed in art. There affirmative culture has displayed the forgotten truths over which 'realism' triumphs in daily life. The medium of beauty decontaminates truth and sets it apart from the present. What occurs in art occurs with no obligation."[9] Marcuse believed that the utopia of a better life expressed in bourgeois art need only be taken at its word. Then, by necessity, the autonomy of art would be eliminated and art would be integrated into the material life process. This elimination of affirmative culture would go together with a revolution of the patterns of bourgeois life: "Beauty will find a new embodiment when it no longer is represented as real illusion but, instead, expresses reality and joy in reality."[10] Habermas has pointed out that in 1937, in view of fascist mass art, Marcuse could have had no delusions about the possibility of a false sublation of culture.[11] But thirty years later, the student revolt in the United States, France, and Germany seemed to be initiating precisely the transformation of culture and the radical change of life patterns which Marcuse had once hoped for.[12]

Since Pop art had a strong impact in the Federal Republic only in the second half of the 1960s, its reception coincided with the high point of the anti-authoritarian revolt and with attempts to create a new culture. This would explain why Pop art was accepted in the Federal Republic (but not in the United States) as an ally in the struggle against traditional bourgeois culture, and why many people believed that Pop art fulfilled Marcuse's demand that art not be illusion but express reality

and the joy in reality. There is an unresolved contradiction inherent in this interpretation of Pop art: how was it possible that an art expressing sensual joy in our daily environment could at the same time be critical of this environment? One might also ask to what extent Marcuse was misunderstood on these matters. It remains highly doubtful whether Marcuse would have interpreted Pop art as a sublation of culture. It is true that Marcuse spoke of the integration of culture into the material life process, but he never explained this idea in detail. If this deficiency is one side of the coin, the other is Marcuse's insistence on bourgeois idealist aesthetics. An example: when Marcuse praises the songs of Bob Dylan, he lifts them out of the material life process and sees in them the promise for a liberated, utopian society of the future. Marcuse's emphasis on this anticipatory, utopian role of the work of art owes as much to bourgeois aesthetics as does Adorno's thesis of the work of art as a total negation of existing reality. But it was just this idealism in Marcuse's thought that appealed to the early student movement, and his influence on the Pop reception in the Federal Republic makes Pop's links with the anti-authoritarian revolt evident.

Warhol and Duchamp—a Digression into Art History

Some observations on art history might be appropriate before moving on to the second phase of Pop reception in the Federal Republic—the critical evaluation of Pop by the New Left, which will have to be discussed in the context of the larger art debate after 1968.

In 1962 Andy Warhol, who is seen as the most representative Pop artist in the Federal Republic,[13] "painted" a series of serial portraits of Marilyn Monroe. I pick one of them for discussion: five times five frontal views of the actress' face arranged in rectangular order. Warhol has chosen one photo and reproduced it with the silk screen technique,[14] adding slight modifications to the original. Art thus becomes the reproduction of a reproduction. It is not reality itself that provides the content of the work of art, but rather a secondary reality— the portrait of the mass idol as the cliché image that appears millions of times in the mass media and that sinks into the consciousness of a mass audience. The work is made up of identical elements and characterized by a simple, theoretically unlimited, serial structure. The artist has surrendered to the principles of anonymous mass reproduction and has documented his closeness to the image world of the mass media. Affirmation or critique—that is the question. By itself, the artistic structure of the Monroe silk screen hardly provides an answer.

One year later, in 1963, Warhol created a similar serial portrait with

the revealing title "Thirty are better than one." This time the subject was not an idol of mass culture, but a reproduction of Leonardo da Vinci's *Mona Lisa*, not even in color, but in the black and white of photography. The Renaissance artist's masterpiece has its renaissance under the production conditions of modern media society. But Warhol not only cites Leonardo's work, which, due to its mass distribution in the form of prints, could be considered part of today's mass culture.[15] He also alludes to one of the fathers of the art of the 1960s—Marcel Duchamp, himself an elite artist par excellence.

In 1919 Duchamp took a reproduction of Leonardo's *Mona Lisa*, pencilled in a moustache and a goatee, and called this "combination ready-made"[16] *L.H.O.O.Q.*, initials which reveal the iconoclastic intention of the work if pronounced in French (elle a chaud au cul, or she has a hot ass).[17] Of course, the "creator" of the ready-mades mainly wanted to provoke and shock a society which had gone bankrupt in World War I. It is not the artistic achievement of Leonardo that is ridiculed by moustache, goatee and obscene allusion, but rather the cult object the *Mona Lisa* had become in that temple of bourgeois art religion, the Louvre. Duchamp challenged the traditional concepts of beauty, creativity, originality, and autonomy still more boldly in 1917, when he declared as a work of art an object designed for reproduction—a urinal, which he called *Fountain* and signed with a pseudonym. An *objet trouvé*, the urinal becomes a work of art only by virtue of the fact that an artist exhibits it. In those days, the audience recognized the provocation and was shocked. It understood all too well that Dada attacked all the holy cows of bourgeois art-religion. And yet Dada's frontal attack was unsuccessful, not only because the movement exhausted itself in negation, but also because even then bourgeois culture was able to co-opt any kind of attack made on it. Duchamp himself saw this dilemma and withdrew from the art scene in 1923. The withdrawal seems only logical considering that today an assiduous audience admires *L.H.O.O.Q.* as a masterpiece of modernism in the museum.

When there was a New York retrospective of his work in 1965, Duchamp once again tried to express the problem artistically. As invitations to the opening, he sent out about one hundred post-Warholian Mona Lisas. They depicted a Mona Lisa without moustache and goatee on the backside of a playing card bearing the title *Rasé L.H.O.O.Q.*. "Through this reconstruction of her identity the Mona Lisa has as a matter of fact completely lost her identity,"[18] the critic Max Imdahl commented. I rather ask myself whether the "certain smile" of the *Mona Lisa* is not ironically directed at an audience that accepts the mere repetition of a provocation as art[19] or that can revel in the thought

that today even provocation has become cliché. Did Duchamp, who never concealed his disapproval of Pop, not see that the outrage of 1919 had degenerated into applause and co-option? Warhol, to be sure, is more consistent in this matter. He does not even want to provoke any more. He simply reproduces mass reproduced reality like Coca-Cola bottles, Brillo boxes, photos of filmstars, and Campbell soup cans. In his polemic against the distinction between non-art and art the dadaist Duchamp still sides with art ex negativo (almost all of his post-Dada work bears witness to this), but Warhol is no longer even interested in such a polemic.[20] This becomes clear in interviews in which his statements are closer to the language of commercial advertising than to any form of art criticism. The following passage, taken from an interview conducted by G. R. Swenson in 1963, shows how Warhol naively praises the reification of modern life as a virtue: "Someone said that Brecht wanted everybody to think alike. I want everybody to think alike. But Brecht wanted to do it through Communism, in a way. Russia is doing it under government: It's happening here all by itself without being under a strict government; so if it's working without trying, why can't it work without being Communist? Everybody looks alike and acts alike, and we're getting more and more that way. I think everybody should be a machine. I think everybody should like everybody. *Is that what Pop Art is all about?* Yes. It's liking things."[21] Warhol seems to be a victim of the advertising slogans he himself helped design before he became an artist. He had made the switch from ad man to artist with a single idea: not to advertise products, but to proclaim those same products and their graphic reproductions as works of art. In accordance with Warhol's slogan "All is pretty," the Pop artists took the trivial and banal imagery of daily life at face value, and the subjugation of art by the laws of a commodity producing capitalist society seemed complete.

Criticism of Pop Art

It is exactly at this point that criticism set in. Pop artists were accused of surrendering to the capitalist mode of production in their techniques and of glorifying the commodity market by their choice of subject.[22] Frequently such criticism took issue with Warhol's soup cans, Lichtenstein's comics, Wesselmann's bathroom arrangements. It was pointed out that several Pop artists had worked in advertising and graphic design before coming to art and that the difference between advertisement and art had shrunk to a minimum in many of their works—a fact which is not to be mistaken for the elimination of the art-life dichot-

omy. Furthermore, it was observed that Pop art, which partly originated in advertising, in turn influenced it. Comics, for instance, began
appearing in ads only after Lichtenstein had made them the main
theme of his work.[23] The mouth canvases of Wesselmann, themselves
part of the lipstick and toothpaste ad tradition, had a visible effect on
such ads. While ads of an earlier period showed the human being
belonging to those lips and teeth, post-Wesselmann ads frequently
blow up the mouth and show nothing but the mouth.[24] It is symptomatic that the artists themselves did not see this link between Pop and
advertising as something negative. James Rosenquist, for instance, who
also came to art from advertising, stated: "I think we have a free
society, and the action that goes on in this free society allows encroachments, as a commercial society. So I geared myself, like an advertiser or
a large company, to this visual inflation—in commercial advertising
which is one of the foundations of our society. I'm living in it, and it has
such impact and excitement in its means of imagery."[25] Of course it is
problematic to take such self-interpretations by artists too literally.
There are quite a few cases in the history of art and literature where a
work revealed an intention or a tendency which blatantly contradicted
the artist's ideological consciousness. But subtle doubts did not seem
appropriate at a time when the theoretical discussion of art had led to a
radical skepticism toward all contemporary art, including Pop. Pop art
in particular had contributed to this radical skepticism—not as the new
art of an imaginary cultural revolution which some of Pop's disciples
hoped for, but rather as an art that revealed the elitist and esoteric
nature of traditional avantgardism because more than any other preceding art movement it laid bare the commodity character of all contemporary art production.[26]

Art as Commodity

It is not surprising that the left's criticism focused on the commodity
character of art in capitalist society. Forums for the discussion were
Kursbuch 15 with essays by Karl Markus Michel, Hans Magnus Enzensberger and Walter Böhlich, and *Die Zeit*, which printed an analysis by
the Berlin SDS collective "Culture and Revolution," programmatically
entitled "Art as a Commodity of the Consciousness Industry."[27] This
theoretical discussion, in which different positions of the New Left
were articulated independently from each other, bears on the critical
evaluation of Pop art even though Pop was mentioned neither in the
SDS paper nor in *Kursbuch*.

The SDS collective's point of departure is the thesis that every

individually produced and supposedly autonomous work of art is swallowed up by the system of distribution (art dealers, galleries, museums). Not only does the artist depend on an efficient organization of the distribution apparatus, but even the reception of the work of art takes place within the framework of the culture industry. By advertising and promoting the works it distributes, the industry generates certain expectations. The aesthetic objectivation achieved in the work of art does not reach the consumer directly; it is filtered through the mode of mediation. The culture industry—which like any other branch of industry is integrated into the economic system of capitalist society—is thus the pivot of art production and art reception. In apparent agreement with Adorno, the SDS collective concludes: "Art, caught up in the distribution system of the culture industry, is subjected to the ideology of supply and demand. It becomes commodity. The culture industry sees the legitimation of producing art only in art's exchange value, not in its use value. In other words, the objective content of art works and their enlightening role become irrelevant in a system based on profit maximization, against which an adequate reception of art would rebel."[28] While low art (Hollywood movies, TV series, bestsellers, hit parades) floods the consumer with positive models which are as abstract as they are unrealistic, the function of high art is to legitimize bourgeois domination in the cultural realm by intimidating the non-specialist, i.e., the majority of a given population. With this evaluation of high art, the SDS analysis goes beyond Adorno, who also condemns the culture industry, but keeps insisting that if high art rejects economic utilization, it can offer the only realm of withdrawal for creative, non-alienated labor. In the SDS analysis, the culture industry's capability for manipulation seems complete. The analysis in effect combines Adorno's attack on low, trivial art with a version of Marcuse's thesis of the affirmative character of high art—a reductionist version, in which high art, viewed as nothing but a means of domination, is deprived of its utopian and anticipatory element.

Given such a gloomy description of the situation, the conclusions reached by the SDS theoreticians seem contradictory. Suddenly they demand that bourgeois aesthetics be dealt with critically—as if the culture industry had not already made bourgeois aesthetics obsolete. They also call for the creation of a progressive art, though clearly it could only be a critique of a negative reality—again a critique of ideology (*Ideologiekritik*). These suggestions are clearly products of a period in the student movement when it was believed that enlightenment would bring about a change of consciousness, that revolutionary change would take place in the superstructure. Which material forces

would bring about this revolution was a question never answered. Despite the fact that at this time critical theory was already being vigorously criticized, the SDS paper documents a continued dependence on Adorno and Marcuse. It focused not on the productive forces and the production relations in the realm of art, but rather on problems of manipulation and consumption which the SDS collective hoped to solve by a critique of ideology.

Similar difficulties emerge in the essays in *Kursbuch* 15 which are characterized by a capitulation to the consciousness industry and by the declaration that art and literature are dead. It is true that Enzensberger condemned the then fashionable *pompes funèbres* that celebrated the death of culture under the banner of a cultural revolution. But his analysis confirmed what at first he wanted to shrug off as a literary metaphor—the death of literature; more precisely, the death of *littérature engagée*, which saw social criticism as its main function, and which had dominated the German scene in the 1950s and early 1960s. This insight resulted largely from the student movement which, as Karl Markus Michel pointed out correctly in the same issue, had zeroed in on the social privileges of artists and writers, and had drawn attention to the distance separating artists from social praxis.[29] Enzensberger adopted this argument when he reproached engaged literature "for not uniting political demands and political praxis."[30] Maybe the left's enthusiasm for cultural revolution was somewhat naive. Maybe Enzensberger was right in criticizing the revolutionary histrionics of the left which "by liquidating literature sought to compensate for its own incompetence."[31] But he should have seen that his desire "to teach Germany the alphabet of politics"[32] was not all that different from the intentions of the student left. After all, Enzensberger too demands a critical art and suggests documentary and reportage as appropriate literary genres. Like the SDS paper, Enzensberger's essay leaves open the question what extent such a critical art could be effective in a culture whose main characteristic is manipulation.[33] A more basic question must be raised as to whether these critical essays do not run the risk of fetishizing the very notion of culture industry. How can one continually demand new forms of critical art if the culture industry in fact suppresses any enlightenment and criticism of capitalist society? How can Enzensberger get around the "law of the market" which "dominates literature perhaps even more than other products"?[34] Where art is seen as commodity and as nothing but commodity, there is an economic reductionism equating the relations of production with what is produced, the system of distribution with what is distributed, the reception of art with the consumption of all commodities. This is a

misunderstanding. We cannot dogmatically reduce art to its exchange value, as if its use value were determined by the mode of distribution rather than by its content.[35] The theory of total manipulation underestimates the dialectical nature of art. Even under the conditions set by the capitalist culture industry and its distribution apparatus, art ultimately can open up emancipatory avenues if only because it is granted autonomy and practical uselessness. The thesis of the total subjugation of art to the market also underestimates possibilities for emancipation inherent in consumption; in general, consumption satisfies needs, and even though human needs can be distorted to an amazing degree, every need contains a smaller or larger kernel of authenticity. The question to ask is how this kernel can be utilized and fulfilled.

The Benjamin Debate

Capitalist culture industry inevitably produces a minimum of art and a maximum of trash and kitsch. Therefore, the task is to change the culture industry itself. But how can it be done? Critical art alone does not suffice, since in the best of cases, its success remains limited to consciousness raising. As early as 1934, Walter Benjamin noted that "the bourgeois apparatus of production and publication is capable of assimilating, indeed of propagating, an astonishing amount of revolutionary themes without ever seriously putting into the question its own continued existence or that of the class which owns it."[36] Critical Theory did not lead out of this dead end street. A return to Benjamin and Brecht, however, seemed to provide a new perspective and new possibilities. It is significant that in the Federal Republic interest in Benjamin initiated by Adorno's and Tiedemann's editions led to an attack on the Frankfurt editors. They were reproached with playing down the importance of Brecht and Marxism for the late Benjamin.[37]

Interest in Benjamin's theses about materialist aesthetics reached a high point after 1968, when the student movement left its anti-authoritarian phase and tried to develop socialist perspectives going beyond "protest against the system" and the "great refusal." The notion of manipulation, on which Adorno's theory of culture industry and Marcuse's theory of one-dimensional man were based, was legitimately criticized, but the critique went too far, frequently ending up as a complete rejection of both Adorno and Marcuse. Their place was now taken by the Benjamin of the mid-1930s. Two of his essays, "The Author as Producer" and "The Work of Art in the Age of Mechanical Reproduction," became particularly influential. It is worth mentioning that Adorno and Horkheimer had conceived the chapter on culture

industry in *Dialektik der Aufklärung* as a reply to Benjamin's 1936 reproduction essay; the latter is also related to Marcuse's essay "The Affirmative Character of Culture," which, like Benjamin's piece, was first published in the *Zeitschrift für Sozialforschung*. Both essays deal with the sublation (*Aufhebung*) of bourgeois culture, albeit in very different ways.[38]

Benjamin was influenced by Brecht, whose major ideas had evolved out of experiences in the Weimar Republic. Like Brecht, Benjamin tried to develop the revolutionary tendencies of art out of the production relations of capitalism. His point of departure was the Marxist conviction that capitalism generates productive forces that make the abolition of capitalism both possible and necessary. For Benjamin, the productive forces in art are the artist himself and the artistic technique, especially the reproduction techniques used in film and photography. He acknowledges that it took much longer for the production relations of capitalist society to make an impact on the superstructure than it took them to prevail at the basis, so much longer that they could only be analyzed in the 1930s.[39] From the very beginning of the essay on reproduction Benjamin insists upon the primacy of revolutionary movement at the basis. But the dialectics of the conditions of production leave their mark on the superstructure too. Recognizing this, Benjamin emphasizes the value of his theses as a weapon in the struggle for socialism. While Marcuse believes that the function of art will change *after* the social revolution, Benjamin sees change developing out of modern reproduction techniques, which drastically affect the inner structure of art. Here lies the importance of Benjamin for a materialist aesthetics still to be written.

Both essays by Benjamin make several references to Dada and cast a new light on the Pop debate. Benjamin found the "revolutionary strength of Dada"[40] in its testing of art for authenticity: by using new means of artistic production, the dadaists proved that this criterion of bourgeois aesthetics had become obsolete. In the reproduction essay Benjamin wrote: "The dadaists attached much less importance to the sales value of their work than to its uselessness for contemplative immersion. The studied degradation of their material was not the least of their means to achieve this uselessness. Their poems are 'word salad' containing obscenities and every imaginable waste product of language. The same is true of their paintings, on which they mounted buttons and tickets. What they intended and achieved was a relentless destruction of the aura of their creations, which they branded as reproductions with the very means of production."[41] Benjamin recognized that Dada had been instrumental in destroying the bourgeois

concept of an autonomous, genial, and eternal art. Contemplative immersion, which had been quite progressive in an earlier phase of bourgeois emancipation, since the late 19th century had served to sabotage any kind of social praxis geared toward change. During the decline of middle-class society, "contemplation became a school for asocial behavior."[42] It is the undeniable merit of the dadaists that they exposed this problem in their works. Benjamin did not overlook the fact that the Dada revolt was ultimately unsuccessful, however. He explored the reasons for its failure in a 1929 essay on surrealism: "If it is the double task of the revolutionary intelligentsia to overthrow the intellectual predominance of the bourgeoisie and to make contact with the proletarian masses, the intelligentsia has failed almost entirely in the second part of this task because it can no longer be performed contemplatively."[43] Out of negation alone, neither a new art nor a new society can be developed.

It was also Benjamin, of course, who praised John Heartfield for salvaging the revolutionary nature of Dada by incorporating its techniques into photomontage.[44] Heartfield, who like other leftist intellectuals (Grosz, Piscator) had joined the KPD in 1918, published his photomontages in such working class publications as *AIZ* (*Arbeiter Illustrierte Zeitung*) and *Volks-Illustrierte*.[45] He fulfilled two of Benjamin's major demands—the application and use of modern artistic techniques (photography and montage), and partisanship and active participation of the artist in the class struggle. For Benjamin, the key question was not the position of a work of art *vis-à-vis* the productive relations of its time, but rather its position *within* them.[46] Nor does Benjamin ask, what is the position of the artist *vis-à-vis* the production process, but rather, what is his position *within* it? The decisive passage in "The Author as Producer" reads: "Brecht has coined the phrase 'functional transformation' (*Umfunktionierung*) to describe the transformation of forms and instruments of production by a progressive intelligentsia—an intelligentsia interested in liberating the means of production and hence active in the class struggle. He was the first to address to the intellectuals the far-reaching demand that they should not supply the production apparatus without, at the same time, within the limits of the possible, changing that apparatus in the direction of Socialism."[47]

In opposition to Adorno, Benjamin held a positive view of modern reproduction techniques as they were applied in art. This disagreement can be traced to their respectively different understanding of capitalism, rooted in different experiences and formed at different times. To put it simply, Adorno was looking at the US of the 1940s,

Benjamin at the Soviet Union of the 1920s. Another important factor is that, like Brecht, Benjamin saw great potential in the "Americanism" introduced in Germany in the 1920s, while Adorno never overcame his deep mistrust of anything American. Both authors, however, have to be criticized for a distortion of perspective which makes it problematic to apply their theories in the 1970s. Just as we should question Adorno's view of the United States, we should be skeptical about Benjamin's idealizing enthusiasm for the early Soviet Union, which sometimes borders on a proletcult position. Neither Adorno's thesis of the total manipulation of culture (cf. his one-dimensional interpretation of jazz), nor Benjamin's absolute belief in the revolutionizing effects of modern reproduction techniques, has withstood the test of time. Benjamin, to be sure, was aware that mass production and mass reproduction in no way automatically guaranteed art an emancipatory function—not when art was subjected to the capitalist production and distribution apparatus. But it was not until Adorno that a theory of manipulated art under the capitalist culture industry was fully developed.

This leads us back to the Pop debate. According to Benjamin's theory, the artist, merely by seeing himself as producer and operating with the new reproduction techniques, would come closer to the proletariat. But this did not happen to the Pop artist, because the role that reproduction techniques play in today's art is totally different from what it was in the 1920s. At that time reproduction techniques called the bourgeois cultural tradition into question; today they confirm the myth of technological progress on all levels. And yet, modern reproduction techniques have a progressive potential even today. The technical innovation at the heart of Warhol's work is the use of photography combined with the silk screen technique. Because this technique makes the unlimited distribution of art works possible, it has the potential to assume a political function. Like film and photography, the silk screen destroys the century-old aura[48] of the work of art, which, according to Benjamin, is the prerequisite for its autonomy and authenticity. It is not surprising that in 1970 a Warhol monograph—using Benjamin's and Brecht's categories—claimed that Warhol's opus was *the* new critical art of our times.[49] The author, Rainer Crone, was right to view the silk screen technique in the light of Benjamin's thesis that "to an ever greater degree the work of art reproduced becomes the work of art designed for reproducibility."[50] Warhol, Crone claimed, forces the observer to redefine the role of painting as a medium. One might object that such a redefinition already had been made necessary

by Dada. There is a more important objection to be made, however. Crone's interpretation is based exclusively on an analysis of Warhol's artistic techniques; he completely ignores Benjamin's linking of artistic technique and political mass movement. Benjamin, who found his model in the revolutionary Russian film, wanted the bourgeois contemplative reception of art replaced by a collective reception. Yet, when Pop art is shown today in the Museum of Modern Art or in the Wallraf-Richartz-Museum on Cologne, the reception remains contemplative and thus Pop remains a form of autonomous bourgeois art. Crone's Warhol interpretation can only be regarded as a failure because he lifts Benjamin's theories out of their political context and neglects all the problems that would be posed by an application of those theories to today's art. A major contradiction of Crone's approach is that on the one hand, he supports Warhol's attack on the autonomy of art and the originality of the artist, and on the other hand, writes a book which glorifies the originality of Warhol and of his art. The aura absent from Warhol's works is thus reintroduced in a kind of star cult, in the "auratization" of the artist Andy Warhol.

In another context, however, Benjamin's theories can be related to Pop art. Benjamin trusted in the capacity of revolutionary art to stimulate the needs of the masses and to turn into material force when those needs could only be satisfied by collective praxis. That Pop was seen as a critical art at the time of the anti-authoritarian protest cannot be understood if one adheres to the thesis art equals commodity. Viewed from Benjamin's perspective, however, this interpretation was valid so long as the Pop reception was part of a political movement in the Federal Republic. We can also understand now that the interpretation of Pop as a progressive art had to change once the anti-authoritarian student movement foundered on its internal and external contradictions. By that time, of course, Pop had already been co-opted by the museums and collectors as the newest form of high art.

Toward a Transformation of Everyday Life

The views of Adorno and Benjamin are diametrically opposed, and neither offers totally satisfying solutions to today's problems. Adorno's thesis of total manipulation and his conclusion that serious art has to maintain an autonomy of negation must be refuted as well as the often naive belief of Brecht and Benjamin that new artistic techniques might lead to an elimination of bourgeois culture. And yet, if Adorno's critique of the capitalist culture industry is combined with the theories

of Brecht and Benjamin, it is still valid. Only from such a synthesis can we hope to develop a theory and praxis leading eventually to the integration of art into the material life process once called for by Marcuse. It does not make much sense to play one position against the other. It is more important to preserve that which can still be of use today—not only certain elements of theory, but also whatever was progressive in the Pop reception of the anti-authoritarian student movement and in the movement itself.

It seems to me that both artists and exhibitors have learned from the reception and critique of United States Pop art. At a recent *Documenta* exhibit,[51] three tendencies could be observed. While the American photorealism continued to adhere closely to reproduced reality (thus drawing the same kind of criticism levelled at Pop art earlier), the Concept artists almost completely withdrew from image into the cerebral. This withdrawal from the reality of pictorial presentation can be interpreted as a reaction against the oversaturation of our consciousness with reproduced images, or as an expression of the problem that in our world many crucial experiences are no longer sensual and concrete. At the same time, however, Concept art perpetuates the suppression of sensuality so characteristic of contemporary capitalist society. It seems to lead back into the vicious circle of abstraction and coldness in which Adrian Leverkühn was trapped. The reduction of the traditionally aesthetic[52] has reached a point where the work no longer communicates with the audience because there is no concrete work left. Here modernism has pursued its course to a logical extreme.

More interesting results of Pop came to light in another area of the *Documenta*, particularly in the documentation of the imagery of daily life which was taken seriously for the first time. Cover pages of the newsweekly *Der Spiegel* were exhibited along with trivial emblems, garden dwarfs, votive pictures, ads, and political posters. A widely publicized show in Düsseldorf had a similar intent. Its theme was the eagle as a sign or symbol. The close relationship to Jasper Johns's flag canvases is obvious.

In 1974 the Berlin Academy of Art presented a documentary show called *Die Strasse* in which photographs and maps of city cultures from around the world were related directly to Berlin's urban renewal plans. Such shows, especially the last one, aim not only at an interpretation of daily life but also at its transformation.

If Pop art has drawn our attention to the imagery of daily life, demanding that the separation of high and low art be eliminated, then today it is the task of the artist to break out of art's ivory tower and

contribute to a change of everyday life. He would be following the precepts of Henri Lefebvre's *La vie quotidienne dans le monde moderne* (*Daily Life in the Modern World*), no longer accepting the separation of the philosophical and the non-philosophical, the high and the low, the spiritual and the material, the theoretical and the practical, the cultivated and the non-cultivated; and not planning only a change of the state, of political life, economic production and judicial and social structures, but also planning a change of everyday life.[53] Aesthetics should not be forgotten in such attempts to change everyday life. The aesthetic activity of human beings not only manifests itself in the iconic arts but in all spheres of human activity. Marx wrote: "An animal forms things in accordance with the measure and the need of the species to which it belongs, while man knows how to produce in accordance with the measure of every species and knows how to apply everywhere the inherent measure to the object. Man, therefore, also forms things in accordance with the laws of beauty."[54] Along with Marx we must understand the transformation of everyday life as "practical human-sensuous activity,"[55] an activity that must enter into all spheres of human production—the forming of nature and cities, of home and work place, of traffic systems and vehicles, of clothing and instruments, body and movement. This does not mean that all differences between art and daily life should be eliminated. In a liberated human society there would be art qua art as well. Today more than ever it is the task of Marxist critics to expose the popular equation of art and life for what it is—nothing but a mystification; what we need is a critical analysis of the unprecedented aesthetization of everyday life that took place in Western countries in the postwar era. While Pop art disclosed the commodity character of art, the Federal Republic witnessed an aesthetization of commodities (including advertising and window displays) which totally subjugated the aesthetic to the interest of capital.[56] Remembering Marx's thesis that the human senses are the result of thousands of years of development, we may legitimately ask whether human sensuality itself might not undergo a qualitative change if the present manipulation of our sensual perceptions is continued over a long period of time. A Marxist theory of sensuality and fantasy under late capitalism must be developed, and this theory should provide an impulse to change everyday life. Even false, crippled needs are needs and—as Ernst Bloch has shown—contain a kernel of human dream, hope, and concrete utopia. In the context of the student movement in the Federal Republic, Pop art succeeded in evoking progressive needs. Today the goal still should be a functional transformation (*Umfunktionierung*) of false

needs in an attempt to change everyday life. In the Paris manuscripts, Marx predicted that the human senses would be liberated as a result of the elimination of private property. We know today that the elimination of private property is at most a necessary condition, but not a sufficient cause for the emancipation of human sensuality. On the other hand, the Pop reception in the Federal Republic has shown that even in capitalism there can arise forces which insist on overcoming the suppression of sensuality, and thus challenge the capitalist system as a whole. To understand and utilize such forces—that is the task at hand.

9

The Search for Tradition:
Avantgarde and
Postmodernism in the 1970s

Imagine Walter Benjamin in Berlin, the city of his childhood, walking through the international avantgarde exhibit *Tendenzen der zwanziger Jahre*, on display in 1977 in the new Nationalgalerie built by Bauhaus architect Mies van der Rohe in the 1960s. Imagine Walter Benjamin as a flaneur in the city of boulevards and arcades he so admirably described, happening upon the Centre Georges Pompidou and its multimedia show *Paris-Berlin 1900–1933*, which was a major cultural event in 1978. Or imagine the theorist of media and image reproduction in 1981 in front of a television set watching Robert Hughes' BBC-produced eight-part series on avantgarde art "The Shock of the New."[1] Would this major critic and aesthetician of the avantgarde have rejoiced in its success—manifest even in the architecture of the museums housing the exhibits—or would shadows of melancholy have clouded his eyes? Would he, perhaps, have been shocked by "The Shock of the New" or would he have felt called upon to revise the theory of post-auratic art? Or would he simply have argued that the administered culture of late capitalism had finally succeeded in imposing the phony spell of commodity fetishism even on that art which more than any other had challenged the values and traditions of bourgeois culture? Maybe after another penetrating gaze at that architectural monument to wholesale technological progress in the heart of Paris, Benjamin

This essay was first published in *New German Critique*, 22 (Winter 1981), 23–40.

would have quoted himself: "In every era the attempt must be made to wrest tradition away from a conformism that is about to overpower it."[2] Thus might he acknowledge not only that the avantgarde—embodiment of anti-tradition—has itself become tradition, but, moreover, that its inventions and its imagination have become integral even to Western culture's most official manifestations.

Of course, there is nothing new in such observations. Already in the early 1960s Hans Magnus Enzensberger had analyzed the aporias of the avantgarde[3] and Max Frisch had attributed to Brecht "the striking ineffectualness of a classic."[4] The use of visual montage, one of the major inventions of the avantgarde, already had become standard procedure in commercial advertising, and reminders of literary modernism popped up in Volkswagen's beetle ads: "Und läuft und läuft und läuft." In fact, obituaries on modernism and the avantgarde abounded in the 1960s, both in Western Europe and the United States.

Avantgarde and modernism had not only been accepted as major cultural expressions of the 20th century. They were fast becoming history. This then raised questions about the status of that art and literature which was produced after World War II, after the exhaustion of surrealism and abstraction, after the death of Musil and Thomas Mann, Valéry and Gide, Joyce and T. S. Eliot. One of the first critics to theorize about a shift from modernism to postmodernism was Irving Howe in his 1959 essay "Mass Society and Postmodern Fiction."[5] And only a year later, Harry Levin used the same concept of the postmodern to designate what he saw as an "anti-intellectual undercurrent" which threatened the humanism and enlightenment so characteristic of the culture of modernism.[6] Writers such as Enzensberger and Frisch clearly continued in the tradition of modernism (and this is true for Enzensberger's poetry of the early 1960s as well as for Frisch's plays and novels), and critics such as Howe and Levin sided with modernism against the newer developments, which they could only see as symptoms of decline. But postmodernism[7] took off with a vengeance in the early to mid-1960s, most visibly in Pop art, in experimental fiction, and in the criticism of Leslie Fiedler and Susan Sontag. Since then the notion of postmodernism has become key to almost any attempt to capture the specific and unique qualities of contemporary activities in art and architecture, in dance and music, in literature and theory. Debates in the late 1960s and early 1970s in the United States were increasingly oblivious to modernism and to the historical avantgarde. Postmodernism reigned supreme, and a sense of novelty and cultural change was pervasive.

How then do we explain the striking fascination of the late 1970s

with the avantgarde of the first three to four decades of this century? What is the meaning of this energetic come-back, in the age of post-modernism, of Dada, constructivism, futurism, surrealism, and the New Objectivity of the Weimar Republic? Exhibits of the classical avantgarde in France, Germany, England and the United States turned into major cultural events. Substantial studies of the avantgarde were published in the United States and in West Germany initiating lively debates.[8] Conferences were held on various aspects of modern-ism and the avantgarde.[9] All of this has happened at a time when there seems to be little doubt that the classical avantgarde has exhausted its creative potential and when the waning of the avantgarde is widely acknowledged as a *fait accompli*. Is this a case, then, of Hegel's owl of Minerva beginning its flight after the shades of night have fallen? Or are we dealing with a nostalgia for the "good years" of 20th-century culture? And if nostalgia it is, does it point to the exhaustion of cultural resources and creativity in our own time or does it hold the promise of a revitalization in contemporary culture? What, after all, is the place of postmodernism in all this? Can we perhaps compare this phenomenon with that other obnoxious nostalgia of the 1970s, the nostalgia for Egyptian mummies (Tut exhibit in United States), medieval emperors (Stauffer exhibit in Stuttgart), or, most recently, Vikings (Minneapo-lis)? A search for traditions seems to be involved in all these instances. Is this search for tradition perhaps just another sign of the conserva-tism of the 1970s, the cultural equivalent, as it were, of the political backlash or the so-called *Tendenzwende*? Or, alternatively, can we inter-pret the museum and TV revival of the classical avantgarde as a defense against the neo-conservative attacks on the culture of modern-ism and avantgardism, attacks which have intensified in these last years in Germany, France and the United States?

In order to answer some of these questions it may be useful to compare the status of art, literature, and criticism in the late 1970s with that of the 1960s. Paradoxically, the 1960s, for all their attacks on modernism and the avantgarde, still stand closer to the traditional notion of the avantgarde than the archeology of modernity so charac-teristic of the late 1970s. Much confusion could have been avoided if critics had paid closer attention to distinctions that need to be made between avantgarde and modernism as well as to the different rela-tionship of each one to mass culture in the United States and Europe respectively. American critics especially tended to use the terms avant-garde and modernism interchangeably. To give just two examples, Renato Poggioli's *Theory of the Avant-Garde*, translated from the Italian in 1968, was reviewed in the United States as if it were a book about

modernism[10] and John Weightman's *The Concept of the Avant-Garde* of 1973 is subtitled *Explorations in Modernism*.[11] Both avantgarde and modernism may legitimately be understood as representing artistic emanations from the sensibility of modernity, but from a European perspective it makes little sense to lump Thomas Mann together with Dada, Proust with André Breton, or Rilke with Russian constructivism. While there are areas of overlap between the tradition of the avantgarde and that of modernism (e.g., vorticism and Ezra Pound, radical language experimentation and James Joyce, expressionism and Gottfried Benn) the overall aesthetic and political differences are too pervasive to be ignored. Thus Matei Calinescu makes the following point: "In France, Italy, Spain and other European countries the avantgarde, despite its various and often contradictory claims, tends to be regarded as the most extreme form of artistic negativism—art itself being the first victim. As for modernism, whatever its specific meaning in different languages and for different authors, it never conveys that sense of universal and hysterical negation so characteristic of the avantgarde. The anti-traditionalism of modernism is often subtly traditional."[12] As to the political differences, the historical avantgarde tended predominantly to the left, the major exception being Italian futurism, while the right could claim a surprising number of modernists among its supporters, Ezra Pound, Knut Hamsun, Gottfried Benn, Erust Jünger among others.

Whereas Calinescu makes much of the negativistic, anti-aesthetic and self-destructive aspects of the avantgarde as opposed to the reconstructive art of the modernists, the aesthetic and political project of the avantgarde might be approached in more positive terms. In modernism art and literature retained their traditional 19th-century autonomy from everyday life, an autonomy which had first been articulated by Kant and Schiller in the late 18th century; the "institution art" (Peter Bürger[13]), i.e., the traditional way in which art and literature were produced, disseminated, and received, is never challenged by modernism but maintained intact. Modernists such as T. S. Eliot and Ortega y Gasset emphasized time and again that it was their mission to salvage the purity of high art from the encroachments of urbanization, massification, technological modernization, in short, of modern mass culture. The avantgarde of the first three decades of this century, however, attempted to subvert art's autonomy, its artificial separation from life, and its institutionalization as "high art" that was perceived to feed right into the legitimation needs of the 19th-century forms of bourgeois society. The avantgarde posited the reintegration of art and life as its major project at a time when that traditional society, especially

in Italy, Russia, and Germany, was undergoing a major transformation toward a qualitatively new stage of modernity. Social and political ferment of the 1910s and 1920s was the breeding ground for avantgarde radicalism in art and literature as well as in politics.[14] When Enzensberger wrote about the aporias of the avantgarde several decades later, he did not just have the cooption of the avantgarde by the culture industry in mind as is sometimes surmised; he fully understood the political dimension of the problem and pointed out how the historical avantgarde had failed to deliver what it had always promised: to sever political, social and aesthetic chains, explode cultural reifications, throw off traditional forms of domination, liberate repressed energies.[15]

If with these distinctions in mind we look at United States culture of the 1960s it becomes clear that the 1960s can be regarded as the closing chapter in the tradition of avantgardism. Like all avantgardes since Saint Simon and the utopian socialists and anarchists up through Dada, surrealism, and the post-revolutionary art of Soviet Russia in the early 1920s, the 1960s fought tradition, and this revolt took place at a time of political and social turmoil. The promise of unlimited abundance, political stability, and new technological frontiers of the Kennedy years was shattered fast, and social conflict emerged dominant in the civil rights movement, in the urban riots, and in the anti-war movement. It certainly is more than coincidental that the protest culture of the period adopted the label 'counter-culture,' thus projecting an image of an avantgarde leading the way to an alternative kind of society. In the field of art, Pop revolted against abstract expressionism and sparked off a series of art movements from Op to Fluxus, Concept, and Minimalism which made the art scene of the 1960s as lively and vibrating as it was commercially profitable and fashionable.[16] Peter Brook and the Living Theatre exploded the endless entrapments of absurdism and created a new style of theatrical performance. The theater attempted to bridge the gap between stage and audience and experimented with new forms of immediacy and spontaneity in performance. There was a participatory ethos in the theater and in the arts which can easily be linked to the teach-ins and sit-ins of the protest movement. Exponents of a new sensibility rebelled against the complexities and ambiguities of modernism embracing camp and pop culture instead, and literary critics rejected the congealed canon and interpretive practices of the New Criticism claiming for their own writing the creativity, autonomy and presence of original creation.

When Leslie Fiedler declared the "Death of Avant-Garde Literature" in 1964,[17] he was really attacking modernism, and he himself

embodied the ethos of the classical avantgarde, American style. I say "American style" because Fiedler's major concern was not to democratize "high art"; his goal was rather to validate popular culture and to challenge the increasing institutionalization of high art. Thus when a few years later he wanted to "Cross the Border—Close the Gap" (1968)[18] between high culture and popular culture he reaffirmed precisely the classical avantgarde's project to reunite these artificially separated realms of culture. For a moment in the 1960s it seemed the Phoenix avantgarde had risen from the ashes fancying a flight toward the new frontier of the postmodern. Or was American postmodernism rather a Baudelairean albatross trying in vain to lift off the deck of the culture industry? Was postmodernism plagued from its very inception by the same aporias Enzensberger had already analyzed so eloquently in 1962? It seems that even in the United States the uncritical embracing of Western and camp, porno and rock, pop and counter-culture as genuine popular culture points to an amnesia which may have been the result of cold war politics as much as of the postmodernists' relentless fight against tradition. American analyses of mass culture did have a critical edge in the late 1940s and 1950s[19] which went all but unacknowledged in the 1960s uncritical enthusiasm for camp, pop, and the media.

A major difference between the United States and Europe in the 1960s is that European writers, artists, and intellectuals then were much more aware of the increasing co-option of all modernist and avantgarde art by the culture industry. Enzensberger after all had not only written about the aporias of the avantgarde, but about the pervasiveness of the "consciousness industry" as well.[20] Since the tradition of the avantgarde in Europe did not seem to offer what, for historical reasons, it could still offer in the United States, one politically feasible way to react to the classical avantgarde and to cultural tradition in general was to declare the death of all art and literature and to call for cultural revolution. But even this rhetorical gesture, articulated most emphatically in Enzensberger's *Kursbuch* in 1968 and in the Parisian graffiti of May '68, was part of the traditional anti-aesthetic, anti-elitist, and anti-bourgeois strategies of the avantgarde. And by no means all writers and artists heeded the call. Peter Handke, for instance, denounced as infantile the attack on all high art and literature and he continued to write experimental plays, poetry, and prose. And the cultural left in West Germany, which agreed with Enzensberger's funeral for art and literature as long as it buried "bourgeois" art only, undertook the task of unearthing an alternative cultural tradition, especially that of the left avantgardes of the Weimar Republic. But the

reappropriation of the left tradition of the Weimar Republic did not revitalize contemporary art and literature in Germany the way the undercurrent of Dada had revitalized the American art scene of the 1960s. Important exceptions to this general observation can be found in the work of Klaus Staeck, Günter Wallraff, and Alexander Kluge, but they remain isolated cases.

It soon became clear that the European attempt to escape from the "ghetto" of art and to break the bondage of the culture industry also had ended in failure and frustration. Whether in the German protest movement or in May '68 in France, the illusion that cultural revolution was imminent foundered on the hard realities of the status quo. Art was not reintegrated into everyday life. The imagination did not come to power. The Centre Georges Pompidou was built instead, and the SPD came to power in West Germany. The vanguard thrust of group movements developing and asserting the newest style seemed to be broken after 1968. In Europe, 1968 marks not the breakthrough then hoped for, but rather the replayed end of the traditional avantgarde. Symptomatic of the 1970s were loners like Peter Handke, whose work defies the notion of a unitary style; cult figures like Joseph Beuys who conjures up an archaic past; or film makers like Herzog, Wenders and Fassbinder whose films—despite their critique of contemporary Germany—lack one of the basic prerequisites of avantgarde art, a sense of the future.

In the United States, however, the sense of the future, which had asserted itself so powerfully in the 1960s, is still alive today in the postmodernist scene, even though its breathing space is shrinking fast as a result of recent economic and political changes (e.g., the cutting of the NEA budget). There also seems to be a major shift of postmodernist interest from the earlier two-pronged concern with popular culture and with experimental art and literature, to a new focus on cultural theory, a shift which certainly reflects the academic institutionalization of postmodernism, but is not fully explained by it. More on this later. What concerns me here is the temporal imagination of postmodernism, the unshaken confidence of being at the edge of history which characterizes the whole trajectory of American postmodernism since the 1960s and of which the notion of a *post-histoire* is only one of the sillier manifestations. A possible explanation of this resilience to the shifting mood of the culture at large, which certainly since the mid-1970s has all but lost its confidence in the future, may lie precisely in the subterranean proximity of postmodernism to those movements, figures and intentions of the classical European avantgarde which were hardly ever acknowledged by the Anglo-Saxon no-

tion of modernism. Despite the importance of Man Ray and the activities of Picabia and Duchamp in New York, New York Dada remained at best a marginal phenomenon in American culture, and neither Dada nor surrealism ever met with much public success in the United States. Precisely this fact made Pop, happenings, Concept, experimental music, surfiction, and performance art of the 1960s and 1970s look more novel than they really were. The audience's expectation horizon in the United States was fundamentally different from what it was in Europe. Where Europeans might react with a sense of déjà vu, Americans could legitimately sustain a sense of novelty, excitement, and breakthrough.

A second major factor comes into play here. If we want to understand fully the power the dadaist subcurrent assumed in the United States in the 1960s, the absence of an American Dada or surrealist movement in the earlier 20th century also needs to be explained. As Peter Bürger has argued, the major goal of the European avantgardes was to undermine, attack, and transform the bourgeois "institution art." Such an iconoclastic attack on cultural institutions and traditional modes of representation, narrative structure, perspective, and poetic sensibility only made sense in countries where "high art" had an essential role to play in legitimizing bourgeois political and social domination, e.g., in the museum and salon culture, in the theaters, concert halls and opera houses and in the socialization and education process in general. The cultural politics of 20th-century avantgardism would have been meaningless (if not regressive) in the United States where "high art" was still struggling hard to gain wider legitimacy and to be taken seriously by the public. Thus it is not surprising that major American writers since Henry James, such as T. S. Eliot, Faulkner and Hemingway, Pound and Stevens, felt drawn to the constructive sensibility of modernism, which insisted on the dignity and autonomy of literature, rather than to the iconoclastic and anti-aesthetic ethos of the European avantgarde which attempted to break the political bondage of high culture through a fusion with popular culture and to integrate art into life.

I would suggest that it was not only the absence of an indigenous American avantgarde in the classical European sense, say in the 1920s, which, forty years later, benefitted the postmodernists' claim to novelty in their struggle against the entrenched traditions of modernism, abstract expressionism, and New Criticism. There is more to it than that. A European-style avantgardist revolt against tradition made eminent sense in the United States at a time when high art had become institutionalized in the burgeoning museum, concert, and paperback

culture of the 1950s, when modernism itself had entered the main-stream via the culture industry, and later, during the Kennedy years, when high culture began to take on functions of political representation (Robert Frost and Pablo Casals at the White House).

All of this, then, is not at all to say that postmodernism is merely a pastiche of an earlier continental avantgarde. It rather serves to point to the similarity and continuity between American postmodernism and certain segments of an earlier European avantgarde, a similarity on the levels of formal experimentation and of a critique of the "institution art." This continuity was already marginally acknowledged in some postmodernist criticism, e.g., by Fiedler and Ihab Hassan,[21] but it emerged in full clarity with the recent retrospectives of and writings on the classical European avantgarde. From the perspective of today, American art of the 1960s—precisely because of its successful attack on abstract expressionism—shines as the colorful death mask of a classical avantgarde which in Europe already had been liquidated culturally and politically by Stalin and Hitler. Despite its radical and legitimate critique of the gospel of modernism, postmodernism, which in its artistic practices and its theory was a product of the 1960s, must be seen as the endgame of the avantgarde and not as the radical breakthrough it often claimed to be.[22]

At the same time it goes without saying that the postmodernist revolt against the institution art in the United States was up against bigger odds than futurism, Dada, or surrealism were in their time. The earlier avantgarde was confronted with the culture industry in its stage of inception while postmodernism had to face a technologically and economically fully developed media culture which had mastered the high art of integrating, diffusing, and marketing even the most serious challenges. This factor, combined with the altered constitution of audiences, accounts for the fact that, compared with the earlier 20th century, the shock of the new was much harder, perhaps even impossible, to sustain. Furthermore, when Dada erupted in 1916 in the placid 19th-century culture of bourgeois Zurich, there were no ancestors to contend with. Even the formally much less radical avantgardes of the 19th century had not yet had a measurable impact on Swiss culture at large. The happenings at the Cabaret Voltaire could not but scandalize the public. When Rauschenberg, Jasper Johns, and the Madison Avenue pop artists began their assault on abstract expressionism, drawing their inspiration as they did from the everyday life of American consumerism, they soon had to face serious competition: the work of dadaist father figure Marcel Duchamp was presented to the American public in major museum and gallery retrospectives, e.g., in Pasadena

(1963) and New York (1965). The ghost of the father was not only out of the closet of art history, but Duchamp himself was always already there in flesh and blood saying, like the hedgehog to the hare: "Ich bin schon da."

All of this goes to show that the mammoth avantgarde spectacles of the late 1970s can be interpreted as the flip side of postmodernism, which now appears much more traditional than it did in the 1960s. Not only do the avantgarde shows of the late 1970s in Paris and Berlin, London, New York, and Chicago help us come to terms with the tradition of the earlier 20th century, but postmodernism itself can now be described as a search for a viable modern tradition apart from, say, the Proust-Joyce-Mann triad and outside the canon of classical modernism. The search for tradition combined with an attempt at recuperation seems more basic to postmodernism than innovation and breakthrough. The cultural paradox of the 1970s is not so much the side-by-side co-existence of a future-happy postmodernism with avant-garde museum retrospectives. Nor is it the inherent contradiction of the postmodernist avantgarde itself, i.e., the paradox of an art that simultaneously wants to be art and anti-art and of a criticism that pretends to be criticism and anti-criticism. The paradox of the 1970s is rather that the postmodernist search for cultural tradition and con-tinuity, which underlies all the radical rhetoric of rupture, discontinu-ity, and epistemological breaks, has turned to that tradition which fundamentally and on principle despised and denied all traditions.

Seeing the avantgarde exhibits of the 1970s in the light of postmod-ernism may also help focus attention on some important differences between American postmodernism and the historical avantgarde. In post–World War II America, the historical realities of massive tech-nological, social, and political change, which had given the myth of avantgardism and innovation its power, persuasiveness, and utopian drive in the earlier 20th century, had all but vanished. During the 1940s and 1950s American art and intellectual life had gone through a period of depoliticization in which avantgardism and modernism actually had been realigned with the conservative liberalism of the times.[23] While postmodernism rebelled against the culture and politics of the 1950s, it nevertheless lacked a radical vision of social and politi-cal transformation that had been so essential to the historical avant-garde. Time and again the future was incanted rhetorically, but it never became clear how and in what forms postmodernism would help implement that alternative culture of the coming age. Despite this ostentatious orientation toward the future, postmodernism may well have been an expression of the contemporary crisis of culture rather

than the promised transcendence toward cultural rejuvenation. Much more than the historical avantgarde, which was surreptitiously connected to the dominant modernizing and anti-traditionalist trends of 19th and 20th-century Western civilization, postmodernism was in danger of becoming affirmative culture right from the start. Most of the gestures which had sustained the shock value of the historical avantgarde were no longer and could no longer be effective. The historical avantgarde's appropriation of technology for high art (e.g., film, photography, montage principle) could produce shock since it broke with the aestheticism and the doctrine of art's autonomy from "real" life which were dominant in the late 19th century. The postmodernist espousal of space age technology and electronic media in the wake of McLuhan, however, could scarcely shock an audience which had been inculturated to modernism via the very same media. Nor did Leslie Fiedler's dive into popular culture cause outrage in a country where the pleasures of popular culture always have been acknowledged (except perhaps in academia) with more ease and less secrecy than in Europe. And most postmodernist experiments in visual perspective, narrative structure, and temporal logic, which all attacked the dogma of mimetic referentiality, were already known from the modernist tradition. The problem was compounded by the fact that experimental strategies and popular culture were no longer connected in a critical aesthetic and political project as they had been in the historical avantgarde. Popular culture was accepted uncritically (Leslie Fiedler) and postmodernist experimentation had lost the avantgardist consciousness that social change and the transformation of everyday life were at stake in every artistic experiment. Rather than aiming at a mediation between art and life, postmodernist experiments soon came to be valued for typically modernist features such as self-reflexivity, immanence, and indeterminacy (Ihab Hassan). The American postmodernist avantgarde, therefore, is not only the endgame of avantgardism. It also represents the fragmentation and the decline of the avantgarde as a genuinely critical and adversary culture.

My hypothesis that postmodernism always has been in search of tradition while pretending to innovation also is borne out by the recent shift toward cultural theory which distinguishes the postmodernism of the 1970s from that of the 1960s. On one level, of course, the American appropriation of structuralist and especially poststructuralist theory from France reflects the extent to which postmodernism itself has been academicized since it won its battle against modernism and the New Criticism.[24] It is also tempting to speculate that the shift toward theory actually points to the falling rate of artistic and literary creativity in the

1970s, a proposition which would help explain the resurgence of historical retrospectives in the museums. To put it simply, if the contemporary art scene does not generate enough movements, figures, and trends to sustain the ethos of avantgardism, then museum directors have to turn to the past to satisfy the demand for cultural events. However, the artistic and literary superiority of the 1960s over the 1970s should not be taken for granted and quantity is no appropriate criterion anyway. Perhaps the culture of the 1970s is just more amorphous and diffuse, richer in difference and variation than that of the 1960s when trends and movements evolved in a more or less "orderly" sequence. Beneath the surface of continuously changing trends, there was indeed a unifying drive behind the culture of the 1960s which was inherited precisely from the tradition of avantgardism. Since the cultural diversity of the 1970s no longer sustained this sense of unity—even if it was the unity of experimentation, fragmentation, *Verfremdung*, and indeterminacy—postmodernism withdrew into a kind of theory which, with its key notions of decentering and deconstruction, seemed to guarantee the lost center of avantgardism. Suspicion is in order that the postmodernist critics' shift to continental theory is the last desperate attempt of the postmodernist avantgarde to hold on to a notion of avantgardism which already had been refuted by certain cultural practices of the 1970s. The irony is that in this peculiarly American appropriation of recent French theory the postmodernist search for tradition comes full circle; for several major exponents of French post-structuralism such as Foucault, Deleuze, Guattari, and Derrida are more concerned with the archeology of modernity than with breakthrough and innovation, with history and the past more than with the year 2001.

Two concluding questions can be posed at this juncture. Why was there this intense search for viable traditions in the 1970s and what, if anything, is historically specific about it? And, secondly, what can the identification with the classical avantgarde contribute to our sense of cultural identity, and to what extent is such an identification desirable? The Western industrialized countries are currently experiencing a fundamental cultural and political identity crisis. The 1970s' search for roots, for history and traditions, was an inevitable and in many ways productive off-shoot of this crisis; apart from the nostalgia for mummies and emperors, we are confronted with a multi-faceted and diverse search for the past (often for an alternative past) which, in many of its more radical manifestations, questions the fundamental orientation of Western societies toward future growth and toward unlimited progress. This questioning of history and tradition, as it informs for in-

stance the feminist interest in women's history and the ecological search for alternatives in our relationship with nature, should not be confused with the simpleminded rearguard assertion of traditional norms and values, although both phenomena reflect, with diametrically opposed political intentions, the same disposition toward tradition and history. The problem with postmodernism is that it relegates history to the dustbin of an obsolete epistémè, arguing gleefully that history does not exist except as text, i.e., as historiography.[25] Of course, if the "referent" of historiography, that which historians write *about*, is eliminated, then history is indeed up for grabs or, to put it in more trendy words, up for "strong misreadings." When Hayden White lamented the "burden of history" in 1966 and suggested, perfectly in line with the early phase of postmodernism, that we accept our lot of discontinuity, disruption, and chaos,[26] he replayed the Nietzschean impetus of the classical avantgarde, but his suggestion is less than helpful in dealing with the new cultural constellations of the 1970s. Cultural practices of the 1970s—postmodernist theory notwithstanding—actually point to the vital need not to abandon history and the past to tradition-mongering neo-conservatives bent on reestablishing the norms of earlier industrial capitalism: discipline, authority, the work ethic, and the traditional family. There is indeed an alternative search for tradition and history going on today which manifests itself in the concern with cultural formations not dominated by logocentric and technocratic thought, in the decentering of traditional notions of identity, in the search for women's history, in the rejection of centralisms, mainstreams, and melting pots of all kinds, and in the great value put on difference and otherness. This search for history is of course also a search for cultural identities today, and as such it clearly points to the exhaustion of the tradition of the avantgarde, including postmodernism. The search for tradition, to be sure, is not peculiar to the 1970s alone. Ever since Western civilization entered the throes of modernization, the nostalgic lament for a lost past has accompanied it like a shadow that held the promise of a better future. But in all the battles between ancients and moderns since the 17th and 18th centuries, from Herder and Schlegel to Benjamin and the American postmodernists, the moderns tended to embrace modernity, convinced that they had to pass through it before the lost unity of life and art could be reconstructed on a higher level. This conviction was the basis for avantgardism. Today, when modernism looks increasingly like a dead end, it is this foundation itself which is being challenged. The universalizing drive inherent in the tradition of modernity no longer holds that *promesse de bonheur* as it used to.

Which brings me to the second question whether an identification with the historical avantgarde—and by extension with postmodernism—can contribute to our sense of cultural identity in the 1980s. I do not want to give a definitive answer, but I suggest that an attitude of skepticism is called for. In traditional bourgeois culture the avantgarde was successful in sustaining difference. Within the project of modernity it launched a successful assault on 19th-century aestheticism, which insisted on the absolute autonomy of art, and on traditional realism, which remained locked into the dogma of mimetic representation and referentiality. Postmodernism has lost that capacity to gain shock value from difference, except perhaps in relation to forms of a very traditional aesthetic conservatism. The counter-measures the historical avantgarde proposed to break the grip of bourgeois institutionalized culture are no longer effective. The reasons that avantgardism is no longer viable today can be located not only in the culture industry's capacity to coopt, reproduce, and commodify, but, more interestingly, in the avantgarde itself. Despite the power and integrity of its attacks against traditional bourgeois culture and against the deprivations of capitalism, there are moments in the historical avantgarde which show how deeply avantgardism itself is implicated in the Western tradition of growth and progress. The futurist and constructivist confidence in technology and modernization, the relentless assaults on the past and on tradition which went hand in hand with a quasi-metaphysical glorification of a present on the edge of the future, the universalizing, totalizing, and centralizing impetus inherent in the very concept of avantgarde (not to speak of its metaphoric militarism), the elevation to dogma of an initially legitimate critique of traditional artistic forms rooted in mimesis and representation, the unmitigated media and computer enthusiasm of the 1960s—all these phenomena reveal the secret bond between avantgarde and official culture in advanced industrial societies. Certainly the avantgardists' use of technology was mostly *verfremdend* and critical rather than affirmative. And yet, from today's perspective the classical avantgarde's belief in technological solutions for culture appears more a symptom of the disease than a cure. Similarly one might ask whether the uncompromising attack on tradition, narration, and memory which characterizes large segments of the historical avantgarde, is not just the other side of Henry Ford's notorious statement that "history is bunk." Perhaps both are expressions of the same spirit of cultural modernity in capitalism, a dismantling of story and perspective indeed paralleling, even if only subterraneously, the destruction of history.

At the same time, the tradition of avantgardism, if stripped of its

universalizing and normative claims, leaves us with a precious heritage of artistic and literary materials, practices, and strategies which still inform many of today's most interesting writers and artists. Preserving elements of the avantgardist tradition is not at all incompatible with the recuperation and reconstitution of history and of story which we have witnessed in the 1970s. Good examples of this kind of coexistence of seemingly opposite literary strategies can be found in the post-experimental prose works of Peter Handke from *The Goalie's Anxiety at the Penalty Kick* through *Short Letter, Long Farewell* and *A Sorrow Beyond Dreams* to *The Left-Handed Woman* or, quite differently, in the work of women writers such as Christa Wolf from *The Quest for Christa T.* through *Self-Experiment* to *No Place on Earth*. The recuperation of history and the reemergence of story in the 1970s are not part of a leap back into a pre-modern, pre-avantgarde past, as some postmodernists seem to suggest. They can be better described as attempts to shift into reverse in order to get out of a dead-end street where the vehicles of avantgardism and postmodernism have come to a standstill. At the same time, the contemporary concern for history will keep us from lapsing back into the avantgardist gesture of totally rejecting the past—this time the avantgarde itself. Especially in the face of recent wholesale neo-conservative attacks on the culture of modernism, avantgardism and postmodernism, it remains politically inportant to defend this tradition against neo-conservative insinuations that modernist and postmodernist culture is to be held responsible for the current crisis of capitalism. Emphasizing the subterranean links between avantgardism, and the development of capitalism in the 20th century can effectively counteract Daniel Bell's propositions which separate an "adversary culture" from the realm of social norms in order to blame the former for the disintegration of the latter.

In my view, however, the problem in contemporary culture is not so much the struggle between modernity and postmodernity, between avantgardism and conservatism, as Jürgen Habermas has argued in his Adorno-prize speech.[27] Of course, the old conservatives, who reject the culture of modernism and the avantgarde, and the neo-conservatives, who advocate the immanence of art and its separateness from the *Lebenswelt*, must be fought and refuted. In that debate, especially, the cultural practices of avantgardism have not yet lost their vigor. But this struggle may well turn out to be a rearguard skirmish between two dated modes of thought, two cultural dispositions which relate to each other like the two sides of one coin: the universalists of tradition pitted against the universalists of a modernist enlightenment. While I stand with Habermas against old conservatives and neo-conservatives, I find

his call for the completion of the project of modernity, which is the political core of his argument, deeply problematic. As I hope to have shown in my discussion of avantgarde and postmodernism, too many aspects of the trajectory of modernity have become suspect and unviable today. Even the asethetically and politically most fascinating component of modernity, the historical avantgarde, no longer offers solutions for major sectors of contemporary culture, which would reject the avantgarde's universalizing and totalizing gesture as much as its ambiguous espousal of technology and modernization. What Habermas as a theoretician shares with the aesthetic tradition of avantgardism is precisely this universalizing gesture, which is rooted in the bourgeois enlightenment, pervades Marxism, and ultimately aims at a holistic notion of modernity. Significantly, the original title of Habermas' text, as it was printed in *Die Zeit* in September 1980, was "Modernity—an Incomplete Project." The title points to the problem—the teleological unfolding of a history of modernity—and it raises a question: to what extent is the assumption of a telos of history compatible with "histories." And this question is legitimate. For not only does Habermas smooth over contradictions and discontinuities in the trajectory of modernity itself, as Peter Bürger has poignantly pointed out.[28] Habermas ignores the fact that the very idea of a holistic modernity and of a totalizing view of history has become anathema in the 1970s, and precisely not on the conservative right. The critical deconstruction of enlightenment rationalism and logocentrism by theoreticians of culture, the decentering of traditional notions of identity, the fight of women and gays for a legitimate social and sexual identity outside of the parameters of male, heterosexual vision, the search for alternatives in our relationship with nature, including the nature of our own bodies—all these phenomena, which are key to the culture of the 1970s, make Habermas' proposition to complete the project of modernity questionable, if not undesirable.

Given Habermas' indebtedness to the tradition of critical enlightenment, which in German political history—and this should be mentioned in Habermas' defense—always was the adversary and underdog current rather than the mainstream, it comes as no surprise that Bataille, Foucault, and Derrida are lumped with the conservatives in the camp of postmodernity. There is no doubt in my mind that much of the postmodernist appropriation of Foucault and especially Derrida in the United States is indeed politically conservative, but that, after all, is only *one* line of reception and response. Habermas himself could be accused of constructing a manichean dualism in his essay where he pits the dark forces of antimodern conservatism against the enlightened

and enlightening forces of modernity. This manichean view manifests itself again in the way Habermas tends to reduce the project of modernity to its rational enlightenment components and to dismiss other, equally important parts of modernity as mistakes. Just as Bataille, Foucault, and Derrida are said to have stepped outside the modern world by removing the imagination, emotionality, and self-experience into the sphere of the archaic (a proposition which is itself debatable), surrealism is described by Habermas as modernity gone astray. Relying on Adorno's critique of surrealism, Habermas reproaches the surrealist avantgarde for having advocated a false sublation (*Aufhebung*) of the art/life dichotomy. While I agree with Habermas that a total sublation of art is indeed a false project fraught with contradictions, I would defend surrealism on three counts. More than any other avantgarde movement, surrealism dismantled false notions of identity and artistic creativity; it attempted to explode the reifications of rationality in capitalist culture and, by focusing of psychic processes, it exposed the vulnerability of all rationality, not only that of instrumental rationality; and, finally, it included the concrete human subject and his/her desires in its artistic practices and in its notion that the reception of art should systematically disrupt perception and senses.[29]

Although Habermas, in the section entitled "Alternatives," seems to retain the surrealist gesture when he speculates about the possibility of relinking art and literature with everyday life, everyday life itself—contrary to surrealism—is defined in exclusively rational, cognitive and normative, terms. Significantly, Habermas' example about an alternative reception of art in which the experts' culture is reappropriated from the standpoint of the *Lebenswelt*, involves young male workers, "politically motivated" and "knowledge hungry"; the time is 1937, Berlin; the art work reappropriated by the workers is the Pergamon altar, symbol of classicism, power, and rationality; and the status of this reappropriation is fiction, a passage in Peter Weiss's novel *Die Ästhetik des Widerstands*. The one concrete example Habermas gives is several times removed from the *Lebenswelt* of the 1970s and its cultural practices, which, in such major manifestations as the women's movement, the gay movement, and the ecology movement, seem to point beyond the culture of modernity, beyond avantgarde and postmodernism, and most certainly beyond neo-conservatism.

Habermas is right in arguing that a relinking of modern culture with everyday praxis can only be successful if the *Lebenswelt* is able "to develop institutions out of itself which set limits to the internal dynamics and to the imperatives of an almost autonomous economic system

and its administrative complements." As a result of the conservative backlash the chances for this may indeed not be very good at the present time. But to suggest, as Habermas implicitly does, that there are as yet no such attempts to steer modernity in different and alternative directions, is a view which results from the blind spot of the European enlightenment, its tendency to homogenize heterogeneity, otherness, and difference.

P.S.: Some time ago avantgarde/postmodernist artist Christo planned to wrap the Berlin Reichstag, an event which, according to Berlin mayor Stobbe, could have led to a stimulating political discussion. Conservative Bundestagspräsident Karl Carstens, however, feared spectacle and scandal, so instead Stobbe suggested the organization of a major historical exhibition about Prussia. When the great Preußen-Ausstellung will open in Berlin in August 1981, the avantgarde will truly be dead. Time for Heiner Müller's *Germania Death in Berlin.*

10

Mapping the Postmodern

A Story

In the summer of 1982 I visited the Seventh Documenta in Kassel, Germany, a periodic exhibition which documents the latest trends in contemporary art every four or five years. My then five-year-old son Daniel was with me, and he succeeded, unintentionally, in making the latest in postmodernism quite palpable to me. Approaching the Fridericianum, the museum housing the exhibit, we saw a huge and extended wall of rocks, seemingly heaped haphazardly alongside the museum. It was a work by Joseph Beuys, one of the key figures of the postmodern scene for at least a decade. Coming closer we realized that thousands of huge basalt blocks were arranged in a triangle formation the smallest angle of which pointed at a newly planted tree—all of it part of what Beuys calls a social sculpture and what in a more tradi- tional terminology would have been called a form of applied art. Beuys had issued an appeal to the citizens of Kassel, a dismal provincial city rebuilt in concrete after the heavy bombings of the last great war, to plant a tree with each of his 7000 "planting stones." The appeal—at least initially—had been enthusiastically received by a populace usually not interested in the latest blessings of the art world. Daniel, for his part, loved the rocks. I watched him climb up and down, across and back again. "Is this art?" he asked matter-of-factly. I talked to him about Beuys's ecological politics and about the slow death of the Ger- man forests (*Waldsterben*) due to acid rain. As he kept moving around on the rocks, listening distractedly, I gave him a few simple concepts

This essay was first published in *New German Critique.* 33 (Fall 1984), 5–52.

about art in the making, sculpture as monument or anti-monument, art for climbing on, and ultimately, art for vanishing—the rocks after all would disappear from the museum site as people would begin to plant the trees.

Later in the museum, however, things turned out quite differently. In the first halls we filed past a golden pillar, actually a metal cylinder entirely covered with golden leaves (by James Lee Byars), and an extended golden wall by Kounellis, with a clothes stand including hat and coat placed before it. Had the artist, as a latter day Wu Tao-Tse, vanished into the wall, into his work, leaving only his hat and coat? No matter how suggestive we might find the juxtaposition of the banal clothes stand and the preciosity of the doorless shining wall, one thing seemed clear: "Am Golde hängt, zum Golde drängt die Postmoderne."

Several rooms further on we encountered Mario Merz's spiral table made out of glass, steel, wood, and plates of sandstone, with bushlike twigs sticking out of the external parameter of the spiral formation— again, it seemed, an attempt to overlay the typical hard materials of the modernist era, steel and glass, with softer, more "natural" ones, in this case sandstone and wood. There were connotations of Stonehenge and ritual, domesticated and brought down to living-room size, to be sure. I was trying to hold together in my mind the eclecticism of materials used by Merz with the nostalgic eclecticism of postmodern architecture or the pastiche of expressionism in the painting of the *neuen Wilden*, prominently exhibited in another building of this Documenta show. I was trying, in other words, to spin a red thread through the labyrinth of the postmodern. Then, in a flash, the pattern became clear. As Daniel tried to feel the surfaces and crevices of Merz's work, as he ran his fingers alongside the stone plates and over the glass, a guard rushed over shouting: "Nicht berühren! Das ist Kunst!" (Don't touch! This is art!) And a while later, tired from so much art, he sat down on Carl André's solid cedar blocks only to be chased away with the admonition that art was not for sitting on.

Here it was again, that old notion of art: no touching, no trespassing. The museum as temple, the artist as prophet, the work as relic and cult object, the halo restored. Suddenly the privileging of gold in this exhibit made a lot of sense. The guards, of course, only performed what Rudi Fuchs, organizer of this Documenta and in touch with current trends, had in mind all along: "To disentangle art from the diverse pressures and social perversions it has to bear."[1] The debates of the last fifteen to twenty years about ways of seeing and experiencing contemporary art, about imaging and image making, about the en-tanglements between avantgarde art, media iconography, and adver-

tising seemed to have been wiped out, the slate cleaned for a new romanticism. But then it fits in all too well with, say, the celebrations of the prophetic word in the more recent writings of Peter Handke, with the aura of the "postmodern" in the New York art scene, with the self-stylization of the film-maker as *auteur* in *Burden of Dreams*, a recent documentary about the making of Werner Herzog's *Fitzcarraldo*. Think of *Fitzcarraldo's* closing images—opera on a ship on the Amazon. *Bâteau Ivre* was briefly considered by the Documenta organizers as the title for the exhibit. But while Herzog's worn-out steam boat was indeed a *bâteau ivre*—opera in the jungle, a ship moved across a mountain—the *bâteau ivre* of Kassel was only sobering in its pretentiousness. Consider this, taken from Fuchs's catalogue introduction: "After all the artist is one of the last practitioners of distinct individuality." Or, again *Originalton* Fuchs: "Here, then, begins our exhibition; here is the euphoria of Hölderlin, the quiet logic of T. S. Eliot, the unfinished dream of Coleridge. When the French traveller who discovered the Niagara Falls returned to New York, none of his sophisticated friends believed his fantastic story. What is your proof, they asked. My proof, he said, is that I have seen it."[2]

Niagara Falls and Documenta 7—indeed we have seen it all before. Art as nature, nature as art. The halo Baudelaire once lost on a crowded Paris boulevard is back, the aura restored, Baudelaire, Marx, and Benjamin forgotten. The gesture in all of this is patently anti-modern and anti-avantgarde. Sure, one could argue that in his recourse to Hölderlin, Coleridge, and Eliot, Fuchs tries to revive the modernist dogma itself—yet another postmodern nostalgia, another sentimental return to a time when art was still art. But what distinguishes this nostalgia from the "real thing," and what ultimately makes it anti-modernist, is its loss of irony, reflexiveness and self-doubt, its cheerful abandonment of a critical consciousness, its ostentatious self-confidence and the *mise en scène* of its conviction (visible even in the spatial arrangements inside the Fridericianum) that there must be a realm of purity for art, a space beyond those unfortunate "diverse pressures and social perversions" art has had to bear.[3]

This latest trend within the trajectory of postmodernism, embodied for me in the Documenta 7, rests on an all but total confusion of codes: it is anti-modern and highly eclectic, but dresses up as a return to the modernist tradition; it is anti-avantgarde in that it simply chooses to drop the avantgarde's crucial concern for a new art in an alternative society, but it pretends to be avantgarde in its presentation of current trends; and, in a certain sense, it is even anti-postmodern in that it abandons any reflection of the problems which the exhaustion of high modernism originally brought about, problems which postmodern art,

in its better moments, has attempted to address aesthetically and some-
times even politically. Documenta 7 can stand as the perfect aesthetic
simulacrum: facile eclecticism combined with aesthetic amnesia and
delusions of grandeur. It represents the kind of postmodern restora-
tion of a domesticated modernism which seems to be gaining ground in
the age of Kohl-Thatcher-Reagan and it parallels the conservative
political attacks on the culture of the 1960s which have increased in
volume and viciousness in these past years.

The Problem

If this were all that could be said about postmodernism it would not be
worth the trouble of taking up the subject at all. I might just as well stop
right here and join the formidable chorus of those who lament the loss
of quality and proclaim the decline of the arts since the 1960s. My
argument, however, will be a different one. While the recent media
hype about postmodernism in architecture and the arts has propelled
the phenomenon into the limelight, it has also tended to obscure its
long and complex history. Much of my ensuing argument will be based
on the premise that what appears on one level as the latest fad, advertis-
ing pitch, and hollow spectacle is part of a slowly emerging cultural
transformation in Western societies, a change in sensibility for which
the term 'postmodernism' is actually, at least for now, wholly adequate.
The nature and depth of that transformation are debatable, but trans-
formation it is. I don't want to be misunderstood as claiming that there
is a wholesale paradigm shift of the cultural, social, and economic
orders;[4] any such claim clearly would be overblown. But in an impor-
tant sector of our culture there is a noticeable shift in sensibility,
practices, and discourse formations which distinguishes a postmodern
set of assumptions, experiences, and propositions from that of a pre-
ceding period. What needs further exploration is whether this trans-
formation has generated genuinely new aesthetic forms in the various
arts or whether it mainly recycles techniques and strategies of modern-
ism itself, reinscribing them into an altered cultural context.

Of course, there are good reasons why any attempt to take the
postmodern seriously on its own terms meets with so much resistance.
It is indeed tempting to dismiss many of the current manifestations of
postmodernism as a fraud perpetrated on a gullible public by the New
York art market in which reputations are built and gobbled up faster
than painters can paint: witness the frenzied brushwork of the new
expressionists. It is also easy to argue that much of the contemporary
inter-arts, mixed-media and performance culture, which once seemed
so vital, is now spinning its wheels and speaking in tongues, relishing,

as it were, the eternal recurrence of the *déjà vu*. With good reason we may remain skeptical toward the revival of the Wagnerian *Gesamtkunstwerk* as postmodern spectacle in Syberberg or Robert Wilson. The current Wagner cult may indeed by a symptom of a happy collusion between the megalomania of the postmodern and that of the premodern on the edge of modernism. The search for the grail, it seems, is on.

But it is almost too easy to ridicule the postmodernism of the current New York art scene or of Documenta 7. Such total rejection will blind us to postmodernism's critical potential which, I believe, also exists, even though it may be difficult to identify.[5] The notion of the art work as critique actually informs some of the more thoughtful condemnations of postmodernism, which is accused of having abandoned the critical stance that once characterized modernism. However, the familiar ideas of what constitutes a critical art (*Parteilichkeit* and vanguardism, *l'art engagé*, critical realism, or the aesthetic of negativity, the refusal of representation, abstraction, reflexiveness) have lost much of their explanatory and normative power in recent decades. This is precisely the dilemma of art in a postmodern age. Nevertheless, I see no reason to jettison the notion of a critical art altogether. The pressures to do so are not new; they have been formidable in capitalist culture ever since romanticism, and if our postmodernity makes it exceedingly difficult to hold on to an older notion of art as critique, then the task is to redefine the possibilities of critique in postmodern terms rather than relegating it to oblivion. If the postmodern is discussed as a historical condition rather than only as style it becomes possible and indeed important to unlock the critical moment in postmodernism itself and to sharpen its cutting edge, however blunt it may seem at first sight. What will no longer do is either to eulogize or to ridicule postmodernism *en bloc*. The postmodern must be salvaged from its champions and from its detractors. This essay is meant to contribute to that project.

In much of the postmodernism debate, a very conventional thought pattern has asserted itself. Either it is said that postmodernism is continuous with modernism, in which case the whole debate opposing the two is specious; or, it is claimed that there is a radical rupture, a break with modernism, which is then evaluated in either positive or negative terms. But the question of historical continuity or discontinuity simply cannot be adequately discussed in terms of such an either/or dichotomy. To have questioned the validity of such dichotomous thought patterns is of course one of the major achievements of Derridean deconstruction. But the poststructuralist notion of endless textuality ultimately cripples any meaningful historical reflection on temporal

units shorter than, say, the long wave of metaphysics from Plato to Heidegger or the spread of *modernité* from the mid-19th century to the present. The problem with such historical macro-schemes, in relation to postmodernism, is that they prevent the phenomenon from even coming into focus.

I will therefore take a different route. I will not attempt here to define what postmodernism *is*. The term '*post*modernism' itself should guard us against such an approach as it positions the phenomenon as relational. Modernism as that from which postmodernism is breaking away remains inscribed into the very word with which we describe our distance from modernism. Thus keeping in mind postmodernism's relational nature, I will simply start from the *Selbstverständnis* of the postmodern as it has shaped various discourses since the 1960s. What I hope to provide in this essay is something like a large-scale map of the postmodern which surveys several territories and on which the various postmodern artistic and critical practices could find their aesthetic and political place. Within the trajectory of the postmodern in the United States I will distinguish several phases and directions. My primary aim is to emphasize some of the historical contingencies and pressures that have shaped recent aesthetic and cultural debates but have either been ignored or systematically blocked out in critical theory *à l'américaine*. While drawing on developments in architecture, literature, and the visual arts, my focus will be primarily on the critical discourse about the postmodern: postmodernism in relation to, respectively, modernism, the avantgarde, neo-conservatism, and poststructuralism. Each of these constellations represents a somewhat separate layer of the post-modern and will be presented as such. And, finally, central elements of the *Begriffsgeschichte* of the term will be discussed in relation to a broader set of questions that have arisen in recent debates about modernism, modernity, and the historical avantgarde.[6] A crucial question for me concerns the extent to which modernism and the avant-garde as forms of an adversary culture were nevertheless conceptually and practically bound up with capitalist modernization and/or with communist vanguardism, that modernization's twin brother. As I hope this essay will show, postmodernism's critical dimension lies precisely in its radical questioning of those presuppositions which linked modern-ism and the avantgarde to the mindset of modernization.

The Exhaustion of the Modernist Movement

Let me begin, then, with some brief remarks about the trajectory and migrations of the term 'postmodernism.' In literary criticism it goes

back as far as the late 1950s when it was used by Irving Howe and Harry Levin to lament the levelling off of the modernist movement. Howe and Levin were looking back nostalgically to what already seemed like a richer past. 'Postmodernism' was first used emphatically in the 1960s by literary critics such as Leslie Fiedler and Ihab Hassan who held widely divergent views of what a postmodern literature was. It was only during the early and mid-1970s that the term gained a much wider currency, encompassing first architecture, then dance, theater, painting, film, and music. While the postmodern break with classical modernism was fairly visible in architecture and the visual arts, the notion of a postmodern rupture in literature has been much harder to ascertain. At some point in the late 1970s, 'postmodernism,' not without American prodding, migrated to Europe via Paris and Frankfurt. Kristeva and Lyotard took it up in France, Habermas in Germany. In the United States, meanwhile, critics had begun to discuss the interface of postmodernism with French poststructuralism in its peculiar American adaptation, often simply on the assumption that the avantgarde in theory somehow had to be homologous to the avant-garde in literature and the arts. While skepticism about the feasibility of an artistic avantgarde was on the rise in the 1970s, the vitality of theory, despite its many enemies, never seemed in serious doubt. To some, indeed, it appeared as if the cultural energies that had fueled the art movements of the 1960s were flowing during the 1970s into the body of theory, leaving the artistic enterprise high and dry. While such an observation is at best of impressionistic value and also not quite fair to the arts, it does seem reasonable to say that, with postmodernism's big-bang logic of expansion irreversible, the maze of the postmodern became ever more impenetrable. By the early 1980s the modernism/ postmodernism constellation in the arts and the modernity/postmo-dernity constellation in social theory had become one of the most contested terrains in the intellectual life of Western societies. And the terrain is contested precisely because there is so much more at stake than the existence or non-existence of a new artistic style, so much more also than just the "correct" theoretical line.

Nowhere does the break with modernism seem more obvious than in recent American architecture. Nothing could be further from Mies van der Rohe's functionalist glass curtain walls than the gesture of random historical citation which prevails on so many postmodern façades. Take, for example, Philip Johnson's AT&T highrise, which is appro-priately broken up into a neoclassical mid-section, Roman colonnades at the street level, and a Chippendale pediment at the top. Indeed, a growing nostalgia for various life forms of the past seems to be a strong

undercurrent in the culture of the 1970s and 1980s. And it is tempting to dismiss this historical eclecticism, found not only in architecture, but in the arts, in film, in literature, and in the mass culture of recent years, as the cultural equivalent of the neoconservative nostalgia for the good old days and as a manifest sign of the declining rate of creativity in late capitalism. But is this nostalgia for the past, the often frenzied and exploitative search for usable traditions, and the growing fascination with pre-modern and primitive cultures—is all of this rooted only in the cultural institutions' perpetual need for spectacle and frill, and thus perfectly compatible with the status quo? Or does it perhaps also express some genuine and legitimate dissatisfaction with modernity and the unquestioned belief in the perpetual modernization of art? If the latter is the case, which I believe it is, then how can the search for alternative traditions, whether emergent or residual, be made culturally productive without yielding to the pressures of conservatism which, with a vise-like grip, lays claim to the very concept of tradition? I am not arguing here that all manifestations of the postmodern recuperation of the past are to be welcomed because somehow they are in tune with the Zeitgeist. I also don't want to be misunderstood as arguing that postmodernism's fashionable repudiation of the high modernist aesthetic and its boredom with the propositions of Marx and Freud, Picasso and Brecht, Kafka and Joyce, Schönberg and Stravinsky are somehow marks of a major cultural advance. Where postmodernism simply jettisons modernism it just yields to the cultural apparatus' demands that it legitimize itself as radically new, and it revives the philistine prejudices modernism faced in its own time.

But even if postmodernism's own propositions don't seem convincing—as embodied, for example, in the buildings by Philip Johnson, Michael Graves and others—that does not mean that continued adherence to an older set of modernist propositions would guarantee the emergence of more convincing buildings or works of art. The recent neoconservative attempt to reinstate a domesticated version of modernism as the only worthwhile truth of 20th-century culture—manifest for instance in the 1984 Beckmann exhibit in Berlin and in many articles in Hilton Kramer's *New Criterion*—is a strategy aimed at burying the political and aesthetic critiques of certain forms of modernism which have gained ground since the 1960s. But the problem with modernism is not just the fact that it can be integrated into a conservative ideology of art. After all, that already happened once on a major scale in the 1950s.[7] The larger problem we recognize today, it seems to me, is the closeness of various forms of modernism in its own time to the mindset of modernization, whether in its capitalist or

communist version. Of course, modernism was never a monolithic phenomenon, and it contained *both* the modernization euphoria of futurism, constructivism, and Neue Sachlichkeit and some of the starkest critiques of modernization in the various modern forms of "romantic anti-capitalism."[8] The problem I address in this essay is not what modernism *really was*, but rather how it was perceived retrospectively, what dominant values and knowledge it carried, and how it functioned ideologically and culturally after World War II. It is a specific image of modernism that had become the bone of contention for the postmoderns, and that image has to be reconstructed if we want to understand postmodernism's problematic relationship to the modernist tradition and its claims to difference.

Architecture gives us the most palpable example of the issues at stake. The modernist utopia embodied in the building programs of the Bauhaus, of Mies, Gropius, and Le Corbusier, was part of a heroic attempt after the Great War and the Russian Revolution to rebuild a war-ravaged Europe in the image of the new, and to make building a vital part of the envisioned renewal of society. A new Enlightenment demanded rational design for a rational society, but the new rationality was overlaid with a utopian fervor which ultimately made it veer back into myth—the myth of modernization. Ruthless denial of the past was as much an essential component of the modern movement as its call for modernization through standardization and rationalization. It is well-known how the modernist utopia shipwrecked on its own internal contradictions and, more importantly, on politics and history.[9] Gropius, Mies and others were forced into exile, Albert Speer took their place in Germany. After 1945, modernist architecture was largely deprived of its social vision and became increasingly an architecture of power and representation. Rather than standing as harbingers and promises of the new life, modernist housing projects became symbols of alienation and dehumanization, a fate they shared with the assembly line, that other agent of the new which had been greeted with exuberant enthusiasm in the 1920s by Leninists and Fordists alike.

Charles Jencks, one of the most well-known popularizing chroniclers of the agony of the modern movement and spokesman for a postmodern architecture, dates modern architecture's symbolic demise July 15, 1972, at 3:32 p.m. At that time several slab blocks of St. Louis' Pruitt-Igoe Housing (built by Minoru Yamasaki in the 1950s) were dynamited, and the collapse was dramatically displayed on the evening news. The modern machine for living, as Le Corbusier had called it with the technological euphoria so typical of the 1920s, had become unlivable, the modernist experiment, so it seemed, obsolete. Jencks

takes pains to distinguish the initial vision of the modern movement from the sins committed in its name later on. And yet, on balance he agrees with those who, since the 1960s, have argued against modernism's hidden dependence on the machine metaphor and the production paradigm, and against its taking the factory as the primary model for all buildings. It has become commonplace in postmodernist circles to favor a reintroduction of multivalent symbolic dimensions into architecture, a mixing of codes, an appropriation of local vernaculars and regional traditions.[10] Thus Jencks suggests that architects look two ways simultaneously, "towards the traditional slow-changing codes and particular ethnic meanings of a neighborhood, and towards the fast-changing codes of architectural fashion and professionalism."[11] Such schizophrenia, Jencks holds, is symptomatic of the postmodern moment in architecture; and one might well ask whether it does not apply to contemporary culture at large, which increasingly seems to privilege what Bloch called *Ungleichzeitigkeiten* (non-synchronisms),[12] rather than favoring only what Adorno, the theorist of modernism par excellence, described as *der fortgeschrittenste Materialstand der Kunst* (the most advanced state of artistic material). Where such postmodern schizophrenia is creative tension resulting in ambitious and successful buildings, and where conversely, it veers off into an incoherent and arbitrary shuffling of styles, will remain a matter of debate. We should also not forget that the mixing of codes, the appropriation of regional traditions, and the uses of symbolic dimensions other than the machine were never entirely unknown to the architects of the International Style. In order to arrive at his postmodernism, Jencks ironically had to exacerbate the very view of modernist architecture which he persistently attacks.

One of the most telling documents of the break of postmodernism with the modernist dogma is a book coauthored by Robert Venturi, Denise Scott-Brown, and Steven Izenour and entitled *Learning from Las Vegas*. Rereading this book and earlier writings by Venturi from the 1960s today,[13] one is struck by the proximity of Venturi's strategies and solutions to the pop sensibility of those years. Time and again the authors use pop art's break with the austere canon of high modernist painting and pop's uncritical espousal of the commercial vernacular of consumer culture as an inspiration for their work. What Madison Avenue was for Andy Warhol, what the comics and the Western were for Leslie Fiedler, the landscape of Las Vegas was for Venturi and his group. The rhetoric of *Learning from Las Vegas* is predicated on the glorification of the billboard strip and of the ruthless shlock of casino culture. In Kenneth Frampton's ironic words, it offers a reading of Las

Vegas as "an authentic outburst of popular phantasy."[14] I think it would be gratuitous to ridicule such odd notions of cultural populism today. While there is something patently absurd about such propositions, we have to acknowledge the power they mustered to explode the reified dogmas of modernism and to reopen a set of questions which the modernism gospel of the 1940s and 1950s had largely blocked from view: questions of ornament and metaphor in architecture, of figuration and realism in painting, of story and representation in literature, of the body in music and theater. Pop in the broadest sense was the context in which a notion of the postmodern first took shape, and from the beginning until today, the most significant trends within postmodernism have challenged modernism's relentless hostility to mass culture.

Postmodernism in the 1960s: An American Avantgarde?

I will now suggest a historical distinction between the postmodernism of the 1960s and that of the 1970s and early 1980s. My argument will roughly be this: 1960s' and 1970s' postmodernism both rejected or criticized a certain version of modernism. Against the codified high modernism of the preceding decades, the postmodernism of the 1960s tried to revitalize the heritage of the European avantgarde and to give it an American form along what one could call in short-hand the Duchamp-Cage-Warhol axis. By the 1970s, that avantgardist postmodernism of the 1960s had in turn exhausted its potential, even though some of its manifestations continued well into the new decade. What was new in the 1970s was, on the one hand, the emergence of a culture of eclecticism, a largely affirmative postmodernism which had abandoned any claim to critique, transgression or negation; and, on the other hand, an alternative postmodernism in which resistance, critique, and negation of the status quo were redefined in non-modernist and non-avantgardist terms, terms which match the political developments in contemporary culture more effectively than the older theories of modernism. Let me elaborate.

What were the connotations of the term postmodernism in the 1960s? Roughly since the mid-1950s literature and the arts witnessed a rebellion of a new generation of artists such as Rauschenberg and Jasper Johns, Kerouac, Ginsberg and the Beats, Burroughs and Barthelme against the dominance of abstract expressionism, serial music, and classical literary modernism.[15] The rebellion of the artists was soon joined by critics such as Susan Sontag, Leslie Fiedler, and Ihab Hassan who all vigorously though in very different ways and to a different

degree, argued for the postmodern. Sontag advocated camp and a new sensibility, Fiedler sang the praise of popular literature and genital enlightenment, and Hassan—closer than the others to the moderns—advocated a literature of silence, trying to mediate between the "tradition of the new" and post-war literary developments. By that time, modernism had of course been safely established as the canon in the academy, the museums and the gallery network. In that canon the New York School of abstract expressionism represented the epitome of that long trajectory of the modern which had begun in Paris in the 1850s and 1860s and which had inexorably led to New York—the American victory in culture following on the heels of the victory on the battlefields of World War II. By the 1960s artists and critics alike shared a sense of a fundamentally new situation. The assumed postmodern rupture with the past was felt as a loss: art and literature's claims to truth and human value seemed exhausted, the belief in the constitutive power of the modern imagination just another delusion. Or it was felt as a breakthrough toward an ultimate liberation of instinct and consciousness, into the global village of McLuhanacy, the new Eden of polymorphous perversity, Paradise Now, as the Living Theater proclaimed it on stage. Thus critics of postmodernism such as Gerald Graff have correctly identified two strains of the postmodern culture of the 1960s: the apocalyptic desperate strain and the visionary celebratory strain, both of which, Graff claims, already existed within modernism.[16] While this is certainly true, it misses an important point. The ire of the postmodernists was directed not so much against modernism as such, but rather against a certain austere image of 'high modernism,' as advanced by the New Critics and other custodians of modernist culture. Such a view, which avoids the false dichotomy of choosing either continuity or discontinuity, is supported by a retrospective essay by John Barth. In a 1980 piece in *The Atlantic*, entitled "The Literature of Replenishment," Barth criticizes his own 1968 essay "The Literature of Exhaustion," which seemed at the time to offer an adequate summary of the apocalyptic strain. Barth now suggests that what his earlier piece was really about "was the effective 'exhaustion' not of language or of literature but of the aesthetic of high modernism."[17] And he goes on to describe Beckett's *Stories and Texts for Nothing* and Nabokov's *Pale Fire* as late modernist marvels, distinct from such postmodernist writers as Italo Calvino and Gabriel Marquez. Cultural critics like Daniel Bell, on the other hand, would simply claim that the postmodernism of the 1960s was the "logical culmination of modernist intentions,"[18] a view which rephrases Lionel Trilling's despairing observation that the demonstrators of the 1960s were prac-

ticing modernism in the streets. But my point here is precisely that high modernism had never seen fit to be in the streets in the first place, that its earlier undeniably adversary role was superseded in the 1960s by a very different culture of confrontation in the streets *and* in art works, and that this culture of confrontation transformed inherited ideological notions of style, form and creativity, artistic autonomy and the imagination to which modernism had by then succumbed. Critics like Bell and Graff saw the rebellion of the late 1950s and the 1960s as continuous with modernism's earlier nihilistic and anarchic strain; rather than seeing it as a postmodernist revolt against classical modernism, they interpreted it as a profusion of modernist impulses into everyday life. And in some sense they were absolutely right, except that this "success" of modernism fundamentally altered the terms of how modernist culture was to be perceived. Again, my argument here is that the revolt of the 1960s was never a rejection of modernism *per se*, but rather a revolt against that version of modernism which had been domesticated in the 1950s, become part of the liberal-conservative consensus of the times, and which had even been turned into a propaganda weapon in the cultural-political arsenal of Cold War anticommunism. The modernism against which artists rebelled was no longer felt to be an adversary culture. It no longer opposed a dominant class and its world view, nor had it maintained its programmatic purity from contamination by the culture industry. In other words, the revolt sprang precisely from the success of modernism, from the fact that in the United States, as in West Germany and France, for that matter, modernism had been perverted into a form of affirmative culture.

I would go on to argue that the global view which sees the 1960s as part of the modern movement extending from Manet and Baudelaire, if not from romanticism, to the present is not able to account for the specifically American character of postmodernism. After all, the term accrued its emphatic connotations in the United States, not in Europe. I would even claim that it could not have been invented in Europe at the time. For a variety of reasons, it would not have made any sense there. West Germany was still busy rediscovering its own moderns who had been burnt and banned during the Third Reich. If anything, the 1960s in West Germany produced a major shift in evaluation and interest from one set of moderns to another: from Benn, Kafka, and Thomas Mann to Brecht, the left expressionists, and the political writers of the 1920s, from Heidegger and Jaspers to Adorno and Benjamin, from Schönberg and Webern to Eisler, from Kirchner and Beckmann to Grosz and Heartfield. It was a search for alternative cultural traditions within modernity and as such directed against the

politics of a depoliticized version of modernism that had come to provide much needed cultural legitimation for the Adenauer restoration. During the 1950s, the myths of "the golden twenties," the "conservative revolution," and universal existentialist *Angst*, all helped block out and suppress the realities of the fascist past. From the depths of barbarism and the rubble of its cities, West Germany was trying to reclaim a civilized modernity and to find a cultural identity tuned to international modernism which would make others forget Germany's past as predator and pariah of the modern world. Given this context, neither the variations on modernism of the 1950s nor the struggle of the 1960s for alternative democratic and socialist cultural traditions could have possibly been construed as *post-modern*. The very notion of postmodernism has emerged in Germany only since the late 1970s and then not in relation to the culture of the 1960s, but narrowly in relation to recent architectural developments and, perhaps more importantly, in the context of the new social movements and their radical critique of modernity.[19]

In France, too, the 1960s witnessed a return to modernism rather than a step beyond it, even though for different reasons than in Germany, some of which I will discuss in the later section on poststructuralism. In the context of French intellectual life, the term 'postmodernism' was simply not around in the 1960s, and even today it does not seem to imply a major break with modernism as it does in the U.S.

I would now like to sketch four major characteristics of the early phase of postmodernism which all point to postmodernism's continuity with the international tradition of the modern, yes, but which—and this is my point—also establish American postmodernism as a movement *sui generis*.[20]

First, the postmodernism of the 1960s was characterized by a temporal imagination which displayed a powerful sense of the future and of new frontiers, of rupture and discontinuity, of crisis and generational conflict, an imagination reminiscent of earlier continental avantgarde movements such as Dada and surrealism rather than of high modernism. Thus the revival of Marcel Duchamp as godfather of 1960s postmodernism is no historical accident. And yet, the historical constellation in which the postmodernism of the 1960s played itself out (from the Bay of Pigs and the civil rights movement to the campus revolts, the anti-war movement and the counter-culture) makes this avantgarde specifically American, even where its vocabulary of aesthetic forms and techniques was not radically new.

Secondly, the early phase of postmodernism included an iconoclastic attack on what Peter Bürger has tried to capture theoretically as the

"institution art." By that term Bürger refers first and foremost to the ways in which art's role in society is perceived and defined, and, secondly, to ways in which art is produced, marketed, distributed, and consumed. In his book *Theory of the Avantgarde* Bürger has argued that the major goal of the historical European avantgarde (Dada, early surrealism, the postrevolutionary Russian avantgarde[21]) was to undermine, attack and transform the bourgeois institution art and its ideology of autonomy rather than only changing artistic and literary modes of representation. Bürger's approach to the question of art as institution in bourgeois society goes a long way toward suggesting useful distinctions between modernism and the avantgarde, distinctions which in turn can help us place the American avantgarde of the 1960s. In Bürger's account the European avantgarde was primarily an attack on the highness of high art and on art's separateness from everyday life as it had evolved in 19-century aestheticism and its repudiation of realism. Bürger argues that the avantgarde attempted to reintegrate art and life or, to use his Hegelian-Marxist formula, to sublate art into life, and he sees this reintegration attempt, I think correctly, as a major break with the aestheticist tradition of the later 19th century. The value of Bürger's account for contemporary American debates is that it permits us to distinguish different stages and different projects within the trajectory of the modern. The usual equation of the avantgarde with modernism can indeed no longer be maintained. Contrary to the avantgarde's intention to merge art and life, modernism always remained bound up with the more traditional notion of the autonomous art work, with the construction of form and meaning (however estranged or ambiguous, displaced or undecidable such meaning might be), and with the specialized status of the aesthetic.[22] The politically important point of Bürger's account for my argument about the 1960s is this: The historical avantgarde's iconoclastic attack on cultural institutions and on traditional modes of representation presupposed a society in which high art played an essential role in legitimizing hegemony, or, to put it in more neutral terms, to support a cultural establishment and its claims to aesthetic knowledge. It had been the achievement of the historical avantgarde to demystify and to undermine the legitimizing discourse of high art in European society. The various modernisms of this century, on the other hand, have either maintained or restored versions of high culture, a task which was certainly facilitated by the ultimate and perhaps unavoidable failure of the historical avantgarde to reintegrate art and life. And yet, I would suggest that it was this specific radicalism of the avantgarde, directed against the institutionalization of high art as a discourse of hegemony and a

machinery of meaning, that recommended itself as a source of energy and inspiration to the American postmodernists of the 1960s. Perhaps for the first time in American culture an avantgardist revolt against a tradition of high art and what was perceived as its hegemonic role made political sense. High art had indeed become institutionalized in the burgeoning museum, gallery, concert, record, and paperback culture of the 1950s. Modernism itself had entered the mainstream via mass reproduction and the culture industry. And, during the Kennedy years, high culture even began to take on functions of political representation with Robert Frost and Pablo Casals, Malraux and Stravinsky at the White House. The irony in all of this is that the first time the U.S. had something resembling an "institution art" in the emphatic European sense, it was modernism itself, the kind of art whose purpose had always been to resist institutionalization. In the form of happenings, pop vernacular, psychedelic art, acid rock, alternative and street theater, the postmodernism of the 1960s was groping to recapture the adversary ethos which had nourished modern art in its earlier stages, but which it seemed no longer able to sustain. Of course, the "success" of the pop avantgarde, which itself had sprung full-blown from advertising in the first place, immediately made it profitable and thus sucked it into a more highly developed culture industry than the earlier European avantgarde ever had to contend with. But despite such cooption through commodification the pop avantgarde retained a certain cutting edge in its proximity to the 1960s culture of confrontation.[23] No matter how deluded about its potential effectiveness, the attack on the institution art was always also an attack on hegemonic social institutions, and the raging battles of the 1960s over whether or not pop was legitimate art prove the point.

Thirdly, many of the early advocates of postmodernism shared the technological optimism of segments of the 1920s avantgarde. What photography and film had been to Vertov and Tretyakov, Brecht, Heartfield, and Benjamin in that period, television, video, and the computer were for the prophets of a technological aesthetic in the 1960s. McLuhan's cybernetic and technocratic media eschatology and Hassan's praise for "runaway technology," the "boundless dispersal by media," "the computer as substitute consciousness"—all of this combined easily with euphoric visions of a postindustrial society. Even if compared to the equally exuberant technological optimism of the 1920s, it is striking to see in retrospect how uncritically media technology and the cybernetic paradigm were espoused in the 1960s by conservatives, liberals, and leftists alike.[24]

The enthusiasm for the new media leads me to the fourth trend

within early postmodernism. There emerged a vigorous, though again largely uncritical attempt to validate popular culture as a challenge to the canon of high art, modernist or traditional. This "populist" trend of the 1960s with its celebration of rock 'n' roll and folk music, of the imagery of everyday life and of the multiple forms of popular literature gained much of its energy in the context of the counter-culture and by a next to total abandonment of an earlier American tradition of a critique of modern mass culture. Leslie Fiedler's incantation of the prefix "post" in his essay "The New Mutants" had an exhilarating effect at the time.[25] The postmodern harbored the promise of a "post-white," "post-male," "post-humanist," "post-Puritan" world. It is easy to see how all of Fiedler's adjectives aim at the modernist dogma and at the cultural establishment's notion of what Western Civilization was all about. Susan Sontag's camp aesthetic did much the same. Even though it was less populist, it certainly was as hostile to high modernism. There is a curious contradiction in all this. Fiedler's populism reiterates precisely that adversarial relationship between high art and mass culture which, in the accounts of Clement Greenberg and Theodor W. Adorno, was one of the pillars of the modernist dogma Fiedler had set out to undermine. Fiedler just takes his position on the other shore, opposite Greenberg and Adorno, as it were, validating the popular and pounding away at "elitism." And yet, Fiedler's call to cross the border and close the gap between high art and mass culture as well as his implied political critique of what later came to be called "eurocentrism" and "logocentrism" can serve as an important marker for subsequent developments within postmodernism. A new creative relationship between high art and certain forms of mass culture is, to my mind, indeed one of the major marks of difference between high modernism and the art and literature which followed it in the 1970s and 1980s both in Europe and the United States. And it is precisely the recent self-assertion of minority cultures and their emergence into public consciousness which has undermined the modernist belief that high and low culture have to be categorically kept apart; such rigorous segregation simply does not make much sense *within* a given minority culture which has always existed outside in the shadow of the dominant high culture.

In conclusion, I would say that from an American perspective the postmodernism of the 1960s had some of the makings of a genuine avantgarde movement, even if the overall political situation of 1960s' America was in no way comparable to that of Berlin or Moscow in the early 1920s when the tenuous and short-lived alliance between avant-gardism and vanguard politics was forged. For a number of historical

reasons the ethos of artistic avantgardism as iconoclasm, as probing reflection upon the ontological status of art in modern society, as an attempt to forge another life was culturally not yet as exhausted in the U.S. of the 1960s as it was in Europe at the same time. From a European perspective, therefore, it all looked like the endgame of the historical avantgarde rather than like the breakthrough to new frontiers it claimed to be. My point here is that American postmodernism of the 1960s was both: an American avantgarde *and* the endgame of international avantgardism. And I would go on to argue that it is indeed important for the cultural historian to analyze such *Ungleich-zeitigkeiten* within modernity and to relate them to the very specific constellations and contexts of national and regional cultures and histories. The view that the culture of modernity is essentially internationalist—with its cutting edge moving in space and time from Paris in the later 19th and early 20th centuries to Moscow and Berlin in the 1920s and to New York in the 1940s—is a view tied to a teleology of modern art whose unspoken subtext is the ideology of modernization. It is precisely this teleology and ideology of modernization which has become increasingly problematic in our postmodern age, problematic not so much perhaps in its descriptive powers relating to past events, but certainly in its normative claims.

Postmodernism in the 1970s and 1980s

In some sense, I might argue that what I have mapped so far is really the prehistory of the postmodern. After all, the term postmodernism only gained wide currency in the 1970s while much of the language used to describe the art, architecture, and literature of the 1960s was still derived—and plausibly so—from the rhetoric of avantgardism and from what I have called the ideology of modernization. The cultural developments of the 1970s, however, are sufficiently different to warrant a separate description. One of the major differences, indeed, seems to be that the rhetoric of avantgardism has faded fast in the 1970s so that one can speak perhaps only now of a genuinely postmodern and post-avantgarde culture. Even if, with the benefit of hindsight, future historians of culture were to opt for such a usage of the term, I would still argue that the adversary and critical element in the notion of postmodernism can only be fully grasped if one takes the late 1950s as the starting point of a mapping of the postmodern. If we were to focus only on the 1970s, the adversary moment of the postmodern would be much harder to work out precisely because of the shift within the

trajectory of postmodernism that lies somewhere in the fault lines between "the '6os" and "the '7os."

By the mid-1970s, certain basic assumptions of the preceding decade had either vanished or been transformed. The sense of a "futurist revolt" (Fiedler) was gone. The iconoclastic gestures of the pop, rock, and sex avantgardes seemed exhausted since their increasingly commercialized circulation had deprived them of their avantgardist status. The earlier optimism about technology, media and popular culture had given way to more sober and critical assessments: television as pollution rather than panacea. In the years of Watergate and the drawn-out agony of the Vietnam war, of the oil-shock and the dire predictions of the Club of Rome, it was indeed difficult to maintain the confidence and exuberance of the 1960s. Counter-culture, New Left and anti-war movement were ever more frequently denounced as infantile aberrations of American history. It was easy to see that the 1960s were over. But it is more difficult to describe the emerging cultural scene which seemed much more amorphous and scattered than that of the 1960s. One might begin by saying that the battle against the normative pressures of high modernism waged during the 1960s had been successful—too successful, some would argue. While the 1960s could still be discussed in terms of a logical sequence of styles (Pop, Op, Kinetic, Minimal, Concept) or in equally modernist terms of art versus anti-art and non-art, such distinctions have increasingly lost ground in the 1970s.

The situation in the 1970s seems to be characterized rather by an ever wider dispersal and dissemination of artistic practices all working out of the ruins of the modernist edifice, raiding it for ideas, plundering its vocabulary and supplementing it with randomly chosen images and motifs from pre-modern and non-modern cultures as well as from contemporary mass culture. Modernist styles have actually not been abolished, but, as one art critic recently observed, continue "to enjoy a kind of half-life in mass culture,"[26] for instance in advertising, record cover design, furniture and household items, science fiction illustration, window displays, etc. Yet another way of putting it would be to say that all modernist and avantgardist techniques, forms and images are now stored for instant recall in the computerized memory banks of our culture. But the same memory also stores all of pre-modernist art as well as the genres, codes, and image worlds of popular cultures and modern mass culture. How precisely these enormously expanded capacities for information storage, processing, and recall have affected artists and their work remains to be analyzed. But one thing seems clear: the great divide that separated high modernism from mass

culture and that was codified in the various classical accounts of modernism no longer seems relevant to postmodern artistic or critical sensibilities.

Since the categorical demand for the uncompromising segregation of high and low has lost much of its persuasive power, we may be in a better position now to understand the political pressures and historical contingencies which shaped such accounts in the first place. I would suggest that the primary place of what I am calling the great divide was the age of Stalin and Hitler when the threat of totalitarian control over all culture forged a variety of defensive strategies meant to protect high culture in general, not just modernism. Thus conservative culture critics such as Ortega y Gasset argued that high culture needed to be protected from the "revolt of the masses." Left critics like Adorno insisted that genuine art resist its incorporation into the capitalist culture industry which he defined as the total administration of culture from above. And even Lukács, the left critic of modernism *par excellence*, developed his theory of high bourgeois realism not in unison with but in antagonism to the Zhdanovist dogma of socialist realism and its deadly practice of censorship.

It is surely no coincidence that the Western codification of modernism as canon of the 20th century took place during the 1940s and 1950s, preceding and during the Cold War. I am not reducing the great modernist works, by way of a simple ideology critique of their function, to a ploy in the cultural strategies of the Cold War. What I am suggesting, however, is that the age of Hitler, Stalin, and the Cold War produced specific accounts of modernism, such as those of Clement Greenberg and Adorno,[27] whose aesthetic categories cannot be totally divorced from the pressures of that era. And it is in this sense, I would argue, that the logic of modernism advocated by those critics has become an aesthetic dead end to the extent that it has been upheld as rigid guideline for further artistic production and critical evaluation. As against such dogma, the postmodern has indeed opened up new directions and new visions. As the confrontation between "bad" socialist realism and the "good" art of the free world began to lose its ideological momentum in an age of *détente*, the whole relationship between modernism and mass culture as well as the problem of realism could be reassessed in less reified terms. While the issue was already raised in the 1960s, e.g., in pop art and various forms of documentary literature, it was only in the 1970s that artists increasingly drew on popular or mass cultural forms and genres, overlaying them with modernist and/or avantgardist strategies. A major body of work representing this tendency is the New German Cinema, and here especially

the films of Rainer Werner Fassbinder, whose success in the United States can be explained precisely in those terms. It is also no coincidence that the diversity of mass culture was now recognized and analyzed by critics who increasingly began to work themselves out from under the modernist dogma that all mass culture is monolithic Kitsch, psychologically regressive and mind-destroying. The possibilities for experimental meshing and mixing of mass culture and modernism seemed promising and produced some of the most successful and ambitious art and literature of the 1970s. Needless to say, it also produced aesthetic failures and fiascos, but then modernism itself did not only produce masterworks.

It was especially the art, writing, film-making and criticism of women and minority artists with their recuperation of buried and mutilated traditions, their emphasis on exploring forms of gender- and race-based subjectivity in aesthetic productions and experiences, and their refusal to be limited to standard canonizations, which added a whole new dimension to the critique of high modernism and to the emergence of alternative forms of culture. Thus, we have come to see modernism's imaginary relationship to African and Oriental art as deeply problematic, and will approach, say, contemporary Latin American writers other than by praising them for being good modernists, who, naturally, learned their craft in Paris. Women's criticism has shed some new light on the modernist canon itself from a variety of different feminist perspectives. Without succumbing to the kind of feminine essentialism which is one of the more problematic sides of the feminist enterprise, it just seems obvious that were it not for the critical gaze of feminist criticism, the male determinations and obsessions of Italian futurism, Vorticism, Russian constructivism, Neue Sachlichkeit or surrealism would probably still be blocked from our view; and the writings of Marie Luise Fleisser and Ingeborg Bachmann, the paintings of Frida Kahlo would still be known only to a handful of specialists. Of course such new insights can be interpreted in multiple ways, and the debate about gender and sexuality, male and female authorship and reader/spectatorship in literature and the arts is far from over, its implications for a new image of modernism not yet fully elaborated.

In light of these developments it is somewhat baffling that feminist criticism has so far largely stayed away from the postmodernism debate which is considered not to be pertinent to feminist concerns. The fact that to date only male critics have addressed the problem of modernity/postmodernity, however, does not mean that it does not concern women. I would argue—and here I am in full agreement with Craig

Owens[28]—that women's art, literature, and criticism are an important part of the postmodern culture of the 1970s and 1980s and indeed a measure of the vitality and energy of that culture. Actually, the suspicion is in order that the conservative turn of these past years has indeed something to do with the sociologically significant emergence of various forms of "otherness" in the cultural sphere, all of which are perceived as a threat to the stability and sanctity of canon and tradition. Current attempts to restore a 1950s version of high modernism for the 1980s certainly point in that direction. And it is in this context that the question of neo-conservatism becomes politically central to the debate about the postmodern.

Habermas and the Question of Neo-Conservatism

Both in Europe and the U.S., the waning of the 1960s was accompanied by the rise of neo-conservatism, and soon enough there emerged a new constellation characterized by the terms postmodernism and neo-conservatism. Even though their relationship was never fully elaborated, the left took them to be compatible with each other or even identical, arguing that postmodernism was the kind of affirmative art that could happily coexist with political and cultural neo-conservatism. Until very recently, the question of the postmodern was simply not taken seriously on the left,[29] not to speak of those traditionalists in the academy or the museum for whom there is still nothing new and worthwhile under the sun since the advent of modernism. The left's ridiculing of postmodernism was of a piece with its often haughty and dogmatic critique of the counter-cultural impulses of the 1960s. During much of the 1970s, after all, the thrashing of the 1960s was as much a pastime of the left as it was the gospel according to Daniel Bell.

Now, there is no doubt that much of what went under the label of postmodernism in the 1970s is indeed affirmative, not critical, in nature, and often, especially in literature, remarkably similar to tendencies of modernism which it so vocally repudiates. But not all of it is simply affirmative, and the wholesale writing off of postmodernism as a symptom of capitalist culture in decline is reductive, unhistorical and all too reminiscent of Lukács' attacks on modernism in the 1930s. Can one really make such clear-cut distinctions as to uphold modernism, today, as the only valid form of 20th-century "realism,"[30] an art that is adequate to the *condition moderne*, while simultaneously reserving all the old epitheta—inferior, decadent, pathological—to postmodernism? And isn't it ironic that many of the same critics who will insist on this distinction are the first ones to declare emphatically that modernism

already had it all and that there is really nothing new in post-modernism . . .

I would instead argue that in order not to become the Lukács of the postmodern by opposing, today, a "good" modernism to a "bad" post-modernism, we try to salvage the postmodern from its assumed total collusion with neo-conservatism wherever possible; and that we explore the question whether postmodernism might not harbor productive contradictions, perhaps even a critical and oppositional potential. If the postmodern is indeed a historical and cultural condition (however transitional or incipient), then oppositional cultural practices and strategies must be located *within* postmodernism, not necessarily in its gleaming façades, to be sure, but neither in some outside ghetto of a properly 'progressive' or a correctly 'aesthetic' art. Just as Marx analyzed the culture of modernity dialectically as bringing both progress and destruction,[31] the culture of postmodernity, too, must be grasped in its gains as well as in its losses, in its promises as well as in its depravations; and yet, it may be precisely one of the characteristics of the postmodern that the relationship between progress and destruction of cultural forms, between tradition and modernity can no longer be understood today the same way Marx understood it at the dawn of modernist culture.

It was, of course, Jürgen Habermas' intervention which, for the first time, raised the question of postmodernism's relationship to neo-conservatism in a theoretically and historically complex way. Ironically, however, the effect of Habermas' argument, which identified the post-modern with various forms of conservatism, was to reinforce leftist cultural stereotypes rather than challenge them. In his 1980 Adorno-prize lecture,[32] which has become a focal point for the debate, Haber-mas criticized both conservatism (old, neo, and young) and postmod-ernism for not coming to terms either with the exigencies of culture in late capitalism or with the successes and failures of modernism itself. Significantly, Habermas' notion of modernity—the modernity he wishes to see continued and completed—is purged of modernism's nihilistic and anarchic strain just as his opponents', e.g., Lyotard's,[33] notion of an aesthetic (post)modernism is determined to liquidate any trace of the enlightened modernity inherited from the 18th century which provides the basis for Habermas' notion of modern culture. Rather than rehearsing the theoretical differences between Habermas and Lyotard one more time—a task which Martin Jay has performed admirably in a recent article on "Habermas and Modernism"[34]—I want to point to the German context of Habermas' reflections which is too

readily forgotten in American debates, since Habermas himself refers to it only marginally.

Habermas' attack on postmodern conservatisms took place on the heels of the political *Tendenzwende* of the mid-1970s, the conservative backlash which has affected several Western countries. He could cite an analysis of American neo-conservatism without even having to belabor the point that the neo-conservative strategies to regain cultural hegemony and to wipe out the effect of the 1960s in political and cultural life are very similar in the FRG. But the national contingencies of Habermas' argument are at least as important. He was writing at the tail end of a major thrust of modernization of German cultural and political life which seemed to have gone awry sometime during the 1970s, producing high levels of disillusionment both with the utopian hopes and the pragmatic promises of 1968/69. Against the growing cynicism, which has since then been brilliantly diagnosed and criticized in Peter Sloterdijk's *Kritik der zynischen Vernunft* as a form of "enlightened false consciousness,"[35] Habermas tries to salvage the emancipatory potential of enlightened reason which to him is the *sine qua non* of political democracy. Habermas defends a substantive notion of communicative rationality, especially against those who will collapse reason with domination, believing that by abandoning reason they free themselves from domination. Of course Habermas' whole project of a critical social theory revolves around a defense of enlightened modernity, which is *not* identical with the aesthetic modernism of literary critics and art historians. It is directed simultaneously against political conservatism (neo or old) and against what he perceives, not unlike Adorno, as the cultural irrationality of a post-Nietzschean aestheticism embodied in surrealism and subsequently in much of contemporary French theory. The defense of enlightenment in Germany is and remains an attempt to fend off the reaction from the right.

During the 1970s, Habermas could observe how German art and literature abandoned the explicit political commitments of the 1960s, a decade often described in Germany as a "second enlightenment"; how autobiography and *Erfahrungstexte* replaced the documentary experiments in prose and drama of the preceding decade; how political poetry and art made way for a new subjectivity, a new romanticism, a new mythology; how a new generation of students and young intellectuals became increasingly weary of theory, left politics and social science, preferring instead to flock toward the revelations of ethnology and myth. Even though Habermas does not address the art and literature of the 1970s directly—with the exception of the late work of Peter

Weiss, which is itself an exception—it seems not too much to assume that he interpreted this cultural shift in light of the political *Tendenz-wende*. Perhaps his labelling of Foucault and Derrida as young conservatives is as much a response to German cultural developments as it is to the French theorists themselves. Such a speculation may draw plausibility from the fact that since the late 1970s certain forms of French theory have been quite influential, especially in the subcultures of Berlin and Frankfurt, among those of the younger generation who have turned away from critical theory made in Germany.

It would be only a small step, then, for Habermas to conclude that a post-modern, post-avantgarde art indeed fits in all too smoothly with various forms of conservatism, and is predicated on abandoning the emancipatory project of modernity. But to me, there remains the question of whether these aspects of the 1970s—despite their occasionally high levels of self-indulgence, narcissism, and false immediacy—do not also represent a deepening and a constructive displacement of the emancipatory impulses of the 1960s. But one does not have to share Habermas' positions on modernity and modernism to see that he did indeed raise the most important issues at stake in a form that avoided the usual apologies and facile polemics about modernity and postmodernity.

His questions were these: How does postmodernism relate to modernism? How are political conservatism, cultural eclecticism or pluralism, tradition, modernity, and anti-modernity interrelated in contemporary Western culture? To what extent can the cultural and social formation of the 1970s be characterized as postmodern? And, further, to what extent is postmodernism a revolt against reason and enlightenment, and at what point do such revolts become reactionary—a question heavily loaded with the weight of recent German history? In comparison, the standard American accounts of postmodernism too often remain entirely tied to questions of aesthetic style or strategy; the occasional nod toward theories of a postindustrial society is usually intended as a reminder that any form of Marxist or neo-Marxist thought is simply obsolete. In the American debate, three positions can be schematically outlined. Postmodernism is dismissed outright as a fraud and modernism held up as the universal truth, a view which reflects the thinking of the 1950s. Or modernism is condemned as elitist and postmodernism praised as populist, a view which reflects the thinking of the 1960s. Or there is the truly 1970s proposition that "anything goes," which is consumer capitalism's cynical version of "nothing works," but which at least recognizes that the older dichoto-

mies have lost much of their meaning. Needless to say, none of these positions ever reached the level of Habermas' interrogation.

However, there were problems not so much with the questions Habermas raised, as with some of the answers he suggested. Thus his attack on Foucault and Derrida as young conservatives drew immediate fire from poststructuralist quarters, where the reproach was turned around and Habermas himself was labelled a conservative. At this point, the debate was quickly reduced to the silly question: "Mirror, mirror on the wall, who is the least conservative of us all?" And yet, the battle between "Frankfurters and French fries," as Rainer Nägele once referred to it, is instructive because it highlights two fundamentally different visions of modernity. The French vision of modernity begins with Nietzsche and Mallarmé and is thus quite close to what literary criticism describes as modernism. Modernity for the French is primarily—though by no means exclusively—an aesthetic question relating to the energies released by the deliberate destruction of language and other forms of representation. For Habermas, on the other hand, modernity goes back to the best traditions of the Enlightenment, which he tries to salvage and to reinscribe into the present philosophical discourse in a new form. In this, Habermas differs radically from an earlier generation of Frankfurt School critics, Adorno and Horkheimer who, in *The Dialectic of Enlightenment*, developed a view of modernity which seems to be much closer in sensibility to current French theory than to Habermas. But even though Adorno and Horkheimer's assessment of the enlightenment was so much more pessimistic than Habermas',[36] they also held on to a substantive notion of reason and subjectivity which much of French theory has abandoned. It seems that in the context of the French discourse, enlightenment is simply identified with a history of terror and incarceration that reaches from the Jacobins via the *métarécits* of Hegel and Marx to the Soviet Gulag. I think Habermas is right in rejecting that view as too limited and as politically dangerous. Auschwitz, after all, did *not* result from too much enlightened reason—even though it was organized as a perfectly rationalized death factory—but from a violent anti-enlightenment and anti-modernity affect, which exploited modernity ruthlessly for its own purposes. At the same time, Habermas' turn against the French post-Nietzschean vision of *modernité* as simply anti-modern or, as it were, postmodern, itself implies too limited an account of modernity, at least as far as aesthetic modernity is concerned.

In the uproar over Habermas' attack on the French poststructuralists, the American and European neo-conservatives were all but forgot-

ten, but I think we should at least take cognizance of what cultural neo-conservatives actually say about postmodernism. The answer is fairly simple and straightforward: they reject it and they think it is dangerous. Two examples: Daniel Bell, whose book on the postindustrial society has been quoted time and again as supporting sociological evidence by advocates of postmodernism, actually rejects postmodernism as a dangerous popularization of the modernist aesthetic. Bell's modernism only aims at aesthetic pleasure, immediate gratification and intensity of experience, all of which, to him, promote hedonism and anarchy. It is easy to see how such a jaundiced view of modernism is quite under the spell of those "terrible" 1960s and cannot at all be reconciled with the austere high modernism of a Kafka, a Schönberg or a T. S. Eliot. At any rate, Bell sees modernism as something like an earlier society's chemical waste deposit which, during the 1960s, began to spill over, not unlike Love Canal, into the mainstream of culture, polluting it to the core. Ultimately, Bell argues in *The Cultural Contradictions of Capitalism*, modernism and postmodernism together are responsible for the crisis of contemporary capitalism.[37] Bell—a postmodernist? Certainly not in the aesthetic sense, for Bell actually shares Habermas' rejection of the nihilistic and aestheticist trend within modernist/postmodernist culture. But Habermas may have been right in the broader political sense. For Bell's critique of contemporary capitalist culture is energized by a vision of a society in which the values and norms of everyday life would no longer be infected by aesthetic modernism, a society which, within Bell's framework, one might have to call post-modern. But any such reflection on neo-conservatism as a form of anti-liberal, anti-progressive postmodernity remains beside the point. Given the aesthetic force-field of the term postmodernism, no neo-conservative today would dream of identifying the neo-conservative project as postmodern.

On the contrary, cultural neo-conservatives often appear as the last-ditch defenders and champions of modernism. Thus in the editorial to the first issue of *The New Criterion* and in an accompanying essay entitled "Postmodern: Art and Culture in the 1980s,"[38] Hilton Kramer rejects the postmodern and counters it with a nostalgic call for the restoration of modernist standards of quality. Differences between Bell's and Kramer's accounts of modernism notwithstanding, their assessment of postmodernism is identical. In the culture of the 1970s, they will only see loss of quality, dissolution of the imagination, decline of standards and values, and the triumph of nihilism. But their agenda is not art history. Their agenda is political. Bell argues that postmodernism "undermines the social structure itself by striking at the motiva-

tional and psychic-reward system which has sustained it."[39] Kramer attacks the politicization of culture which, in his view, the 1970s have inherited from the 1960s, that "insidious assault on the mind." And like Rudi Fuchs and the 1982 Documenta, he goes on to shove art back into the closet of autonomy and high seriousness where it is supposed to uphold the new criterion of truth. Hilton Kramer—a postmodernist? No, Habermas was simply wrong, it seems, in his linkage of the postmodern with neo-conservatism. But again the situation is more complex than it seems. For Habermas, modernity means critique, enlightenment, and human emancipation, and he is not willing to jettison this political impulse because doing so would terminate left politics once and for all. Contrary to Habermas, the neo-conservative resorts to an established tradition of standards and values which are immune to criticism and change. To Habermas, even Hilton Kramer's neo-conservative defense of a modernism deprived of its adversary cutting edge would have to appear as post-modern, post-modern in the sense of anti-modern. The question in all of this is absolutely not whether the classics of modernism are or are not great works of art. Only a fool could deny that they are. But a problem does surface when their greatness is used as unsurpassable model and appealed to in order to stifle contemporary artistic production. Where that happens, modernism itself is pressed into the service of anti-modern resentment, a figure of discourse which has a long history in the multiple *querelles des anciens et des modernes*.

The only place where Habermas could rest assured of neo-conservative applause is in his attack on Foucault and Derrida. Any such applause, however, would carry the proviso that neither Foucault nor Derrida be associated with conservatism. And yet, Habermas was right, in a sense, to connect the postmodernism problematic with poststructuralism. Roughly since the late 1970s, debates about aesthetic postmodernism and poststructuralist criticism have intersected in the United States. The relentless hostility of neo-conservatives to both poststructuralism and postmodernism may not prove the point, but it is certainly suggestive. Thus the February 1984 issue of *The New Criterion* contains a report by Hilton Kramer on the Modern Language Association's centennial convention in New York, and the report is polemically entitled "The MLA Centennial Follies." The major target of the polemic is precisely French poststructuralism and its American appropriation. But the point is not the quality or the lack thereof in certain presentations at the convention. Again, the real issue is a political one. Deconstruction, feminist criticism, Marxist criticism, all lumped together as undesirable aliens, are said to have subverted

American intellectual life via the academy. Reading Kramer, the cultural apocalypse seems near, and there would be no reason for surprise if *The New Criterion* were soon to call for an import quota on foreign theory.

What, then, can one conclude from these ideological skirmishes for a mapping of postmodernism in the 1970s and 1980s? First, Habermas was both right and wrong about the collusion of conservatism and postmodernism, depending on whether the issue is the neo-conservative political vision of a post-modern society freed from all aesthetic, i.e., hedonistic, modernist and postmodernist subversions, or whether the issue is aesthetic postmodernism. Secondly, Habermas and the neo-conservatives are right in insisting that postmodernism is not so much a question of style as it is a question of politics and culture at large. The neo-conservative lament about the politicization of culture since the 1960s is only ironic in this context since they themselves have a thoroughly political notion of culture. Thirdly, the neo-conservatives are also right in suggesting that there are continuities between the oppositional culture of the 1960s and that of the 1970s. But their obsessive fixation on the 1960s, which they try to purge from the history books, blinds them to what is different and new in the cultural developments of the 1970s. And, fourthly, the attack on poststructuralism by Habermas and the American neo-conservatives raises the question of what to make of that fascinating interweaving and intersecting of poststructuralism with postmodernism, a phenomenon that is much more relevant in the U.S. than in France. It is to this question that I will now turn in my discussion of the critical discourse of American postmodernism in the 1970s and 1980s.

Poststructuralism: Modern or Postmodern?

The neo-conservative hostility toward both is not really enough to establish a substantive link between postmodernism and poststructuralism; and it may indeed be more difficult to establish such a link than it would seem at first. Certainly, since the late 1970s we have seen a consensus emerge in the U.S. that if postmodernism represents the contemporary "avantgarde" in the arts, poststructuralism must be its equivalent in "critical theory."[40] Such a parallelization is itself favored by theories and practices of textuality and intertextuality which blur the boundaries between the literary and the critical text, and thus it is not surprising that the names of the French *maîtres penseurs* of our time occur with striking regularity in the discourse on the postmodern.[41] On a superficial level, the parallels seem indeed obvious. Just as postmod-

ern art and literature have taken the place of an earlier modernism as the major trend of our times, poststructuralist criticism has decisively passed beyond the tenets of its major predecessor, the New Criticism. And just as the New Critics championed modernism, so the story goes, poststructuralism—as one of the most vital forces of the intellectual life of the 1970s—must somehow be allied with the art and literature of its own time, i.e., with postmodernism.[42] Actually, such thinking, which is quite prevalent if not always made explicit, gives us a first indication of how American postmodernism still lives in the shadow of the moderns. For there is no theoretical or historical reason to elevate the synchronism of the New Criticism with high modernism into norm or dogma. Mere simultaneity of critical and artistic discourse formations does not *per se* mean that they have to overlap, unless, of course, the boundaries between them are intentionally dismantled, as they are in modernist and postmodernist literature as well as in poststructuralist discourse.

And yet, however much postmodernism and poststructuralism in the U.S. may overlap and mesh, they are far from identical or even homologous. I do not question that the theoretical discourse of the 1970s has had a profound impact on the work of a considerable number of artists both in Europe and in the U.S. What I do question, however, is the way in which this impact is automatically evaluated in the U.S. as postmodern and thus sucked into the orbit of the kind of critical discourse that emphasizes radical rupture and discontinuity. Actually, both in France and in the U.S. poststructuralism is much closer to modernism than is usually assumed by the advocates of postmodernism. The distance that does exist between the critical discourses of the New Criticism and poststructuralism (a constellation which is only pertinent in the U.S., not in France) is not identical with the differences between modernism and postmodernism. I will argue that poststructuralism is primarily a discourse of and about modernism,[43] and that if we are to locate the postmodern in poststructuralism it will have to be found in the ways various forms of poststructuralism have opened up new problematics in modernism and have reinscribed modernism into the discourse formations of our own time.

Let me elaborate my view that poststructuralism can be perceived, to a significant degree, as a theory of modernism. I will limit myself here to certain points that relate back to my discussion of the modernism/postmodernism constellation in the 1960s and 1970s: the questions of aestheticism and mass culture, subjectivity and gender.

If it is true that postmodernity is a historical condition making it sufficiently unique and different from modernity, then it is striking to see how deeply the poststructuralist critical discourse—in its obsession

with *écriture* and writing, allegory and rhetoric, and in its displacement of revolution and politics to the aesthetic—is embedded in that very modernist tradition which, at least in American eyes, it presumably transcends. What we find time and again is that American poststructuralist writers and critics emphatically privilege aesthetic innovation and experiment; that they call for self-reflexiveness, not, to be sure, of the author-subject, but of the text; that they purge life, reality, history, society from the work of art and its reception, and construct a new autonomy, based on a pristine notion of textuality, a new art for art's sake which is presumably the only kind possible after the failure of all and any commitment. The insight that the subject is constituted in language and the notion that there is nothing outside the text have led to the privileging of the aesthetic and the linguistic which aestheticism has always promoted to justify its imperial claims. The list of 'no longer possibles' (realism, representation, subjectivity, history, etc., etc.) is as long in poststructuralism as it used to be in modernism, and it is very similar indeed.

Much recent writing has challenged the American domestication of French poststructuralism.[44] But it is not enough to claim that in the transfer to the U.S. French theory lost the political edge it has in France. The fact is that even in France the political implications of certain forms of poststructuralism are hotly debated and in doubt.[45] It is not just the institutional pressures of American literary criticism which have depoliticized French theory; the aestheticist trend *within* poststructuralism itself has facilitated the peculiar American reception. Thus it is no coincidence that the politically weakest body of French writing (Derrida and the late Barthes) has been privileged in American literature departments over the more politically intended projects of Foucault and Baudrillard, Kristeva and Lyotard. But even in the more politically conscious and self-conscious theoretical writing in France, the tradition of modernist aestheticism—mediated through an extremely selective reading of Nietzsche—is so powerful a presence that the notion of a radical rupture between the modern and the postmodern cannot possibly make much sense. It is furthermore striking that despite the considerable differences between the various poststructuralist projects, none of them seems informed in any substantial way by postmodernist works of art. Rarely, if ever, do they even address postmodernist works. In itself, this does not vitiate the power of the theory. But it does make for a kind of dubbing where the poststructuralist language is not in sync with the lips and movements of the postmodern body. There is no doubt that center stage in critical theory is held by the classical modernists: Flaubert, Proust and Bataille

in Barthes; Nietzsche and Heidegger, Mallarmé and Artaud in Derrida; Nietzsche, Magritte and Bataille in Foucault; Mallarmé and Lautréamont, Joyce and Artaud in Kristeva; Freud in Lacan; Brecht in Althusser and Macherey, and so on *ad infinitum*. The enemies still are realism and representation, mass culture and standardization, grammar, communication, and the presumably all-powerful homogenizing pressures of the modern State.

I think we must begin to entertain the notion that rather than offering a *theory of postmodernity* and developing an analysis of contemporary culture, French theory provides us primarily with an *archeology of modernity*, a theory of modernism at the stage of its exhaustion. It is as if the creative powers of modernism had migrated into theory and come to full self-consciousness in the poststructuralist text—the owl of Minerva spreading its wings at the fall of dusk. Poststructuralism offers a theory of modernism characterized by *Nachträglichkeit*, both in the psychoanalytic and the historical sense. Despite its ties to the tradition of modernist aestheticism, it offers a reading of modernism which differs substantially from those offered by the New Critics, by Adorno or by Greenberg. It is no longer the modernism of "the age of anxiety," the ascetic and tortured modernism of a Kafka, a modernism of negativity and alienation, ambiguity and abstraction, the modernism of the closed and finished work of art. Rather, it is a modernism of playful transgression, of an unlimited weaving of textuality, a modernism all confident in its rejection of representation and reality, in its denial of the subject, of history, and of the subject of history; a modernism quite dogmatic in its rejection of presence and in its unending praise of lacks and absences, deferrals and traces which produce, presumably, not anxiety but, in Roland Barthes' terms, *jouissance*, bliss.[46]

But if poststructuralism can be seen as the *revenant* of modernism in the guise of theory, then that would also be precisely what makes it postmodern. It is a postmodernism that works itself out not as a rejection of modernism, but rather as a retrospective reading which, in some cases, is fully aware of modernism's limitations and failed political ambitions. The dilemma of modernism had been its inability, despite the best intentions, to mount an effective critique of bourgeois modernity and modernization. The fate of the historical avantgarde especially had proven how modern art, even where it ventured beyond art for art's sake, was ultimately forced back into the aesthetic realm. Thus the gesture of poststructuralism, to the extent that it abandons all pretense to a critique that would go beyond language games, beyond epistemology and the aesthetic, seems at least plausible and logical. It certainly frees art and literature from that overload of responsibili-

ties—to change life, change society, change the world—on which the historical avantgarde shipwrecked, and which lived on in France through the 1950s and 1960s embodied in the figure of Jean Paul Sartre. Seen in this light, poststructuralism seems to seal the fate of the modernist project which, even where it limited itself to the aesthetic sphere, always upheld a vision of a redemption of modern life through culture. That such visions are no longer possible to sustain may be at the heart of the postmodern condition, and it may ultimately vitiate the poststructuralist attempt to salvage aesthetic modernism for the late 20th century. At any rate, it all begins to ring false when poststructuralism presents itself, as it frequently does in American writings, as the latest "avantgarde" in criticism, thus ironically assuming, in its institutional *Selbstverständnis*, the kind of teleological posturing which poststructuralism itself has done so much to criticize.

But even where such pretense to academic avantgardism is not the issue, one may well ask whether the theoretically sustained self-limitation to language and textuality has not been too high a price to pay; and whether it is not this self-limitation (with all it entails) which makes this poststructuralist modernism look like the atrophy of an earlier aestheticism rather than its innovative transformation. I say atrophy because the turn-of-the-century European aestheticism could still hope to establish a realm of beauty in opposition to what it perceived as the vulgarities of everyday bourgeois life, an artificial paradise thoroughly hostile to official politics and the kind of jingoism known in Germany as *Hurrapatriotismus*. Such an adversary function of aestheticism, however, can hardly be maintained at a time when capital itself has taken the aesthetic straight into the commodity in the form of styling, advertising, and packaging. In an age of commodity aesthetics, aestheticism itself has become questionable either as an adversary or as a hibernating strategy. To insist on the adversary function of *écriture* and of breaking linguistic codes when every second ad bristles with domesticated avantgardist and modernist strategies strikes me as caught precisely in that very overestimation of art's transformative *function* for society which is the signature of an earlier, modernist, age. Unless, of course, *écriture* is merely practiced as a glass bead game in happy, resigned, or cynical isolation from the realm the uninitiated keep calling reality.

Take the later Roland Barthes.[47] His *The Pleasure of the Text* has become a major, almost canonical formulation of the postmodern for many American literary critics who may not want to remember that already twenty years ago Susan Sontag had called for an erotics of art intended to replace the stuffy and stifling project of academic inter-

pretation. Whatever the differences between Barthes' *jouissance* and Sontag's erotics (the rigors of New Criticism and structuralism being the respective *Feindbilder*), Sontag's gesture, at the time, was a relatively radical one precisely in that it insisted on presence, on a sensual experience of cultural artifacts; in that it attacked rather than legitimized a socially sanctioned canon whose prime values were objectivity and distance, coolness and irony; and in that it licensed the flight from the lofty horizons of high culture into the netherlands of pop and camp.

Barthes, on the other hand, positions himself safely within high culture and the modernist canon, maintaining equal distance from the reactionary right which champions anti-intellectual pleasures and the pleasure of anti-intellectualism, and the boring left which favors knowledge, commitment, combat, and disdains hedonism. The left may indeed have forgotten, as Barthes claims, the cigars of Marx and Brecht.[48] But however convincing cigars may or may not be as signifiers of hedonism, Barthes himself certainly forgets Brecht's constant and purposeful immersion in popular and mass culture. Barthes' very un-Brechtian distinction between *plaisir* and *jouissance*—which he simultaneously makes and unmakes[49]—reiterates one of the most tired topoi of the modernist aesthetic and of bourgeois culture at large: there are the lower pleasures for the rabble, i.e., mass culture, and then there is the *nouvelle cuisine* of the pleasure of the text, of *jouissance*. Barthes himself describes *jouissance* as a "mandarin praxis,"[50] as a conscious retreat, and he describes modern mass culture in the most simplistic terms as petit-bourgeois. Thus his appraisal of *jouissance* depends on the adoption of that traditional view of mass culture that the right and the left, both of which he so emphatically rejects, have shared over the decades.

This becomes even more explicit in *The Pleasure of the Text* where we read: "The bastard form of mass culture is humiliated repetition: content, ideological schema, the blurring of contradictions—these are repeated, but the superficial forms are varied: always new books, new programs, new films, news items, but always the same meaning."[51] Word for word, such sentences could have been written by Adorno in the 1940s. But, then, everybody knows that Adorno's was a theory of modernism, not of postmodernism. Or was it? Given the ravenous eclecticism of postmodernism, it has recently become fashionable to include even Adorno and Benjamin into the canon of postmodernists *avant la lettre*—truly a case of the critical text writing itself without the interference of any historical consciousness whatsoever. Yet the closeness of some of Barthes' basic propositions to the modernist aesthetic

could make such a rapprochement plausible. But then one might want to stop talking of postmodernism altogether, and take Barthes' writing for what it is: a theory of modernism which manages to turn the dung of post-68 political disillusionment into the gold of aesthetic bliss. The melancholy science of Critical Theory has been transformed miraculously into a new "gay science," but it still is, essentially, a theory of modernist literature.

Barthes and his American fans ostensibly reject the modernist notion of negativity replacing it with play, bliss, *jouissance*, i.e., with a presumably critical form of affirmation. But the very distinction between the *jouissance* provided by the modernist, "writerly" text and the mere pleasure (*plaisir*) provided by "the text that contents, fills, grants euphoria,"[52] reintroduces, through the back door, the same high culture/low culture divide and the same type of evaluations that were constitutive of classical modernism. The negativity of Adorno's aesthetic was predicated on the consciousness of the mental and sensual depravations of modern mass culture and on his relentless hostility to a society which needs such depravation to reproduce itself. The euphoric American appropriation of Barthes' *jouissance* is predicated on ignoring such problems and on enjoying, not unlike the 1984 yuppies, the pleasures of writerly connoisseurism and textual gentrification. That, indeed, may be a reason why Barthes has hit a nerve in the American academy of the Reagan years, making him the favorite son who has finally abandoned his earlier radicalism and come to embrace the finer pleasures of life, pardon, the text.[53] But the problems with the older theories of a modernism of negativity are not solved by somersaulting from anxiety and alienation into the bliss of *jouissance*. Such a leap diminishes the wrenching experiences of modernity articulated in modernist art and literature; it remains bound to the modernist paradigm by way of simple reversal; and it does very little to elucidate the problem of the postmodern.

Just as Barthes' theoretical distinctions between *plaisir* and *jouissance*, the readerly and the writerly text, remain within the orbit of modernist aesthetics, so the predominant poststructuralist notions about authorship and subjectivity reiterate propositions known from modernism itself. A few brief comments will have to suffice.

In a discussion of Flaubert and the writerly, i.e., modernist, text Barthes writes: "He [Flaubert] does not stop the play of codes (or stops it only partially), so that (and this is indubitably the proof of writing) *one never knows if he is responsible for what he writes* (if there is a subject *behind* his language); for the very being of writing (the meaning of the labor that constitutes it) is to keep the question *Who is speaking?* from ever

being answered."[54] A similarly prescriptive denial of authorial subjectivity underlies Foucault's discourse analysis. Thus Foucault ends his influential essay "What Is an Author?" by asking rhetorically "What matter who's speaking?" Foucault's "murmur of indifference"[55] affects both the writing and the speaking subject, and the argument assumes its full polemical force with the much broader anti-humanist proposition, inherited from structuralism, of the "death of the subject." But none of this is more than a further elaboration of the modernist critique of traditional idealist and romantic notions of authorship and authenticity, originality and intentionality, self-centered subjectivity and personal identity. More importantly, it seems to me that as a postmodern, having gone through the modernist purgatory, I would ask different questions. Isn't the "death of the subject/author" position tied by mere reversal to the very ideology that invariably glorifies the artist as genius, whether for marketing purposes or out of conviction and habit? Hasn't capitalist modernization itself fragmented and dissolved bourgeois subjectivity and authorship, thus making attacks on such notions somewhat quixotic? And, finally, doesn't poststructuralism, where it simply denies the subject altogether, jettison the chance of challenging the *ideology of the subject* (as male, white, and middle-class) by developing alternative and different notions of subjectivity?

To reject the validity of the question Who is writing? or Who is speaking? is simply no longer a radical position in 1984. It merely duplicates on the level of aesthetics and theory what capitalism as a system of exchange relations produces tendentially in everyday life: the denial of subjectivity in the very process of its construction. Poststructuralism thus attacks the appearance of capitalist culture—individualism writ large—but misses its essence; like modernism, it is always also in sync with rather than opposed to the real processes of modernization.

The postmoderns have recognized this dilemma. They counter the modernist litany of the death of the subject by working toward new theories and practices of speaking, writing and acting subjects.[56] The question of how codes, texts, images, and other cultural artifacts constitute subjectivity is increasingly being raised as an always already historical question. And to raise the question of subjectivity at all no longer carries the stigma of being caught in the trap of bourgeois or petit-bourgeois ideology; the discourse of subjectivity has been cut loose from its moorings in bourgeois individualism. It is certainly no accident that questions of subjectivity and authorship have resurfaced with a vengeance in the postmodern text. After all, it *does* matter who is speaking or writing.

Summing up, then, we face the paradox that a body of theories of modernism and modernity, developed in France since the 1960s, has come to be viewed, in the U.S., as the embodiment of the postmodern in theory. In a certain sense, this development is perfectly logical. Poststructuralism's readings of modernism are new and exciting enough to be considered somehow beyond modernism as it has been perceived before; in this way poststructuralist criticism in the U.S. yields to the very real pressures of the postmodern. But against any facile conflation of poststructuralism with the postmodern, we must insist on the fundamental non-identity of the two phenomena. In America, too, poststructuralism offers a theory of modernism, not a theory of the postmodern.

As to the French theorists themselves, they rarely speak of the postmodern. Lyotard's *La Condition Postmoderne*, we must remember, is the exception, not the rule.[57] What French intellectuals explicitly analyze and reflect upon is *le texte moderne* and *la modernité*. Where they talk about the postmodern at all, as in the cases of Lyotard and Kristeva,[58] the question seems to have been prompted by American friends, and the discussion almost immediately and invariably turns back to problems of the modernist aesthetic. For Kristeva, the question of postmodernism is the question of how anything can be written in the 20th century and how we can talk about this writing. She goes on to say that postmodernism is "that literature which writes itself with the more or less conscious intention of expanding the signifiable and thus the human realm."[59] With the Bataillean formulation of writing-as-experience of limits, she sees the major writing since Mallarmé and Joyce, Artaud and Burroughs as the "exploration of the typical imaginary relationship, that to the mother, through the most radical and problematic aspect of this relationship, language."[60] Kristeva's is a fascinating and novel approach to the question of modernist literature, and one that understands itself as a political intervention. But it does not yield much for an exploration of the differences between modernity and postmodernity. Thus it cannot surprise that Kristeva still shares with Barthes and the classical theorists of modernism an aversion to the media whose function, she claims, is to collectivize all systems of signs thus enforcing contemporary society's general tendency toward uniformity.

Lyotard, who like Kristeva and unlike the deconstructionists is a political thinker, defines the postmodern, in his essay "Answering the Question: What is Postmodernism?," as a recurring stage within the modern itself. He turns to the Kantian sublime for a theory of the nonrepresentable essential to modern art and literature. Paramount

are his interest in rejecting representation, which is linked to terror
and totalitarianism, and his demand for radical experimentation in the
arts. At first sight, the turn to Kant seems plausible in the sense that
Kant's autonomy aesthetic and notion of "disinterested pleasure"
stands at the threshold of a modernist aesthetic, at a crucial juncture of
that differentiation of spheres which has been so important in social
thought from Weber to Habermas. And yet, the turn to Kant's sublime
forgets that the 18th-century fascination with the sublime of the uni-
verse, the cosmos, expresses precisely that very desire of totality and
representation which Lyotard so abhors and persistently criticizes in
Habermas' work.[61] Perhaps Lyotard's text says more here than it means
to. If historically the notion of the sublime harbors a secret desire for
totality, then perhaps Lyotard's sublime can be read as an attempt to
totalize the aesthetic realm by fusing it with all other spheres of life,
thus wiping out the differentiations between the aesthetic realm and
the life-world on which Kant did after all insist. At any rate, it is no
coincidence that the first moderns in Germany, the Jena romantics,
built their aesthetic strategies of the fragment precisely on a rejection
of the sublime which to them had become a sign of the falseness of
bourgeois accommodation to absolutist culture. Even today the sub-
lime has not lost its link to terror which, in Lyotard's reading, it
opposes. For what would be more sublime and unrepresentable than
the nuclear holocaust, the bomb being the signifier of an ultimate
sublime. But apart from the question whether or not the sublime is an
adequate aesthetic category to theorize contemporary art and litera-
ture, it is clear that in Lyotard's essay the postmodern as aesthetic
phenomenon is not seen as distinct from modernism. The crucial
historical distinction which Lyotard offers in *La Condition Postmoderne* is
that between the *métarécits* of liberation (the French tradition of en-
lightened modernity) and of totality (the German Hegelian/Marxist
tradition) on the one hand, and the modernist experimental discourse
of language games on the other. Enlightened modernity and its pre-
sumable consequences are pitted against aesthetic modernism. The
irony in all of this, as Fred Jameson has remarked,[62] is that Lyotard's
commitment to radical experimentation is politically "very closely re-
lated to the conception of the revolutionary nature of high modernism
that Habermas faithfully inherited from the Frankfurt School."

No doubt, there are historically and intellectually specific reasons for
the French resistance to acknowledging the problem of the postmod-
ern as a historical problem of the late 20th century. At the same time,
the force of the French rereading of modernism proper is itself shaped
by the pressures of the 1960s and 1970s, and it has thus raised many of

the key questions pertinent to the culture of our own time. But it still has done very little toward illuminating an emerging postmodern culture, and it has largely remained blind to or uninterested in many of the most promising artistic endeavors today. French theory of the 1960s and 1970s has offered us exhilarating fireworks which illuminate a crucial segment of the trajectory of modernism, but, as appropriate with fireworks, after dusk has fallen. This view is borne out by none less than Michel Foucault who, in the late 1970s, criticized his own earlier fascination with language and epistemology as a limited project of an earlier decade: "The whole relentless theorization of writing which we saw in the 1960s was doubtless only a swansong."[63] Swansong of modernism, indeed; but as such already a moment of the postmodern. Foucault's view of the intellectual movement of the 1960s as a swansong, it seems to me, is closer to the truth than its American rewriting, during the 1970s, as the latest avantgarde.

Whither Postmodernism?

The cultural history of the 1970s still has to be written, and the various postmodernisms in art, literature, dance, theater, architecture, film, video, and music will have to be discussed separately and in detail. All I want to do now is to offer a framework for relating some recent cultural and political changes to postmodernism, changes which already lie outside the conceptual network of "modernism/avantgardism" and have so far rarely been included in the postmodernism debate.[64]

I would argue that the contemporary arts—in the widest possible sense, whether they call themselves postmodernist or reject that label—can no longer be regarded as just another phase in the sequence of modernist and avantgardist movements which began in Paris in the 1850s and 1860s and which maintained an ethos of cultural progress and vanguardism through the 1960s. On this level, postmodernism cannot be regarded simply as a sequel to modernism, as the latest step in the never-ending revolt of modernism against itself. The postmodern sensibility of our time is different from both modernism *and* avantgardism precisely in that it raises the question of cultural tradition and conservation in the most fundamental way as an aesthetic and a political issue. It doesn't always do it successfully, and often does it exploitatively. And yet, my main point about contemporary postmodernism is that it operates in a field of tension between tradition and innovation, conservation and renewal, mass culture and high art, in which the second terms are no longer automatically privileged over the

first; a field of tension which can no longer be grasped in categories such as progress vs. reaction, left vs. right, present vs. past, modernism vs. realism, abstraction vs. representation, avantgarde vs. Kitsch. The fact that such dichotomies, which after all are central to the classical accounts of modernism, have broken down is part of the shift I have been trying to describe. I could also state the shift in the following terms: Modernism and the avantgarde were always closely related to social and industrial modernization. They were related to it as an adversary culture, yes, but they drew their energies, not unlike Poe's *Man of the Crowd*, from their proximity to the crises brought about by modernization and progress. Modernization—such was the widely held belief, even when the word was not around—had to be traversed. There was a vision of emerging on the other side. The modern was a world-scale drama played out on the European and American stage, with mythic modern man as its hero and with modern art as a driving force, just as Saint-Simon had envisioned it already in 1825. Such heroic visions of modernity and of art as a force of social change (or, for that matter, resistance to undesired change) are a thing of the past, admirable for sure, but no longer in tune with current sensibilities, except perhaps with an emerging apocalyptic sensibility as the flip side of modernist heroism.

Seen in this light, postmodernism at its deepest level represents not just another crisis within the perpetual cycle of boom and bust, exhaustion and renewal, which has characterized the trajectory of modernist culture. It rather represents a new type of crisis *of* that modernist culture itself. Of course, this claim has been made before, and fascism indeed was a formidable crisis *of* modernist culture. But fascism was never the alternative to modernity it pretended to be, and our situation today is very different from that of the Weimar Republic in its agony. It was only in the 1970s that the historical limits of modernism, modernity, and modernization came into sharp focus. The growing sense that we are not bound to *complete* the project of modernity (Habermas' phrase) and still do not necessarily have to lapse into irrationality or into apocalyptic frenzy, the sense that art is not exclusively pursuing some telos of abstraction, non-representation, and sublimity—all of this has opened up a host of possibilities for creative endeavors today. And in certain ways it has altered our views of modernism itself. Rather than being bound to a one-way history of modernism which interprets it as a logical unfolding toward some imaginary goal, and which thus is based on a whole series of exclusions, we are beginning to explore its contradictions and contingencies, its tensions and internal resistances to its own "forward" movement. Postmodernism is far from making

modernism obsolete. On the contrary, it casts a new light on it and appropriates many of its aesthetic strategies and techniques inserting them and making them work in new constellations. What has become obsolete, however, are those codifications of modernism in critical discourse which, however subliminally, are based on a teleological view of progress and modernization. Ironically, these normative and often reductive codifications have actually prepared the ground for that repudiation of modernism which goes by the name of the postmodern. Confronted with the critic who argues that this or that novel is not up to the latest in narrative technique, that it is regressive, behind the times and thus uninteresting, the postmodernist is right in rejecting modernism. But such rejection affects only that trend within modernism which has been codified into a narrow dogma, not modernism as such. In some ways, the story of modernism and postmodernism is like the story of the hedgehog and the hare: the hare could not win because there always was more than just one hedgehog. But the hare was still the better runner . . .

The crisis of modernism is more than just a crisis of those trends within it which tie it to the ideology of modernization. In the age of late capitalism, it is also a new crisis of art's relationship to society. At their most emphatic, modernism and avantgardism attributed to art a privileged status in the processes of social change. Even the aestheticist withdrawal from the concern of social change is still bound to it by virtue of its denial of the status quo and the construction of an artificial paradise of exquisite beauty. When social change seemed beyond grasp or took an undesired turn, art was still privileged as the only authentic voice of critique and protest, even when it seemed to withdraw into itself. The classical accounts of high modernism attest to that fact. To admit that these were heroic illusions—perhaps even necessary illusions in art's struggle to survive in dignity in a capitalist society—is not to deny the importance of art in social life.

But modernism's running feud with mass society and mass culture as well as the avantgarde's attack on high art as a support system of cultural hegemony always took place on the pedestal of high art itself. And certainly that is where the avantgarde has been installed after its failure, in the1920s, to create a more encompassing space for art in social life. To continue to demand today that high art leave the pedestal and relocate elsewhere (wherever that might be) is to pose the problem in obsolete terms. The pedestal of high art and high culture no longer occupies the privileged space it used to, just as the cohesion of the class which erected its monuments on that pedestal is a thing of the past; recent conservative attempts in a number of Western countries to

restore the dignity of the classics of Western Civilization, from Plato via Adam Smith to the high modernists, and to send students back to the basics, prove the point. I am not saying here that the pedestal of high art does not exist any more. Of course it does, but it is not what it used to be. Since the 1960s, artistic activities have become much more diffuse and harder to contain in safe categories or stable institutions such as the academy, the museum or even the established gallery network. To some, this dispersal of cultural and artistic practices and activities will involve a sense of loss and disorientation; others will experience it as a new freedom, a cultural liberation. Neither may be entirely wrong, but we should recognize that it was not only recent theory or criticism that deprived the univalent, exclusive and totalizing accounts of modernism of their hegemonic role. It was the activities of artists, writers, film makers, architects, and performers that have pro- pelled us beyond a narrow vision of modernism and given us a new lease on modernism itself.

In political terms, the erosion of the triple dogma modernism/ mo- dernity/avantgardism can be contextually related to the emergence of the problematic of "otherness," which has asserted itself in the socio- political sphere as much as in the cultural sphere. I cannot discuss here the various and multiple forms of otherness as they emerge from differences in subjectivity, gender and sexuality, race and class, tem- poral *Ungleichzeitigkeiten* and spatial geographic locations and disloca- tions. But I want to mention at least four recent phenomena which, in my mind, are and will remain constitutive of postmodern culture for some time to come.

Despite all its noble aspirations and achievements, we have come to recognize that the culture of enlightened modernity has also always (though by no means exclusively) been a culture of inner and outer imperialism, a reading already offered by Adorno and Horkheimer in the 1940s and an insight not unfamiliar to those of our ancestors involved in the multitude of struggles against rampant modernization. Such imperialism, which works inside and outside, on the micro and macro levels, no longer goes unchallenged either politically, economi- cally, or culturally. Whether these challenges will usher in a more habitable, less violent and more democratic world remains to be seen, and it is easy to be skeptical. But enlightened cynicism is as insufficient an answer as blue-eyed enthusiasm for peace and nature.

The women's movement has led to some significant changes in social structure and cultural attitudes which must be sustained even in the face of the recent grotesque revival of American machismo. Directly and indirectly, the women's movement has nourished the emergence

of women as a self-confident and creative force in the arts, in literature, film, and criticism. The ways in which we now raise questions of gender and sexuality, reading and writing, subjectivity and enunciation, voice and performance are unthinkable without the impact of feminism, even though many of these activities may take place on the margin or even outside the movement proper. Feminist critics have also contributed substantially to revisions of the history of modernism, not just by unearthing forgotten artists, but also by approaching the male modernists in novel ways. This is true also of the "new French feminists" and their theorization of the feminine in modernist writing, even though they often insist on maintaining a polemical distance from an American-type feminism.[65]

During the 1970s, questions of ecology and environment have deepened from single-issue politics to a broad critique of modernity and modernization, a trend which is politically and culturally much stronger in West Germany than in the U.S. A new ecological sensibility manifests itself not only in political and regional subcultures, in alternative life-styles, and the new social movements in Europe, but it also affects art and literature in a variety of ways: the work of Joseph Beuys, certain land art projects, Christo's California running fence, the new nature poetry, the return to local traditions, dialects, and so on. It was especially due to the growing ecological sensibility that the link between certain forms of modernism and technological modernization has come under critical scrutiny.

There is a growing awareness that other cultures, non-European, non-Western cultures must be met by means other than conquest or domination, as Paul Ricoeur put it more than twenty years ago, and that the erotic and aesthetic fascination with "the Orient" and "the primitive"—so prominent in Western culture, including modernism—is deeply problematic. This awareness will have to translate into a type of intellectual work different from that of the modernist intellectual who typically spoke with the confidence of standing at the cutting edge of time and of being able to speak for others. Foucault's notion of the local and specific intellectual as opposed to the "universal" intellectual of modernity may provide a way out of the dilemma of being locked into our own culture and traditions while simultaneously recognizing their limitations.

In conclusion, it is easy to see that a postmodernist culture emerging from these political, social, and cultural constellations will have to be a postmodernism of resistance, including resistance to that easy postmodernism of the "anything goes" variety. Resistance will always have to be specific and contingent upon the cultural field within which it

operates. It cannot be defined simply in terms of negativity or non-identity à la Adorno, nor will the litanies of a totalizing, collective project suffice. At the same time, the very notion of resistance may itself be problematic in its simple opposition to affirmation. After all, there are affirmative forms of resistance and resisting forms of affirmation. But this may be more a semantic problem than a problem of practice. And it should not keep us from making judgments. How such resistance can be articulated in art works in ways that would satisfy the needs of the political *and* those of the aesthetic, of the producers and of the recipients, cannot be prescribed, and it will remain open to trial, error and debate. But it is time to abandon that dead-end dichotomy of politics and aesthetics which for too long has dominated accounts of modernism, including the aestheticist trend within post-structuralism. The point is not to eliminate the productive tension between the political and the aesthetic, between history and the text, between engagement and the mission of art. The point is to heighten that tension, even to rediscover it and to bring it back into focus in the arts as well as in criticism. No matter how troubling it may be, the landscape of the postmodern surrounds us. It simultaneously delimits and opens our horizons. It's our problem and our hope.

NOTES

Chapter 1. The Hidden Dialectic

1. The term "historical avantgarde" has been introduced by Peter Bürger in his *Theory of the Avant-Garde*, trans. Michael Shaw (Minneapolis: University of Minnesota Press, 1984). It includes mainly dadaism, surrealism and the post-revolutionary Russian avantgarde.

2. Cf. Theodor W. Adorno, "Culture and Administration," *Telos*, 37 (Fall 1978), 93–111.

3. See Donald Drew Egbert, *Social Radicalism and the Arts: Western Europe* (New York: Alfred A. Knopf, 1970).

4. On the authorship of relevant sections of the *Opinions*, see Matei Calinescu, *Faces of Modernity: Avantgarde, Decadence, Kitsch* (Bloomington: Indiana University Press, 1977), p. 101f.

5. See Egbert, *Social Radicalism and the Arts*; on bohemian subcultures, see Helmut Kreuzer, *Die Boheme* (Stuttgart: Metzler, 1971).

6. See David Bathrick and Paul Breines, "Marx und/oder Nietzsche: Anmerkungen zur Krise des Marxismus," in *Karl Marx und Friedrich Nietzsche*, ed. R. Grimm and J. Hermand (Königstein/Ts.: Athenäum, 1978).

7. See Andreas Huyssen, "Nochmals zu Naturalismus-Debatte und Linksopposition," in *Naturalismus-Ästhetizismus*, ed. Christa Bürger, Peter Bürger, and Jochen Schulte-Sasse (Frankfurt am Main: Suhrkamp, 1979).

8. V. I. Lenin, '*The Re-Organization of the Party*' and '*Party Organization and Party Literature*' (London: IMG Publications, 1972), p. 17.

9. See Hans-Jürgen Schmidt and Godehard Schramm, eds., *Sozialistische Realismuskonzeptionen: Dokumente zum 1. Allunionskongress der Sowjetschriftsteller* (Frankfurt am Main: Suhrkamp, 1974).

10. Jürgen Habermas, *Legitimation Crisis*, trans. Thomas McCarthy (Boston: Beacon Press, 1975); Oskar Negt and Alexander Kluge, *Öffentlichkeit und Erfahrung* (Frankfurt am Main: Suhrkamp, 1972).

11. See Bürger, *Theory of the Avant-Garde*, esp. chapter 1.

12. See Rainer Stollmann, "Fascist Politics as a Total Work of Art: Tendencies of the Aesthetization of Political Life in National Socialism," *New German Critique*, 14 (Spring 1978), 41–60.

13. See Walter Benjamin, "The Author as Producer," in *Understanding Brecht*, trans. Anna Bostock (London: New Left Books, 1973), p. 94

14. See Burkhardt Lindner and Hans Burkhard Schlichting, "Die Dekonstruktion der Bilder: Differenzierungen im Montagebegriff," *Alternative*, 122/123 (Oct./Dec. 1978), 218–21.

15. George Grosz and Wieland Herzfelde, "Die Kunst ist in Gefahr. Ein Orientierungsversuch" (1925), cited in Diether Schmidt, ed., *Manifeste—Manifeste. Schriften deutscher Künstler des 20. Jahrhunderts*, I (Dresden, n.d.), pp. 345–46.

16. See Karla Hielscher, "Futurismus und Kulturmontage," *Alternative*, 122/123 (Oct./Dec. 1978), 226–35.

17. Sergej Tretjakov, *Die Arbeit des Schriftstellers: Aufsätze, Reportage, Porträts* (Reinbek: Rowohlt, 1972), p. 87.

18. Ibid., p. 88.

19. Max Horkheimer and Theodor W. Adorno, *Dialectic of Enlightenment*, trans. John Cumming (New York: Herder & Herder, 1972).

20. See Walter Benjamin, "Theses on the Philosophy of History," in *Illuminations*, ed. Hannah Arendt (New York: Schocken Books, 1969).

Chapter 2. Adorno in Reverse

1. Jürgen Habermas, *Strukturwandel der Öffentlichkeit* (Neuwied/Berlin: Luchterhand, 1962). See also Habermas, "The Public Sphere," *New German Critique*, 3 (Fall, 1974), 49–55.

2. John Brenkman, "Mass Media: From Collective Experience to the Culture of Privatization," *Social Text*, 1 (Winter 1979), 101.

3. Ibid.

4. For a recent discussion of the interface between modernism and popular culture in Germany see Peter Jelavich, "Popular Dimensions of Modernist Elite Culture: The Case of Theatre in Fin-de-Siècle Munich," in Dominick LaCapra and Steven L. Kaplan, eds., *Modern European Intellectual History* (Ithaca and London: Cornell University Press, 1982), pp. 220–250.

5. Anthony Giddens, "Modernism and Postmodernism," *New German Critique*, 22 (Winter, 1981), 15. For a different approach to the problem of changes in perception in the 19th century see Anson G. Rabinbach, "The Body without Fatigue: A 19th-Century Utopia," in Seymour Drescher, David Sabean and Allan Sharlin, eds., *Political Symbolism in Modern Europe* (New Brunswick, N.J.: Transaction Books, 1982), pp. 42–62.

6. Wolfgang Schivelbusch, *Geschichte der Eisenbahnreise. Zur Industrialisierung von Raum und Zeit im 19. Jahrhundert* (Munich and Vienna: Hanser, 1977). Translated into English as *The Railway Journey* (New York: Urizen, 1979).

7. At the same time it should be noted that the major accounts of modernism in literature and art rarely if ever try to discuss the relationship of the modernist work of art to the social and cultural process of modernization at large.

8. I do not know of any specific study which traces the pervasive impact of the culture industry thesis on mass culture research in Germany. For the impact of Adorno and Horkheimer in the United States see Douglas Kellner, "Kulturindustrie und Massenkommunikation. Die kritische Theorie und ihre Folgen," in *Sozialforschung als Kritik*, ed. by Wolfgang Bonss and Axel Honneth (Frankfurt am Main: Suhrkamp, 1982), pp. 482–515.

9. For an excellent discussion of the theoretical and historical issues involved in an analysis of the modernism/mass culture/popular culture nexus see Thomas Crow, "Modernism and Mass Culture in the Visual Arts," in S. Guilbaut and D. Solkin, eds., *Modernism and Modernity* (Halifax, Nova Scotia: The Press of the Nova Scotia College of Art and Design, 1983).

10. Horkheimer/Adorno, *Dialectic of Enlightenment*, trans. John Cumming (New York: Herder & Herder, 1972), p. 121.

11. On the notion of affirmative culture see Herbert Marcuse, "The Affirmative Character of Culture," in *Negations* (Boston: Beacon Press, 1968).

12. Adorno, "Culture Industry Reconsidered," *New German Critique*, 6 (Fall 1975), 13.

13. Adorno, *Dissonanzen*, in *Gesammelte Schriften*, vol. 14 (Frankfurt am Main: Suhrkamp, 1973), p. 20.

14. On the usage of ship and ocean metaphors in the history of department stores see Klaus Strohmeyer, *Warenhäuser. Geschichte, Blüte und Untergang im Warenmeer* (Berlin: Wagenbach, 1980). For a recent study of commodity culture in late 19th-century France see Rosalind H. Williams, *Dream Worlds: Mass*

Consumption in Late 19th-Century France (Berkeley/Los Angeles/London: University of California Press, 1982).

15. Adorno, *Minima Moralia: Reflections from a Damaged Life*, trans. E. F. N. Jephcott (London: New Left Books, 1974), p. 229.

16. Ibid., p. 230.

17. Jessica Benjamin, "Authority and the Family Revisited: Or, World Without Fathers?," *New German Critique*, 13 (Winter 1978), 35–58.

18. Printed in Walter Benjamin, *Gesammelte Schriften*, I:3 (Frankfurt am Main: Suhrkamp, 1974), p. 1003.

19. Fred Jameson, "Reification and Utopia in Mass Culture," *Social Text*, 1 (Winter 1979), 135.

20. Ibid.

21. Miriam Hansen, "Introduction to Adorno's 'Transparencies on Film'," *New German Critique*, 24–25 (Fall/Winter 1981–82), 186–198.

22. Horkheimer/Adorno, "Das Schema der Massenkultur," in Adorno, *Gesammelte Schriften*, 3 (Frankfurt am Main: Suhrkamp, 1981), p. 331.

23. Ibid.

24. Jochen Schulte-Sasse, "Gebrauchswerte der Literatur," in Christa Bürger, Peter Bürger and Jochen Schulte-Sasse, eds., *Zur Dichotomisierung von hoher und niederer Literatur* (Frankfurt am Main: Suhrkamp, 1982), pp. 62–107.

25. Adorno, "Zu Subjekt und Objekt," in *Stichworte* (Frankfurt am Main: Suhrkamp, 1969), p. 165.

26. Ibid. On Adorno's relationship to early German romanticism see Jochen Hörisch, "Herrscherwort, Geld und geltende Sätze: Adornos Aktualisierung der Frühromantik und ihre Affinität zur poststrukturalistischen Kritik des Subjekts," in B. Lindner/W. M. Lüdke, *Materialien zur ästhetischen Theorie Th. W. Adornos* (Frankfurt am Main: Suhrkamp, 1980), pp. 397–414.

27. Adorno, "Sexualtabus und Rechte heute," in *Eingriffe* (Frankfurt am Main: Suhrkamp, 1963), p. 104 f.

28. Adorno, *Negative Dialectics*, trans. E. B. Ashton (London: Seabury Press, 1973), p. 221 f. (trans. modified).

29. See for instance Bertold Hinz, *Die Malerei im deutschen Faschismus* (Munich: Hanser, 1974).

30. Peter Bürger, *Theory of the Avant-Garde* (Minneapolis: University of Minnesota Press, 1984).

31. Adorno, *Philosophy of Modern Music* (New York: Seabury Press, 1973), p. 30.

32. Peter Bürger, *Vermittlung-Rezeption-Funktion* (Frankfurt am Main: Suhrkamp, 1979), p. 130 f. Eugene Lunn, in his valuable study *Marxism and Modernism* (Berkeley, Los Angeles and London: University of California, 1982), has emphasized Adorno's indebtedness to the "aesthetic of objectified expression" prevalent in Trakl, Heym, Barlach, Kafka and Schönberg.

33. Adorno, *Ästhetische Theorie* (Frankfurt am Main: Suhrkamp, 1970), p. 16.

34. Ibid., p. 38.

35. Ibid.—The problem here is a historical one, namely that of non-simultaneous developments in different countries and different art forms. Explaining such *Ungleichzeitigkeiten* is no easy task, but it certainly requires a theory of modernism able to relate artistic developments more cogently to social, political and economic context than Adorno's (theoretically grounded) *Berührungsangst* would permit him to do. This is not to say that Adorno misunderstood the genuine modernity of Baudelaire or Manet. On the contrary, it is precisely in the way in which Adorno distinguishes Wagner from the early French modernists that we can glimpse his recognition of such *Ungleichzeitigkeiten*. More on this later.

36. Adorno, *Noten zur Literatur*, I (Frankfurt am Main: Suhrkamp, 1958), p. 72.

37. Horkheimer/Adorno, *Dialectic of Enlightenment*, p. 163.

38. Adorno, *Ästhetische Theorie*, p. 352.

39. Ibid.

40. Ibid., p. 355.

41. Adorno, *Gesammelte Schriften*, 13 (Frankfurt am Main: Suhrkamp, 1971), p. 504. For a good discussion of Adorno's Schönberg interpretation see Lunn, *Marxism and Modernism*, pp. 256–266. The question of whether Adorno is right about Wagner from a musicological standpoint cannot be addressed here. For a musicological critique of Adorno's Wagner see Carl Dahlhaus, "Soziologische Dechiffrierung von Musik: Zu Theodor W. Adornos Wagner Kritik," *International Review of the Aesthetics and Sociology of Music*, 1:2 (1970), 137–146.

42. Adorno, *Gesammelte Schriften*, 16 (Frankfurt am Main: Suhrkamp, 1978), p. 562.

43. Adorno, *In Search of Wagner*, trans. Rodney Livingstone (London: New Left Books, 1981), p. 31 (transl. modified).

44. Ibid. Cf. also Michael Hays, "Theater and Mass Culture: The Case of the Director," *New German Critique*, 29 (Spring/Summer 1983), 133–146.

45. Ibid., p. 32.

46. Ibid., p. 46.

47. Ibid., p. 33.

48. Adorno, *Gesammelte Schriften*, 13, p. 499.

49. Adorno, *In Search of Wagner*, p. 49.

50. Ibid., p. 50.

51. Ibid., p. 101.

52. Adorno, "Wagners Aktualität," in *Gesammelte Schriften*, 16, p. 555.

53. Adorno, *In Search of Wagner*, p. 50.

54. Ibid., p. 90.

55. Ibid.

56. Ibid., p. 95.

57. Ibid., p. 119.

58. Ibid., p. 123.

59. Ibid., p. 101.

60. Ibid., p. 107.

61. Ibid., p. 106.

62. Adorno, *Philosophy of Modern Music*, p. 5 (transl. modified).

Chapter 3. Mass Culture as Woman

1. Gustave Flaubert, *Madame Bovary*, trans. Merloyd Lawrence (Boston: Houghton Mifflin, 1969), p. 29.

2. Flaubert, p. 30.

3. Cf. Gertrud Koch, "Zwitter-Schwestern: Weiblichkeitswahn und Frauenhass—Jean-Paul Sartres Thesen von der androgynen Kunst," in *Sartres Flaubert lesen: Essays zu Der Idiot der Familie*, ed. Traugott König (Rowohlt: Reinbek, 1980), pp. 44–59.

4. Christa Wolf, *Cassandra: A Novel and Four Essays* (New York: Farrar, Straus, Giroux, 1984), p. 300f.

5. Wolf, *Cassandra*, p. 301.

6. Wolf, *Cassandra*, p. 300.

7. Stuart Hall, paper given at the conference on mass culture at the Center for Twentieth Century Studies, Spring 1984.

8. Theodor W. Adorno, "Culture Industry Reconsidered," *New German Critique*, 6 (Fall 1975), 12.

9. Max Horkheimer and Theodor W. Adorno, *Dialectic of Enlightenment* (New York: Continuum, 1982), p. 141.

10. Max Horkheimer and Theodor W. Adorno, "Das Schema der Massenkultur," in Adorno, *Gesammelte Schriften*, 3 (Frankfurt am Main: Suhrkamp, 1981), p. 305.

11. Siegfried Kracauer, "The Mass Ornament," *New German Critique*, 5 (Spring 1975), pp. 67–76.

12. Sandra M. Gilbert and Susan Gubar, "Sexual Linguistics: Gender, Language, Sexuality," *New Literary History*, 16, no. 3 (Spring 1985), 516.

13. For an excellent study of male images of femininity since the 18th century see Silvia Bovenschen, *Die imaginierte Weiblichkeit* (Frankfurt am Main: Suhrkamp, 1979).

14. Teresa de Lauretis, "The Violence of Rhetoric: Considerations on Representation and Gender," *Semiotica* (Spring 1985), special issue on the Rhetoric of Violence.

15. Edmond and Jules de Goncourt, *Germinie Lacerteux*, trans. Leonard Tancock (Harmondsworth: Penguin, 1984), p. 15.

16. *Die Gesellschaft*, 1, no. 1 (January 1885).

17. Cf. Cäcilia Rentmeister, "Berufsverbot für Musen," *Ästhetik und Kommunikation*, 25 (September 1976), 92–113.

18. Cf., for instance, the essays by Carol Duncan and Norma Broude in *Feminism and Art History*, ed. Norma Broude and Mary D. Garrard (New York: Harper & Row, 1982) or the documentation of relevant quotes by Valerie Jaudon and Joyce Kozloff, "'Art Hysterical Notions' of Progress and Culture," *Heresies*, 1, no. 4 (Winter 1978), 38–42.

19. Friedrich Nietzsche, *The Case of Wagner*, in *The Birth of Tragedy and the Case of Wagner*, trans. Walter Kaufmann (New York: Random House, 1967), p. 161.

20. Nietzsche, *The Case of Wagner*, p. 179.

21. Friedrich Nietzsche, *Nietzsche Contra Wagner*, in *The Portable Nietzsche*, ed. and trans. Walter Kaufmann (Harmondworth and New York: Penguin, 1976), pp. 665f.

22. Nietzsche, *The Case of Wagner*, p. 183.

23. Nietzsche, *Nietzsche Contra Wagner*, p. 666.

24. For a recent discussion of semantic shifts in the political and sociological discourse of masses, elites, and leaders from the late 19th century to fascism see Helmuth Berking, "Mythos und Politik: Zur historischen Semantik des Massenbegriffs," *Ästhetik und Kommunikation*, 56 (November 1984), 35–42.

25. An English translation of the two-volume work will soon be published by the University of Minnesota Press.

26. Gustave Le Bon, *The Crowd* (Harmondworth and New York: Penguin, 1981), p. 39.

27. Le Bon, p. 50.

28. Le Bon, p. 102.

29. Naturalism is not always included in the history of modernism because of its close relationship to realistic description, but it clearly belongs to this context as Georg Lukács never ceased to point out.

30. On the relationship of the production/consumption paradigm to the mass culture debate see Tania Modleski, "Femininity as Mas(s)querade: A Feminist Approach to Mass Culture," forthcoming in Colin MacCabe, ed., *High Theory, Low Culture*, University of Manchester Press.

31. Clement Greenberg, "Avant-Garde and Kitsch," in *Art and Culture: Critical Essays* (Boston: Beacon Press, 1961), p. 5f.

32. Letter of March 18, 1936, in Walter Benjamin, *Gesammelte Schriften*, 1, 3 (Frankfurt am Main: Suhrkamp, 1974), p. 1003.

33. T. S. Eliot, *Notes towards the Definition of Culture*, published with *The Idea of a Christian Society* as *Christianity and Culture* (New York: Harcourt, Brace, 1968), p. 142.

34. For a discussion of the neo-conservatives' hostility toward postmodernism see the essay "Mapping the Postmodern."

35. While critics seem to agree on this point in theory, there is a dearth of specific readings of texts or art works in which such a merger has been attempted. Much more concrete analysis has to be done to assess the results of this new constellation. There is no doubt in my mind that there are as many failures as there are successful attempts by artists, and sometimes success and failure reside side by side in the work of one and the same artist.

36. On this distinction between late 19th-century modernism and the historical avantgarde see Peter Bürger, *Theory of the Avant-Garde* (Minneapolis: University of Minnesota Press, 1984).

37. Cf. Gislind Nabakowski, Helke Sander, and Peter Gorsen, *Frauen in der Kunst*, 2 volumes (Frankfurt am Main: Suhrkamp, 1980), especially the contributions by Valie Export and Gislind Nabakowski in volume 1.

38. I owe this critical reference to Baudrillard to Tania Modleski's essay "Femininity as Mas(s)querade."

Chapter 4. The Vamp and the Machine

1. Cf. Paul M. Jensen, "Metropolis: The Film and the Book," in Fritz Lang, *Metropolis* (New York: Simon & Schuster, 1973), p. 13; Lotte Eisner, *The Haunted Screen* (Berkeley and Los Angeles: University of California Press, 1969), pp. 223 ff.

2. Randolph Bartlett, "German Film Revision Upheld as Needed Here," *The New York Times* (March 13, 1927).

3. Stresemann was one of the leading "reformist" politicians of the stabilization phase of the Weimar Republic after 1923.—Axel Eggebrecht, "Metropolis," *Die Welt am Abend* (January 12, 1927).

4. Goebbels at the Nuremburg Party Convention of 1934.

5. Siegfried Kracauer, *From Caligari to Hitler* (Princeton, New Jersey: Princeton University Press, 1947), p. 165.

6. Ibid., p. 164.

7. On the *Neue Sachlichkeit* see John Willett, *Art and Politics in the Weimar Period: The New Sobriety, 1917–1933* (New York: Pantheon Books, 1978). On the machine-cult of the 1920s see Helmut Lethen, *Neue Sachlichkeit 1924–1932* (Stuttgart: Metzler, 1970) and Teresa de Lauretis et al. (eds.), *The Technological Imagination* (Madison, Wisconsin: Coda Press, 1980), especially the section "Machines, Myths, and Marxism."

8. Stephen Jenkins, "Lang: Fear and Desire," in S. J. (ed.), *Fritz Lang: The Image and the Look* (London: British Film Institute, 1981), pp. 38–124, esp. pp. 82–87.

9. In the following I am indebted to Peter Gendolla, *Die lebenden Maschinen: Zur Geschichte der Maschinenmenschen bei Jean Paul, E. T. A. Hoffmann und Villiers de l'Isle Adam* (Marburg: Guttandin und Hoppe, 1980).

10. Examples would be Jean Paul's *Ehefrau als bloßem Holze (1789)*, Achim von Arnim's Bella in *Isabella von Ägypten* (1800), E. T. A. Hoffmann's Olympia in *Der Sandmann* (1815), and Villiers de l'Isle Adam's Hadaly in *L'Eve future* (1886), a novel which most strongly influenced Thea von Harbou in the writing of *Metropolis*. More recent examples would be Stanislav Lem's *The Mask* (1974), the puppet mistress in Fellini's *Casanova* (1976/77), and a number of works in the Franco-German art exhibit *Les machines célibataires* (1975).

11. The disruptions which the early railroads inflicted upon the human perceptions of time and space have been magnificently analyzed by Wolfgang Schivelbusch in his book *Geschichte der Eisenbahnreise: Zur Industrialisierung von Raum und Zeit* (Munich: Hanser, 1977); an English translation was published by Urizen in 1979. Cf. also Leo Marx, *The Machine in the Garden: Technology and the Pastoral Ideal in America* (New York: Oxford University Press, 1964).

12. Thea von Harbou, *Metropolis* (New York: Ace Books, 1963), p. 54.

13. Silvia Bovenschen, *Die imaginierte Weiblichkeit: Exemplarische Untersuchungen zu kulturgeschichtlichen und literarischen Präsentationsformen des Weiblichen* (Frankfurt am Main: Suhrkamp, 1979).

14. Norbert Elias, *The Civilizing Process: The Development of Manners* (New York: Urizen Books, 1978).

15. Ibid., p. 203.

16. See Max Horkheimer, *Eclipse of Reason* (New York: Oxford University Press, 1947) and Theodor W. Adorno/Max Horkheimer, *Dialectic of Enlightenment*, trans. John Cumming (New York: Herder & Herder, 1972).

17. In his thorough analysis of the Freikorps literature of the early Weimar Republic Klaus Theweleit has shown how in the presentation of proletarian women the themes of revolution and threatening sexuality are consistently interwoven. The way in which Lang places the working-class women in his film corroborates Theweleit's findings. Klaus Theweleit, *Männerphantasien: Frauen, Fluten, Körper, Geschichte*, vol. 1 (Frankfurt am Main: Verlag Roter Stern, 1977), esp. pp. 217 ff. English translation forthcoming from University of Minnesota Press.

18. See Cäcilia Rentmeister, "Berufsverbot für Musen," *Ästhetik und Kommunikation*, 25 (September 1976), 92–112.

19. "Allegory of the men-devouring machine." Veber's painting is discussed in Rentmeister's essay (see note 18) in relation to Georg Scholz' painting "Fleisch und Eisen" of 1923, a painting that can be attributed to *Neue Sachlichkeit*; it is also discussed in Theweleit, p. 454.

20. Eduard Fuchs, *Die Frau in der Karikatur* (Munich, 1906), p. 262.

21. On the cultural and political implications of Lang's ornamental style in *Metropolis*, cf. Siegfried Kracauer, "The Mass Ornament," *New German Critique*, 5 (Spring 1975), 67–76.

22. See Robert A. Armour, *Fritz Lang* (Boston: Twayne Publishers, 1977), p. 29.

23. That is the way Jenkins reads the sequence, "Lang: Fear and Desire," p. 86.

Chapter 5. Producing Revolution

Mauser was first published in an American translation in *New German Critique*, 8 (Spring 1976), 122–149. Quotations in this essay are from that edition.

1. For a more thorough discussion of *The Measures Taken* as *Lehrstück*, see Reiner Steinweg, *Das Lehrstück: Brechts Theorie einer politisch-ästhetischen Erziehung* (Stuttgart: Metzler, 1972) and Steinweg's articles in *Alternative*, 78–79 (June–August, 1971).

2. *Alternative*, 78–79 (June–August, 1971), 132.

3. *Sozialistisches Drama nach Brecht* (Neuwied: Luchterhand, 1974), p. 212 f. See also Schivelbusch's essay, "Optimistic Tragedies: The Plays of Heiner Müller," *New German Critique*, 2 (Spring, 1974), 104–113.

4. V. I. Lenin, "One Step Forward, Two Steps Back" in *Collected Works*, Vol. 7 (Moscow, 1965), p. 391.

5. See François George, "Forgetting Lenin," *Telos*, 18 (Winter, 1973–74), 53–88.

6. Concerning behaviorism, Brecht said: "Behaviorism is a psychology which begins with the needs of commodity production in order to develop methods with which to influence buyers, i.e., it is an active psychology, progressive and revolutionizing kathode (*Kathoxen*). In keeping with its capitalist function, it has its limits (the reflexes are biological; only in a few Chaplin films are they already social). Here, too, the path leads only over the dead body of capitalism, but here, too, this is a good path." "Der Dreigroschenprozess," in *Schriften zur Literatur und Kunst*, Vol. 1 (Frankfurt am Main: Suhrkamp, 1967), pp. 184–5.

Chapter 6. The Politics of Identification

1. F. J. Raddatz, "Rampe als Shiloh-Ranch," *Die Zeit*, American Edition, 11 (March 16, 1979), 7.

2. Alexander and Margarete Mitscherlich, *Die Unfähigkeit zu trauern: Grundlagen kollektiven Verhaltens* (Munich: Piper, 1967), esp. pp. 13–85.

3. Theodor W. Adorno, "Was bedeutet: Aufarbeitung der Vergangenheit?" (1959), in T. W. A., *Erziehung zur Mündigkeit* (Frankfurt am Main: Suhrkamp, 1972), pp. 10–28; Wolfgang Fritz Haug, *Der hilflose Antifaschismus* (Frankfurt am Main: Suhrkamp, 1970); Reinhard Kühnl, "Die Auseinandersetzung mit dem Faschismus in BRD und DDR," in: *BRD—DDR. Vergleich der Gesellschaftssysteme* (Cologne: Pahl-Rugenstein, 1971), pp. 248–278.

4. The first serious discussion of the guilt problematic was offered by Karl Jaspers in his book *Die Schuldfrage* which was first published in 1946. Significantly, it was reissued after the German showing of "Holocaust" in 1979, Piper Verlag, Munich.

5. *Im Kreuzfeuer: Der Fernsehfilm "Holocaust": Eine Nation ist betroffen*, ed. by Peter Märthesheimer and Ivo Frenzel (Frankfurt am Main: Fischer, 1979), p. 12 f.

6. Ibid., p. 15 f.

7. Ibid., p. 17.

8. Examples would be Carl Zuckmayer, *Des Teufels General* (1946), Walter Erich Schäfer, *Die Verschwörung* (1949), and Peter Lotar, *Das Bild des Menschen* (1952). For a more detailed discussion of these and other plays of the 1940s and 1950s see Andreas Huyssen, "Unbewältigte Vergangenheit—Unbewältigte Gegenwart," in *Geschichte im Gegenwartsdrama*, ed. by Reinhold Grimm and Jost Hermand (Stuttgart: Kohlhammer, 1976), pp. 39–53.

9. Anne Frank, *The Diary of a Young Girl* (New York: Doubleday, 1967), p. 306.

10. Bertolt Brecht, *Der Dreigroschenprozess*, Gesammelte Werke, 18 (Frankfurt am Main: Suhrkamp, 1967), p. 161.

11. Examples would be Hermann Moers' *Koll* (1962), Gert Hoffmann's *Der Bürgermeister* (1963).

12. Influential were especially Carl J. Friedrich, *Totalitäre Diktatur* (Stuttgart, 1957) and Hannah Arendt, *Elemente und Ursprünge totaler Herrschaft* (Frankfurt am Main: Ullstein, 1958).

13. See Hans Otto Ball in *Theater heute*, 3 (1961), 42, and Albert Schulze-Vellinghausen, *Theaterkritik 1952–1960* (Hannover: Velber, 1961), p. 226.

14. Heinz Beckmann, *Nach dem Spiel: Theaterkritiken 1950–1962* (Munich/Vienna: A. Langen/G. Müller, 1963), p. 313.

15. See Max Frisch, *Öffentlichkeit als Partner* (Frankfurt am Main: Suhrkamp, 1967), p. 68 f.

16. See Hans Mayer, *Zur deutschen Literatur der Zeit* (Reinbek: Rowohlt, 1967), pp. 300–319.

17. *Die Alternative oder Brauchen wir eine neue Regierung?*, ed. Martin Walser (Reinbek: Rowohlt, 1961).

18. Ulrich Sonnemann, "Der verwirkte Protest," *Merkur*, 178 (December 1962), 1147.

19. Martin Walser, "Vom erwarteten Theater," in *Erfahrungen und Leseerfahrungen* (Frankfurt am Main: Suhrkamp, 1965), p. 64.

20. See especially *Summa iniuria oder Durfte der Papst schweigen?*, ed. Fritz J. Raddatz (Reinbek: Rowohlt, 1963).

21. Theodor W. Adorno, "Offener Brief an Rolf Hochhuth," *Noten zur Literatur*, IV (Frankfurt am Main: Suhrkamp, 1974), pp. 137–146.

22. Rolf Hochhuth, "Die Rettung des Menschen," in *Festschrift zum achtzigsten Geburtstag von Georg Lukács*, ed. Frank Benseler (Neuwied: Luchterhand, 1965), pp. 484–490.

23. Adorno, "Offener Brief," p. 143.

24. See Ernst Bloch, "Non-Synchronism and the Obligation to Its Dialectics," *New German Critique*, 11 (Spring 1977), 22–38.

25. Significantly, the sequences in "Holocaust" showing members of the Weiss family in the extermination camp including the gas chambers are probably the least adequate of the film.

26. Peter Weiss, *Rapporte* (Frankfurt am Main: Suhrkamp, 1968), p. 114.

27. Published in book form as Bernd Naumann, *Auschwitz: A Report on the Proceedings Against R. K. L. Mulka and Others Before the Court at Frankfurt* (New York: Praeger, 1966).

28. Peter Weiss, *The Investigation*, tr. Jon Swan and Ulu Grosbard (New York, 1977), p. 108f.

29. See Moishe Postone's discussion of the West German Left and its relationship to Nazism and anti-Semitism in *New German Critique*, 19 (Winter 1980), 97–116.

30. Of course, there also must have been identification with the Dorf family. But if this identification lasted throughout the series rather than being increasingly displaced by identification with the Weiss family, then this would only point to the strength of repression mechanisms. Such an attitude is of course in itself anti-Semitic and not the subject matter of this essay.

Chapter 7. Memory, Myth, and the Dream of Reason

1. See the catalog *Der Maler Peter Weiss: Bilder, Zeichnungen, Collagen, Filme* (Berlin: Frölich und Kaufmann, n.d.).

2. Klaus R. Scherpe, "Reading *The Aesthetics of Resistance: Ten Working Theses*," *New German Critique*, 30 (Fall 1983), 97.

3. For more information on the German reception see the essay by Klaus Scherpe in *New German Critique*, 30 (Fall 1983) as well as Burkhardt Lindner's interview with Peter Weiss in the same issue.

4. In order to explore this question, which I cannot do in this essay, one might want to compare the relationship between *Die Ästhetik des Widerstands* and the accompanying *Notizbücher* [2 vols. (Frankfurt am Main: Suhrkamp, 1981)] to the relationship between Kafka's and Musil's novels and their respective diaries or that between Thomas Mann's *Doctor Faustus* and his *The Story of a Novel*.

5. Peter Weiss, *Notizbücher 1971–1980*, I (Frankfurt am Main: Suhrkamp, 1981), p. 172 f.

6. Peter Weiss im Gespräch mit Burkhardt Lindner, in: *Die Ästhetik des*

Widerstands lesen, ed. by Karl-Heinz Götze and Klaus R. Scherpe (Berlin: Argument Verlag, 1981), p. 155 f. An American translation of this interview appeared in *New German Critique,* 30 (Fall 1983), 107–126.

7. Peter Weiss, *Notizbücher 1971–1980,* II, p. 634. On Brecht in Weiss' novel cf. Jost Hermand, "The Super-Father: Brecht in *Die Ästhetik des Widerstands,*" *Communications from the International Brecht Society,* XIII:2 (April 1984), 3–12; Herbert Claas, "Ein Freund nicht, doch ein Lehrer. Brecht in der 'Ästhetik des Widerstands'," in *Die 'Ästhetik des Widerstands' lesen,* 146–149.

8. Some of these unflattering observations are actually not contained in the novel, but rather in the *Notizbücher.* See especially vol. I, p. 98 f.

9. Jost Hermand, "The Super-Father: Brecht in *Die Ästhetik des Widerstands,*" 4.

10. Weiss, *Notizbücher,* II, p. 543.

11. The noticeable differences between the surrealism of Weiss's novel and the *actes gratuits,* or the *écriture automatique* of the French surrealists, would deserve further detailed exploration. On this problem see Karl Heinz Bohrer, "Katastrophenphantasie oder Aufklärung? Zu Peter Weiss' 'Die Ästhetik des Widerstands'," *Merkur,* 332 (1976), 85–90; also Bohrer's work on the earlier Weiss in his *Die gefährdete Phantasie, oder Surrealismus und Terror* (Munich: Hanser, 1970). Bohrer's attempt to claim Weiss for a Nietzschean "aesthetics of terror" is convincingly criticized by Klaus Scherpe as an inadequate and short-circuited approach to Weiss. See Scherpe, "Kampf gegen die Selbstaufgabe: Ästhetischer Widerstand und künstlerische Authentizitat in Peter Weiss's Roman," in: *Die "Ästhetik des Widerstands" lesen,* p. 67 ff.

Chapter 8. The Cultural Politics of Pop

1. See Jost Hermand, *Pop International* (Frankfurt am Main: Athenäum, 1971), pp. 47–51.

2. In the early 1960s there were less than a thousand galleries in the FRG; in 1970 the number of galleries had more than doubled. See Gottfried Sello, "Blick zurück im Luxus," *Die Zeit,* 44 (November 1, 1974), 9.

3. See Hermand, *Pop International,* p. 14; Jürgen Wissmann, "Pop Art oder die Realität als Kunstwerk," *Die nicht mehr schönen Künste,* ed. H. R. Jauss (Munich: Wilhelm Fink, 1968), pp. 507–530.

4. Alan R. Solomon, "The New Art," *Art International,* 7:1 (1963), 37.

5. Thomas Mann, *Doctor Faustus,* trans. H. T. Lowe-Porter (New York: Alfred A. Knopf, 1948), p. 238 f.

6. Ibid., p. 240.

7. Theodor W. Adorno and Max Horkheimer, *Dialectic of Enlightenment,* trans. John Cumming (New York: Herder & Herder, 1972).

8. Theodor W. Adorno, "Résumé über die Kulturindustrie," *Ohne Leitbild* (Frankfurt am Main: Suhrkamp, 1967), p. 60. American translation "Culture Industry Reconsidered," *New German Critique,* 6 (Fall 1975), 12–19.

9. Herbert Marcuse, "The Affirmative Character of Culture," *Negations: Essays in Critical Theory* (Boston: Beacon Press, 1968), p. 114.

10. Ibid., p. 131.

11. Jürgen Habermas, "Bewußtmachende oder rettende Kritik—die Aktualität Walter Benjamins," *Zur Aktualität Walter Benjamins* (Frankfurt am Main: Suhrkamp, 1972), p. 178 f. American translation "Consciousness-Raising or Redemptive Criticism: The Contemporaneity of Walter Benjamin," *New German Critique,* 17 (Spring 1979), 30–59.

12. See Herbert Marcuse, *An Essay on Liberation* (Boston: Beacon Press, 1969); later, of course, Marcuse differentiated and modified his theses on

the basis of new developments within the student revolt, underground and counter-culture; see Herbert Marcuse, *Counterrevolution and Revolt* (Boston: Beacon Press, 1972).

13. This is so even though again and again there are critics who do not count Warhol among the Pop artists but see him as a genius sui generis.

14. For a description of Warhol's silk screen technique see Rainer Crone, *Andy Warhol* (New York: Praeger, 1970), p. 11.

15. In April 1974, the real *Mona Lisa* was carried in procession from the Louvre to Japan and was exhibited there rather as a stimulus to French national pride and Japanese business (cf. *Newsweek*, May 6, 1974, 44) than as a genuine attempt to take the masterpiece to the masses.

16. Cf. Catalogue of the latest Marcel Duchamp exhibit, edited by Anne d'Harnoncourt and Kynaston McShine (New York, 1973).

17. For a more elaborate interpretation of this work see Max Imdahl, "Vier Aspekte zum Problem der ästhetischen Grenzüberschreitung in der bildenden Kunst," *Die nicht mehr schönen Künste*, ed. H. R. Jauss (Munich: Wilhelm Fink, 1968), p. 494.

18. Ibid., p. 494.

19. The playing card Mona Lisa was exhibited at the latest Duchamp exhibit in New York (1973) and Chicago (1974).

20. See Hartmut Scheible, "Wow, das Yoghurt ist gut," *Frankfurter Hefte*, 27:11 (1972), 817–824.

21. Reprinted in John Russel and Suzi Gablik, *Pop Art Redefined* (New York: Praeger, 1969), p. 116.

22. See the essays collected and edited by Hermann K. Ehmer, *Visuelle Kommunikation: Beiträge zur Kritik der Bewußtseinsindustrie* (Cologne: Dumont, 1971) and Hermand, *Pop International*.

23. One might theorize that critical interest in comics as a form of popular culture is not unrelated to Lichtenstein's introduction of comics into the realm of high art.

24. See the essays by Heino R. Möller, Hans Roosen and Herman K. Ehmer in *Visuelle Kommunikation* for further discussion of the relationship between Pop and advertising.

25. Interview conducted by G. R. Swenson. Reprinted in Russel and Gablik, *Pop Art Redefined*, p. 111.

26. Cf. Hermand, *Pop International*, p. 50 f.

27. *Kursbuch*, 15 (November, 1968); *Die Zeit*, 48 (November 29, 1968), 22.

28. Ibid.

29. Karl Markus Michel, "Ein Kranz für die Literatur," *Kursbuch*, 15 (November, 1968), 177.

30. Hans Magnus Enzensberger, "Gemeinplätze, die Neueste Literatur betreffend," *Kursbuch*, 15 (November, 1968), 190.

31. Ibid., 195.

32. Ibid., 197.

33. This presentation of Enzensberger's position limits itself to the 1968 *Kursbuch* article. It neither deals with his earlier ideas nor with his later development, which would go beyond the scope of the problems under consideration in this article.

34. Ibid., 188.

35. This is not to deny that frequently the distribution apparatus has a direct impact on artistic production itself.

36. Walter Benjamin, "The Author as Producer," *Understanding Brecht*, trans. Anna Bostock (London: New Left Books, 1973), p. 94.

37. The debate took place in *Das Argument*, 46 (March, 1968), *Alternative*,

56/57 (October/December, 1967), and 59/60 (April/June, 1968), *Merkur*, 3 (1967) and 1–2 (1968), and *Frankfurter Rundschau*. For a detailed bibliography see *Alternative*, 59/60 (April/June, 1968), 93.

38. For differences between Benjamin and Marcuse see Habermas, "Bewußtmachende oder rettende Kritik," pp. 177–185.

39. Walter Benjamin, "The Work of Art in the Age of Mechanical Reproduction," in *Illuminations*, ed. by Hannah Arendt, trans. Harry Zohn (New York: Schocken Books, 1969), p. 217 f.

40. Benjamin, "Author as Producer," p. 94.

41. Ibid., p. 296.

42. Ibid.

43. Walter Benjamin, "Surrealism," in *Reflections*, ed. by Peter Demetz, trans. Edmond Jephcott (New York & London: Harcourt Brace Jovanovich, 1978), p. 191.

44. Benjamin, "Author as Producer," p. 94.

45. See the first book of Heartfield's work published in the Federal Republic; John Heartfield, *Krieg im Frieden* (Munich: Hanser, 1972).

46. Ibid., p. 87.

47. Ibid., p. 93.

48. For an explanation of Benjamin's notion of aura see Habermas, "Bewußtmachende oder rettende Kritik," Michael Scharang, *Zur Emanzipation der Kunst* (Neuwied: Luchterhand, 1971), pp. 7–25, Lienhard Wawrzyn, *Walter Benjamins Kunsttheorie. Kritik einer Rezeption* (Neuwied: Luchterhand, 1973), especially pp. 25–39.

49. Crone, *Warhol*.

50. Benjamin, "Mechanical Reproduction," p. 224.

51. *Documenta* V, Kassel 1972.

52. Hans Dieter Junker, "Die Reduktion der ästhetischen Struktur—Ein Aspekt der Kunst der Gegenwart," *Visuelle Kommunikation*, pp. 9–58.

53. See Henri Lefebvre, *Das Alltagsleben in der modernen Welt* (Frankfurt am Main: Suhrkamp, 1972), p. 26.

54. Karl Marx, *Economic and Philosophic Manuscripts of 1844*. Quoted from Marx and Engels, *On Literature and Art*, ed. Lee Baxandall and Stefan Morawski (St. Louis and Milwaukee, 1973), p. 51.

55. Karl Marx, *Theses on Feuerbach* (thesis 5).

56. For a discussion of commodity aesthetics see Wolfgang Fritz Haug, *Kritik der Warenästhetik* (Frankfurt am Main: Suhrkamp, 1971), and Lutz Holzinger, *Der produzierte Mangel* (Starnberg: Raith Verlag, 1973).

Chapter 9. The Search for Tradition

1. Catalogues: *Tendenzen der Zwanziger Jahre: 15. Europäische Kunstausstellung* (Berlin, 1977); *Wem gehört die Welt: Kunst und Gesellschaft in der Weimarer Republik*, Neue Gesellschaft für bildende Kunst (Berlin, 1977); *Paris—Berlin 1900–1933*, Centre Georges Pompidou (Paris, 1978). Robert Hughes' television series has also been published in book form as *The Shock of the New* (New York: Alfred A. Knopf, 1981). See also *Paris—Moscow 1900–1930*, Centre Georges Pompidou (Paris, 1979).

2. Walter Benjamin, "Theses on the Philosophy of History," in *Illuminations*, ed. Hannah Arendt (New York: Schocken Books, 1969).

3. Hans Magnus Enzensberger, "Die Aporien der Avantgarde," in *Einzelheiten: Poesie und Politik* (Frankfurt am Main: Suhrkamp, 1962). In this essay Enzensberger analyzes the contradictions in the temporal sensibility of avantgardism, the relationship of artistic and political avantgardes, and certain

post-1945 avantgarde phenomena such as *art informel*, action painting, and the literature of the beat generation. His major thesis is that the historical avantgarde is dead and that the revival of avantgardism after 1945 is fraudulent and regressive.

4. Max Frisch, "Der Autor und das Theater" (1964), in *Gesammelte Werke in zeitlicher Folge*, vol. 5:2 (Frankfurt am Main: Suhrkamp, 1976), p. 342.

5. *Partisan Review*, 26 (1959), 420–436. Reprinted in Irving Howe, *The Decline of the New* (New York: Harcourt, Brace and World, 1970), pp. 190–207.

6. Harry Levin, "What Was Modernism?" (1960), in *Refractions* (New York: Oxford University Press, 1966), p. 271.

7. It is not my purpose in this essay to define and delimit the term "postmodernism" conceptually. Since the 1960s the term has accumulated several layers of meaning which should not be forced into the straight-jacket of a systematic definition. In this essay the term "postmodernism" will variously refer to American art movements from pop to performance, to recent experimentalism in dance, theater and fiction, and to certain avantgardist trends in literary criticism from the work of Leslie Fiedler and Susan Sontag in the 1960s to the more recent appropriation of French cultural theory by American critics who may or may not call themselves postmodernists. Some useful discussions of postmodernism can be found in Matei Calinescu, *Faces of Modernity: Avant-Garde, Decadence, Kitsch* (Bloomington and London: Indiana University Press, 1977), especially pp. 132–143; and in a special issue on postmodernism of *Amerikastudien*, 2:1 (1977); this issue also contains a substantive bibliography on postmodernism, ibid., pp. 40–46.

8. Calinescu (see note 7); Peter Bürger, *Theorie der Avantgarde* (Frankfurt am Main: Suhrkamp, 1974), Engl. translation: *Theory of the Avant-Garde* (Minneapolis: University of Minnesota Press, 1984) *'Theorie der Avantgarde': Antworten auf Peter Bürgers Bestimmung von Kunst und bürgerlicher Gesellschaft*, ed. W. Martin Lüdke (Frankfurt am Main: Suhrkamp, 1976); Bürger's reply to his critics is contained in the introduction to his *Vermittlung-Rezeption-Funktion* (Frankfurt am Main: Suhrkamp, 1979); special issue on *Montage/Avantgarde* of the Berlin journal *Alternative*, 122–123 (1978). See also the essays by Jürgen Habermas, Hans Platscheck and Karl Heinz Bohrer in *Stichworte zur 'Geistigen Situation der Zeit,'* 2 vols., ed. Jürgen Habermas (Frankfurt am Main: Suhrkamp, 1979).

9. E.g., the 1979 conference on fascism and the avantgarde in Madison, Wisconsin: *Faschismus und Avantgarde*, ed. by Reinhold Grimm and Jost Hermand (Königstein/Ts.: Athenäum, 1980).

10. References in Calinescu, *Faces of Modernity*, p. 140 and p. 287, fn. 40.

11. John Weightman, *The Concept of the Avantgarde* (La Salle, Ill.: Library Press, 1973).

12. Calinescu, *Faces of Modernity*, p. 140.

13. Peter Bürger, *Theory of the Avant-Garde* (Minneapolis: University of Minnesota Press, 1984).

14. On the political aspects of the left avantgarde, see David Bathrick, "Affirmative and Negative Culture: Technology and the Left Avant-Garde," in *The Technological Imagination*, eds. Teresa de Lauretis, Andreas Huyssen, and Kathleen Woodward (Madison, Wis.: Coda Press, 1980), pp. 107–122.

15. See Enzensberger, "Aporien," p. 66f.

16. On Pop Art see my essay "The Cultural Politics of Pop" in this volume.

17. Leslie Fiedler, *The Collected Essays of Leslie Fiedler*, vol. II (New York: Stein and Day, 1971), pp. 454–461.

18. Reprinted in Leslie Fiedler, *A Fiedler Reader* (New York: Stein and Day, 1977), pp. 270–294.

19. Cf. many essays in the anthology *Mass Culture: The Popular Arts in America*, eds. Bernard Rosenberg and David Manning White (New York: The Free Press, 1957).

20. Hans Magnus Enzensberger, *Einzelheiten I: Bewußtseinsindustrie* (Frankfurt am Main: Suhrkamp, 1962).

21. Ihab Hassan, *Paracriticisms: Seven Speculations of the Times* (Urbana, Chicago, London: University of Illinois Press, 1975). See also Ihab Hassan, *The Right Promethean Fire: Imagination, Science and Cultural Change* (Urbana, Ill.: University of Illinois Press, 1980).

22. For an incisive critique of postmodernism from an aesthetically rather conservative position see Gerald Graff, "The Myth of the Postmodernist Breakthrough," TriQuarterly, 26 (1973), 383–417. The essay also appeared in Graff, *Literature Against Itself: Literary Ideas on Modern Society* (Chicago: University of Chicago Press, 1979), pp. 31–62.

23. See Serge Guilbaut, "The New Adventures of the Avant-Garde in America," *October*, 15 (Winter, 1980), 61–78. Cf. also Eva Cockroft, "Abstract Expressionism: Weapon of the Cold War," *Artforum*, XII (June 1974).

24. I am not identifying poststructuralism with postmodernism, even though the concept of postmodernism has recently been incorporated into French poststructuralist writing in the works of Jean-François Lyotard. All I am saying is that there are definite links between the ethos of postmodernism and the American appropriation of poststructuralism as the latest avantgarde in theory. For more on the postmodernism–poststructuralism constellation see the essay "Mapping the Postmodern."

25. For a sustained critique of the denial of history in contemporary American literary criticism see Fredric Jameson, *The Political Unconscious: Narrative as a Socially Symbolic Act* (Ithaca, N.Y.: Cornell University Press, 1981), especially chapter 1.

26. Hayden White, "The Burden of History," reprinted in *Tropics of Discourse: Essays in Cultural Criticism* (Baltimore, London: Johns Hopkins University Press, 1978), pp. 27–50.

27. Jürgen Habermas, "Modernity vs. Postmodernity," *New German Critique*, 22 (Winter 1981), 3–14.

28. Peter Bürger, "Avantgarde and Contemporary Aesthetics: A Reply to Jürgen Habermas," *New German Critique*, 22 (Winter 1981), 19–22.

29. See Peter Bürger, *Der französische Surrealismus* (Frankfurt am Main: Athenäum, 1971).

Chapter 10. **Mapping the Postmodern**

1. Catalogue, *Documenta 7* (Kassel: Paul Dierichs, n.d. [1982]), p. XV.

2. Ibid.

3. Of course, this is not meant as a "fair" evaluation of the show or of all the works exhibited in it. It should be clear that what I am concerned with here is the dramaturgy of the show, the way it was conceptualized and presented to the public. For a more comprehensive discussion of Documenta 7, see Benjamin H. D. Buchloh, "Documenta 7: A Dictionary of Received Ideas," *October*, 22 (Fall 1982), 105–126.

4. On this question see Fredric Jameson, "Postmodernism or the Cultural Logic of Capitalism," *New Left Review*, 146 (July–August 1984), 53–92, whose attempt to identify postmodernism with a new stage in the developmental logic of capital, I feel, overstates the case.

5. For a distinction between a critical and an affirmative postmodernism, see Hal Foster's introduction to *The Anti-Aesthetic* (Port Townsend, Washington:

Bay Press, 1984). Foster's later essay in *New German Critique*, 33 (Fall 1984), however, indicates a change of mind with regard to the critical potential of postmodernism.

6. For an earlier attempt to give a *Begriffsgeschichte* of postmodernism in literature, see the various essays in *Amerikastudien*, 22:1 (1977), 9–46 (includes a valuable bibliography). Cf. also Ihab Hassan, *The Dismemberment of Orpheus*, second edition (Madison: University of Wisconsin Press, 1982), especially the new "Postface 1982: Toward a Concept of Postmodernism," pp. 259–271.— The debate about modernity and modernization in history and the social sciences is too broad to document here; for an excellent survey of the pertinent literature, see Hans-Ulrich Wehler, *Modernisierungstheorie und Geschichte* (Göttingen: Vandenhoeck & Ruprecht, 1975).—On the question of modernity and the arts, see Matei Calinescu, *Faces of Modernity* (Bloomington: Indiana University Press, 1977); Marshall Berman, *All That Is Solid Melts Into Air: The Experience of Modernity* (New York: Simon & Schuster, 1982); Eugene Lunn, *Marxism and Modernism* (Berkeley and Los Angeles: University of California Press, 1982); Peter Bürger, *Theory of the Avantgarde* (Minneapolis: University of Minnesota Press, 1984). Also important for this debate is the recent work by cultural historians on specific cities and their culture, e.g., Carl Schorske's and Robert Waissenberger's work on fin-de-siècle Vienna, Peter Gay's and John Willett's work on the Weimar Republic, and, for a discussion of American anti-modernism at the turn of the century, T. J. Jackson Lears's *No Place of Grace* (New York: Pantheon, 1981).

7. On the ideological and political function of modernism in the 1950s cf. Jost Hermand, "Modernism Restored: West German Painting in the 1950s," *New German Critique*, 32 (Spring/Summer 1984), 23–41; and Serge Guilbaut, *How New York Stole the Idea of Modern Art* (Chicago: Chicago University Press, 1983).

8. For a thorough discussion of this concept see Robert Sayre and Michel Löwy, "Figures of Romantic Anti-Capitalism," *New German Critique*, 32 (Spring/Summer 1984), 42–92.

9. For an excellent discussion of the politics of architecture in the Weimar Republic see the exhibition catalogue *Wem gehört die Welt: Kunst und Gesellschaft in der Weimarer Republik* (Berlin: Neue Gesellschaft für die bildende Kunst, 1977), pp. 38–157. Cf. also Robert Hughes, "Trouble in Utopia," in *The Shock of the New* (New York: Alfred A. Knopf, 1981), pp. 164–211.

10. The fact that such strategies can cut different ways politically is shown by Kenneth Frampton in his essay "Towards a Critical Regionalism," in *The Anti-Aesthetic*, pp. 23–38.

11. Charles A. Jencks, *The Language of Postmodern Architecture* (New York: Rizzoli, 1977), p. 97.

12. For Bloch's concept of *Ungleichzeitigkeit*, see Ernst Bloch, "Non-Synchronism and the Obligation to its Dialectics," and Anson Rabinbach's "Ernst Bloch's *Heritage of our Times* and Fascism," in *New German Critique*, 11 (Spring 1977), 5–38.

13. Robert Venturi, Denise Scott Brown, Stephen Izenour, *Learning from Las Vegas* (Cambridge: MIT Press, 1972). Cf. also the earlier study by Venturi, *Complexity and Contradiction in Architecture* (New York: Museum of Modern Art, 1966).

14. Kenneth Frampton, *Modern Architecture: A Critical History* (New York and Toronto: Oxford University Press, 1980), p. 290.

15. I am mainly concerned here with the *Selbstverständnis* of the artists, and not with the question of whether their work really went beyond modernism or whether it was in all cases politically "progressive." On the politics of the Beat

rebellion see Barbara Ehrenreich, *The Hearts of Men* (New York: Doubleday, 1984), esp. pp. 52–67.

16. Gerald Graff, "The Myth of the Postmodern Breakthrough," in *Literature Against Itself* (Chicago: University of Chicago Press, 1979), pp. 31–62.

17. John Barth, "The Literature of Replenishment: Postmodernist Fiction," *Atlantic Monthly*, 245:1 (January 1980), 65–71.

18. Daniel Bell, *The Cultural Contradictions of Capitalism* (New York: Basic Books, 1976), p. 51.

19. The specific connotations the notion of postmodernity has taken on in the German peace and anti-nuke movements as well as within the Green Party will not be discussed here, as this article is primarily concerned with the American debate.—In German intellectual life, the work of Peter Sloterdijk is eminently relevant for these issues, although Sloterdijk does not use the word "postmodern"; Peter Sloterdijk, *Kritik der zynischen Vernunft*, 2 vols. (Frankfurt am Main: Suhrkamp, 1983), American translation forthcoming from University of Minnesota Press. Equally pertinent is the peculiar German reception of French theory, especially of Foucault, Baudrillard, and Lyotard; see for example *Der Tod der Moderne. Eine Diskussion* (Tübingen: Konkursbuchverlag, 1983). On the apocalyptic shading of the postmodern in Germany see Ulrich Horstmann, *Das Untier. Konturen einer Philosophie der Menschenflucht* (Wien-Berlin: Medusa, 1983).

20. The following section will draw on arguments developed less fully in the preceding article entitled "The Search for Tradition: Avantgarde and Postmodernism in the 1970s."

21. Peter Bürger, *Theory of the Avant-Garde* (Minneapolis: University of Minnesota Press, 1984). The fact that Bürger reserves the term avantgarde for mainly these three movements may strike the American reader as idiosyncratic or as unnecessarily limited unless the place of the argument within the tradition of 20th-century German aesthetic thought from Brecht and Benjamin to Adorno is understood.

22. This difference between modernism and the avantgarde was one of the pivotal points of disagreement between Benjamin and Adorno in the late 1930s, a debate to which Bürger owes a lot. Confronted with the successful fusion of aesthetics, politics, and everyday life in fascist Germany, Adorno condemned the avantgarde's intention to merge art with life and continued to insist, in best modernist fashion, on the autonomy of art; Benjamin, on the other hand, looking backward to the radical experiments in Paris, Moscow, and Berlin in the 1920s, found a messianic promise in the avantgarde, especially in surrealism, a fact which may help explain Benjamin's strange (and, I think, mistaken) appropriation in the U.S. as a postmodern critic *avant la lettre*.

23. Cf. my essay, "The Cultural Politics of Pop." From a different perspective, Dick Hebdige developed a similar argument about British pop culture at a talk he gave last year at the Center for Twentieth Century Studies at the University of Wisconsin-Milwaukee.

24. The Left's fascination with the media was perhaps more pronounced in Germany than it was in the United States. Those were the years when Brecht's radio theory and Benjamin's "The Work of Art in the Age of Mechanical Reproduction" almost became cult texts. See, for example, Hans Magnus Enzensberger, "Baukasten zu einer Theorie der Medien," *Kursbuch*, 20 (March 1970), 159–186. Reprinted in H. M. E., *Palaver* (Frankfurt am Main: Suhrkamp, 1974). The old belief in the democratizing potential of the media is also intimated on the last pages of Lyotard's *The Postmodern Condition*, not in relation to radio, film or television, but in relation to computers.

25. Leslie Fiedler, "The New Mutants" (1965), *A Fiedler Reader* (New York: Stein and Day, 1977), pp. 189–210.

26. Edward Lucie-Smith, *Art in the Seventies* (Ithaca: Cornell University Press, 1980), p. 11.

27. For a lucid discussion of Greenberg's theory of modern art in its historical context see T. J. Clark, "Clement Greenberg's Theory of Art," *Critical Inquiry*, 9:1 (September 1982), 139–156. For a different view of Greenberg see Ingeborg Hoesterey, "Die Moderne am Ende? Zu den ästhetischen Positionen von Jürgen Habermas und Clement Greenberg," *Zeitschrift für Ästhetik und allgemeine Kunstwissenschaft*, 29:2 (1984). On Adorno's theory of modernism see Eugene Lunn, *Marxism and Modernism* (Berkeley and Los Angeles: University of California Press, 1982); Peter Bürger, *Vermittlung-Rezeption-Funktion* (Frankfurt am Main: Suhrkamp, 1979), esp. pp. 79–92; Burkhardt Lindner and W. Martin Lüdke, eds., *Materialien zur ästhetischen Theorie: Th. W. Adornos Konstruktion der Moderne* (Frankfurt am Main: Suhrkamp, 1980).

28. See Craig Owens, "The Discourse of Others," in Hal Foster, ed., *The Anti-Aesthetic*, pp. 65–90.

29. It is with the recent publications of Fred Jameson and of Hal Foster's *The Anti-Aesthetic* that things have begun to change.

30. Of course, those who hold this view will not utter the word "realism" as it is tarnished by its traditionally close association with the notions of "reflection," "representation," and a transparent reality; but the persuasive power of the modernist doctrine owes much to the underlying idea that only modernist art and literature are somehow adequate to our time.

31. For a work that remains very much in the orbit of Marx's notion of modernity and tied to the political and cultural impulses of the American 1960s see Marshall Berman, *All That Is Solid Melts Into Air: The Experience of Modernity* (New York: Simon and Schuster, 1982). For a critique of Berman see David Bathrick, "Marxism and Modernism," *New German Critique*, 33 (Fall 1984), 207–218.

32. Jürgen Habermas, "Modernity versus Postmodernity," *New German Critique*, 22 (Winter 1981), 3–14. (Reprinted in Foster, ed., *The Anti-Aesthetic*.)

33. Jean-François Lyotard, "Answering the Question: What is Postmodernism?," in *The Postmodern Condition* (Minneapolis: University of Minnesota Press, 1984), pp. 71–82.

34. Martin Jay, "Habermas and Modernism," *Praxis International*, 4:1 (April 1984), 1–14. Cf. in the same issue Richard Rorty, "Habermas and Lyotard on Postmodernity," 32–44.

35. Peter Sloterdijk, *Kritik der zynischen Vernunft*. The first two chapters of Sloterdijk's essay appeared in English in *New German Critique*, 33 (Fall 1984), 190–206. Sloterdijk himself tries to salvage the emancipatory potential of reason in ways fundamentally different from Habermas', ways which could indeed be called postmodern. For a brief, but incisive discussion in English of Sloterdijk's work see Leslie A. Adelson, "Against the Enlightenment: A Theory with Teeth for the 1980s," *German Quarterly*, 57:4 (Fall 1984), 625–631.

36. Cf. Jürgen Habermas, "The Entwinement of Myth and Enlightenment: Re-reading *Dialectic of Enlightenment*," *New German Critique*, 26 (Spring–Summer 1982), 13–30.

37. Of course there is another line of argument in the book which *does* link the crisis of capitalist culture to economic developments. But I think that as a rendering of Bell's polemical stance my description is valid.

38. The editors, "A Note on *The New Criterion*," *The New Criterion*, 1:1 (September 1982), 1–5. Hilton Kramer, "Postmodern: Art and Culture in the 1980s," ibid., 36–42.

39. Bell, *The Cultural Contradictions of Capitalism*, p. 54.

40. I follow the current usage in which the term "critical theory" refers to a multitude of recent theoretical and interdisciplinary endeavors in the humanities. Originally, Critical Theory was a much more focused term that referred to the theory developed by the Frankfurt School since the 1930s. Today, however, the critical theory of the Frankfurt School is itself only a part of an expanded field of critical theories, and this may ultimately benefit its reinscription in contemporary critical discourse.

41. The same is not always true the other way round, however. Thus American practitioners of deconstruction usually are not very eager to address the problem of the postmodern. Actually, American deconstruction, such as practiced by the late Paul de Man, seems altogether unwilling to grant a distinction between the modern and the postmodern at all. Where de Man addresses the problem of modernity directly, as in his seminal essay "Literary History and Literary Modernity" in *Blindness and Insight*, he projects characteristics and insights of modernism back into the past so that ultimately all literature becomes, in a sense, essentially modernist.

42. A cautionary note may be in order here. The term poststructuralism is by now about as amorphous as 'postmodernism,' and it encompasses a variety of quite different theoretical endeavors. For the purposes of my discussion, however, the differences can be bracketed temporarily in order to approach certain similarities between different poststructuralist projects.

43. This part of the argument draws on the work about Foucault by John Rajchman, "Foucault, or the Ends of Modernism," *October*, 24 (Spring 1983), 37–62, and on the discussion of Derrida as a theorist of modernism in Jochen Schulte-Sasse's introduction to Peter Bürger, *Theory of the Avantgarde*, pp. vii–xlvii.

44. Jonathan Arac, Wlad Godzich, Wallace Martin, eds., *The Yale Critics: Deconstruction in America* (Minneapolis: University of Minnesota Press, 1983).

45. See Nancy Fraser, "The French Derrideans: Politicizing Deconstruction or Deconstructing Politics," *New German Critique*, 33 (Fall 1984), 127–154.

46. 'Bliss' is an inadequate rendering of *jouissance* as the English term lacks the crucial bodily and hedonistic connotations of the French word.

47. My intention is not to reduce Barthes to the positions taken in his later work. The American success of this work, however, makes it permissible to treat it as a symptom, or, if you will, as a "*mythologie.*"

48. Roland Barthes, *The Pleasure of the Text* (New York: Hill and Wang, 1975), p. 22.

49. See Tania Modleski, "The Terror of Pleasure: The Contemporary Horror Film and Postmodern Theory," paper given at a conference on mass culture, Center for Twentieth Century Studies, University of Wisconsin-Milwaukee, April 1984.

50. Barthes, *The Pleasure of the Text*, p. 38.

51. Ibid., p. 41 f.

52. Ibid., p. 14.

53. Thus the fate of pleasure according to Barthes was extensively discussed at a forum of the 1983 MLA Convention while, in a session on the future of literary criticism, various speakers extolled the emergence of a new historical criticism. This, it seems to me, marks an important line of conflict and tension in the current litcrit scene in the U.S.

54. Roland Barthes, *S/Z* (New York: Hill and Wang, 1974), p. 140.

55. Michel Foucault, "What Is an Author?" in *language, counter-memory, practice* (Ithaca: Cornell University Press, 1977), p. 138.

56. This shift in interest back to questions of subjectivity is actually also

present in some of the later poststructuralist writings, for instance in Kristeva's work on the symbolic and the semiotic and in Foucault's work on sexuality. On Foucault see Biddy Martin, "Feminism, Criticism, and Foucault," *New German Critique*, 27 (Fall 1982), 3–30. On the relevance of Kristeva's work for the American context see Alice Jardine, "Theories of the Feminine," *Enclitic*, 4:2 (Fall 1980), 5–15; and "Pre-Texts for the Transatlantic Feminist," *Yale French Studies*, 62 (1981), 220–236. Cf. also Teresa de Lauretis, *Alice Doesn't: Feminism, Semiotics, Cinema* (Bloomington: Indiana University Press, 1984), especially ch. 6 "Semiotics and Experience."

57. Jean François Lyotard, *La Condition Postmoderne* (Paris: Minuit, 1979). English translation *The Postmodern Condition* (Minneapolis: University of Minnesota Press, 1984).

58. The English translation of *La Condition Postmoderne* includes the essay, important for the aesthetic debate, "Answering the Question: What is Postmodernism?" For Kristeva's statement on the postmodern see "Postmodernism?" *Bucknell Review*, 25:11 (1980), 136–141.

59. Kristeva, "Postmodernism?" 137.

60. Ibid., 139 f.

61. In fact, *The Postmodern Condition* is a sustained attack on the intellectual and political traditions of the Enlightenment embodied for Lyotard in the work of Jürgen Habermas.

62. Fredric Jameson, "Foreword" to Lyotard, *The Postmodern Condition*, p. XVI.

63. Michel Foucault, "Truth and Power," in *Power/Knowledge* (New York: Pantheon, 1980), p. 127.

64. The major exception is Craig Owens, "The Discourse of Others," in Hal Foster, ed., *The Anti-Aesthetic*, p. 65–98.

65. Cf. Elaine Marks and Isabelle de Courtivron, eds., *New French Feminisms* (Amherst: University of Massachusetts Press, 1980). For a critical view of French theories of the feminine cf. the work by Alice Jardine cited in note 56 and her essay "Gynesis," *diacritics*, 12:2 (Summer 1982), 54–65.

Index of Names